✓ P9-CIT-099 3 1235 00181 5096

2/15

MAY 0 4 1994

ETRUSCAN CITIES AND THEIR CULTURE

ETRUSCAN CITIES AND THEIR CULTURE

Luisa Banti

translated by Erika Bizzarri

913,325 B228 1974

181-5096 Wel

WASHOE COUNTY LIBRARY RENO, NEVADA d1

University of California Press Berkeley and Los Angeles 1973

> WASHOE COUNTY LIBRARY RENO, NEVADA

University of California Press Berkeley and Los Angeles, California First published as Il mondo degli Etruschi (1968) by Biblioteca Di Storia Patria, Rome. First English language edition 1973 Published in Great Britain by B. T. Batsford Ltd, London. Copyright © Biblioteca Di Storia Patria, 1968

ISBN 0-520-1910-5 Library of Congress Catalog Card Number 74-145781

Printed in Great Britain.

CONTENTS

List of maps vi Acknowledgements vi

1. The Boundaries General Questions 1

2. Etruscan Art 22

3. Southern Etruria Caere 37 Veii 52
The Falisco-Capenate Territory 62 Tarquinii 70
Vulci; Statonia; The Valley of the River Fiora 84
Sovana and the Region of the Rock Tombs; Bisenzio, Tuscania 100

4. Central Etruria 110 Saturnia; Marsiliana 110 The Lake of Bolsena; Volsinii; Orvieto 118

5. Northern Etruria Vetulonia; Rusellae (Roselle) 128 Populonia 140 Volterra (ancient Volaterrae) 146 The Territory North of the Arno: Florence; Fiesole 156 Chiusi; Arezzo; Cortona; Perugia 162

6. Religion 179

7. Writing and Language 193

The History and Government of Etruscan Cities

 —The Problem of the Origins 199
 Etruscan Origins 208
 Notes on the Plates 212
 Select Bibliography 281
 Index of Authors 309
 General Index 310

V

MAPS

Ancient Etruria 3 Etruscan expansion in the plain of the Po 7 Etruscan expansion in Latium and Campania II Caere and its cemeteries 38 Veii: walls and cemeteries 55 The territory of Faleri and Capena 65 Villanovan graves near Tarquinia 71 The cemeteries at Vulci 91 Vetulonia 131 Populonia and its cemeteries 145 Volaterrae and its cemeteries 153 Chiusi and its cemeteries 165 Chiusi and the Val di Chiana 175

ACKNOWLEDGEMENTS

This book could not have been written without the help and unstinting collaboration of various people. I wish to express my unreserved thanks to the editorial director of the Biblioteca di Storia Patria, who smoothed out many difficulties for me; to the Soprintendenza alle Antichità in Florence and especially to the Superintendent himself, Dottore G. Maetzke; and to the American Academy in Rome, which did all it could to facilitate my work and research. But above all I wish to thank Professor Giovanni Camporeale, formerly my assistant, for the help which he gave so freely in some of the final collation and especially in the long, difficult revision of the proofs, which I was unable to supervise personally. To all, and especially to Professor Camporeale, my sincere gratitude.

Luisa Banti

General Questions

I

Etruria, the region of ancient Italy that was inhabited by the Etruscans, corresponds neither to modern Tuscany nor to the Etruria of Roman times.

We have no properly clear picture of just where the boundaries of Etruria were until 27 B.C. when the Emperor Augustus reorganized Italy for administrative purposes. The northern boundaries were then placed at the river Magra and the Apennines; those to the east and to the south at the Tiber for almost all its course. But the Etruria of 27 B.C. was the seventh region of Roman Italy, and not the Etruria of Etruscan times.

Nothing but approximate data is available for the period preceding the Roman conquest, which is the one we are interested in. This is partly due to the fact that boundaries change through the centuries, and these changes cannot always be verified, and partly for want of detailed descriptions of the kind Thucydides, a Greek historian who lived in the second half of the 5th century, supplied for Sicily before he went on to describe the Peloponnesian war. No historical, or geographical, works written by the Etruscans have survived.

By examining the occasional references of the ancient writers and comparing them with the area in which Etruscan inscriptions and objects, (made—as far as we know—by the Etruscans,) have been found, boundaries can be traced, but they should always be considered approximate. To the north these consisted of the Arno (Pisa on the right bank seems to have been outside Etruscan territory), its righthand tributary, the Ombrone, and the southernmost hills of the Apennines north of Pistoia; to the south, the Tiber; to the west, the Tyrrhenian Sea. The eastern limits present more of a problem. Between the point where the Arno swings out in a wide curve towards the Trasimene Lake and the lake itself, the Etruscans stopped at the foot of the Apennines, avoiding the mountains. It was not until the end of the 6th century B.C. that they went beyond Lake Trasimene and reached the Tiber. To the south it is questionable whether the Faliscans and the Capenati (see the map of the area, p. 3) to the right of the Tiber, were ever really conquered by the nearby Etruscan cities.

Within these boundaries lived a people which spoke and wrote Etruscan, a people whom the Greeks and Romans called Tyrrhenoi, or Etrusci, or Tusci, but which, according to Dionysius of Halicarnassus (1, 30) called itself Rasenna.

Ancient writers have given us the names of a few Etruscan cities, generally their Latin ones. The Etruscan names of others are known thanks to the inscriptions on late coins, but it is not always clear to which Roman or modern city the name corresponds. Other centres have been brought to light in the course of excavations but their names remain a mystery. Our knowledge of the history of individual cities is based primarily on their relations with Rome and their foundation legends, which were collected in the first half of the 2nd century B.C. by the Roman writer and statesman, Cato. Ancient writers were more interested in these legends than in factual history, but it is hard to say just how much truth there is in them. Each city wanted to have its own illustrious ancestors, if possible Greek, for the Etruscans, like the Romans after them, fell under the spell of Greece, although in a different way. They were aware above all of Greek art; they imported objects which served as models for artists and craftsmen; they acquired their style of temple decoration from the Greeks, or from Greek colonies. Greece, or her colonies, gave them their alphabet in the first half of the 7th century B.C. The oldest Etruscan inscriptions are probably those on the silver vessels found in the Regolini-Galassi tomb in Caere and dated around the middle of the 7th century B.C. Greece provided the Etruscans with those myths and legends which they transformed into pleasing decorative motifs. It is not strange therefore that they should readily have attributed the origin of their cities to a Greek, especially when the city had a name which more or less corresponded to one in Greece.

The smaller and less important a place was, the greater the tendency to have its origins shrouded in the mists of centuries. A small city like Cortona, certainly not one of the oldest, proudly claimed as its founder no less a personage than the father of Dardans who is said to have founded Troy when he arrived in Phrygia, in Asia Minor. This would make Cortona much older than Rome, which could trace its history no further back than Aeneas. So far excavations have failed to confirm the legendary Greek settlements on Etruscan coasts, at Pyrgi,

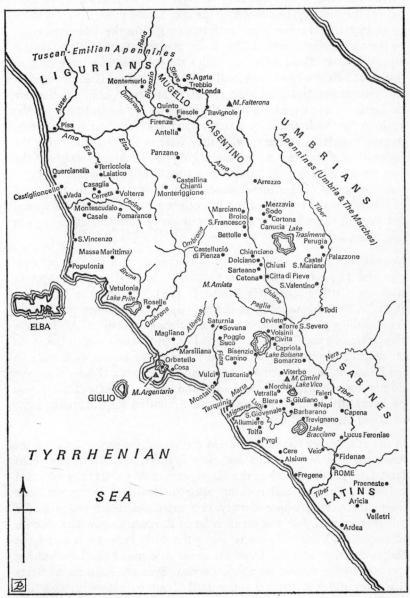

Talamone, Cosa, Pisa, and inland at Agylla (Caere), Cortona, Perugia, etc. On the contrary, in many cases the excavations prove the cities to be more recent (and sometimes much more so) than the date given them by their philhellenic legend. This is the case with Perugia, Cortona, and especially Cosa. These legends, which Cato collected in a book entitled Origines at a time when Rome itself had made a cult of Greece, are often still accepted on this great Roman writer's authority, although they are no better or more credible than those which local scholars, from the 17th to the 19th centuries A.D., worked out for their native cities, seeking founders in Greece, or, if they were in Etruria, attributing the foundation of the town to Porsenna, king of Clusium. Throughout the ages people have wanted famous ancestors to boast about.

At the height of their development and power, that is from the end of the 7th to the middle of the 5th century B.C., the Etruscans spread out beyond these boundaries and temporarily occupied other regions of ancient Italy.

Not much is known about an Etruscan occupation of Corsica. Between 540 and 535 B.C. the Etruscans alone (Diodorus V, 13), or together with the Carthaginians (Herodotus I, 166), defeated the Phocaeans at Alalia, in Corsica, and took the city. By 'Etruscans' they meant only the inhabitants of Caere, since the prisoners taken at Alalia were slaughtered by the Caeretans, who had to send an embassy to Delphi in atonement. Diodorus attributes the founding of Nicaea in Corsica to the Etruscans, but the name would seem to indicate a Greek origin. We do not know when the Etruscans lost the island, but in 452 B.C. it was probably still in their possession, for Syracusan ships devastated the coasts of Etruria and Corsica.

In the 6th century B.C. the Etruscans conquered the region between the Arno and the Magra rivers but they founded no cities there. Luni (anc. Luna) at the mouth of the Magra, came into existence as a Roman colony in 177 B.C. and nothing prior to that date has as yet been found there. Pisa, whose activity as a maritime centre began in the 7th century B.C., does not seem to be of Etruscan origin. The absence of important inhabited centres along the coast between Pisa and the Magra explains why the Etruscans never discovered the Luna marble quarries in the mountains above Carrara. Even the Romans, as far as that goes, did not discover them until about 50 B.C.—although they had lived at Luni for more than a century, only a short distance from

the wild steep valleys of the Apuan Alps, and had been using the port of Luna for almost two centuries. The Etruscan conquest north of Pisa was brief—it probably ended at the close of the 5th century B.C. when the Celts conquered the Po valley. The Etruscans did not settle in the swampy coastal area, only at the eastern extremity of the Arno valley, between the Ombrone River and the Apennines. The two routes which connected Etruria to Bologna passed here—the earlier one which follows the valleys of the Ombrone and of the Reno, the later route through the Mugello and the Giogo pass.

Ancient writers have had little to say about the conquest of the Po valley (see map, p. 7) and what little they have said is often vague and contradictory. Individual Etruscan cities are supposed to have founded cities in the area around the Po; according to Livy (V, 39) each Etruscan city had its own colony. Other sources refer to legendary foundations. According to Verrius Flaccus and Caecina, the Tarquinian hero Tarchon passed the Apennines and founded twelve cities in the Po valley after he had founded Tarquinii and the twelve Etruscan cities. The source for this version is obviously a Tarquinian tradition. Another local legend, which originated in Perugia, is the one mentioned by Servius (ad Aen., X, 198) according to which Ocnus, a brother or son of Aulestes, the founder of Perugia, emigrated to what is called Etruria Padana, where he founded Felsina (Bologna), and, according to Virgil, Mantua.

Livy (V, 33, 10) says that the Etruscans occupied the whole plain, up to the Alps, except the northeast corner where the Veneti lived. But it is probable that they never went further west than the Ticino River, and that Livy himself provides us with the extreme limits of Etruscan expansion when he writes that in the 4th century the Etruscans fought the Gauls, who were invading Italy, at the Ticino. There are no traces of the Etruscans in Piedmont: the crude funeral stele with an Etruscan inscription, found at Busca in the province of Cunea, in the territory of the Ligurian Vagienni, is too isolated to indicate an Etruscan conquest. The same can be said for the inscriptions in Genoa and Nice, either signs of commercial contacts, such as the Etruscan inscription on an ivory tablet in Carthage, or of an Etruscan settler, as the wrappings of the Egyptian mummy now in Zagreb. The Etruscans were good businessmen and the exigencies of their trade carried them far indeed from their native land, which quite agrees with what the ancients have to say about the Etruscan domain of the seas and with the cosmopolitan character of their civilization and their art.

Traditionally there were twelve Etruscan cities north of the Apennines, but the names of only five are known: Felsina (Bologna), Mantua (Mantova), a name thought to derive from Mantus, an Etruscan god of the underworld, a town called Melpum (whose whereabouts has never been settled) which is identified by some, without the slightest proof, with Milan; and the two port cities of Spina and Adria. We can add the nameless Etruscan city excavated at Marzabotto, south of Bologna, just where the Reno river and the road from Etruria leave the mountains for the plains. Whether Modena, Parma and Piacenza existed then as cities is doubtful. Livy does not say that they were Etruscan, but only that they were in territory which had belonged to the Etruscans, which is not at all the same thing. Only occasional finds have come from these two centres and their immediate surroundings, and they are insufficient to indicate an inhabited centre. Nor is it possible to decide whether Piacenza already existed when the Etruscans were in the Po valley. Here too we lack both regular excavations and chance finds dating to Etruscan times. True, the famous bronze liver with Etruscan inscriptions was found near the city, but that proves nothing for it dates from the 3rd century B.C. The Etruscans had left the valley of the Po more than a century before. They settled principally around Bologna and Spina.

The objects imported to the Po Valley from Etruria are few in number and, above all, rather unimportant. They consist of a few vases from Volterra or Clusium, which are however later than the date generally accepted for the end of Etruscan rule north of the Apennines; a few pieces of gold jewellery of the late 7th century, made in Vetulonia; a bucchero, an occasional ivory plaque (500-480 B.C.); the handle of a crater (Pl, 60) found at Spina, a bronze tripod (a verghette: with rod legs) also from Spina, various small bronzes and candelabra belonging to the group known as Vulci bronzes, which Etruria exported to various parts of Europe. The fine Attic pottery for which the excavations of Spina are famous, and which was also found at Adria and Felsina and (in lesser number) at Marzabotto, as well as a Corinthian vase, did not come via Etruria but arrived directly from Greece at the ports of Adria and Spina. While there are not many Etruscan inscriptions, they confirm Etruscan occupation. Inscriptions also reveal that Greeks lived together with the Etruscans at Adria and at Spina, and there were even some Veneti at Adria. There seems to have been virtually no trade between the valley of the Po and Corinth.

Greek and Roman sources mention various peoples as inhabitants of the Po valley: Ligurians, Pelasgians, Etruscans, Umbrians, Gauls, and along the coast, the Greeks. When the Romans conquered the region, they found Ligurians in the Apennines, and Gauls on the plains. They knew that Etruscans had been there before the Gallic conquest. Excavations in the area have revealed the presence of a Stone Age culture, a Bronze Age one, and, later, an Iron Age culture. Their features vary from one site to another. South-east of the Po we can form a fairly clear picture of the Villanovan culture in the Iron Age and of the Roman culture, but the intermediate Etruscan and Gallic periods remain obscure.

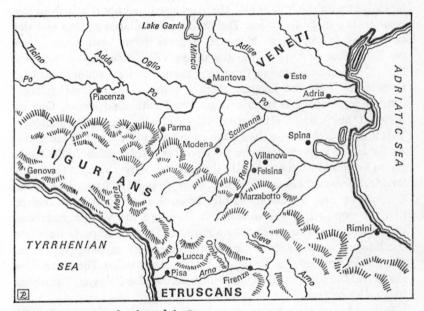

Etruscan expansion in the plain of the Po

Finds and excavations seem to indicate that the Villanovans were an agricultural people who lived in small villages. There were no major urban centres which might have gone by the name of 'cities'. Where Bologna was later to be there were independent groups of huts, the dwellings of peoples attracted to the area because it was crossed by the 'salt route' as well as by the route which joined Etruria to the Po

valley passing through the Apennines. They were a peaceful people: no fortifications have been found and the very fact that they lived on the plains shows that they were not worried about defending themselves against possible enemies.

The Etruscans may have arrived as the result of an economic expansion. The cities involved seem to have been primarily those of northern Etruria. Inscriptions testify to the presence of a Volterran family, the Caecina, at Bologna. It was the Etruscans who brought the alphabet to the Po valley. Marzabotto testifies to the fact that not until then was the concept of 'city' formed. The oldest temple north of the Apennines is the one at Marzabotto (5th century B.C.).

Bologna, the Etruscan Felsina, owes its growth, as previously stated, to its being on the 'salt route', the road used to import salt from the coast to the inner Po valley. The remains of Villanovan huts and the cemeteries belonging to these settlements have been found. The small number of tombs from the oldest Villanovan period indicates that this civilization began there later than it did in southern Etruria. Cemeteries from the Etruscan period contain fossa tombs (trench tombs) for cremation burials, often lined with field stones. One of these, in the Giardino Margherita, was faced with dressed stone blocks. This tomb is erroneously thought to have been a free-standing structure. As far as we know there were no chamber tombs either built above ground or dug into the rock, like the contemporary chamber tombs in Etruria. Etruscan Felsina has not been found. Perhaps, like other Etruscan centres, it was on the hill. From the necropolis it is evident that the population was wealthy; it imported many Attic vases and even a Corinthian one found its way there. The first imports were late black-figure vases, to be followed by quantities of red-figure ware. The tombs were marked by cippi and particularly stelae. The horse-shoe shape and the low flat relief were characteristic for Bologna. The oldest had a disc on top.

Early scholars who wrote on Bologna (Gozzadini, Grenier, Ducati) stated that the cemeteries of Villanovan Bologna and those of the Etruscan centres were distinct from each other, but this is not so.

The Etruscan town of Marzabotto, on the left bank of the Reno, the only Etruscan city whose plan is clear to us, is a special case. Brizio already recognized its regular urban layout. The main street running north—south (the cardo) is crossed by streets that run east—west (the decumanus and two parallel streets). Narrow secondary streets,

parallel to the cardo, cut the decumanus. A large pebble was set upright in the ground below street level at the intersection of the cardo and the decumanus. It had two grooves in the form of a cross cut on the top. This stone marks the centre of the urban system. Three other similar cippi were found at the crossings of other streets, under which they had been buried in antiquity. They play an important part in ancient city planning. Recent excavations have shown that Marzabotto is a compromise between Etruscan doctrine and Greek city planning. The southern part of the city has been eaten away by the river Reno.

Various buildings were on the hill above the city, the acropolis. Only the foundations, which have been interpreted as temple foundations, remain, but over zealous restoration has obscured their plans. One seems to have been a temple, perhaps with three cellae. The attributions of three other buildings are questionable. In the city only the foundations of houses have so far come to light. The hypothesis that the Roman house with a central atrium (Tuscan atrium) came to Rome from Etruria has not been confirmed by excavations at Marzabotto.

The trade route through the valleys of the Ombrone and the Reno across the Apennines (see pp. 154 ff.), may explain the early finds and the hut floors mentioned by Brizio as having been found at Marzabotto, but nothing remains of these. The city has a different origin.

Recent excavations have turned up the remnants of a foundry and iron slag. The ore came from a mine in the Apennines, a mine whose existence was still known in the Middle Ages. This explains the presence of an inhabited centre with a regular city plan in an area unsuitable both for farming and for defending the valley of the Reno from incursions by the Ligurians who lived in the Apennines. Marzabotto came into being as a centre which exploited iron, perhaps at the beginning of the 6th century B.C.

In the entire Po valley Etruscan influence is most evident at Marzabotto. The mouldings of two buildings on the acropolis are quite close to Etruscan ones; a cippus, with rams' heads at the corners, also belongs to the Etruscan repertory; an ivory plaque carved in relief with doves looks Etruscan; the only stele found there is closer to those of northern Etruria than to those of Bologna. Some fine small bronzes, recently published by G. A. Mansuelli, are of higher quality, artistically, than any that had previously been found in Marzabotto. It is difficult to establish what Etruscan centre they came from. The dark impasto

pottery should perhaps be related to that found in the so-called 'Ligurian' tombs north of the Arno where it continued up to Roman times. We also find definite contacts with the Po region and its culture: the head of a Greek kouros did not arrive at Marzabotto via Etruria. The antefixes, such as the ones with palmettes, are more like those in Campania than those in Etruria. The amber jewellery too indicates contact with the Po valley.

Two 'Etruscan' cemeteries—one to the north and one to the east of Marzabotto—have been found, as well as a Gallic one. But the whole question of the Gallic period at Marzabotto needs to be re-examined.

The original name of the city is not known. Misano, by which the site is now known, may preserve the name of the small Etruscan city, but it is more likely that the name is of Roman origin and the remains of a building from that period have been found.

At present Bologna and Marzabotto are the most important centres for the study of the Etruscans in the Po valley. They are the only cities in which occasional contacts with Etruria proper can be identified (see 'Volterra', chapter 5.)

Spina, to which so much attention has been drawn because of the successful excavations of its rich cemeteries, is of little importance as far as Etruria is concerned. Ancient writers mention the port of Spina, at the mouth of the Po. It was founded by the Pelasgians according to Hellanicus and Dionysius of Halicarnassus (I, 18), but for Pseudo-Scylax it is a Greek city in an Etruscan territory. It would be wrong to exaggerate Etruscan influence. Spina was a commercial centre where merchants from various places met. The Etruscans may have been the dominant element for a short time, but not for long. All trace of Spina had been lost until the city and its cemeteries were rediscovered in the excavations which began in 1922, and were then suspended until 1953. It seems to have been founded towards the end of the 6th century B.C. (the oldest finds up to date in the necropolis consist of late black-figure Attic pottery). Like Venice later on, Spina was built on piles and the port consisted of a wide canal which connected it to the sea. The city was important principally for its commerce with Athens. Some of the finest Attic red-figure pottery of the 5th century B.C. was imported and distributed to various cities in northern Italy, especially Felsina. So far as is known this pottery was never exported to Etruria from Spina. On the contrary, from the end of the second quarter of the 5th century B.C. on, Spina took over commerce with

Attica from the Etruscan cities. A local pottery made in northern Italy about the late 4th and early 3rd centuries B.C. is found around the northern Adriatic sea and is therefore called 'Alto Adriatica'. It never seems to have reached Etruria, and may have been produced in Spina itself.

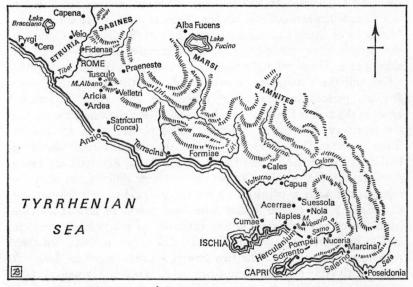

Etruscan expansion in Latium and Campania

Ancient sources contradict each other in what they have to say about Adria, which lies north of Spina. They call it a Greek city, or an Etruscan city in the territory of the Veneti. Unfortunately the finds have all been sporadic, but they do include a great many Attic vases which are earlier than those of Spina.

Ancient references to Etruscan rule in Campania are more numerous and less legendary than those on the Po valley (see the map of the region on p. 11). Etruscan cities were: Capua, the most important in Etruscan Campania; Acerra; Herculaneum; Pompeii, Noa (which the Etruscans probably called Hyria); Nocera; Sorrento. Coins found in Campania give us the names of other cities not as yet identified. South of Campania, according to Pliny (III, 70), the Picentine district (ager Picentinus), that is the territory between the Sorrentine peninsula and the Silarus (Sele) river, was also Etruscan. Here the Etruscans are said to have founded a colony, Marcina, which may have been at Fratte, a suburb of Salerno, where graves have been found which could be attributed to the period of Etruscan occupation.

Archaeological evidence for Etruscan dominion in this area is scarce, so scarce indeed that 19th-century scholars doubted whether the Etruscans had ever been in Campania. Contacts between the Etruscan and Campanian civilizations are few. There is much more evidence in Campania of Greek than of Etruscan influence. While both Campania and Etruria have painted tombs, the decorative motifs-except for chariot races, for which R. Bronson has proved a non-Etruscan origindiffer, and the Campanian painted tombs mostly belong to a post-Etruscan period. In temple decoration the only point of contact between the two is the great development of terracotta revetments, but the repertory of types is different. Relief plaques with a narrative frieze, such as those which protected the wooden roof beams of buildings in Etruria, are not found in Campania. Acroteria are much simpler. On the whole, Campanian antefixes differ from Etruscan ones. Those with a palmette or with a gorgoneion are frequent in Campania. None of the former have been found in Etruria and the latter are exceedingly rare. A few examples of gorgoneion antefixes, said to be from Caere, are in the Chigi Collection in Siena, but their provenance is doubtful. The two fine gorgoneion antefixes found at Veii greatly differ from Campanian ones. Two late antefixes (4th century) from Orvieto are isolated.

Small Etruscan bronzes have been found, such as a satyr and a maenad at Pompeii, but Etruscan bronzes were widely exported in the Mediterranean and in Europe, and prove nothing in the way of conquest. The Campanian black-figure pottery of the late 6th and early 5th centuries has so many points in common with Etruscan ware that it has often been believed to be Etruscan. The same decorative motifs may occur. A lioness on a Campanian amphora found in Capua is like one on a vase by the Micali Painter. The bucchero of Campania recalls Etruscan ware, but is locally made and therefore proves commercial contacts rather than occupation.

On the other hand it is not hard to understand why such a numerically small group of conquerors, more concerned with trade and profit than with consolidating their conquests, should have left such a slight mark on an area where the artistic level was so high.

The Etruscan inscriptions—more than a hundred of them—found in Capua, Acerra, Marcianise, Nola, Cales, Suessola, Pompeii and in the territory of Sorrento are mostly posterior to Etruscan rule in Campania.

The Etruscans may have reached Campania via land, as some say, or they may have come by sea and have first conquered the coastal cities south of Cumae and Naples so as to provide bases for the control of the Tyrrhenian Sea. In either case, an empire in Campania presupposes one in Latium.

Official Roman records ignore an Etruscan phase in the history of Rome. Most of us are familiar with the correct version, ad usum delphini, expounded by Livy. When Tarquinius Superbus was driven from Rome in 509 B.C., he turned for help to Lars Porsenna, king of Clusium. Porsenna was an Etruscan king, who had repeatedly and unsuccessfully tried to conquer Rome. The final episode in the struggle was the battle at Aricia, in 504 B.C., in which the Latins, aided by Aristodemus of Cumae, defeated the Etruscans and forced them to leave Latium. But alongside this official tradition with its emphasis on Roman victories and on the admiration of Porsenna for Rome, another version was current in Rome itself. This second tradition relates that a group of Etruscans, under the leadership of Caelius Vibenna and his brother Aulus, settled in Rome on the hill which was later named Caelius. According to Varro this took place during the struggle between Romulus and the Sabines. Tacitus and Festus however place the arrival of the Vibenna at the time of Tarquinius Priscus or Tarquinius Superbus. In a Latin insciption found at Lyons, the Emperor Claudius affirms that 'according to Etruscan tradition' Caelius Vibenna had a faithful companion named Mastarna with him when he settled in Rome, and that Mastarna later changed his name to Servius Tullius and ruled in Rome 'with great benefit'. The Emperor Claudius grants that an Etruscan king ruled in Rome, although the fact of the Etruscan conquest is prudently minimized. But we also know what the 'Etruscan tradition' to which Claudius alludes does say: the paintings in an Etruscan tomb at Vulci, the François tomb (Pl. 99 below) illustrate it for us. On the walls of the central cella, in the place of honour, are five groups of two figures each. The story begins on the back wall, to the right of the door. Caelius Vibenna extends his bound hands to Mastarna (represented on the right side wall) who cuts his cords. Next come three persons, among whom Aulus Vibenna, each shown killing an enemy identified

by the name of his city. The painting continues on the right wall where a Marce Camitlnas—otherwise unknown—is shown killing Cneve Tarchunies Romach, that is Gnaeus Tarquinius of Rome.

The Etruscan tradition then, as shown in the paintings, was that the Vibenna brothers and Mastarna established themselves in Rome after their victory over a certain Tarquinius and his Etruscan allies. The presence of Etruscans in Rome is also confirmed by the Etruscan inscriptions on three vases found in Rome: one—the earliest, dated about 600 B.C.—was found in the Forum Boarium; another, on the Capitoline Hill; a third one on the Palatine. Further confirmation is provided by the name of a street, or of a quarter of Rome, the Vicus Tuscus, i.e. the Etruscan street (or the Etruscan quarter). Neither of these facts, by itself, is strong enough to prove political domination of the Etruscans in Rome. Their importance lies in their reciprocal confirming of each other.

Traces of Etruscan supremacy in Latium have been noted by scholars. But alternative explanations are possible each time. Cato mentions Etruscans at Ardea and in the land of the Volsci, but he may be repeating a legend; a vase with an Etruscan inscription was found among the offerings in a sanctuary in Satricum (Conca) but it proves only that an Etruscan brought a gift to the goddess worshipped there. The name of the city of Tuscolo brings to mind that of the Tusci; the name of the river Melpis, an affluent of the Liri, recalls the Etruscan city Melpum in the Paduan region, but the two names may belong to a pre-Etruscan cultural-linguistic period. Of greater importance as evidence for Etruscan rule in Praeneste (Palestrina) are the princely tombs found there, for the material they contained corresponds so well to that found in Etruscan tombs, especially at Caere, while there is nothing else like it at Praeneste. Etruscan or Latin chiefs—note the Latin name Vetusia had precious objects sent from Etruria, probably from Caere.

The late 6th-century terracotta decorations of the small temple at Velletri were made with moulds which came from a city in southern Etruria. But this does not mean that Velletri was then Etruscan. It only goes to prove—as we knew—the existence of wandering terracotta craftsmen who were called wherever needed. Each fact, by itself, is not quite convicing, but such a number of facts cannot simply be dismissed. In any case, the struggle for the possession of Aricia which ended with the defeat of the Etruscans in 504 B.C. proves that at that time the Etruscans were in Latium.

The defeat of 504 seems to have put an end to easy communications via land between Etruria and Campania. The naval defeat of 454 B.C. in the waters of Cumae was a serious blow to Etruscan dominion, for it deprived the Etruscans of their control of the seas. The Cumaeans were aided by Hieron of Syracuse who was given the island of Ischia in exchange for his help. He established a garrison there which stayed until it was driven out by an eruption (Strabo, V, 247 C). The Etruscans could no longer keep their Campanian ports, Pompeii, Herculaneum, Sorrento, dominated and kept under watch as they were by the all too near Syracusan garrison. In 423 B.C. the Samnites took over Capua: it was the end of Etruscan supremacy. Some Etruscans however continued to live in Campania: inscriptions reveal that Etruscan was still being spoken and written a century after the Etruscans had lost their political control.

The generic terms 'Etruria' and 'Etruscans' have been used here in speaking of Etruscan expansion. It would however be more exact to refer to the enterprises of a single city or of groups of individuals, but we lack the information necessary to define the parts they played. Expansion beyond the ancient frontiers was not the result of a collective effort by all the Etruscans for the purpose of increasing the entire Etruscan empire. Only rarely did antiquity experience collective efforts. It happened in Greece when the Greeks, faced with the threat of a Persian invasion, had to unite. The Etruscans could have acted as a nation only had they had a single leader, whom all the cities obeyed. Not only were the cities completely independent but they disagreed to such an extent that they could not even unite against their common enemy, Rome, which was able to overthrow them one by one. The concept of collective action is a transferral to antiquity of modern ideas and conditions. Etruscan expansion was the result of the independent ventures of one or more cities and, in many cases, of discontented groups, or of adventurers, who sought their fortunes in far-off lands. We even have precise information regarding one stage of this expansion, in which both the Etruscan and Roman traditions agree. This is the above mentioned enterprise of the two Vibenna brothers, who settled in Rome, on the Caelian Hill, with a group of friends and followers, one of whom became the king of Rome.

Political squabbling and lack of union, which prevented the conquering Etruscan groups from keeping the lands they had occupied, is also reflected in Etruscan art, for in this field each Etruscan city

differs from its neighbour. While their art has a basically Etruscan character, the various cities each have their own distinctive personalities. It was not a matter of wealth, but of a difference in customs and habits. The types of tomb and their decoration, the way in which they are marked in the various cemeteries, vary surprisingly. Vaults, for example, are known throughout Etruria and were used for tombs, but the plan and structure of these tombs varied from town to town. The chamber tombs of Orvieto differ from those of nearby Chiusi and those of Caere from those of Tarquinia. Chiusi, Orvieto, Vulci, and Tarquinia use cippi to mark their tombs but the shape and decoration change from one city to another. Fiesole borrowed the stele from Volterra but their decoration was influenced by Chiusi. Sculpture in Caere, at least so far, is in terracotta, that of Vulci in nenfro. The gold jewellery of Praeneste is different from that of Vetulonia.

In art and in politics ancient Etruria must have resembled medieval Tuscany, where geographically close cities, independent and prizing their independence above all, were separated not so much by distance as by suspicion, hate, old rancours and struggles; where the art of Florence, for example, differed not only from that of Pisa or Lucca, or Siena, but also from that of Prato, barely 15 kilometres away.

There are some features common to all Etruscan cities:

1. They are built on naturally fortified sites which can be easily defended. In southern Etruria they are generally on rather low-lying plateaus with such steep slopes that, when they were fortified in the zth century or later, city walls were necessary only at a few strategic points. In northern Etruria, where there were no plateaux, the cities were built on steep hills. Only small farming settlements are to be found on the plains. The most obvious explanation is that each city feared attack.

2. The Etruscan cities, even those which had far-flung maritime trade, lie at least 6 or 7 kilometres from the sea. It is not a great distance about the same as that which, in Greece, separates Athens from its port, Piraeus, and ancient Corinth from the sea. The Greek geographer Strabo was aware of this characteristic of Etruscan cities and noted that only Populonia was built on the sea. In antiquity this distance between a maritime city and its port seems to have been characteristic of those cities, such as Athens and Corinth, for which maritime trade represented a later stage in their development.

The Territories of the Cities and their Boundaries Southern Etruria; Northern Etruria

It is difficult, often impossible, to determine the territory which belonged to the Etruscan city-states, a problem which often arises when dealing with any city or state in antiquity.

Various sources can be used in the search for these boundaries:

1. Information provided by ancient sources. This is the most reliable method, but it can rarely be followed due to lack of trustworthy information. The case of the Roman municipium of Velleia, in the Apennines north of Piacenza, is unique. Here an inscription (C.I.L., XI, 1147) from the age of Trajan lists all the holdings of the territory and therefore supplies us with exact boundaries. Generally the information given by ancient sources—historical, geographical, antiquarian—is vague. Nor is it certain which period is being referred to. Take Caere as an example. Servius says that the river Minio marked the boundary between Caere and Tarquinii, but he does not specify when this was. Nor does this information always coincide with what we know about Caeretan territory (see Caere). This is also the case with Volterra: according to Servius it possessed Populonia, but what we know about the two cities makes this seem unlikely (see pp. 140 ff.).

2. The artistic and cultural spheres of a city are considered by some scholars to be synonymous with its territorial limits: the types of tombs, burial rites, style of the objects found, supposedly reveal just how far the art, habits, and customs, and consequently the territory of the city, had extended. This criterion is useful and feasible only when the territory is limited, as in southern Etruria: we shall see that the region north-east of the river Mignone—Luni, San Giovenale, Blera, San Giuliano, Trevignano—may, at least temporarily, have belonged to Caere, which influenced funerary architecture and tomb furniture. For the same reasons the upper valley of the Fiora probably belonged to Vulci. But when the cities are distant from each other, this criterion is not applicable: it is often difficult to tell whether what we find indicates occupation, or the influence of imported ware. In the Valdelsa, at Monteriggioni, the chamber tombs—such as the one of the Calini Sepus family—are similar in plan to tombs at Clusium (Chiusi), but the urns and other material they contained point to Volterra.

3. Some scholars adopt a convenient formula when trying to establish the boundaries of an ancient town: the medieval boundaries of a diocese, they say, are identical with those of the Roman municipium, or colony. When the episcopal districts were formed in the 4th century A.D. their boundaries were made to agree with the administrative boundaries of a municipium or a colony. True, documents referring to episcopal boundaries are very late, often later than A.D. 1000—we have none for the early years of Christianity but it is a well-known fact that anything having to do with religion and cult is conservative. Therefore the ecclesiastical boundaries we find in late documents are still the old boundaries of the original 4th-century A.D. diocese. In Etruria this statement has been extended to include pre-Roman boundaries: scholars often find the territorial extent of the Etruscan cities of the first millennium B.C. in documents which generally date to after the year 1000.

The affirmation that when possible, the 4th-century diocese often took over the boundaries of the municipium may be exact, but this was not always the case. Cardarelli has drawn attention to this fact in a study on the boundaries of Vetulonia. It should be added that in the thousand years—or almost—that lapsed between the late imperial municipia and the first medieval documents which give us the boundaries of the diocese, a number of changes had taken place: new dioceses came into being where there had been no municipium, at Bomarzo in Etruria for example; not all Roman municipia became dioceses, as with Velleia in the Apennines above Piacenza, or Sestinum, or Vetulonia; some dioceses took over parts of the neighbouring ones, as did Lucca in the Longobard period; some dioceses disappeared, such as that of Pitinum Mergens, in Umbria, which was divided, after 500, among Cagli, Urbino, and Fossombrone.

Another fact to remember concerning the Roman municipia is that episcopal boundaries—providing we had those of the first few centuries after Christ—would only refer to the municipia of Diocletian's administrative reform (A.D. 290–300) which might easily be at odds with those of Augustus' administrative divisions of 27 B.C. Velleia, for instance, disappeared in this period. All the more reason why those

boundaries should be unacceptable for the Etruscan cities: too many changes took place as the result of war or decadence in the Etruscan period and, then, the Roman conquest. We know what happened in some cities—Civitavecchia, for example, is a diocese made up of territory which once belonged to Caere; Roselle annexed Vetulonia and Populonia. Still, if used prudently, these documents may furnish valuable clues, confirm hypotheses deduced from ancient material, and validate the status quo in the early Middle Ages. But they should not be expected to furnish exact information about boundaries in antiquity, information it is entirely beyond their power to provide.

The general characteristics of any one part of Etruria vary from those in the other parts of the territory. I have already referred to the differences found from one city to the next. On the whole we may say that art, customs, and life in southern Etruria differ from those of northern Etruria and that the problems are not the same.

Southern and northern Etruria are not separated by natural boundaries such as rivers or mountain ridges, nor by political governments, but rather by their economic and artistic development-by the diverse conditions of life. Conventionally it may be said that northern Etruria is the region north of an imaginary line which goes from Talamone to the river Paglia and the Tiber. Vulci, on the coast, is the last city with characteristics and features typical of southern Etruria. But immediately to the north, a few kilometres from the river Fiora and from Vulci, the lay of the land changes. One no longer finds the many small towns, which testify the uncontested artistic influence of Vulci. The southern boundary of central Etruria may be set at an imaginary line that passes north of the river Fiora and Sovana, to the lake of Bolsena, following its northern and western shores, and joins the Tiber south of Orvieto. The intermediate zonethe valley of Albegna and Marsiliana, Magliano, and Saturnia, Volsinii and Orvieto-has features of both southern and northern Etruria but is part of neither.

Broadly speaking it can be said that:

I. In southern Etruria the large cities are close together. Each is surrounded by small centres which reflect its culture in the types of tombs, funeral monuments, pottery, etc. The sphere of influence and character of each of these large cities can be defined, but these may not correspond to the political boundaries. In northern Etruria

the cities are few and far between; in the intervening countryside the inhabitants lived in small scattered groups of houses.

2. Northern Etruria was agricultural; the south, commercial. The contacts between the north and the Mediterranean world were therefore limited and its interest in navigation was secondary. But the picture presented by the south is that of a region of brisk trade and of rich merchants in constant contact with the large centres of the Mediterranean. The south became agricultural only after the Roman conquest had deprived it of its ports, thereby shutting the door on further trade.

3. The art and culture of southern Etruria were particularly important. This region owed a great deal to Greece and Asia, kept in constant touch with their cultures and readily accepted their artistic ideas and influences. Often southern Etruria was the intermediary between the Mediterranean centres and the cities of northern Etruria. Oriental motifs, and, from the 6th century on. Greek motifs and myths-even if the latter were often distorted and misinterpreted-were common in southern Etruria but rare in the north until the 4th-3rd centuries B.C. At this point a complete reversal set in-we do not know exactly why north Etruria now turned to Greek mythology for inspiration, as illustrated by the cinerary urns, while in the south there was a sharp decline. These contacts with Asia and Greece have made it easier to date the locally produced sculpture and painting in the coastal cities of southern Etruria between the 7th and 4th centuries on the basis of comparisons, even though the dating rests approximate. In the north, where the latest trends in art arrived only after they had been acclimatized in a coastal city, it is difficult to determine the time-lag involved in the appearance of a motif or style (see p. 23).

4. In general, the contents of tombs, which are our most important and often sole source for the art and history of the Etruscan cities, vary in character. They are rich throughout Etruria. The many local and imported objects they contain differ from one place to another. The contents of individual tombs in southern Etruria and in Praeneste, and Latium—which are so similar to those of Caere that most of them may have been imported from that city—are not simply collections of magnificent objects, of jewellery, ivories, etc., but also the personal belongings of individuals who loved being surrounded with art objects, people who wanted to enjoy the sight of beautiful,

finely wrought objects in their afterlife. They were merchants, true, but they were merchants in the sense of a Cosimo or a Lorenzo de' Medici, those Renaissance merchants who took pleasure in using magnificently wrought silver table services made by a great artist and who surrounded themselves with fine bronzes, beautiful statues, lovely paintings. In northern Etruria, on the other hand, tomb furnishings were not so much luxury articles as they were objects of daily use, which the deceased would need in his afterlife. They are beautiful as to line but restrained. Bronze objects decorated in repoussé are plentiful in southern Etruria, while in northern Etruria repoussé rarely appears except for imported pieces such as those of Castel San Mariano or the Loeb tripods, which were both found near Perugia but were made elsewhere. The sheet bronze objects of the north retain a simplicity of line relying only on graceful ornaments of lotus flowers, heads, figurines, protomes in cast bronze for their decoration. Unless this be kept in mind, one runs the risk of mistakenly judging as impoverished something which merely indicates a difference in taste. This is most striking in the jewellery.

The cultural differences between southern and northern Etruria also depend on their geological diversity. True, chamber tombs differ in type; in southern Etruria they are mainly hewn out of the tufa; in the north they are often built on the ground with blocks or slabs of stone. The underlying reason is that the tufa of southern Etruria is extremely easy to quarry and cut, while the rock of northern Etruria—often lying just below a layer of earth—is extremely hard to work. In fact, wherever there is tufa in northern Etruria the tombs are dug out of the rock, as in the south.

Differences between the cities will be treated in the individual chapters on each centre.

The term 'Etruscan art' is generally used only for what was produced in Etruria between the 7th and the 1st centuries B.C. Consequently this would exclude the Stone Age, which falls under prehistory, and the Bronze Age, the so-called Apenninic civilization, the relationship of which with later Etruria is not as clear as it might be, since inhabited sites rarely coincide with later ones of the Iron Age. Moreover while the Apenninic culture seems, at present, to have developed primarily in the interior of Etruria, the oldest Iron Age settlements are near the coast.

Between the end of the Bronze Age and the beginning of the Iron Age —actually the term is improper since iron was not used until much later—a great change took place in Etruria which had been only sparsely settled up to then. Etruria was rapidly transformed into a region of flourishing human settlements.

Actually the oldest period of the Iron Age, the Villanovan culture, which took its name from Villanova, a village a few kilometres north of Bologna where it was first discovered in 1870, should be excluded. But the relationship between Villanovan culture and Etruscan art is so close that it would be difficult to speak of the latter without referring to the former. Moreover the main Etruscan cities are on Villanovan sites and continue them without noticeable modifications or differences.

We will do no more here than give a general outline and résumé of Etruscan art and the related facts indispensable for an understanding of its general development. The contribution of each city in the various fields of arts and crafts will be dealt with in separate chapters, dedicated to the principal Etruscan cities. The individual monuments are covered more thoroughly in the descriptions which accompany the plates (pp. 212-280).

What makes the study of Etruscan art so difficult is the havoc raised by clandestine excavators, by unpublished or insufficiently published excavations, by the fact that so many imports, both oriental and Greek, have been studied to the neglect of the local production. The resulting picture is therefore one-sided. Only in the last few decades has interest in what is truly Etruscan grown, but lack of information on excavations makes this study difficult. The chronology of what has been discovered in Etruria varies greatly. Not until the 7th century B.C., when comparison with eastern Mediterranean cultures becomes possible, is there any relative agreement. But even here numerous difficulties arise. It was once thought that the dates of the non-Greek material found in archaic tombs of the late 8th, 7th and first half of the 6th centuries B.C. would be the same as those of the Greek painted vases (Proto-Corinthian and Corinthian), whose chronology was relatively reliable, with which they were found. But in Etruria by far the majority of the vases thought to be Corinthian are local imitations. These so-called Etrusco-Corinthian vases may and often do—lag behind the Greek vases whose form they imitate by more than a century. By the 6th and 5th centuries, when the influence of Greek art was felt in Etruria and parallels with the development of Greek art can be established, the dating of an Etruscan piece becomes relatively simpler.

'Relatively' because the style, or the motifs, were often extraordinarily late in arriving or in being accepted, especially in the inland centres. A painted tomb, recently discovered in Tarquinia, the Tomb of the Olympic Games (Tomba delle Olimpiadi), includes a chariot race among its paintings of sporting events. The painter has cleverly made use of a lively anecdote. The last contestant has had an accident and one of his horses has fallen and lies with its legs in the air; the charioteer has been thrown clear of the chariot, feet first. The painter did not himself invent this motif, but was inspired by a chariot race painted on a Greek amphora which he must have seen, since it was found at Tarquinia. His version is much livelier, though. An Etruscan amphora, found at Vulci and painted by a local artist, bears a similar scene on its shoulder. In Chiusi, in the tomb of the Deposito de' Dei, the painter took over the same motif from Tarquinia, but with variations. Here the charioteer is coming down head first, while the chariot has been thrown up in the air. Despite these slight differences, the paintings at Vulci and Chiusi were derived from the Tomb of the Olympic Games, not from the Greek amphora. This amphora, of Tyrhennian provenance, was painted between 575 and 550 B.C. The tomb in Tarquinia is not prior to 520-500 B.C., that of Chiusi, an inland city and therefore slower to receive the latest trends, may be dated about 470-450 B.C. Tarquinii, where the Greek model arrived, was about 50 years behind Greece, Vulci about 70 or 75 and Clusium (Chiusi) 100 years. But in appearance the tomb at Chiusi looks more archaic than that at

Tarquinia. If the local character of Clusine art and the fact that artistic stimuli had to arrive there from the coast were not taken into account, the Tomb of the Olympic Games would appear to be later than the tomb of the Deposito de' Dei. This would lead to the erroneous conclusion that Tarquinii had imitated Clusium. Before judging the art of any given place, we must always keep in mind what that city was capable of, which in turn depended on its contacts with Greece and on the particular period in its history. The art of southern Etruria differs from that of the north both in its development and characteristics (see pp. 19 ff., 134 ff.).

We will often-both now and later-refer to the influence exerted by Greece and the East on Etruscan art. An explanation is required. The art of every country is subject to external influences but this by no means signifies that its art is not as good as that produced in the country which influenced it. Italian 14th-century art was strongly influenced by French Gothic art, and the antiquities of ancient Rome are the foundation upon which the Italian Renaissance, and through it the entire European Renaissance, were based. Yet no one would ever think of accusing Giovanni Pisano of a lack of originality because his figures repeat Gothic formulae, nor of considering the Italian 14th-century cathedrals as unworthy of a place in the history of art because they were inspired by French ones. Nor would one dream of saying that Leon Battista Alberti was an unimaginative architect because he was dependent on the architecture of ancient Rome. It is not what the artist has accepted from others that matters, but his interpretation thereof and how he has re-experienced and transformed it.

The artist who made the sarcophagus in the Villa Giulia Museum in Rome (Pl. 7) undoubtedly turned to Greek formulae for inspiration, and, to all appearances, adhered closely to them. But this is only a first impression, for he reshaped them according to his own vision and sensibility; he translated them into his own language and left his mark on them. The figures have lost the calm tranquility, the spiritual equilibrium and classical beauty so typical of Greek works and have become enigmatic, restless, and disturbing. The Greek formulae have acquired an Etruscan character. A Greek could never have expressed himself like that, in a way so completely at odds with his vision of life and art, his ideal of formal perfection. In fact, it is not surprising that students of the sarcophagus have been unable to find any immediate comparisons in Greek, not to speak of Ionic, art. Exactly the same holds

true for the Apollo of Veii. Therefore references to Greek influences on Etruscan art do not at all mean imitation or servile copying. On the contrary, there are changes and they are profound because the Etruscans are so basically different. But although an imitation by an Etruscan craftsman may be quite pleasing despite its lack of inspiration and the frequent misinterpretation of the model, it remains an imitation. But if it is the work of an Etruscan artist he will have succeeded in finding something new, something interesting. The Etruscans received a great deal and were influenced by Greece. They do not seem to have influenced Greek art, although a few objects of Etruscan make—bronzes and some vases—arrived as far as the Balkan peninsula. Exportation to the north was greater, but, with the exception of the Po valley, influence was negligible.

The oldest period of Iron Age culture in Etruria, from about 850 to 700 B.C., is known as the Villanovan culture. Just when it began, though, has been greatly discussed by scholars who place it anywhere from the 14th-13th century B.C. to the 8th, and even to the end of the 8th century B.C. Nor does 850 B.C., the date given above, correspond to the one most commonly accepted. It is only the date which the author, on the basis of a study of the Villanovan centres, considers the most likely.

The people lived in huts the form of which can be reconstructed thanks to the excavations of hut sites, to a chamber tomb in Caere, the Tomb of the Hut (Tomba della Capanna), and to the ash urns typical of Latium, the so-called hut-urns. These hut-urns (Pl. 27), which have also been found in Etruria, reproduce the primitive hut in miniature, with a door, one or more windows, roof beams which cross at the summit, and a smoke hole. The dead were cremated and the ashes were placed in the hut-urn or in the typical biconical Villanovan urn of gray impasto, with a single handle and covered by a shallow bowl, often inverted, or by a helmet. The urn was placed in a cylindrical pit (tomba a pozzetto), dug in the earth or in the rock. The burial was always of one person only. The pozzetto is sometimes lined with stones; the cinerary urn may be deposited in a stone receptacle.

Trench tombs (fossa tombs) dug in the earth and sometimes lined with stone slabs (tombe a cassone) appeared later alongside the pozzetto burials and gradually replaced them. Trench tombs were almost always inhumation graves, but in the older trench tombs cremation was still customary. It continued to be practised in all periods, up to the

25

81-3076

end of the Etruscan civilization, alongside inhumation, in chamber tombs and in simple graves (tombe a buca). Occasionally cremation burials of the 8th and 7th centuries have the ash urn and tomb furniture inside a large earthenware jar (dolio tombs). Funeral accessories, that is the objects to be used by the deceased in the afterlife, were laid next to or inside the urn, or near the corpse. This belief has enabled us to reconstruct the civilization and art of the people who lived in Etruria. After 750 B.C. the tomb accessories were often spectacularly rich and in great number-pottery or bronze vessels, fibulae (brooches used to fasten folds of clothing and reminiscent of modern safety pins), weapons, razors, bronze belts, gold jewellery, etc. These objects were decorated with engraving or repoussé. Decoration consisting of human and animal figurines in the round, used as a handle or on the rim of a vessel, was particularly prized. This sculptural decoration provides a foretaste of tendencies which were to be developed and come to the fore in the 7th century. Greek influence is evident in the pottery, decorated with the old Villanovan motifs together with those found on Geometric Greek ware (Italo-Geometric pottery). The fabric is no longer gray impasto, but a light-coloured clay. There were already considerable differences in the Villanovan period between the various centres both in the types of tombs and ash urns, and in the objects laid in the tombs; in subsequent periods the differences continued and increased.

The Villanovan culture developed primarily along the Etruscan coast at Tarquinia (which is perhaps the oldest and richest of all), at Veii, where it seems to have lasted longer than elsewhere, and at Caere, Vulci, Vetulonia, Populonia. Smaller, less evolved centres were at Bisenzio, Bolsena, Clusium, Volterra. They were not real cities, but only groups of villages which subsequently united to form cities.

For a long time the Villanovan culture was believed to be limited to Emilia and Etruria. But lately Villanovan settlements in the Marche and around Salerno have been excavated.

Just when the Villanovan civilization ended and the Orientalizing period began is problematical. The Tomb of the Warrior at Tarquinia —not to be confused with another and later Tarquinian tomb of the same name, the Tomb of the Reclining Warrior, or Avvolta tomb—is generally considered to be the earliest Orientalizing tomb. But the material that is supposed to have come from this tomb is far from reliable; more than one scholar is of the opinion that the antique dealers through whose hands the material passed before ending up in the Museum of Berlin added objects which did not belong to the tomb.

New influences from the East appear now and then in tombs of the second half of the 8th century B.C. and become more numerous around 700 B.C. There is never a clean break: influences and changes are gradual. The beginning of the period known as Orientalizing in Etruria is set approximately between the middle and the end of the 8th century. It modifies, but does not destroy, the preceding Villanovan civilization. The orientalizing phenomenon was limited to Etruria. It had already appeared in Greece before it began in Etruria. New imaginary and curvilinear motifs, originating in the East, were added to the repertory of geometric motifs-incised or painted-of the preceding period. Rows of domestic animals (horses, oxen, goats), wild animals (lions, panthers), and fantastic beasts (chimeras, griffins, winged creatures) are frequent. In Etruria a motif unlike anything in the Orient or in Greece was added to the repertory-rows of lions or other animals, wild or domestic, with an arm or a leg or part of a human body dangling from their jaws, a motif which passed from Etruria to the Venetic culture. The normal type of burial was the fossa tomb and inhumation predominated.

In the 7th century B.C. the tombs of the rich became monumental both in form and size. The chamber tombs (a camera) were so called because their quadrangular plan recalls the rooms of a house and because they are the house in which the deceased reposes. They are underground, excavated in the tufa. The entrance is through a sloping corridor or down steps. If there is more than one chamber, they are arranged around a vestibule. Other tombs may be built above the ground, with slabs (but they are rare). There are also monumental tombs, partially or entirely built of superposed blocks or rows of slabs, which progressively project until a single block closes the opening. These are the false vault (Pls. 3, 4) and false dome (Pl. 5) tombs. The latter have been found only in northern Etruria. These imposing tombs are the first surviving evidence of Etruscan architecture, for the buildings, built of wood or sundried bricks of clay and straw, have almost all long since perished. The chamber tombs were covered by a tumulus which often enclosed chamber tombs of varying dates under one mound (Pl. 2, above). The tumulus may be circumscribed by stones, or by a drum, either smooth or with mouldings (Pls. 5, 6a, 6c, 71a, 72b).

Chamber tombs have often been held to be a copy of the Etruscan

house, but plans vary so greatly between southern and northern Etruria and even from one city to the next and in the selfsame necropolis, that any deductions, however approximate, are extremely arbitrary. Various details (doors, windows, chairs, stools, shapes of couches) will only suggest what the actual architectural motifs or Etruscan furniture were like. Lately, however, interesting remains of houses have been excavated.

In the more important tombs the funeral equipment was extremely rich, with vessels in silver, gold, and bronze, and fine pottery. Jewellery was exceedingly beautiful but heavy and over decorated. Some of the objects found in rich tombs were imported from Greece or Asia, but most of them were made by local craftsmen who adapted the foreign model to local taste, often misinterpreting the motifs. The fabulous wealth of Caere in the Orientalizing period—the other cities of southern Etruria were just as rich, but less spectacularly so—was probably due to mining activity in the mountains of La Tolfa and Allumiere. The ore-rich zones of northern Etruria seem to have belonged to Populonia and to Vetulonia. In the 7th and early 6th centuries B.C. Vetulonia was the richest city in northern Etruria, with a fine local production of bronzes, pottery, jewellery. Imported goods predominated in Marsiliana. As far as Roselle is concerned, we must wait for future excavation to tell us what was produced locally and what was imported.

Some of the new motifs reached Etruria directly from the East, some via Greece. The role played by Greece is more important than generally thought. A point not to forget is that some of the Etruscan centres—especially Tarquinii and Caere—had direct contacts with the coast of Asia Minor, with the Greek cities, above all Corinth, and with the Greek colonies of southern Italy and Sicily. Veii and the Faliscan territory seem to have been in contact with the East and Greece, mostly via the island of Ischia and Cumae.

The chimera, for instance—that imaginary lion-like beast with the tail of a snake and the head of a goat issuing from its back—first appeared in the Etruscan repertory of decorative motifs in the two forms found only at Corinth—one with the goat's head, and the other with a human head, rising from the lion's back. But the Etruscan craftsmen, particularly those in southern Etruria, elaborated the motif and all kinds of heads sprouted from the backs and even tails of other animals, bulls, horses, panthers, etc.—all local elaborations of the Greek chimera not found elsewhere, neither in the East, nor in Greece.

The contents of the princely tombs of Praeneste can be included in

the general picture of Etruscan 7th-century production. Nothing else like the magnificent objects in the Barberini and Bernardini tombs was found in this small Latian city, nor are there any known precedents. They were imported from southern Etruria, perhaps Caere, where both local and imported products are akin to those found in Praeneste.

The years between 600 and 450 B.C. witnessed the flowering of archaic Etruscan art, the finest and most original period in its history. It was then that Etruscan sculpture and painting came into being, and the first temples appeared. The industrial production of the preceding period was replaced by real works of art. From 600 to 550 B.C. is a preparatory period, in which the orientalizing formulae still linger on next to innovations of Greek origin. The earliest paintings, at Caere, have orientalizing motifs; two painted tombs of Veii, the Tomb of the Ducks (Tomba delle Anatre) and the Campana Tomb, remain isolated. About the middle of the 6th century B.C., or shortly after, the cycle of great tomb paintings began at Tarquinii. They were to set the style for decorative funerary painting (pp. 75 ff.) and were imitated at Chiusi (pp. 23, 169 ff.).

In the decoration of their chamber tombs the Etruscans seem to have developed independently. In Greece, the outstanding artistic influence in the 7th and 6th centuries B.C., the dead were not buried in chamber tombs. Egypt had had beautiful painted tombs in the 3rd and 2nd millennium B.C., but by the 6th century B.C. most of the tombs were no longer painted, and if they were the decorative principle involved was not the same as the Etruscan one. Etruscan painters seem to have turned for models to the painted Greek vases, in particular Attic, of the first half of the 6th century, which were just then flooding Etruria. In dividing the walls in horizontal zones separated by bands they seem to echo the way in which the various motifs were distributed over the body of the Greek vases. There was a main frieze with a narrative subject and one or more secondary decorative friezes. With rare exceptions, the narrative subjects were inspired by Etruscan life. The fact that occasionally the friezes were also adapted to the architecture of the tombs seems of secondary importance to me.

Attempts have been made to group together some early tombs as being the work of a single master, but the results are not convincing. True, some early painted tombs are very close. They have motifs which also occur on painted vases, such as animals and purely decorative motifs. But upon close examination of the narrative scenes with human

figures, which is where a painter's personality becomes evident, the similarities stop and the difference in style becomes clear.

Vase painting also shows Greek influence. In the 7th-century Greek Geometric vases (Italo-Geometric ware) had been imitated. Now it was the turn of the Corinthian vases (Etrusco-Corinthian), Attic blackand red-figure ware and the red-figure pottery of the Ionian coast. Etruscan pottery is primarily a product of southern Etruria; in the north painted vases were not produced locally until the 4th century B.C. Some of the painters were outstanding. It is difficult to say just what part the various Greek centres played in the production of Geometric vases. Euboea seems to have sent a few Geometric vases via its western colonies, Cumae and Ischia. At present, however, this period is not well known. One of the centres of production seems to have been at Tarquinia.

The bucchero ware, both black and red, is Etruscan. The latter is limited to southern Etruria.

The two principal centres for sculpture were Vulci and Caere. No important early sculpture has so far been found at Tarquinia, though future excavations may increase the number of cities in this list. Between 600 and 550 B.C. the belated Daedalic style spread from southern Italy and Sicily to Vulci, whose sculpture in turn influenced Clusium and probably Veii. Caere on the other hand was in touch with Samos, the Ionian islands, and the Ionian colonies of Asia Minor. Around 550 B.C. the Ionian style also spread through Etruria, furthered by the work of one or perhaps several potters who had come from the coast of Asia Minor. This style finds expression in the rather mannered profiles with high foreheads and receding chins, in the soft modelling, in the light garments, the curvilinear rhythms which had been particularly popular for decorative motifs in the preceding century. Often the artists surrendered themselves to the pleasure of drawing curved lines and their work became pure calligraphy. But even in the period of dominating Ionian influence, the principal formative element upon which artists and craftsmen depended was constituted by the Attic vases, which arrived in such enormous quantities that 19th-century scholars thought them to be Etruscan. The patterns offered by Attic vases were often subjected to Ionian formulae and mannerisms by the Etruscan craftsmen.

Attic influence triumphed around 490 B.C., when the Ionian style went out of fashion in Etruria, as it had in Greece some decades previously.

The earliest archaeological evidence for an Etruscan religious building, dating around 550 B.C., is at Veii, on the acropolis of Piazza d'Armi. It is a modest rectangular room of which only the foundations remain. The walls must have been of wood or sundried brick and the roof was gabled, forming a pediment on the façade. The pediment beams were protected by terracotta plaques in low relief. The ends of the joint tiles of the roof were concealed by antefixes decorated with heads of women, probably maenads (Pl. 34, above). This building does not correspond to the generally accepted type of Etruscan temple, described by Vitruvius as a 'Tuscan' temple, which was built on a high base or podium, almost square in plan, with three cellae preceded by a porch with two rows of columns and a flight of stairs leading up to it. The 'Tuscan' temple with three cellae appears almost contemporaneously in Etruria and in Latium. As things stand, the oldest 'Tuscan' temple which can be dated is the temple of the Capitoline Triad in Rome, dedicated in 509 B.C. but begun much earlier under the Tarquins.

All the known Etruscan temples with three cellae are later than this. The famous Portonaccio temple at Veii, sometimes called 'of Apollo', was also built at the end of the 6th century B.C., judging from its decorations—sculpture and antefixes—but there seems to be little doubt that it had but one cella. The oldest indisputable example of an Etruscan temple with three cellae is Temple A at Pyrgi on the Caeretan coast (c. the first quarter of the 5th century B.C.). The dates of the presumed temples on the acropolis at Marzabotto are doubtful. Only one definitely seems to have had three cellae, but just when it was built is open to question. The early date recently proposed seems to be unfounded. Other temples with three cellae (at Santa Marinella, at Orvieto, in Faliscan territory) are later.

The three cellae type is not the only type of temple in Etruria in the first half of the century, contrary to general belief. The oldest of the two temples at Pyrgi, Temple B (late 6th century B.C.), is peripteral—its cella surrounded by a colonnade like a Greek temple. The temple of the Ara della Regina at Tarquinia seems to have been similar.

Etruria had temples with a single cella, like the one at Veii mentioned previously. Examples of an Etruscan temple with a single cella and two wings (alae) can also be found at Fiesole and at Bolsena: the former was preceded by a portico; the latter had no columns. Sacred precincts with an aedicule, an altar or altars, and porticoes, seem to have been common. But we know too little. The unusual plan of temples such as

that of La Civita, near Bolsena, is probably due to the fact that they were in provincial centres.

It has always been stated that the columns of the temples were of wood, sometimes with terracotta revetments. But at Pyrgi both temples had columns in tufa which seem to have been part of the original structure. Other temples also seem to have had tufa columns, at least from the 4th century on.

The uncertainty surrounding the plans and forms of the temples is due to the fragile building materials used. Recent excavations have opened up new prospects and paved the way for new hypotheses which future studies will define.

Much of the characteristic fictile decoration has however survived: revetment slabs that protected the wooden beams (antepagmenta) had narrative scenes until the early 5th century and were succeeded by purely formal decoration: antefixes, acroteria, etc. Immediate precedents for the revetment plaques of the 6th century B.C. can be found in Ionian cities on the coast of Asia Minor. Models for the antefixes probably came from Campania, although in Etruria decoration took its own course. The typical Campanian antefixes of the 6th-5th centuries B.C. are not found in Etruria. Those attributed to Caere, in the Museum of Siena, were probably found in Campania. Figures in the round were heaped upon the temples—along the edge of the roof overhanging the pediment and along the ridge. And even when they were as fine as the statues of Apollo and Hercules at Veii, they tended to suffocate the architectural lines, just as 'baroque' as some of the gold work and bronzes of the Orientalizing period.

The use of figures in the round or in high relief in the triangular pediment began in the 4th century B.C. What at Pyrgi had first seemed to be pedimental sculptures from the first half of the 5th century B.C. turned out to be terracotta slabs decorated in relief which had covered the ends of the central beam (columen) and of the two side beams (mutuli).

Temple decorations found in the various cities of Etruria and Latium are often similar, sometimes even identical. Matrixes for revetment plaques and antefixes were taken from one city to another. Workers in clay, specializing in the decoration of temples and public buildings, went wherever they were needed. At the end of the 6th century B.C. they were summoned from all over Etruria to decorate the Capitoline temple in Rome, but the acroteria and cult statues were commissioned from Veii. Temple decorations of the 6th and 5th centuries B.C. in Latium and Veii are very similar. In the Hellenistic period the same motifs, even the same matrixes, are found throughout Etruria.

After the Etruscans were defeated in the waters of Cumae in 474 B.C. direct contacts with Greek art ceased, or diminished. Etruscan art went into a decline that was clearly visible by 450 B.C. With less wealth in circulation-which had of course provided an incentive for artists and craftsmen-there was also a drop in originality. The workshops continued to repeat the old modes, use the same old formulae. The resulting time lag makes it difficult to judge just how much later an Etruscan work is than the model on which it is based. This time lag was responsible for the so called 'lacuna in Etruscan art' still stressed by archaeologists at the beginning of the century. But this lacuna, which depended on an erroneous dating of works in the archaic style and on a more limited production, is only a myth. This period of decadence continued up to the second half of the 4th century B.C. Etruria seems to have been practically untouched by the principal trends of Greek art and really good pieces are rare. Hardly any imitations of Polykleitos (Pls. 76, 77) and Pheidias are to be found. Derivations from 4th-century Greek sculpture did not appear until much later, in the 3rd and 2nd centuries B.C., in the Hellenistic renaissance. Just how much of this apparent decline is due to a lack of good artists, and how much is the result of Roman plundering is an open question. The bronze and terracotta statues which aroused Roman cupidity when they conquered the cities-at Volsinii the Romans carried off 2,000 statues and the same probably happened in all or almost all the conquered cities-were probably made between 470 and 300 B.C., which was the period most easily understood by the Romans.

Besides paintings in the archaic style, with hackneyed motifs such as the monotonous banquet scenes, one can find works of art as lovely as the head of a woman of the Velcha family (Pl. 95) in the Tomb of Orcus. The date proposed by scholars varies anywhere from 450 to 300 B.C. The earlier date—450 B.C.—is based on the resemblance of the profile to heads of women on white-ground Attic vases of 460–450 B.C. Yet it would be more exact to compare the painting to vases a few decades later, since that kind of mouth, with the inner corner drawn down and the protruding lower lip, first appeared in Greece around 430-420 B.C. Despite this resemblance it is impossible to date the head

prior to the second half of the 4th century B.C.: late 4th century B.C. might be even more precise, not only because of the sad expression on the face, but above all because a border of grape or ivy leaves and tendrils (visible only in old drawings of the tomb) runs along the top of the painting. This motif does not exist in Etruscan 5th-century tombs.

The magnificent chimera from Arezzo (Pl. 72), one of the best known Etruscan bronzes, may belong to this period, but lack of comparisons makes it impossible to establish a precise date.

Bronze mirrors are frequently found in excavations. There are a few rare pieces dating to the late 6th century. They became common in the 5th-4th centuries B.C. Many were quite plain, but the majority had engravings on the back; the finest examples were decorated in a low flat relief. In general they were produced in series and mirrors with the same two, three, or four personages appear over and over. The names written next to the figures vary, but the composition and the figures themselves are so similar that it is questionable whether the names correspond to the figures. The representation was strongly influenced by Greek mythology, but the scene was often transformed into a love scene.

In the 4th and 3rd centuries B.C. south Italian influence can be noted in some bronze mirrors and in the pottery.

Bronze cistae (boxes) frequently occur among the objects found in the tombs of the 4th to the 2nd century B.C. in Praeneste (Palestrina). They were probably used as chests for jewellery and other small objects. Although they are generally cylindrical, one lovely example in the Vatican Museum, perhaps still 5th century, is oval. The cistae were engraved, the feet and handles cast. They were probably made at Praeneste, but were strongly influenced by Etruscan art, and it is possible that Etruscan craftsmen worked there. The Ficoroni cista has an inscription on its handle 'Novios Plautios med Romai fecid. Dindia Macolnia fileai dedit' ('Novius Plautius made me at Rome. Dindia Macolnia gave me to her daughter'), which would seem to indicate a workshop in Rome. Sometimes the engraver was inspired by extant paintings. One cista reproduces the painting from which one of the episodes in the François tomb (Vulci) was derived : the slaughter of the Trojan prisoners.

The last period of Etruscan art, from 320-310 B.C. to the 1st century B.C., represents the final outburst before it merged with Roman art.

The paintings which decorated tombs are often interesting—the François tomb at Vulci, the tomb of Orcus (Tomba dell'Orco), the Tomb of the Cardinal (Tomba del Cardinale) at Tarquinia—but with few exceptions they are artistically inferior. In sculpture practically nothing but urns and sarcophagi were produced.

As some scholars have noted, Hellenistic influence from Asia Minor prevailed in northern Etruria. Three cities, Clusium, Volterra, and Perugia specialized in small urns in tufa, alabaster and terracotta. Sarcophagi are rare in these towns, since the predominant rite was incineration. In Volterra a few urns dating to the 4th century or perhaps earlier were found. They are plain or decorated with sculptured or painted ornamental motifs. Urns with figured scenes were to appear later, almost simultaneously both there and at Clusium.

The urns from each of these three towns have a distinct character and even the way in which the relief is felt varies. In the 2nd and 1st centuries B.C. the figures on the urns made in Volterra and Perugia were almost in the round. They move on a projecting base, rather like a stage, and seem to advance, often almost at a run, towards the spectator, evoking a space which is actually non-existent. In Clusium, where Greek influence was stronger, the relief is high but remains within the classic tradition; the composition the sculptors preferred is oblique, either diverging (fan-like—Pl. 106, below), or converging.

The subjects were taken from Greek mythology, or from the life of the deceased, or from funeral ceremonies, or they might be solely decorative. Some are common to all centres of production, but others are limited to a single centre. Generally, even when the subject is the same, the way in which it is treated varies from one city to the next. Giuliano Bocci, in an unpublished work, has concluded that in each series a master (only rarely can we speak of artists, for this was a commercial production, produced in series) supplied the model urn. The workshop copied it, adding or subtracting personages according to the dimensions of the urn and, probably, the price the customer was willing to pay. On the whole, differences between urns in a given series are slight. At Volterra the figures tend to be crowded and are monotonously repeated; in Clusium the oblique composition is sometimes artificial and forced. This explains the monotony of some museum halls, where the urns are all set in a row and are more or less alike in size, material, and composition. This is often quite unfair, for some merit a more kindly verdict. Some urns from Volterra are very pleasant

and lively. The same may be said for a group of cinerary urns made in Clusium. Actually when they are taken one by one, the undeniable uniformity of certain compositions disappears. The liveliness, the impetus, the hasty gestures which animate the individual figures successfully conceal the lack of inspiration. We may call it a craft, but it is a craft which occasionally succeeds in being art.

Nor was the master who prepared the urn which served as a model for his workshop particularly creative. He was undoubtedly inspired by models which have not reached us. It is difficult to tell just how faithful he was to them and how much of his own ideas he added. References have been made to cartoons, pattern albums, from which designs for this mass production were derived. It is possible, indeed quite likely, that they did exist. But they would hardly have provided the compositional scheme as it is found on the small urns. The master's task was to adapt Greek—or perhaps even Etruscan—compositions, which in some cases might be quite broad and complex, to the reduced requirements and limitations of an urn relief. In one case the Volterran sculptor was inspired by the same painting which served as model for one of the paintings in the François tomb (Pl. 99, above) in Vulci, showing Achilles sacrificing the Trojan prisoners. The excerpts, differences, and abridgements are considerable. It is quite unlikely that the models had that movement toward the spectator, which is so noticeable in Volterra; this is surely an adaptation. The male and female demons are also Etruscan additions. It was easier for the Clusine craftsmen to find the converging or diverging composition they preferred in their Greek models since that was the norm for Greece.

Sarcophagi are characteristic for southern Etruria in this period since inhumation was usual. On the front (only rarely were both front and back decorated) and on the ends the decoration is close in style to that of continental Greece. The relief is low, the figures are often isolated against a uniform background, or are set in groups of two, rarely three. The composition is that used for the paintings of local events in the François tomb (Pl. 99, below). The quality of the work, especially at Tarquinii (Pl. 105) and Vulci (Pl. 105) was very high. Rather unconvincing attempts have been made to prove that some sarcophagi were imported from southern Italy where one or more workshops were supposedly located.

The figures on the lids of the urns and sarcophagi belong to the series of idealized or naturalistic portraits frequent in late Etruscan production.

Caere

In his Descrittione di tutta Italia published in 1561, Leandro Alberti was the first to realize that the village of Cervetri, (Cerveteri, from Caere vetus) preserved the name of the ancient city. But the identification remained purely theoretical, and during the next two and a half centuries neither he nor anyone else identified the ruins of Caere or its cemeteries, where the tumuli of all sizes, characteristic and unforgettable, had almost entirely disappeared. Indeed, the medieval village of Ceri, several kilometres from the ancient city, was thought to be Caere. Luigi Canina in his Cere antica, published in 1838, definitely identified the remains of the city and necropolis and drew a rough plan of its ruins. It is not known exactly how far the territory of Caere extended. Its borders varied through the years. In the 4th century B.C. Servius says that the river Minio (Mignone) was the boundary line between Caere and Tarquinii, thus giving Caere the ore-producing area of Tolfa and Allumiere. This information probably reflects the state of affairs prior to the Roman conquest, although tombs of the 6th-4th centuries B.C., similar to contemporary Tarquinian tombs, have been found at Cava della Scaglia, south of the Mignone, between the river and the small stream Nome di Dio (north of Civitavecchia). In the nearby necropolis of Pisciarelli, south of the stream, Tarquinian objects were also found in the tombs. This led Mengarelli to suppose that the area between the river Mignone and Civitavecchia had belonged to Tarquinii. Beyond the Mignone, the southern zone of rock tombs-Blera, San Giuliano, San Giovenale, etc.-is generally considered Tarquinian, but both the tomb architecture and the tomb material reveal a strong Caeretan influence. We do not know whether or not this area belonged-even temporarily-to Caere. Caere seems to have controlled the shores of the lake of Bracciano, except perhaps for the eastern shore. North of the lake characteristically Caeretan tomb material comes from Trevignano Romano. Ancient sources give us no clues as to the frontier between Caere and Veii. The modern hypothesis which places it along the southern Arrone river is unfounded. It seems more likely that the border

CAERE

between the two cities was further south. The fact that in 243 B.C. the Romans founded a colony at Fregenae, on the river Arrone, would seem to indicate that the area was included in the stretch of coast which Caere had been obliged to hand over to Rome in 274-273 B.C. and where Rome founded a group of colonies in the 3rd century B.C.

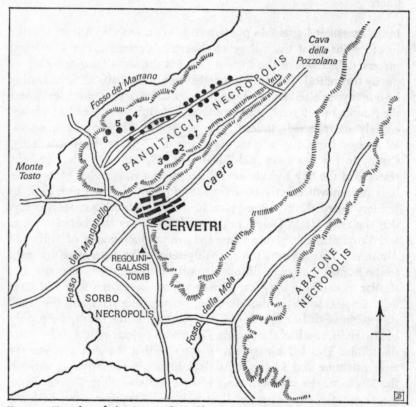

Key: 1. Tumulus of the Seats and Shields; 2. Tumulus of the Painted Animals;
Tumulus of the Ship; 4. Tomb of the Sarcophagi; 5. Tomb of the Triclinium;
Tomb of the Tarquini.

Caere and its cemeteries

The Greeks called the city Agylla; the Romans, Caere; the Etruscan name, confirmed by an inscription found at Pyrgi, was Cisra.

Like other Etruscan cities, Caere was on an upland plain (see map, p. 38) whose sides dropped almost vertically to the two streams surrounding it, the Manganello and the Vaccina. According to Dennis there was a wall all along the edge, but Mengarelli says it was only where the cliff was lower. To the north-east the plateau merges with the nearby mountains. A large ditch was dug here to shut off access to the city. Mengarelli has identified six temples and aedicula near a spring, but there may have been others. Architectural decorations from Caere are found in many foreign and Italian museums. Only two of these temples have been excavated, the temple of the Manganello-very small and with a single cella, probably 3rd century B.C. and with an imposing number of votive offerings-and that attributed to Hera from the 3rdcentury inscriptions incised or painted on vases. Architectural decoration indicates that it was built in the 6th century B.C. Nothing remains of the temple itself but a kiln where the architectural terracottas necessary for restoration were probably made.

The city was not on the coast, but about 6 or 7 kilometres inland. Its port was Pyrgi (S. Severa), which served as a base for piracy, according to some, or trade, according to others. Perhaps both, for in antiquity the two were often synonymous.

It may seem strange that the port was so far from the city—about 13 kilometres in a straight line—when a much closer one existed to the south at Alsium (Palo). Alsium was also inhabited by Etruscans and Etruscan tombs dating to the late 7th or early 6th century B.C. were found there in the 19th century. Pyrgi's fame depended on its famous sanctuary, mentioned by ancient sources (see pp. 51 ff.), and perhaps also on the fact that of all the ports which were the natural outlet for the minerals of the Tolfa area, it was the one closest to Caere.

Caere owed its wealth and its commercial and artistic development to its ownership of this ore-rich area, for then as now metals were what made people rich and were also the most widespread article of barter. But it should be noted that prior to the 7th century B.C. Caere does not seem to have been any richer in metals than other Etruscan cities. Judging from what we find in tombs, in Villanovan times and especially in the 8th century, Tarquinii was the most important centre in Etruria for the working of copper and bronze. The Villanovan tombs of Caere, cremation graves (a pozzetto) as well as inhumation trench tombs (a fossa), contained material that was not nearly as rich.

The oldest necropolis is that of the Sorbo, south of the city, with

pozzetto tombs, either simple, or in two levels with the cinerary urn in the lower part and a dividing slab, or with a tufa receptacle. The later tombs are trench tombs (a fossa). Characteristic for this necropolis is the use of lime in both types of tombs. The tomb material is very simple and not plentiful; in the oldest pozzetti it is sometimes completely absent. Fewer Villanovan tombs have been found at Caere than in any other centre of Etruria, such as Veii or Tarquinia.

Around the middle of the 7th century B.C. Caere equalled and even surpassed Tarquinia in quantity and quality of its manufactured goods in bronze.

Tarquinia may originally—that is up to the 8th century B.C.—have controlled the rich mining area of La Tolfa, which Caere may then possibly have taken over in the first half of the 7th century B.C. Whether or not this hypothesis corresponds to fact, one thing is certain, and that is that Caere's prosperity began in the first half of the 7th century B.C., coinciding with the onset of a period of relative decline at Tarquinia.

In the 7th century, thanks to its metals, Caere was in touch with the brilliant civilizations of the eastern Mediterranean. Ancient traditions agree in their references to the wealth of Caere. Excavations too have confirmed it and show that foreign products poured into the city. The great cauldrons, or *lebeti*, with winged human attachments and griffin or lion protomes were imported to Etruria in the 7th century, some say from Asia, some from Greece. They have been found in Praeneste and in Vetulonia, but Caere was probably their point of entry. The oldest bronze imitations (Pl. 16, above) come from the Regolini-Galassi tomb there.

In the 7th century Corinth exported its pottery to Caere, particularly the linear Geometric cups and the pretty aryballoi (perfume bottles) decorated with rows of animals which contained the perfumes so important in Corinth's trade. The Etruscan cities which have given us the greatest number of Corinthian vases, dating from the first quarter of the 7th century to the middle of the 6th century B.C., are Caere and Vulci. Vases of true Corinthian manufacture are rarer in other Etruscan cities, while Etruscan imitations are plentiful. Relations with Attica did not begin until the last quarter of the 7th century B.C. Crude terracotta vases with inscriptions in the Attic alphabet show that Athens exported oil to Caere. The earliest Attic black-figure vase found in Etruria is from Caere. It is a fragment of a vase by the Netos Painter, similar in subject to an amphora found in the Kerameikos cemetery

40

in Athens. Other Greek vases—Laconian, Rhodian, Ionian, Clazomenian, etc.—also found their way to Caere.

Syria, or Cyprus, or, some say, the Phoenicians, sent vessels of gold, silver, and of bronze, decorated in repoussé. Ivory came from the East and the Caeretan craftsmen learned to work it. Both the taste for jewellery (Pls. 18, 19, above) and the techniques used to produce it arrived from the East or from Rhodes. Soon the Caeretan goldsmiths outdid their models and masters and exported their products to other cities in Etruria, Latium, and as far as Cumae, in southern Italy.

In the second half of the 6th century B.C., a vase painter, who probably came from a Greek centre on the coast of Asia Minor, settled in Caere where he founded a pottery workshop which produced the so-called 'Caeretan hydriae' and employed Etruscan assistants. The earliest hydria has Greek inscriptions next to the figures. Other Greek potters may also have set up shop at Caere. According to a recent hypothesis the crater signed by Aristonothos was painted at Caere in the second half of the 7th century B.C. Some also affirm that the socalled 'Campana dinoi' were produced there in the second half of the 6th century, but there is no proof for this. The hypothesis according to which the 'Chalcidian' vases were made in Caere has been discarded.

Greek dedications and inscriptions dating to the 3rd century B.C. in a sanctuary of Hera indicate that Greeks were living in Caere at that time. Although the temple already existed in the 6th century there is no evidence of the presence of Greeks prior to the 3rd century. Caere more than any other Etruscan city had direct contacts with Greece and the Greek colonies: Hellenic ideas and mythology were most widespread there. Caere is the only Etruscan city to have had its own treasury in the sanctuary of Apollo at Delphi. The legend that the Greeks had settled at Pyrgi and at Caere before the coming of the Etruscans—a legend which excavations have not as yet been able to confirm since Greek material is completely absent from the earliest cemeteries—may have originated in the philohellenism of Caere, in her lasting contacts with the Greek cities, in the fact that at least in the 3rd century B.C. Greeks brought votive offerings to a female divinity which they identified with Hera.

Our knowledge of the art of Caere is derived almost solely from the tombs.

From the late 8th century B.C. onwards Caere had chamber tombs. The earliest were built above ground with courses of rectangular blocks of stone. They were covered with a false vault, each successive course

overlapping the one below until the top could be closed by a horizontal slab. Semi-subterranean chamber tombs came later: a trench was dug out of the tufa, lined with blocks which continued above ground for about half the height of the tomb, and covered by a false vault. These chamber tombs were generally small, for one or two persons. They were covered by a tumulus, a mound of earth, circumscribed by slabs, and rather small in early times. Tombs of this type are also frequent in Tarquinia. The most famous and most monumental semi-subterranean tomb at Caere is the Regolini-Galassi (Pl. 6a) in the Sorbo necropolis. This tomb was covered by an imposing tumulus (48 m. in diameter) and contained three burials-one in the cella, one in the antechamber, one in a loculus (niche)-with extremely rich grave accessories. Bronze shields decorated the walls of the cella. Tumuli over tombs continued down to the 5th century B.C. and later. Late tumuli are large and cover several groups of chamber tombs completely hewn in the tufa and almost always belonging to different periods. The base of the tumulus is a drum or round podium carved directly out of the tufa and sometimes ornamented with mouldings. Some tombs seem to herald the cube tombs (tombe a cubo) found in the area of rock tombs.

The so-called a caditoia tombs (6th and ζ th centuries B.C.) all along the sepulchral avenues are not unusual. The tiny vestibule has a hole in the ceiling which communicates with the outside where it is closed by a slab. Similar tombs were found in Tarquinia (see p. 82) and Vulci (see p. 89), but there the hole is in the ceiling of the burial chamber. The portico tombs of Falerii Novi, also late, had a tube in the ceiling of the vestibule (see pp. 65-6). Between the 5th and the 3rd centuries burials at Caere also were in covered stone coffins (cassa) which often had a cippus on top of the lid.

Large tombs with a single chamber, one or more pillars and one or more rows of benches along the walls on which the bodies were placed began to appear in the 4th century B.C.

The most famous cemeteries of Caere are Monte Abatone to the east, and the Banditaccia, between the course of the Manganello and that of the Marmo, to the west of the city. In the Banditaccia (Pl. 5a) the tombs are aligned along streets and piazzas. The city of the dead had its 'town plan' just as did that of the living.

The chamber tombs of Caere are decorated with carvings and sculptures cut out of the tufa. Cornice mouldings and engaged pilasters

decorate the walls, columns and pillars, with a variety of bases and capitals, support the beams and crossbeams of the ceiling. Doors framed by a characteristic moulding and windows open onto the vestibule from the side chambers. The furniture is also carved out of the tufa. The funeral couch (kline), usually meant for men, is set against the wall; the coffins or sarcophagi are generally but not exclusively reserved for women. Chairs with rounded or rectangular backs and footstools flank the doors. The tomb of the Shields and Seats (Tomba degli Scudi e delle Sedie—Pl. 5b) has circular shields hewn into the walls, like the ones in bronze found in the Regolini-Galassi tomb. A chamber tomb discovered in 1863 and since lost had male and female terracotta statuettes seated on five of the tomb's eight chairs. Only three statues have been preserved (see p. 45).

A 6th-century tomb, recently discovered in the Banditaccia, has architectural motifs on the façade, executed in a variety of colours and materials. This type of decoration is quite new both at Caere and elsewhere. One tumulus had low relief decoration on its drum. The late and well-known tomb of the Reliefs (Tomba dei Rilievi) has various objects of daily use modelled in stucco and painted on its walls and pillars. These include helmets, greaves, shields, cups, etc., as well as domestic animals such as the dog, duck and cat. This is probably the oldest example of a room decorated in stucco.

Tombs with painted walls are rare. Five painted terracotta slabs now in the British Museum were found in a tiny chamber tomb. The painted slabs now in the Louvre (Pl. 6b) may have come from buildings rather than from a tomb. Other painted slabs, often poorly preserved and fragmentary, may have decorated temples or buildings. Caere seems to have used such painted terracotta slabs more than any other Etruscan city. The rare tombs decorated with paintings directly on the wall are, up to date, either among the oldest—Tomb of the Ship (Tomba della Nave), of the Painted Lions (dei Leoni Dipinti), of the Painted Animals (degli Animali Dipinti), dell'Argilla—or the most recent, such as the Tomb of the Triclinium or that of the Sarcophagi (Pl. 6c). The Tomb of the Sarcophagi was probably painted at a later date than the 5th- and 4th-century B.C. sarcophagi it contained. What is left of the painting cannot be earlier than the 3rd or 2nd century B.C. None of the painted tombs is as fine as those of Tarquinia.

Burial in the 6th- and 5th-century chamber tombs was generally with the inhumation rite. Cremation was unusual, but continued until Roman conquest in simple buca tombs and even in chamber tombs, where the ashes were placed in pottery jars or small urns.

Even the two famous terracotta sarcophagi in the Villa Giulia Museum (Pl. 7) and in the Louvre (510-500 B.C.), with husband and wife reclining on a banqueting couch, according to a pattern which began in Etruria in the second half of the 6th century B.C., may have been used as cinerary urns, despite their size. The Louvre sarcophagus has a small cavity where the ashes could have been put. Several terracotta urns were found in the same tomb as the sarcophagus in the Louvre. One of the cinerary urns repeats on a smaller scale the composition and motif of the sarcophagi. The others also have the kline with turned legs and the typically Etruscan puffy mattress which falls down at either end of the couch, but the deceased on it is stretched out in the sleep of death (Pl. 50). These urns are so alike that they were probably produced by the same workshop. Lids of similar urns, recently discovered, and the fine sarcophagus of the Lions, from a tomb in Procoio di Ceri, show that Caere, like Chiusi (see pp. 167 ff.) produced sarcophagi and ash urns of a high artistic quality in the second half of the 6th and in the early 5th century. In Chiusi they are in pietra fetida, in Caere normally in terracotta.

The large size sculpture of Caere is not in tufa, nor in alabaster, but seems to have been solely in terracotta. It appears likely that there were also large statues in bronze, now lost. As Professor Riis has pointed out, the softness of the modelling is characteristic of Caeretan production, but neither he nor anyone else seems to have noted that from the late 7th century to 550 B.C. Caeretan sculpture did not follow the artistic current which inspired the sculpture of the leading Etruscan cities. Caere was influenced above all by Ionia, by the Greek cities and islands along the coast of Asia Minor, with which it must have had frequent contacts. The characteristically soft modelling is Ionian and we already find it, together with local Etruscan elements such as the garment, the long braid, the rectangular mantle attached at the shoulders, in the latest supporting figures of the bucchero cups. The modelling of the male figure on the finest bucchero piece, exquisitely slender and elegant as he stands upright on the back of a fabulous beast (Pl. 12a), is summarily rendered but characterized by an attempt to avoid angles.

Features merge gradually in the head of a woman found in a chamber tomb in 1865. It has been suggested that this head is the work of a

sculptor from the East, or trained in an eastern school. There are, undeniably, oriental features (almond eyes, snub nose) but while they were accepted by the sculptor he considered them to be of secondary importance. What he stressed was the bony structure of the head, the shape of the skull emphasized by the smooth close-fitting hair, the high cheekbones, the decisive chin. The expressive modelling is lively, almost quivering, and it is completely in contrast with the distant, indifferent, unfathomable expression of oriental heads.

An old restoration had given this and another female statue a hairstyle with a chignon at the nape. The hair is actually not in a chignon at all, but is engraved with the incising ending at the neck just like the female canopic jars of Chiusi. Points of contact between Caere and Chiusi are evident, but hard to explain, for Clusine sculpture of the 6th century was following in the wake of a delayed Daedalic current while that of Caere was under the influence of Ionia.

The terracotta sarcophagus 'degli Sposi' in the Museum of Villa Giulia (Pl. 7) is particularly fine, superior to the one in the Louvre, which is beautifully made but has been over-restored and is colder and more academic. Softness of modelling is evident particularly in the heads. And it is this feature which underlies the generally accepted theory that the two sarcophagi were influenced by Ionian art. The wide planes merge in gentle passages, details are few, there are no undue indications of muscle and bone. The profiles, the hair, which begins high upon the receding foreheads and is stylized into barely indicated corkscrew curls, the slanting almond eyes, are all characteristic features of 'Ionian' sculpture, as is the contrast between the smooth surface of the cloak and the undulating narrow folds of the long skirts. But the sculptor did not simply accept this 'Ionian style' as an empty formula. He felt it in his own way, re-experienced it, modified it. The folds of the feminine garments lack the effects of light and shadow and the free and easy undulating surface of Ionian garments. When the master who modelled the sarcophagus broke the broad planes of the cloaks he did it so as to model folds of a plasticity and volume quite at odds with the artistic temperament of Ionia. Neither the masses of ample folds which fall on the cushions, nor the deep grooves of the chiton are Ionian. Nor is the clean cut of the mouth. And despite the purely surface modelling of shoulders and breast, the male nude reveals a powerful vigorous torso. The originality and charm of the Caeretan group consists in this mixture of two different artistic languages.

CAERE

The same Ionian tendency, the same softness of modelling, are present in the antefixes with the head of a maenad or a satyr—and not only in those belonging to the first quarter of the 5th century B.C. which were influenced by the sarcophagus—but also in the earlier group from the mid-6th century B.C., which is very close to some of the terracottas from Samos.

Around the middle of the 6th century B.C. Caere came to the fore in the working of bronze, especially sheet bronze decorated in repoussé, a field where Tarquinii had prevailed until then. Caeretan metalworkers active between 650 and 600 B.C. must have made the great bronze sheets (Pl. 14, right) used for the wooden furniture of the two inhumation burials in the Regolini-Galassi tomb, for similar bronzes have been found in other Caeretan tombs. The repoussé shields nailed to the walls of the dromos may however have been made in Tarquinii where similar shields were found. The cast bronzes (Pl. 13, below right) from the princely tombs of Praeneste (Palestrina)—for which no prototypes or successors are known in Latium—could perhaps be attributed to Caere, to which they are close in style. The cauldrons with three feet, decorated in repoussé, from these tombs and from others in the Faliscan region, were certainly made in Caere.

The three bronze tripods in repoussé found in Marciano near Perugia and some of the repoussé bronzes from Castel San Mariano, not far from Perugia (Pl. 87), all from the second half of the 6th century B.C., were made in Caere. Some of the cast bronze statuettes from the same deposit in Castel San Mariano, such as the fish-tailed man leaning forward on his arms (Pl. 88a) which has the soft modelling typical of Caere, may also be from there. The modelling on this figure is so soft that it was believed to be female.

Caere played an important role in the production of black 'bucchero' vases, a kind of pottery also found elsewhere, though nowhere was it so widely used as in 7th- and 6th-century Etruria. Bucchero is of levigated clay, the surface of the vessel may be dully lustrous, or very shiny. The finest specimens have a glossy black surface and extremely thin walls, from which they take the name bucchero sottile, applied to the production of southern Etruria. Several cities—Vulci, Tarquinii, Veii—produced bucchero sottile, outstanding in technique and shapes, but no other city has bucchero vases equal to some of those found at Caere, in the Sorbo necropolis, and wrongly attributed at times to the Regolini-Galassi tomb. The walls of these highly original vases are very

thin; the shapes are unique, the elegant wide ribbon handles and the decoration (stripes, incisions, low flat relief) were inspired by bronze, gold, and silver ware.

The very thin walls and the brilliant surface caused some scholars to attribute the finer bucchero ware to Greek potters, who were supposed to have adopted Etruscan types and worked for the Etruscan market. Behind this arbitrary distinction is the prejudice that anything really good cannot be Etruscan. Not only is there no proof for a Greek origin of these buccheros, but the animals in relief which decorate them are similar to those on the repoussé bronzes from the Regolini-Galassi tomb. They have the same elongated bodies in which the natural forms are translated into decorative curves, but avoid becoming calligraphic. The masterpiece of the Caeretan workshops takes us into an unreal and fabulous world. An animal with the body of a bird and twin horses' heads (Pl. 10a) has the ribbon handle characteristic of this workshop. Upright on its back stands a male figurine, whose unreal fluid forms harmonize with the fantastic smooth curves of this twoheaded creature. A Greek potter would have modelled the youthful body in the more naturalistic style of the late 7th century B.C. The Etruscan potter realized that a greater precision of form would have ruined the harmony of this lovely vase. It was found in the Sorbo necropolis and has occasionally been erroneously attributed to the Regolini-Galassi tomb. A cup with relief protomae (Pl. 11a) from Tomb II of the Ship (Tomba della Nave) presupposes a model in gold. Although this bucchero ware was found primarily in Caere, a few rare pieces also found their way to northern Etruria, to Rusellae, Vetulonia, Clusium, and Monteriggioni.

A 'red' bucchero ware with shiny red surface and impressed decoration was also produced in Caere. The later pieces date far into the second half of the 6th century B.C. Caere, which imported quantities of Proto-Corinthian and Corinthian vases (see pp. 40 ff.), had local workshops where they were imitated. These Etruscan vases with rows of animals, the so-called Etrusco-Corinthian ware, were also made in other Etruscan cities and only recently have we begun to define the characteristics of each workshop. Generally they are carelessly executed, and the glaze is poor. Very few pieces rise above this rather ordinary level. The large amphoras with incised scale designs and plaits, separated by bands of animals, birds, etc., were also made in Caere.

The jewellery from the Regolini-Galassi tomb has always been greatly

admired. This south Etrurian jewellery is generally rather 'baroque', but some pieces, such as a gold and amber necklace (Pl. 18), are in excellent taste. Other famous pieces-the large ceremonial fibula, the bracelets and the pectoral-are worked in repoussé and granulation. These two techniques existed both in the East and in Greece and were highly developed in Etruria. Repoussé decoration was done from the reverse with dies. Just how the minute grains of gold were attached to the gold lamina is still a mystery, despite what has been written on this subject. The details of the repoussé figures and the geometric ornamental motifs were picked out in granulation. In southern Etruria rows of tiny animals in the round (lions, geese, sirens, chimera) were made from two sheets of gold worked in repoussé and then soldered together. Some of this excessively ornate jewellery is of rather questionable taste, but the effect is highly original and not always unpleasing, and the technique is almost perfect. The fibulae and clasps from the Praenestine tombs, a fibula from Vulci (Pl. 20, above), the 'Corsini' fibula from Marsiliana d'Albegna, can be attributed to Caeretan workshops. This jewellery illustrates the same tendency for over-modelled and rounded forms which is found on the tripod cauldrons from the Barberini and Bernardini tombs at Praeneste (Pl. 2c) and other similar ones, and which reappears a century later in the bronze sphinxes and lions on the rim of the cauldron from Marsciano (Pl. 86a) and in the lions on the lid of the sarcophagus of the Lions from Caere.

A group of gold rings with an oval bezel (Pl. 14c) were engraved in Caere, or in Vulci. The motifs and the provenance point to either city. A ring from Chiusi and one from Populonia were probably imported from the south. These rings are similar and were made in one workshop, but not all by the same goldsmith. The earliest group, decorated with real or imaginary beasts, derives, as some scholars have stated, from rings found either in Carthage or in centres where Carthage traded. The late group was influenced by mythological scenes on Greek pottery painted between 540 and 520 B.C. A few rings are decorated in relief, like the one from Populonia (Pl. 67b).

Caere must also be considered as a likely centre for ivory carving. If the ivories found in northern Etruria, at Chiusi and Marsiliana, were made locally, they were made by craftsmen from southern Etruria. No one is still of the opinion that Etruscan ivories were imported from Phoenicia or Cyprus. According to some scholars foreign craftsmen came to Etruria and set up local schools. If this hypothesis is correct,

then these foreign artisans came to Etruria at the end of the Orientalizing period, since the earliest ivories (Marsiliana, Praeneste) are from tombs that date to the late 7th century B.C. But these ivories are not worked as was usual in the East or in Greece. The surface is not so shiny or highly polished. Some pieces, such as the forearms and the cups from the Barberini tomb in Praeneste, are reminiscent of wood-carving. This would suggest that they were made by Etruscan craftsmen acquainted with oriental ivories, but trained in Etruria (see p. 41). The pyxides found in Caere (Pl. 15a) and wrongly attributed to the Regolini-Galassi tomb are technically more skilful.

After the middle of the 5th century B.C. Caere declined. Fictile revetments of temples clearly show this. A wide variety of antefixes and friezes in great number made between 550 and the second half of the 5th century B.C. has survived. Later their number dropped and the decorative patterns were limited to such types as were usual in Etruria from the late 5th century to the 1st century B.C. Late terracotta friezes (1st century B.C., such as the one with flowers, tendrils, putti and human heads) are cold and heavy (Pl. 17a).

Red-figure vases, generally decorated with heads of women the Genucilia group and the Torcop group—found at Caere date to the second half of the 4th century B.C. They are closely connected to vases from the Faliscan area and were also influenced by South Italian vase painting. Like all Etruscan vases of this period, they never are anything but second-rate.

A fine sarcophagus of white limestone, from the late 5th century B.C., with the dead man lying full length on the lid (Pl. 18b), was found in the tomb of the Sarcophagi, in the Banditaccia necropolis, together with three other simpler sarcophagi. Two of these, both with a human figure lying on the lid, are unique in that the dead man's image faced the wall (Pl. 6c). No other examples have been found, either in Caere or in the rest of Etruria. The Tomb of the Sarcophagi is the only tomb at Caere where late sarcophagi were found.

It seems unlikely that this lack of finds, this apparent standstill of artistic activity in the 4th and 3rd centuries B.C., is to be accounted for by systematic looting at the hands of clandestine diggers, with the result that material from Caere may be in museums and collections without any indication of its place of origin. There may have been internal strife such as that which hastened the downfall of Volsinii or Veii, which might have checked the artistic development of the city. Conflict between Rome and the Etruscans is not to blame, for Caere did not fight against Rome. On the contrary, the two cities must have been on particularly friendly terms if the Romans sent all they held most holy—their priests, their Vestal virgins, their cult objects (Livy, V, 40)—to Caere when the Gallic threat appeared on the horizon in 390 B.C. The only clash with Rome occurred in 354 B.C. when Caere, influenced by Tarquinii, invaded Roman territory, but withdrew immediately, asked for peace, and friendly relations were reestablished. According to Livy (IX, 36, 2), in the 4th century B.C. noble Roman families sent their sons to Caere to study Etruscan letters; that is to finish and perfect their studies.

There is one possible explanation. The prosperity of Caere depended on trade, which in turn depended on the freedom of the seas, essential to Caere more than any other Etruscan city. The alliance between Caere and Carthage against the Phocaeans, mentioned by Herodotus, was aimed at destroying Greek maritime competition. And when the Etruscans were defeated in the waters off Cumae, the defeat hit Caere harder than any of the other cities, for Syracuse stopped future maritime communications.

Of course it took some time for the consequences to be felt. With its commercial activity destroyed—or almost—Caere became an agricultural centre and was forced to exploit her fertile lands. The final blow came from Rome, in 274 or 273 B.C., when Caere was deprived of the entire coastal zone with the ports and the mining region of La Tolfa, where Rome then founded the colonies of Castrum Novum, Pyrgi, Alsium and Fregenae. By 205 B.C. the transformation from an industrial to an agricultural city was complete. Other cities furnished arms and industrial products for the war against Hannibal, but Caere supplied only wheat and food. Some scholars believe that the magistrates of Caere in Roman times were a continuation of the old Etruscan magistrates.

A good many votive terracottas of the 3rd, 2nd and 1st centuries B.C. have been found within the boundaries of the city. Most of them are of little value artistically. Nor do they throw any light on the cults of Caere, for the repertory of votive offerings is too varied to make interpretation possible. They consist of reproductions of parts of the human body, winged figures, warriors, Minerva statues, lyre or flute players, seated women with children, quadrupeds, birds, even mice. But some of the heads of children and of adults, dating to the 2nd and the 1st

centuries B.C., are remarkable for their simplicity, for the freshness of modelling, and the skilful touch, as in a fine head in the Vatican Museum (Pl. 15b, Pl. 16) and others from the temple of Manganello, at the Museum of Villa Giulia.

A number of minor centres around Caere, especially along the coast, date to Etruscan times. The most important of these, both in antiquity and now, after the successful excavations carried out by the Istituto di Etruscologia e Antichità Italiche of the University of Rome, is Pyrgi (S. Severa). It was the port of Caere, linked to the city by an important road. Recent excavations, begun in 1957, have brought to light the remains of two temples—one, from the first quarter of the 5th century B.C., was Tuscan in plan (Temple A); the other, from the late 6th century B.C., had the plan of a Greek peripteral temple (Temple B). There was a sacred precinct (area C), a bothros, various inscriptions of great interest (Pls. 94a, 95, 96) as well as the name of a magistrate of Caere, Thefarie Velianas, called zilath in the Etruscan text and 'king' in the Punic one. The excavations of Pyrgi have greatly contributed to our knowledge of Etruscan temple architecture and religion.

The Greeks identified the goddess worshipped at Pyrgi with Leucothea (Aristoteles), or with Eileithya (Strabo); Etruscan inscriptions mention Uni, perhaps Tina, and Astarte. The excavations have shown the hypothesis which identified the goddess of Pyrgi as the Mater Matuta to be false.

In 384 B.C. the sanctuary of Pyrgi was sacked by the fleet of Dionysus of Syracuse. But it does not seem to have been destroyed until later, perhaps in 273 B.C. when the territory passed into Roman hands.

Along the road from Caere to Pyrgi, near the great tumulus of Montetosto, are the remains of a cemetery with chamber tombs and a large temple. The foundation platform measures about 60×45 m.— larger than anything found in Etruria. Possibly the temple occupied only a part of the platform.

A sanctuary of Minerva with a temple built in the 6th century B.C. has been excavated at Punta della Vipera, near Santa Marinella. It was probably the single cella type (approx. $8 \times 8m$.) with columns on the front. It was destroyed in the 4th century B.C. and rebuilt, and was modified in the 3rd century B.C. At the end of the 1st century B.C. the temple was destroyed. A leaden tablet with an inscription (see p. 196) was found in a well belonging to the sanctuary.

Remains dating to Etruscan times have been identified by Mengarelli

in various places along the coast: not far from Castrum Novum, at the Vignacce, at Pian Sultano, etc. Particularly interesting is a small centre near Civitavecchia, not far from the ruins of a Roman bath built near a medicinal spring, at a place called 'Pisciarelli'. A necropolis was discovered here and some of the tombs were excavated. Two of them contained large bronze discs with an animal protome at the centre. These discs are similar to the so called Tarquinian 'shields' and were evidently imported from Tarquinii.

The area around La Tolfa was already inhabited in the Stone Age. There were several centres there in Proto-Villanovan times. The Etruscan period however has not yet been sufficiently studied and there is need of research as well as excavations. Around the close of the 7th century B.C. there was an Etruscan village at Colle di Mezzo. Caeretan influence is evident in the local imitations of red bucchero.

Veii

Perhaps the most famous of Etruscan cities is Veii. The wars, both real and legendary, which Veii fought against Rome, traditionally began under Romulus and ended in 396 B.C. with the conquest of the city. They have been described in detail by ancient historians. In the field of art too we fare better than we do with other Etruscan cities, for ancient sources have furnished a number of references. At the end of the 6th century B.C. Veii had a flourishing school of sculptors specialized in temple decorations. When the Romans decorated their most important temple, that of Jupiter Capitolinus, they turned to Veii. We even know the name of one of their sculptors, Vulca, said to have made two statues in Rome, the Capitoline Jupiter and a Hercules mentioned by Pliny. In modern times Veii is famous, and rightly so, for the fine terracottas found in the excavation of a temple at Portonaccio, in a sense atoning for the oblivion and indifference of centuries. At the beginning of the 20th century the site of Veii was still unknown. When it was finally identified as being near Isola Farnese scholars were interested primarily in finding the subterranean passage which had permitted Camillus and the Roman army to capture the city.

As elsewhere, the Etruscan city was preceded by small Villanovan villages—groups of huts some of which have been found—each built on a small part of the area on which the city was later to be. Every

52

village had its own cemeteries along ancient roads (Pl. 5). A village located on the subsequent site of the north-east gate buried its dead at Grotta Gramiccia, along the road to Nepi and Tarquinia. The cemeteries of the villages at Portonaccio and on Piazza d'Armi are unknown. We have not found the villages associated with the cemetery of Valle la Fata, bordering the earliest road to Rome; nor have we found the villages that buried their dead at the Quattro Fontanili and at the Vacchereccia, along the road to Capena. Villanovan villages and cemeteries seem to be later than those of other cities in southern Etruria. The finds are not so rich as those found in the cities along the coast. They also show contacts with Latium. Immigrants from Latium may have lived there together with the Villanovans. Although some of the finds are rather interesting (such as an impasto vase with a ship incised on it) their artistic quality is modest. At this time Veii already traded with the Chalcidian colonies in Campania.

Etruscan Veii (see plan, p. 55) was built on a tufa plateau, more or less triangular in shape and naturally fortified. Except for a short stretch at the north-west gate the slopes fall steeply down to the two streams which surround it, the Fosso di Formello and the Fosso dei due Fossi, which flow into the Fosso di Valchetta, the ancient Cremera, famous for the part it played in the battle of the Fabii against Veii. A triangular spur, the so-called 'Piazza d'Armi' seems to have been the acropolis of the city, where, according to Livy (V, 22), the temple of Juno Regina, patron goddess of Veii, was to be found. This temple has not come to light and it was probably destroyed when Camillus transferred the statue and cult of the goddess to Rome. A simple temple with a rectangular ground plan (15.35×8.07m.) has been identified at the Piazza d'Armi. We do not know to whom it was dedicated and there is nothing that would lead one to identify it with the temple of Juno Regina. It had a single cella; the antefixes date it to about the middle of the 6th century B.C. It may be the earliest, or one of the earliest, Etruscan temples of which anything is left. It had a wooden beam inside, which probably supported the roof. A late votive deposit (3rd-1st century B.C.) of a healer god, found in the ditch under the acropolis, also seems to have had nothing to do with Juno Regina. An enclosure dedicated to Ceres was at Campetti; many votive terracottas were found there, women with children, warriors, female heads, lyre players, etc. A well-known sanctuary with a precinct wall, a temple, an altar, a sacrificial pit, a tank, was at Portonaccio. The goddess worshipped there, perhaps Minerva, was a healing divinity. Except for the temple at Piazza d'Armi, these cults continued into Hellenistic times.

The numerous cuniculi (rock-cut tunnels for the drainage of the land and for water supply) found in the recent excavations of the British School in the territory of Veii and Latium are characteristic of Veii. They give us a good idea of the skill of the Etruscans in hydraulic engineering.

Remains of Etruscan houses have been found: at the Quarticcioli, at Macchia Grande, at Piazza d'Armi. Near the north-west gate traces of a 6th-century B.C. timber building came to light. It had two rooms which opened onto a porch. This building was destroyed somewhat later and a second building was set up on the same site. It had a foundation of stone and walls of unbaked brick. In plan it repeated that of the underlying house and was destroyed when the city walls were built in the 5th century B.C. Several houses have been excavated not far from the north-east gate, more complex in plan, and built of stone. One still had its hearth. The city walls rose between the middle of the 5th and the beginning of the 4th century B.C. On the outside a high wall of tufa blocks reinforced the earth rampart. There were various city gates, some Roman, some Etruscan.

One of the sights of Veii is the Ponte Sodo (Pl. 19) over the bed of the Fosso di Formello (not to be confused with the Ponte Sodo of Vulci). The water runs through a tunnel dug out of the rock, about 70 m. long and between 3.50 and 4m. wide. The tunnel may have been natural, but it was widened and adapted by man.

Ancient writers refer to Veii as the richest and most powerful city in Etruria, fortified by nature and by man and the equal of Rome in military power. One of the reasons for such statements was probably an attempt to make the first enemy against which Romulus's small city tried her strength appear all the more formidable. In any case they project 5th-century Veii back to the 8th and 7th centuries B.C.

Cemeteries lie all around the city. The tombs are arranged chronologically from the summit to the base of the hill at Quattro Fontanili and at Grotta Gramiccia, and perhaps in other Veientine cemeteries. The earliest, pozzo tombs, are on the crest of the hill. Further down are the pozzo tombs with a lateral recess or loculus to house the grave furniture, or with a second narrower pozzetto annexed. This group of pozzo tombs was interspersed with earlier trench (fossa) tombs. Large tufa discs, circular or oval, either convex or roof-shaped, probably

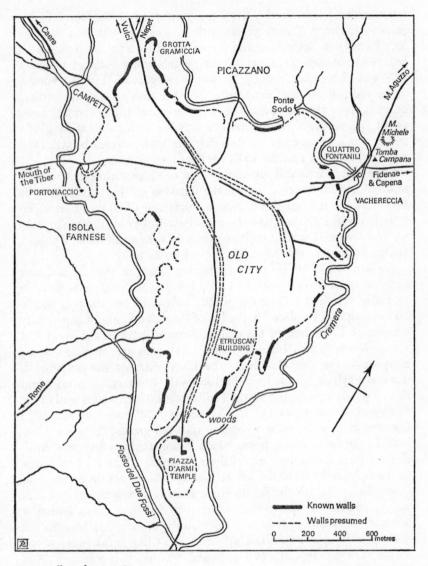

Veii: walls and cemeteries

covered the pozzo tombs. They are similar to those found in the Faliscan territory. Trench graves with a recess or with one or more loculi are later. Sometimes the corpse was laid into the trench on a hollowed-out tree trunk, as in the neighbouring Faliscan territory. Veii was also influenced by its second neighbour, Latium. Further down the hill are the rectangular chamber tombs, with or without benches along the walls, and the characteristic chamber tombs known as 'ad area scoperta' or 'con tramite a forma di fossa' consisting of a trench tomb, or an open, roofless chamber tomb entered by stairs and with niches hewn into the walls for the funerary urns.

Large isolated tumuli containing one or more chamber tombs or tombs 'ad area scoperta' are on the outskirts of the necropolis. The best known is the tumulus of Monte Aguzzo, or Chigi tomb, in which were found the Chigi olpe—the most beautiful Proto-Corinthian vase we know—and a small bucchero amphora with an Etruscan alphabet, known as the Formello alphabet, incised on its body.

The tombs of Veii are not well known. Some of the old and new excavations have been published only lately. It is therefore impossible to know where the Campana tomb, discovered in 1843 at Monte Michele, should be placed in the list of Veientine tombs. It is generally considered to be one of the earliest Etruscan painted tombs. It had a corridor with two lions in tufa-their heads are missing-at the entrance to the two chambers. The inner chamber has six shields, some say kylixes, painted on the back wall. Cinerary urns, vases and funeral goods were on the bench. The decoration on the back wall of the first chamber is important. It was strongly influenced by the large Caeretan vases with white decoration on a red ground. This is evident both in the lotus flower frieze which frames the painting, as well as in the figures themselves, especially the animals. There are two panels to the right and two to the left of the door. Three are decorated with Orientalizing motifs, the fourth has a narrative scene showing a man with a double axe upon his shoulder preceded by a youth leading a horse. On the horse are a tiny rider and a quadruped; beneath the horse a dog turns its muzzle upwards. The filling ornaments of the background are typical: multicoloured volutes, palmettes, etc. The bodies of the animals are painted in contrasting colours (red with yellow dots and yellow with red dots) which destroy the unity of the body. The colour is nothing but a means for achieving a decorative effect. The tomb has been the object of a great deal of discussion

56

and is variously dated. Scholars oscillate from the first quarter of the 7th century B.C. (Rumpf) to the second half of the 6th century B.C. A late date seems preferable. Similar decorative effects are found on vases of the late 7th and first half of the 6th century B.C.; also, some motifs do not appear in Greece before the third quarter of the 6th century. Moreover, an early dating would make tomb painting in Veii precede tomb painting in all the coastal cities by almost a century. It is unlikely that the city was as important as that in the 7th century B.C.

It was not until the 6th century B.C. that Veii developed into an outstanding artistic centre. J. Ward-Perkins recognized 'that there was a considerable time-lag between the cities of the coastal belt and their neighbours inland' that is between tombs at Veii and those of Caere and Tarquinii. Bronzes generally are not very numerous and when compared to those of other Etruscan cities downright poor and meagre. Gold jewellery, which is a sure sign of wealth and prosperity, is almost non-existent. This may be due to looting, but if there had been much in the way of ivories, jewellery and bronzes, some fragments, at least, would be left. Perhaps future excavations in Veii will also turn up rich Orientalizing tombs like the ones found in other Etruscan cities. What we have reveals a very modest and short Orientalizing period.

Veii seems to have had potters' workshops of its own. A group of Italo-Corinthian olpai decorated in an imbricated pattern have recently been attributed to a local workshop. Local black bucchero is technically good, simple but elegant. Decoration, when there is any, is prevalently incised. A group of bucchero cups with caryatid supports has been included in the Veientine production. These buccheros are not as fine as some of the pieces from Caere found in the Sorbo necropolis, but they stand up quite well when compared with what other cities made. The red bucchero, as far as one can tell, seems to have been imported from Caere.

A second painted chamber tomb was found in 1958. It is called the Tomb of the Ducks (Tomba delle Anatre) after a frieze of ducks in simple outline drawing. The painter was definitely second rate and the horizontal lines above and under the frieze were not even drawn straight. This tomb confirms the low quality and the time-lag of the Orientalizing period in Veii. The painting looks archaic, but, as its artistic level is so low, it is difficult to judge if, and by how much, the painting is behind the times. I should set it perhaps at the end of the 7th century. So far Veii has given us only two painted tombs, but whatever their date, Etruscan tomb painting took its first steps here and in Caere.

The tombs indicate that there was a much more limited importation of Greek vases, both Corinthian and Attic, here than in the rest of southern Etruria. Veii certainly reached down to the coast. Dionysius of Halicarnassus (II, 55, 5) and Plutarch say that Veii owned the salt works at the mouth of the Tiber. Veientine river boats traded with the inland and transported salt and wheat. It does not appear to have had a port right on the Tyrrhenian coast, or maritime commerce. Geometric cups from Euboea did however find their way to Veii, probably brought to the mouth of the Tiber by the Chalcidian colonists who lived on the islands of Ischia, the ancient Pithekousai.

The earliest examples of sculpture in Veii are the tufa lions in the corridor of the Campana tomb. They are quite unusual: funerary sculptures in the form of tomb guardians were not customary at Veii. From the middle of the 6th century on, great quantities of architectural terracottas and statues and terracotta figurines were made. The earliest are from the small rectangular temple on the acropolis. The antefixes (Pl. 20c) decorated with the head of a woman reveal influences from Vulci, for they recall the head of the Polledrara statue (Pl. 43a). The architectural terracottas from this temple and those, in more or less fragmentary condition, found elsewhere in the city fall into the repertory of architectural terracottas typical for southern Etruria and Latium. They resemble those from Velletri (Velitrae) most closely.

The three cinerary urns found in the second chamber of the Campana tomb are only slightly later. They are quite distinctive with their semicylindrical lids and human heads. Those found in the tomb have lost their heads, but a similar urn (Pl. 21) is in the Museo Gregoriano at the Vatican.

In the second half of the 6th century B.C. Veii became one of the most important artistic centres in Etruria for the production of terracottas. A school of clay sculptors (see p. 52) arose there and finds show it to have been extremely active shortly before 500 B.C. Unless Roman tradition has set the date for the construction of the Capitoline temple too early, this school was already famous in the last quarter of the 6th century B.C. Revetment slabs from temples in many cities of Latium and southern Etruria can be attributed to Veii. Those of the temple of Velletri (Velitrae) for instance, are so close to some in Veii that it is logical to consider them to be the work of Veientine artists. Velletri,

58

which produced no architectural decoration prior to the appearance of these terracotta revetments, could hardly have made them and so of course could not have exported such work to other cities. The clay sculptors went with their moulds to the various cities. The terracottas found in the excavations of the Portonaccio temple, often erroneously called 'temple of Apollo'—even though Minerva was worshipped there as a healing goddess—must be attributed to this school. The statues which seem to have decorated the ridgepole, especially the main group of Apollo and Hercules fighting for the sacred hind, are justly famous. Their sculptor, whom some propose to identify with the Vulca who was active in Rome, was a first-class artist who interpreted the Greek formulae with great originality and freedom. The supports for these statues have two opposing rams—a motif not found elsewhere in Etruria and which is probably due to influence from the Faliscan Capenate region, where the ram frequently appears as a decorative motif.

A number of antefixes were found in the excavation of the temple. The head of a woman (Pl. 23b) is striking. The features are similar to one of the best known and most beautiful statues from the Acropolis in Athens, the peplos kore. But a comparison between the two shows how far the school of Veii is from Attic style and how deeply it was transformed even when the sculptor imitated it.

The many votive terracottas found in the Portonaccio precinct were made by this school, which was familiar with the artistic styles of Greece; of Attica (see the antefix, Pl. 23b); of the Peloponnese (as is shown by a male statue, influenced, according to some scholars, by the Master of Olympia; see also Pls. 23 c-d); of the Greek islands and of the Asiatic coast. I do not however believe that it is possible, as has been done, to speak of Greek sculptors working in Veii. Votive and architectural terracottas are related to those of Latium.

It should also be noted that the votive offerings at Portonaccio are often much larger than is usual for Etruscan temple offerings. This may be due to the high social standing of some of the visitors, who could afford gifts that were larger and finer than the simpler more modest offerings of most.

The school of Veii, which produced works of such high quality, seems to have had little influence on the rest of Etruria. At this time Caere was producing her characteristic sarcophagi, terracottas and bronzes, all quite different in style from Veientine works. Even Tarquinii and Vulci differed from Veii, despite the fact that they too were influenced by Ionia. Clusium was even further away. A fragmentary antefix, close to some of the Veientine ones, has just recently been found at Rusellae, but it is artistically inferior. The authenticity of some of the terracottas in various museums is too suspect to consider them works influenced by Veii.

As far as we can judge, Veii worked primarily in clay. As to painting, besides the two tombs mentioned previously, a few painted terracotta plaques from the 5th century B.C. derive from Attic vase painting. Some have freshness and skill in their drawing, but their quality is inferior to that of the contemporary painted tombs at Tarquinia. Bronzes are rare. Nor have we been able to identify a group that could be attributed to Veii. There are no Etruscan vases, black-figure or red-figure, which might have been painted there. As far as we can gather, in the 6th and 5th centuries B.C. Veii reached a very high level, but it was curiously unilateral.

Many votive gifts have come from the temple excavations. The beautiful head of a woman wearing a diadem (Pl. 23c), of Polykleitan inspiration, and the statue of a youth in which the Polykleitan influence is much less marked (Pl. 23d) were probably made by Veientine sculptors. A war elephant and its young are the translation into sculpture of a scene painted on a plate found in Capena and made by a workshop in southern Etruria, perhaps Falerii. The two elephants were probably made where the plate was painted and may be the offering of a foreigner.

In the 3rd century B.C. the Faliscans also visited the sanctuaries of Veii: L. Tolonios incised his name on small vases which he offered at Campetti and at Portonaccio. His name has been interpreted as being that of a citizen of Veii, maybe a descendant of the king of Veii, Lars Tolumnius, who died near Fidenae in the 12th war against Rome in 434 B.C. But Weinstock has shown that the name 'Tolonios' has nothing to do with the Etruscan name Tolumnius. It is a Faliscan name ending in-onios, like other names from Falerii.

Ancient tradition lists Veii as an Etruscan city. But the scarcity of Etruscan inscriptions caused scholars to hesitate in their acceptance of this fact for a long time. The discovery of the votive inscriptions of Portonaccio corroborated what the ancient historians affirmed. Of course the dedications are not all by inhabitants of Veii. Foreigners frequently came to visit famous sanctuaries, even from afar. The L. Tolonios just mentioned, for example, was not from Veii. Nor was the Avile Vipiiennas who left a bucchero vase as an offering in the 6th

century B.C. He was probably from Vulci, since the François Tomb provides evidence for the Vibenna family at Vulci. So does the inscription (Avles Vpinas) on one of the earliest Etruscan red-figure cups, painted at Vulci around 450 B.C.

In 396 B.C., after a ten-year siege, Rome took Veii. The strategem which supposedly ended the war, a cuniculus hewn out of the rock up into the centre of the city, is also mentioned in the conquest of Fidenae and of Narni.

Livy speaks of 'sack' and of the 'end of Veii'. This does not conflict with the fact that the two sanctuaries, at Campetti and at Portonaccio, continued to be frequented, since it is not unusual for a cult to continue even after the inhabitants have left the area. In Falerii, too, the temples continued to be visited even after the inhabitants had been transferred several kilometres away.

The temple of Minerva, at Portonaccio, was destroyed in 396 B.C. and does not seem to have been rebuilt, for there are no architectural terracottas dating later than the fall of Veii. It evidently continued to be a place of open-air worship and was visited, as was that of Ceres at Campetti and the Piazza d'Armi, down to the end of the 3rd century B.C. and perhaps even later. Other signs of life in the city are rare. There are no burial inscriptions or tombs, no terracotta or nenfro sarcophagi such as are commonly found even in secondary centres of southern Etruria. After the Roman conquest Veii was rarely inhabited. According to Diodorus (XIV, 116) the Roman army took refuge in the city when it was defeated at the Allia by the Gauls in 390 B.C. Livy (V, 50) tells us that the tribunes urged the Romans to move to Veii. This does not imply that the city still existed, but it does not mean that it was uninhabited either.

The city came to life again in the second half of the 1st century B.C., when Veii became a Roman municipium, but the Roman centre occupied only a part of the Etruscan area, as it did in all the large cities of Etruria. It is to this that Propertius alludes (IV, 10, 27 ff.) when he bemoans the fact that shepherds keep their flocks where once had stood a powerful city.

The ancient boundaries of the territory of Veii cannot be reconstructed. When Rome arose Veii had the right bank of the Tiber, at least from Fidenae to the Tyrrhenian Sea. The first wars between Rome and Veii are legendary, but strife between the two must have begun early. Rome was too close, too exposed to attacks by its rival. The rivalry between Rome

THE FALISCO-CAPENATE TERRITORY

and Veii was primarily a matter of trade along the Tiber. And that is why Falerii—which was also interested in this trade—helped Veii. It also explains the indifference of the other Etruscan cities, concerned only with maritime commerce. The boundary between Veii and Caere cannot be reconstructed (see p. 37). All that can be said about the interior is that Veii must have adjoined the territory of Capena. It is unlikely that Veii included the shores of Lake Bracciano and reached as far as the Ciminian hills.

The Falisco-Capenate Territory

Both the art and the culture of the Faliscan and Capenate territory was influenced by southern Etruria. According to Servius (Ad Aen., VII, 697) Capena was founded by a group of colonists sent there from Veii by an otherwise unknown king, Propertius. However nothing found at Capena seems to confirm this legend, and the city is more Faliscan than it is Veientine. There are nevertheless many signs of Etruscan influence in the territory. Although the language spoken was an Italic one, there are many Etruscan inscriptions. Scholars hesitate in judging this territory and its centres and they speak of Etruscan cities-especially Falerii-even though the territory is considered ethnically diverse from Etruria. Nor should the possibility that the people of Falerii and Capena, or part of their territory, were conquered even briefly by Caere, Veii or Tarquinii be excluded. Livy (V, 8, 5) refers to them as two Etruscan peoples. But at the same time he calls Nepi and Sutri (Nepet and Sutrium) the 'gates of Etruria' ('gates' of course for Falerii and Capena with reference to Veii, Caere and Tarquinii) and at war with the Etruscans. This would seem to indicate that both the Faliscan-Capenate territory and the two cities were independent. True, Falerii and Capena repeatedly sought Etruscan aid on behalf of Veii, but this does not necessarily mean they were dependent on Veii. It might simply mean that they realized that if Veii were defeated, their own independence was also lost.

Not much is known about the region. The two principal cities about which other lesser centres gravitated were—to judge from our sources— Falerii and Capena. No mention is made as to whether they were reciprocally independent, whether each had its own independent territory, or whether one city was at the head of the others, and in this case, which one.

The extent of this territory can be reconstructed only approximately (see map, p. 65). The Tiber marked the boundary to the east and to the south—but it would not be surprising if, at least temporarily, Falerii and Capena had also taken over territory on the left bank of the river. To the north the Ciminian hills formed the boundary. It is impossible to say where the line fell to the west. The southern part, from the Tiber to the Bracciano lake, bordered with Veii, but whether it bordered with Veii, or Caere, or Tarquinii to the north of the lake is not known. Some set the line west of Sutrium and Nepet, but others include the eastern shore of the lake of Bracciano, Sutrium, Nepet, and up to the Ciminian hills in the territory of Veii. If this were so, Veii would have completely separated the territory of Capena and Falerii from that of Caere and Tarquinii. But there is no proof of this: the area between the lake of Bracciano and the lake of Vico was so strongly influenced by Caere in the 7th and 6th centuries B.C.-note the rich tombs lately excavated at Trevignano Romano-that unless there is proof to the contrary it cannot have belonged to Veii. Even the chamber tombs and especially the funeral couches of Sutrium are much closer to the funeral architecture of Caere than that of Veii.

The principal centre of the Faliscan-Capenate territory was Falerii, known as Falerii Veteres (ancient Falerii) to distinguish it from the city founded in 241 B.C., Falerii Novi. Its contacts with the Mediterranean world were very close and the art was highly developed. Part of the tufa plateau on which it stood is now occupied, as it was in the middle ages, by the town of Civita Castellana. The plateau is bounded by the Rio Maggiore, the Rio Vicano and the Treia, which have eaten deep, steep, picturesque ravines around the city and where the cemeteries of Falerii were excavated—Monterano Penna, Colonnette, Colle, Valsiarosa. The acropolis was on the hill of Vignale, north-east of Civita Castellana. The city could be entered only from the west. No signs of fortifications have been found, but the position is so impregnable that it is easy to understand what Plutarch has to say about the indifference of the inhabitants to the Roman siege.

Falerii is perhaps the earliest inhabited centre of this territory. Pliny (III, 51) says it was founded by Argos, in Peloponnesus, and Dionysius of Halicarnassus (I, 21) assures us that in his time they still used the ancient Greek arms and armour such as spears and shields and that the temple of Juno Curitis, the goddess of Falerii, was built in the same fashion as the temple of Hera at Argos and the manner of the sacrificial

ceremonies was similar. Excavations however do not seem to corroborate the affirmations of the Greek historian, neither concerning the arms and armour used by the Faliscans, nor the plan of the temple of Juno.

The cemeteries of Falerii were richer than those of other centres of the ager Faliscus. There are cremation pozzi and inhumation trenches (fossa tombs). The ossuaries are often decorated with metal applications, or have a white slip and red-brown geometric patterns (Pl. 24a). In addition to incised motifs, the impasto vases often have figurines modelled in the round, particularly ram protomes (the ram is one of the favourite animals throughout this area) and men holding two horses. A unique piece is a bronze ossuary shaped like a rectangular hut with panelled walls decorated in repoussé, but with four feet like a wooden chest. A few Proto-Corinthian vases imported from Greece were found in trench and chamber tombs. It has been suggested that a Corinthian potter worked at Falerii, but I think this can be excluded. Excavations at Cumae, and in particular on the island of Pithekousai (Ischia), show that these two Campanian centres traded with south Etruria at this time. They also probably traded with Falerii. Trade between Falerii and Campania, as well as that with Veii, may have been via the Tiber, to which Livy refers again and again. The boats brought not only salt from the mouth of the Tiber to the inland settlements but foreign goods as well. Contacts between Falerii and Greece continued in later times and considerable quantities of Attic vases were imported. Local production also betrays Greek influence.

Falerii fought various wars against Rome. The first was in 437 B.C. when, together with Veii, it helped Fidenae which had been attacked by the Romans. When Veii was taken, in 394 B.C., Falerii had to submit to Rome for the first time. When Falerii revolted, in 241 B.C., the city was destroyed and the inhabitants (Zonara, VIII, 7) were transferred to the plain 5 kilometres away, where Falerii Novi, the New Falerii, was built. A ruined church, S. Maria di Falleri, has preserved the name of the new centre which was more Roman than Etruscan. Parts of the city still remain. The walls in tufa blocks, with a number of towers, and nine gates are well preserved. Two gates, the Porta di Giove and the Porta Bove, have a relief head on them, presumably for apothropaic purposes. In the former the head is on the keystone of the arch, and the latter has it in the centre of the cornice. As in other cities built ex-novo, the plan of New Falerii was regular.

With the fall of ancient Falerii the contingent territory seems to have passed to the Romans.

In the neighbourhood of Civita Castellana and the New Falerii a group of characteristic tombs were found. They are hewn out of the tufa wall. Each has a portico (from one to three arches), with sarcophagi dug out of the ground, or with benches along the walls, and a door

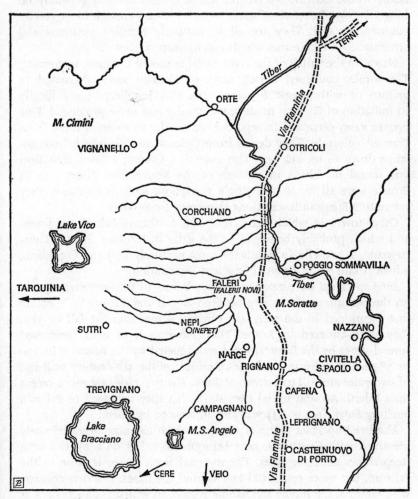

The territory of Faleri and Capena

opening onto an antechamber set before the burial chamber, which often has a pillar in the centre. There is a vertical opening in the ceiling of the antechamber. It resembles a chimney and communicates with the outside. Tombs with such chimney openings, but without a porch, are found at Caere, Vulci, and occasionally at Tarquinia and Orvieto.

The many extensive cemeteries found in the Faliscan territory testify to the existence of centres whose ancient name is generally no longer known. But none of them seem important enough to suggest an autonomous city. They are all in naturally fortified positions and circumscribed by streams which run in deep ravines.

Narce, in the valley of the river Treia, is one of the most interesting. The tombs contained a rich array of impasto vases, decorated in graffito or with plastic figurines. The rich jewellery, made locally in imitation of Etrurian models, was cruder and more provincial. Fine bronze vases decorated in repoussé are similar to some of those from Praenestine tombs. They derive from Oriental models which have not come down to us, but were also copied in Greece; a Greek imitation was found in Athens in a tomb of the Kerameikos. The pieces in Etruria were all made in a single workshop, perhaps in Caere. Very interesting Etruscan inscriptions also come from Narce.

Other towns in which material similar to that of Falerii was found and which probably belonged to the Faliscan territory include Campagnano, Vignanello (which is the most northerly site) and Corchiano, which is said to be the site of ancient Fescennium.

Sutri and Nepi were near the western border of Faliscan territory and on the communication route between Falerii and Tarquinia. They are first mentioned in the early 4th century when, after the fall of Veii, they were annexed to Rome. They seem to have been conquered several times by the Etruscans and reconquered by the Romans. In 390 or 383 B.C. they became colonies. Remains of the 4th-century wall and of two gates are still to be seen at Sutri. The two cities are more recent than Falerii. Art and burial rites show that they belonged to Faliscan territory Sutri. (see p. 63) was also influenced by Caere.

Another important city was Capena, which has now been definitely identified with Civitucola, near Leprignano. It lies on a plateau with steep slopes on three sides. The material from graves is close to the Faliscan, but more provincial and behind the times. It shows contacts with Umbria, the Picene and Sabine region, to which products such as belts of hammered bronze were exported. Only scant remains of the

pre-Roman settlement still exist. It began to be inhabited later than Falerii. It has trench tombs and the dead were often placed in wooden coffins. In the struggle against Rome it followed the fate of Falerii. Latin inscriptions show that feasts were celebrated there—ludi and iuvendia—but we do not know if they dated back to pre-Roman times.

Not far from Capena—Livy repeats it time and again—was Lucus Feroniae, the sanctuary of the goddess Feronia, where a famous fair was held. It drew not only the local population but also Etruscans, Sabines and Latins. Its site has been the subject of much discussion and the most varied and fantastic identifications have been made. In 1952 Lucus Feroniae was definitely identified with Scorano, near Capena, on the Fosso di Gramiccia, the ancient river Capenas, an identification which had been made in the 18th century. Dionysius of Halicarnassus (III, 32) describes the festivities; Strabo (V, 29) confuses them with those of Apollo Sorano on Mount Soratte. The goddess, protectress of slaves and of freedmen, was worshipped throughout central Italy, but her two main sanctuaries were at Scorano and Terracina. The sanctuary at Scorano was plundered by Hannibal in 211 B.C. but the cult continued.

Finds in this area, which at the time was covered by dense woods and sparsely inhabited, indicate the presence of various minor sites, with finds that recall those of Capena. They too date back no further than the end of the Villanovan age. Nazzano, which lies where there was once a ford across the Tiber, is called civitas Sepenatium, 'city of the Sepernati', in some Latin inscriptions. The ancient pre-Roman name of the city may have been 'Seperna'. At Civitella San Paolo, in addition to the impasto vases characteristic of Capenate territory, were some strange and interesting bronzes, decorated in repoussé with monstrous twolegged beasts: one leg ends in three great claws, the other in a human leg and foot. At Fontanile di Vacchereccia and at Grotta Colonna tombs were found containing bucchero and impasto ware, Etruscan or in the Etruscan style. At Fontanile di Vacchereccia a wall built of large blocks may date back to pre-Roman days.

In the Iron Age Capena and its territory were very close to the culture of Latium. Influences from Sabine territory also reached Capena. The characteristic pottery is of brown impasto with decoration either incised or hollowed into the surface of the vase and filled in with a red or white paste (Pl. 24b). Other vases have a white slip and ornaments painted in dull red. This gouging technique is characteristic of Capena, and appears fairly commonly in Capenate territory. Elsewhere in Etruria it appears only exceptionally. Pottery of this type found at Chiusi may be from Capena. The most frequent decorative motifs are fishes, horses, birds, goats. The figure of a man flanked by two horses whose bridles he holds (the 'Master of the Horses') seems to be characteristic of Capenate ware and appears in relief or incised on the bodies of the vases, as well as in the round on the rim or on the handles. In Etruria it is very rare. A frieze of winged horses is also commonly used in Capena and is in fact so common that vases with this motif can be presumed to have been made locally.

Tombs of the 7th and first half of the 6th century B.C. have fine bronze vessels and gold jewellery in granulation technique or in filigree. They imitate Etruscan jewellery but are cruder. Quite a few Attic vases were imported to Faliscan territory but they are rare in Capena and its territory.

Falerii's struggle with Rome does not seem to have destroyed, or handicapped, artistic production in the area. The output was outstanding between 437 B.C., the year in which the first war between Falerii and Rome was fought (Livy, IV, 17), and 214 B.C., when the inhabitants were transferred to Falerii Novi.

In the first half of the 4th century B.C. an important workshop of red-figure vases known as Faliscan ware (Pl. 25a), the finest vases in central Italy, was probably at Falerii itself. Faliscan ware has few connections with southern Italy but is quite close to the Attic production of the late 5th and early 4th centuries B.C., more so than any other workshop in Etruria or Latium. One may ask whether this excellent ware-superior in quality to anything else produced in Etruria at the time-could not possibly have been made by an immigrant potter. Most of these vases were found in Faliscan territory, especially Falerii. Elsewhere, even in the Capenate area, they are much rarer. They are technically very fine. The large craters and stamnoi are striking and the cups and plates are pleasing. In the second half of the 4th century, Faliscan production (the 'Fluid Group') fell off in quality. A group of late vases decorated with female heads was also produced in Falerii. Relief vases inspired by south Italian ware were made in the 4th and grd centuries. They were in turn imitated at Volsinii.

The temples of Falerii, Fosso dei Cappuccini, Sassi Caduti, Scasato, Celle, Vignale, have furnished quite a few revetment plaques and decorative terracottas, dating from the 5th to the 1st centuries B.C.

These indicate that some of the places of worship in the city still existed and were frequented even after the inhabitants had been transferred several kilometres distant. This we knew, for Ovid, at the end of the 1st century A.D., described the annual festival of Juno Curitis at Falerii, which he himself attended. The terracottas of the temple at Sassi Caduti date back to the 5th century in their most archaic phase and conform to the general characteristics of Etruscan architectural decoration. The temple itself is particularly important in the history of Italic religion because of the inscriptions in the votive deposit. There were two temples within the limits of the old city. The terracottas of the one in the Lo Scasato locality were inspired by the works of the great Greek sculptors of the 4th century, Skopas, Praxiteles and Lysippus. The best known of the pediment figures, especially after the Exhibition of Etruscan Art and Culture organized by the Italian government in 1955, is that of Apollo (Pl. 26b), who was probably seated. The beautiful head has been compared with the portrait of Alexander the Great attributed to Lysippus. Another figure, slender and youthful, with a bowed head and a melancholy expression, is in the style of Praxiteles: the very slender body is in the style of the late imitators more than in that of the master himself. Other pedimental figures and the antefixes are in the style of Praxiteles (Pl. 26a) and Skopas. This mixture of different styles, this exasperation of the stylistic formulae, points to works of the late 3rd, perhaps even first half of the 2nd century B.C. A fine bearded head, evidently influenced by Pheidias' Zeus, came from another temple in the same locality.

The temple of a female divinity, in a narrow wild gorge along the Rio Maggiore, in the Celle locality north-west of Civita Castellana, has been identified by some scholars with the temple of Juno Curitis, but the identification is uncertain. In addition to sculptural decoration the temple also had painted plaques. The best preserved fragment shows a delicate profile of a youth (Pl. 24c), similar to that of the cupbearer in the tomb of the Velii at Orvieto.

We do not know which gods were worshipped in these temples, except for the Vignale temple, which seems to have been dedicated to Mercury. Inscriptions and ancient writers mention a cult of Minerva at Falerii and one of Ceres; a statue of a four-faced Janus was brought to Rome.

We know of no temples at Capena. Perhaps Lucus Feroniae had become the accepted cult of the town.

Tarquinii

Both Greek and Roman tradition place Tarquinii first among the Etruscan cities in political as well as religious matters. It is said to have been founded by wise Tarchon, brother or son of Tyrrhenus, whom legend names as the leader of the Etruscans when they left Lydia. Tarchon was said to have founded the principal cities in Etruria, and even non-Etruscan ones, such as Pisa and Mantua. The legend of Tages is also related to Tarquinii: Tages was a boy who rose out of the ground and taught the Etruscans the rules which regulated the relationship between the gods and men, and the science of divination from the flight of birds and examination of the entrails of animals. But the supremacy of Tarquinii and the antiquity of its founding might be nothing but local inventions meant to glorify the city. This time, however, legend is corroborated by fact in the sense that, as far as the Villanovan period is concerned, excavations have proved Tarquinii to be one of the earliest, if not the earliest, city in Etruria and the most important up to the first half of the 7th century in wealth, decorative sense and skill in the working of metals. It is also one of the cities which had been in contact with the other regions of the Mediterranean as early as the late Villanovan and early Orientalizing periods.

Tarquinii is about 8–9 kilometres from the sea. On the coast it was bounded by Vulci on the north, and by Caere on the south (see pp. 32, 84). Inland it may have extended to the lake of Bolsena, which Pliny (II, 95) called a Tarquinian lake. It can even be presumed that the numerous interesting bronzes and some of the vases found in the Villanovan tombs of the Etruscan city which later became the Roman Visentium may have been made under Tarquinian influence, or even in Tarquinian workshops. It is impossible to try and establish the boundary with Volsinii, Orvieto, the zone of the rock tombs, and with Caere. The territory between the lakes of Vico and Bracciano was under Caere's sphere of artistic influence (see p. 37).

We have no reliable coins with the Etruscan name of Tarquinii. The funeral inscriptions of two magistrates contain the words tarchnalth, tarchnalthi (=of Tarquinii, in Tarquinii) indicating the city where they held office. If these do refer to Tarquinia the Etruscan name would have been Tarchna.

It has long been a matter of discussion whether pre-Etruscan and Etruscan Tarquinii (see map, p. 71) was on the same site as the medieval

town of Corneto (where the modern city now is), or further east on a wide plateau where the hillside drops away abruptly, known as La Civita or Pian di Civita, where the remains of the Roman municipium can still be seen. Both sites are naturally fortified, one of the requisites of an Etruscan city, and both have ancient ruins. Trial excavations by P. Romanelli have shown that the Villanovan and Etruscan Tarquinii was at La Civita. Remains of perimetral walls, built in the 4th century, have been found. Their total length was about 8 kilometres and they were from 0.85 to 2.40m. thick. Walls were probably only where the cliff provided insufficient protection. The gates correspond to the valleys, set in recesses that were easy to defend. Nothing confirms the hypothesis that the acropolis was at Castellina, the hill at the eastern end of the plateau. The buildings that have been excavated are no earlier than the late 4th and 3rd centuries, while within the city area (approx. 135 hectares) earlier remains have been found, including architectural terracottas from the 6th to the 1st century B.C., fragments of bucchero and vases from the 7th century to Roman times. A late

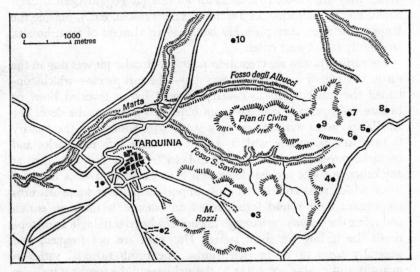

Key: 1. Rose di Bruschi; 2. Villa Bruschi; 3. Monterozzi and Arcatelle; 4. Poggio Quarto degli Archi; 5. Poggio dell'Impiccato; 6–7. Poggio Selciatello; 8. Macchia della Turchina; 9. Pian di Civita; 10. Poggio Gallinaro.

Villanovan graves near Tarquinia.

TARQUINII

votive deposit was found at the north gate. A temple at the 'Ara della Regina' (Altar of the Queen) had two magnificent terracotta winged horses in its pediment (Pl. 40a).

A small village was also on the site of modern Tarquinia. Villanovan tombs, later than those at Tarquinii, and some Hellenistic ones have been found. A small building of the 3rd-2nd century B.C. at the base of the cliff of the modern city may have belonged to this village.

No Villanovan huts have been found. Nor is there proof for Schachermeyr's hypothesis that Villanovan Tarquinii was on the coast. Many cemeteries succeed each other all along the hills near 'Civita'. The earliest ones, dating from the 9th to the 7th centuries B.C., are Poggio Selciatello above Selciatello, and Poggio dell'Impiccato. They are Villanovan and are the nearest to the city, which seems to indicate that the Villanovan settlement was also at La Civita. The cemetery at Monterozzi, the largest and most important of the Tarquinian cemeteries, began in the second half of the 8th century B.C. Tombs of all kinds, ranging from late Villanovan to Roman, have been found there. When they are isolated or in small groups (at Poggio Quarto degli Archi, Poggio Gallinaro, La Turchina, Villa Bruschi, etc.,), outside the larger cemeteries, they probably belonged to clusters of farm houses, frequently found near cities.

The earliest tombs are cremation pozzetti. A circular pit was dug in the earth. In its floor a smaller pit was dug-the real pozzetto-which contained the usual biconical ossuary covered by an inverted bowl or bronze or impasto helmet and such objects as are given the dead. The smaller pozzetto was covered by a stone slab. Sometimes the ossuary is in a tufa receptacle with a stone top. More tufa receptacles and ossuaries covered with helmets have been found at Tarquinia than at any other site. The incised decoration is in excellent taste. A meander frieze which runs around the most important parts of some ash urns emphasizes their round form. When an attempt is made to enrich and refine the decoration through the use of a heavier triangle or metope motif the feeling for form suffers. Hut urns are not frequent and generally seem to be in rich tombs. The tomb material varies in quantity and quality according to the richness of the tomb; it includes impasto vases of various kinds and bronze vessels. The number and variety of objects increases in the fossa tombs and the later pozzetti, which have urns, situlae, bottles, belts and large vases decorated in parallel or concentric friezes with dotted studs, nails, dashes, geese and

horses. A tufa cippus, shaped like the roof of a hut and with a central support, was over the pozzetto. Only one person was buried in each pozzetto, but in some cases the pozzetto tomb of a man and that of a woman were set one right above the other. Perhaps they were husband and wife.

The trench (fossa) tombs of the Monterozzi cemetery date to the second half of the 8th century B.C. The earliest trench tombs have cremation burials; they are followed by fossa tombs with inhumation burials. Imported objects were sometimes part of the rich tomb equipment and a number of bronzes and bucchero ware was also found in 8th century trench tombs. Cremation continued alongside inhumation in the chamber tombs and in the so-called tombe a buca (simple 'hole' tombs).

Other cities in southern Etruria, especially Caere, produced objects of hammered bronze, but until the middle of the 7th century Tarquinii was the leading centre. Some of these bronzes, such as shields of the type found in the Regolini-Galassi tomb, appear over such a wide-spread area, including Etruria, Latium, Campania, that they must have been produced in various centres. The earliest shields however come from Tarquinii. Some of the fossa tombs prior to 700 B.C. are famous. These include the Warrior's Tomb, the contents of which are in Berlin, and the Bocchoris Tomb, so-called because it contained a faience vase with the name of Boken-ranf (720–713 B.C.), an Egyptian king known to the Greeks as Bocchoris.

A new type of tomb, the tomba a corridoio (corridor tomb) was introduced in Tarquinii in the second half of the 7th century. It constitutes the passage from the fossa to the chamber tomb. Tombs of this kind have been found at the Monterozzi cemetery, particularly at the Arcatelle. They are fossa tombs completely hewn out of the tufa, and have a long rectangular plan, an entrance corridor, high benches along the side walls, barrel vaults. They are often decorated with groups of coloured bands halfway up the wall, and at the top of the wall. In the centre of the barrel vault is a group of black lines which run from the door to the back wall. Some corridor tombs have walls that slant inwards and are closed along the top by slabs of tufa. The latest of these corridor tombs is probably the Labrouste tomb (late 6th century B.C.), unusual in that it has a painted decoration on the back wall.

From the 6th century on, chamber tombs cut into the rock, with an entrance corridor, became usual. Unlike the complex structures at

TARQUINII

Caere they often have a single chamber with a gabled ceiling. In a few later tombs the ceiling is often flat. In the 4th century Tarquinii followed the general trend: chamber tombs tended to be larger, with many depositions in wooden coffins or sarcophagi—for the inhumation burials—and in terracotta vases for the cremation burials.

Up until the 7th century Tarquinii was the richest and most important city in Etruria, at least judging from the objects found in the cemeteries. In the first half of the 7th century, Tarquinia lost its supremacy to Caere, and around 600 B.C. was surpassed even by Vulci. Excavations testify to a decline in the wealth and originality of the funeral equipment but provide no causes. One hypothesis is that the rich ore-producing territory of La Tolfa and Allumiere, which Servius sets under Caere when he gives the Mignone as its boundary (confirmed by finds; see pp. 37 ff., 39 ff.), may originally have belonged to Tarquinii. This would explain the wealth of the Villanovan period in Tarquinii and its relative decadence when the mines passed to Caere. This decline is evident both in local production and imported material. Much elegantly shaped black bucchero with thin walls was found in tombs of the second half of the 7th and 6th centuries. Tarquinii certainly had a local production of bucchero from the end of the 7th to the 5th century. Included, for example, are the oinochoai with a female head at the upper joint of the handle. But the buccheros of Tarquinia are not as fine as those of Caere. The beautiful gold jewellery recalls that of Caere and probably came from there. Tarquinii is also in second place concerning imports from Greece and the eastern Mediterranean. Gold and silver vessels, cauldrons and lebeti with lion and griffin protomes arrived at Caere, but none have so far been discovered at Tarquinia. In the number of Greek vases found, Tarquinii is surpassed by both Vulci and Caere. Its Proto-Corinthian ware is not as frequent or important as that found at Caere and the number of Corinthian vases found at Caere and Vulci again is greater than those found at Tarquinii, despite the fact that tradition connects Tarquinii with Corinth. A citizen of Corinth, Demaratus, forced to leave his city when Cypselus overthrew the government, settled at Tarquinii and Corinthian artists supposedly came with him. Excavations at Tarquinia have not confirmed this tradition. Even if one makes allowances for the fact that tombs were plundered in antiquity, proof of artistic influence from Corinth is far less than at Caere. One is inclined to wonder if this legend is not a case of self-glorification on the part of Tarquinii; particularly

since the legend adds that Demaratus taught the Etruscans the use of the alphabet. This is an unacceptable statement, for the Corinthian alphabet has no relation with the Etruscan one.

Ivory relief plaques which once decorated small wooden boxes may have been made by local Etruscan craftsmen. Several were found in Tarquinia and those from Orvieto were probably also made there.

Fewer Attic vases were found in Tarquinii than in Vulci. But Tarquinii ranks first when it comes to wall-paintings in chamber tombs (see pp. 76 ff.). Other places in Etruria have tomb paintings that are older (Caere and Veii) but only in Tarquinii can an evolution of style and motifs be studied in paintings that are certainly Etruscan.

The paintings are not always contemporary with the tomb they decorate. In the Tomb of the Chariots (Tomba delle Bighe), for instance, it can be proved that they were painted later. The Tomb of Orcus (Tomba dell'Orco) was remodelled at a later date. A considerable number of painted tombs have been preserved and others, which no longer exist, are known to us through descriptions and drawings. In the 16th century Michelangelo drew a head of Hades, king of the Underworld, similar, though not identical, with that in the tomb of Orcus. We no longer know the tomb from which it was copied.

One of the oldest painted tombs in Tarquinia is the Tomb of the Bulls (Tomba dei Tori), the only archaic tomb inspired by Greek mythology. It shows the ambush laid by the Greek hero Achilles for Troilus, one of the sons of Priam, during the siege of Troy. Achilles is hiding behind the fountain in the sanctuary of Apollo, waiting to kill Troilus upon his arrival. The painter was rather mediocre but he had considerable decorative skill, visible in the animals in the pediments and minor friezes. In the principal scene the landscape elements (the plants and flowers, the lovely palm tree, the vivacious colours) successfully hide the poverty of inspiration and composition.

In the Tomb of Hunting and Fishing (Tomba della Caccia e Pesca) (Pl. 30), painted in the last years of the 6th century B.C., the artist stressed nature. Interest has been shifted from man to his natural environment, and it is the latter which is the subject of the painting. The men who are fishing, hunting, or diving into the ocean are nothing but secondary elements. The real lords of the tomb are the dolphins which leap above the surface of the sea and the birds—blue, red, white —which singly or in groups alight on the waves or cleave the sky. Man, in order to be tolerated in a world where the real lords are the

TARQUINII

animals, has shrunk in size and is proportionately much smaller. It is almost as if he had tried to escape notice.

The most frequent subjects in the 6th and 5th centuries B.C. are athletic contests, banquets, the dance, in other words scenes and ceremonies which seem to have accompanied the burial of the wealthy. Athletic contests are represented in one of the finest tombs of the 6th century B.C., the Tomb of the Augurs (degli Auguri-520-510 B.C.) It is perhaps the first example of 'Etruscan' contests no longer completely under Greek influence. The back wall (Pl. 31a) is dedicated to the dead man. In the centre is a painted door behind which the deceased is thought to be. On either side is the figure of a man who touches his forehead with one hand and extends the other before him in the Etruscan gesture of lamenting the dead. This mourning scene, solemn, immobile, silent, occupies the entire back wall. The other walls are full of movement and life in their depictions of athletic contests in honour of the deceased (Pl. 31, 32b). There is a group composed of two judges accompanied by two small slaves, one of whom is carrying a folding stool, a symbol of office, never used for women. The second slave is sitting on the ground asleep, a motif also found on a funerary stele in Greece. Not all the sporting-events are shown, only wrestling, boxing and a strange, typically Etruscan scene which also appears in the recently discovered Tomb of the Olympic Games (Tomba delle Olimpiadi). Dr Bronson and Dr Roncalli also recognized it in the Tomba delle Bighe and it may be in other tombs as well. A masked man (Pl. 31b) with a long beard, dressed in a variegated tunic and a pointed cap, urges on a dog. The animal is attacking and biting a man whose head is covered with a white cloth so that he cannot see the dog. An inscription next to the masked man gives his name as 'Phersu'. The fight between dog and man is limited to Etruria and has so far been found only in the painted tombs of Tarquinii. Is this a strictly funeral game? Or was it a common spectacle in all Etruscan athletic contests? Interestingly enough the group with Phersu was not included in the painted tombs of Chiusi (Pl. 2a), although the paintings there were derived from this Tarquinian tomb. The bird above the wrestlers and, in general, all the birds in the tomb reveal the decorative feeling and skill of the painter. The curious comb-like pattern of the wings also appears on an Etruscan black-figure vase.

The games in the Tomb of the Augurs do not show a strong Greek influence. Although the wrestling and boxing scenes repeat motifs

known from Greece-for example those on the Greek amphoras made by Nikosthenes-these games are as old as man himself, and probably existed in Etruria long before any Greek influence arrived. The first tomb to give us the characteristic Greek games is the Tomb of the Olympic Games (Tomba delle Olimpiadi: 520-500 B.C.) with its chariot race, foot race, discus throwing, jumping and, as in the Tomb of the Augurs, the group with Phersu. The left wall (chariot race) is full of life (see pp. 23 ff.). As previously noted, the painter skilfully transformed and animated a Greek motif. The short garments of the charioteers as well as the reins tied on the horses' backs are Etruscan. The right wall is of inferior quality. The isolated figures follow each other monotonously. The painter had no models to inspire him as he must certainly have had for the left wall. Another tomb with athletic contests has been linked with the Tomb of the Olympic Games: that of the Master of the Olympic Games (Tomba del Maestro delle Olimpiadi), but on insufficient grounds. It is a summary of the former, but not nearly as interesting or delightful.

The Greek games are found in complete but summary form on an Etruscan amphora (Pl. 32a) painted between 520 and 500 B.C., an early work by a south Etrurian ceramic artist known as the Micali Painter: boxing, discus and javelin throwing, chariot racing, dancing—dancing is an Etruscan addition. There is also a flute player, a judge holding a rod, the emblem of his office, a youth with an aryballos and the unguents for the athletes and there is a group of women. There is also a strange scene which has no counterpart in Etruria in which a young man is shown climbing a long pole. It recalls the game played at 19-century country fairs in which the prizes were at the top of a greasy pole.

All the Greek games are depicted in the small frieze (height 0.31m.) which runs along the top of the walls in the Tomba delle Bighe (490–480 B.C.). Greek influence is so evident in this fine tomb that some have considered it the work of a Greek painter (Weege, Cagiano) which I do not believe. The painter was Etruscan, even though the colours he used were different from those of the other painters. The Tomba delle Bighe influenced the paintings of athletic contests in Chiusi, those in the Casuccini tombs, in the Tomb of the Monkey and, to some extent, in the Deposito de' Dei. This is also the tomb which definitely set the 5th-century pattern for the banquet accompanied by dances.

The banquet scene was extremely popular from the second half of the

6th century to the end of Etruscan art. Around 520 B.C. we find it in the Tomb of the Lionesses (Tomba delle Leonesse), where the banqueting guests, imposing and monumental, stand out against the white ground of the side walls; on the back wall are three dancers with a doublepipe player and a lyre player in between. The dance, here and in many other painted tombs, seems to be indispensable at a banquet. In the earliest tombs, and contrary to the practice in Greece, the banquet is generally a quiet peaceful family scene: husband and wife recline on the kline, a cupbearer is about to pour them wine. Beside them are the craters and the cups. There are also handmaidens weaving garlands (Tomb of Hunting and Fishing), children (Tomb of the Painted Vases), a flute player (Tomb of the Old Man-Tomba del Vecchio). At the beginning of the 5th century the family circle widened to include all the relatives who partake of the banquet in honour of the deceased. This pattern is first found in the Tomba delle Bighe, and in modified form continued to the middle of the 4th century and even later. Two men recline on each couch (kline), sometimes a man and a woman. A table is in front of the kline, and underneath it is a long bench on which the sandals of the banqueters are often placed. The scene seems to be in the open, for there are branches and small trees. The banquet is on the back wall; on the side walls men and women, separated by small trees, are dancing.

These two motifs appear again in the Tomb of the Triclinium (465-460 B.C.). On the side walls men and women dancers, a flute player, and a lyre player are separated by small trees: birds flutter among their branches, or peck at the clusters of berries, a cat climbs a tree, a hare lies on the ground. It is the most beautiful of all the dance scenes we have, with its grace, variety of movement and restrained gestures. There is nothing exaggerated or violent about it. The goodlooking girl in the corner of the right wall, with her head thrown back, half open lips, one arm around her head, has charm and dignity. The painter was a great artist, who has given unity to his composition and has skilfully interrelated the figures. The trees do not separate the figures but only give us the surroundings, the sensation of peace and tranquillity. In style and type this tomb is close to that of the Funeral Couch (Tomba del Letto Funebre, c. 450 B.C.); some say it is by the same painter. But the drawing of the latter is harder—note the hands and is not as harmonious or unified. The youth and his white horse recall the horsemen of the Parthenon.

The Tomb of the Leopards (c. 450 B.C.) is generally considered to be earlier than the Tomb of the Triclinium. M. Cagiano de Azevedo however has justly observed that it is by an extremely backward painter, who imitates the Tomb of the Triclinium but retains his archaic style. The excellent preservation and the lively colours conceal the careless insensitive drawing, the inferior quality, the monotony of the heavy folds which flatten the figures. Composition and motifs have begun to lose their flexibility. They are already hard, tired and cold in the Tomb of the Pulcella. The movements of the figures are agitated and confused. There are archaic elements, but the winged demons, the gorgoneion with its winged head, the attempt at rounding out the bodies by stressing the curved contour of the garments, necessarily lower the date to c. 400 B.C. or shortly before.

Tombs like that of the Jugglers (Tomba dei Giocolieri) drew on motifs from various periods. The profile of the beautiful dancer on the right wall with her large nose and egg shaped skull, as well as the vigour of her body, are close in style to the paintings in the Tomb of the Augurs and to the late 6th century. They contrast sharply with the elongated bodies and small heads of the slender figures painted in the same tomb, which are 5th-century in style (Pl. 35).

In the Tomb of the Ship (Tomba della Nave, first half of the 4th century B.C.) the figures are elongated and their heads are proportionately too small; the banquet is monotonous and uninteresting. True, the dancers raise their arms in the gestures of the dance, but they are motionless and there is no sense of movement. The scene on the left wall is unusual and lively. A sailboat with men on board is near a varicoloured striated rock. Two tombs painted around the middle of the 4th century, the Querciola I tomb and that of the Sow (Tomba della Scrofa) are archaic in style. The banquet and dance scenes—which had by then become hackneyed motifs—are of little interest, but the genre scenes (hunting, men on foot and on horseback, warlike episodes) are lively, vigorous and with a wealth of movement.

In the second half of the 4th century painting took a new lease. The motifs changed and a new subject made its appearance in Tarquinii and elsewhere—the Underworld with its male and female demons. Wars against Rome, defeat, loss of independence have been given as the underlying reason for this change. But it is more likely that it reflects south Italian influence, where this motif had already put in an appearance. The earliest examples in Etruria combined it with the banquet,

TARQUINII

which is thus transferred to the kingdom of the dead, in the presence of the rulers of the Underworld, Hades and Persephone. This we find in the Tomb of Orcus (Pl. 36; 37) which consists of two chambers joined by a corridor. The first chamber, which is the earliest (last quarter of the 4th century B.C.), was seriously damaged in the 19th century by an attempt to remove the paintings. The head of a young woman of the Velcha family is still well preserved (Pl. 36). Old copies show her to have been reclining on a kline together with her husband, who was holding a branch in his hand. Another couple was painted on the adjacent wall, separated from the first couple by a blue-black demon with a hooked nose, the ears of a beast, with snakes round his shoulders and legs, and a halo. The Greek Underworld is painted on the walls of the second chamber, which is much later (first quarter of the 3rd century B.C.). Its ancient heroes and most famous culprits are depicted: three-headed Geryon reminiscent in pose of the Mars of Todi, Theseus, Ulysses, Sisyphus, Memnon (or Agamemnon) and the seer Teiresias. This is an Etruscan interpretation of the Greek Hades. which was probably introduced to Etruria on the large amphoras from south Italy. The painter added a menacing demon, Tuchulcha, who waves a snake over Theseus' head. The gods of the Underworld are also present: Hades (Aita) wearing a hood in the shape of a wolf's head, and Persephone (Phersipnai) wearing a crown of small serpents (Pl. 37). A banquet may also have been depicted in this room, but all that is left is a cupbearer and a table with a wine service.

The Tomb of the Shields (Tomba degli Scudi), which is also badly deteriorated, is an example of the large chamber tomb of Hellenistic times. The layout of the banquet is new (Pl. 38a)—the man, nude to the waist, is still reclining on the kline, but the woman is now shown seated at his feet as on some of the large ash urns from around Chiusi. The dishes full of fruit and food, on the table next to the bed, are tipped forward so that their contents can be seen in a rudimentary attempt at perspective. The woman wears a rich array of jewels, many more than at 5th-century banquets. Her large earrings are of a type that came into fashion at the beginning of the 4th century B.C. Her diadem of leaves is similar to examples found in gold. In her hand she holds an egg, which the man is just about to take.

The Tarquinian tombs drawn by Byres around the middle of the 18th century were probably late, including that of the Biclinium. The Tomb of the Cardinal, of which only drawings remain, is surely as late

as the second century. It represented the journey of the souls to the Underworld. The Tomba della Tappezzeria had curtains painted all around and two winged demons keeping watch at the entrance. This motif is frequent in other late tombs (Tomba dei Caronti at Tarquinia, tombs of Orvieto). But in the Querciola II tomb the two demons are guarding the door of Hades. The large Tomb of the Typhon (Tomba del Tifone), with its painted central pillar, is already Roman in spirit and in style; it is a belated echo of the giants on the altar of Pergamon. The lost Tomb of the Ceisinie had a similar repertory. The late tombs discovered in recent years are of inferior quality.

It is strange that a city like Tarquinii, where wall painting was so popular, had no local shops of fine painted vases with narrative scenes. At least nothing has so far come to light. Some scholars have given a group of black-figure vases, the 'Pontic' vases, to Tarquinii but Vulci, the great pottery centre from the end of the 7th to the 3rd century B.C., seems more likely. Recently Zilagy has been able to prove that some painters of Etrusco-Corinthian vases were active there.

Statues and reliefs in limestone and in terracotta, large bronzes, even small bronzes, are not very frequent in Tarquinia. Nenfro reliefs have been found at the Monterozzi, and a few at Poggio Quarto degli Archi: they are characteristically Tarquinian. A fragment found at Vulci and another from Chiusi were undoubtedly imports from Tarquinii. They are slabs (Pl. 38) on which figured panels in low relief alternate with a step-like element. The panel decoration is geometric, or has palmettes, animals, human figures, or occasionally mythological scenes (Hercules and the Centaurs, death of Ajax, etc.). They are crude rather than archaic, as is proved by some of the decorative motifs : the hippocamp for instance does not appear in Etruria prior to the second half of the 6th century B.C. Their exact use has not been ascertained. Some were found closing the entrance to a chamber tomb, but they may have been reused (Pl. 38b).

It was unusual at Tarquinii to have animals sculpted in the round (panthers, lions, sphinxes, griffins, etc.) used on tombs. Late tombs had small cippi in the shape of a truncated cone set on a square base.

In the Hellenistic period Tarquinii had two chamber tombs with sculpted decoration. The best known is the Tomba della Mercareccia, also called Tomb of the Sculptures, which is in extremely bad shape. It was drawn by Byres in the 18th century and by Labrouste in 1829. A

TARQUINII

double frieze of reliefs ran round the walls of the first chamber. The bottom frieze, which was the wider of the two, had human figures one was seated—and horses; it may have had one of the standard processions found in late painted tombs (Bruschi tomb, Tomb of the Typhon). The upper frieze had animal fights—a winged sphinx can still be made out. Two lions seizing a man is a characteristic motif repeated on two walls. The ceiling is interesting: each side wall slants up to a square opening at the centre, which tapers up to the surface of the ground above. There is one other tomb with a ceiling opening like this in Tarquinii; similar tombs were frequent at Vulci and Civita Castellana.

Fragments of large rectangular slabs carved in high relief, now in the Museum of Tarquinia, belonged to another tomb, but in this case the relief was not carved directly into the wall. It is not known what part of the tomb they decorated.

The production of sarcophagi, which began around the close of the 5th century B.C., was of great importance. Tarquinii has more sarcophagi of all types and all periods than any other city. The chest, in nenfro, alabaster or marble, had a flat or gabled lid on which was an effigy of the dead. One of the most interesting and best known is the sarcophagus of Laris Partunu, known as the sarcophagus of the priest. It is also one of the earliest (4th century B.C.). Some scholars believe it to be a Carthaginian import, since sarcophagi with similar lids have been found there. In any case the painted decoration on the chest and the inscription were done in Tarquinii. The sarcophagus of the 'Magnate', which belonged to Velthur Partunu, another member of the same family, came from the same tomb. A group of four sarcophagi in nenfro were made in one workshop, perhaps even by the same sculptor. They are all decorated with scenes of wild animals-lions, lionesses, griffins-attacking a domestic animal. The sarcophagus of Laris Pulena, later than the others, is famous, and rightly so, because of the large scroll which the dead man is just opening and on which his ancestors and the offices he held are listed. On the chest itself is a scene in relief: his journey to the Underworld, accompanied by infernal demons.

With one exception, painted sarcophagi and urns have been found only at Tarquinia. One of the urns is still archaic (early 5th century B.C.). It depicts a horse between two young men and is reminiscent of the Tomb of the Baron. The later sarcophagus of Ramtha Huzenai, known

as the Sarcophagus of the Amazons (Pl. 39) from the subject of the paintings on all four sides, is outstanding in quality. Some scholars consider the painter to have been a Greek, perhaps from Taranto or southern Italy, others an Etruscan educated in Greece. The interpretation of the myth and the motifs, some of which are found only in Etruria, suggest that the painter was Etruscan. The subject-the battle between the Greeks and the Amazons-seems to have been quite popular, for it was painted on the sarcophagus of the priest and carved on that of the Magnate. The artist who painted the sarcophagus of the Amazons was undoubtedly one of the most talented painters of his time. The composition, each group, even each figure, testify to his skill, verve and inventiveness in alternating and varying the motif, monotonous in itself, of an Amazon fighting a Greek. The craftsman who sculptured the lid was mediocre. Dates for this sarcophagus have varied from the first to the second half of the 4th century B.C. The use of chiaroscuro makes it later than the first chamber in the Tomb of Orcus and it therefore probably dates to the late 4th or early 3rd century B.C.

One of the most interesting sarcophagi is that of a woman, said to have been found in the Tomb of the Triclinium (Pl. 40b). The kantharos which she holds, the fawn nearby, the leopard skin she wears, probably allude to the cult of Dionysius. The graceful figure lying on the lid in such a quiet natural pose is in pleasing contrast to the pompous figures so often found on sarcophagus lids (Pl. 40b).

Only one large bronze has been found in Tarquinii—that of a nude boy sitting on the ground, with a bulla around his neck (2nd century B.C.) and with a votive inscription to the god Selvans on his arm. It is not particularly good. One would have expected something finer from Tarquinii.

A large temple within the city limits, with a high podium and a flight of stairs, is of the 4th-3rd century B.C. It had a long, narrow ground plan, with columns on three sides. The pediment was decorated with terracotta figures, including two winged horses (Pl. 40a), which were probably drawing the chariot of a god. Votive terracottas found at the base of the plateau, towards the south, prove the existence there of a late place of worship. Other votive objects come from another sanctuary near the north-west gate of the old city.

Recent excavations have confirmed the hypothesis that the harbour of Tarquinii was at Porto Clementino, south of the mouth of the river Marta, where the Roman colony of Graviscae was established in 181

VULCI; STATONIA; THE VALLEY OF THE RIVER FIORA

B.C. The Romans spared the Etruscan site with its monuments and buildings. A Greek sanctuary, built in the second half of the 6th century B.C. was found in the Etruscan part of the town; it proves the presence of Greeks in the area. Greek inscriptions, scratched on fragments of vases found in the excavations, show that the goddess Hera was worshipped there. A marble cippus with a Greek inscription (late 6th century B.C.), dedicated by a certain Sostrates to Apollo Aegineta also came to light. This is the only Greek inscription on stone found in Etruria. A store-room contained a rich deposit of oil lamps. A nuragic boat is evidence of contact with Sardinia.

Vulci; Statonia; The Valley of the River Fiora

From the second half of the 7th to the 4th century B.C., Vulci, on the right bank of the river Fiora, was one of the richest cities of southern Etruria. We do not know its Etruscan name and various hypotheses purporting to identify it in inscriptions are far from satisfying. Up to the 19th century the name was preserved in the designation Pian di Voce, given to the place where the city had once been. Vulci did not coin its own money, which seems to indicate that it had already fallen into decadence by the 3rd and 2nd centuries B.C.

Attempts to find the territorial boundaries of the Etruscan city go no further than rather unsatisfactory surmises. On the south Vulci adjoined Tarquinii, but setting the boundary line—as has been done—at the river Arrone is quite arbitrary. It may have bordered on the north-west with Rusellae, but this is also a hypothesis. At the beginning of the 3rd century B.C. Vulci was in possession of the coastal area at least as far as Monte Argentario, because this territory was taken over by Rome in 280 B.C.: the Roman colony of Cosa was founded there in 273 B.C. But, except along the coast, Vulci does not seem to have exerted any influence in the area prior to the 3rd century B.C.

The upper basin of the river Fiora was influenced by Vulci and may have belonged to the town, at least in the 6th and 5th centuries B.C. The question arises whether the prosperity and riches of Vulci, already evident in the second half of the 7th century B.C., might not have been the result of Vulcian possession of the mines of Monte Amiata. This would explain the wealth of metals in the cemeteries, in tombs such as that of the Bronze Chariot (7th century B.C.).

Vulci lies 11–12 kilometres from the sea. Tradition says nothing about a port, but contacts with southern Italy and with Greece, at least in the 6th and 5th centuries B.C., point to its existence. For a long time the port was thought to have been at Cosa, since Pliny mentions 'Cosa Vulcentium', Cosa of the Vulcians, and Virgil includes Cosa in his list of ancient Etruscan cities. But recent American excavations at Cosa trace its origins to the Romans without any Etruscan precedents. The harbour could not have been at Orbetello, near which Etruscan tombs, and even a painted one, have been found, for it is too far away. Besides which the fact that Vulci has no archaic necropolis along the road to Cosa proves beyond the shadow of a doubt that its port was neither at Cosa nor at Orbetello. The only tombs are late, later than the founding of the Roman colony at Cosa. If the river 'Armine', or 'Arnine', or 'Armenta', mentioned in the Itinerarium Maritimum as a landing place for ships (habet positionem), really corresponds to the river Fiora, then the port of Vulci prior to the Roman conquest was probably at the mouth of the river itself, for Vulci's most important cemeteries are along its course.

Contacts with the other cities of southern Etruria were easy for Vulci. One road crossed the river and headed from Ponte Rotto directly for Tarquinii without going down to the sea. That was why the necropolis of Ponte Rotto beyond the river Fiora was so rich and important. A second road went up the river and brought prosperity to many small flourishing centres along the river or its tributaries. From the north gate the road crossed the cemetery of Osteria, continued along the upper valley of the river, passed north of Lake Bolsena and branched off into two roads—one road went to Volsinii and Orvieto; a second road to Acquapendente, crossed the river Paglia, and reached Clusium via Sarteano or Cetona. Cultural influences and imports reveal its existence even if it cannot be traced exactly. The numerous finds dating to the second millennium B.c. would appear to indicate that it was already used in pre-historical and pre-Etruscan times. Etruscan and Greek objects directed to Orvieto, Clusium and beyond, in the Val di Chiana, and to Umbria passed along this road.

and to Umbria passed along this road. A road certainly existed between Vulci and the coastal cities— Rusellae, Vetulonia, Populonia—but as stated previously it does not seem to have been direct. It may have followed the river downstream, from Vulci to its port, and then gone along the coast on what was later to be the Roman Via Aurelia.

The first mention we have of Vulci is in the Fasti Capitolini which lists the triumphs of the Roman consul Ti. Coruncanius over Volsinii and Vulci in 280 B.C. That was also the year in which Vulci became subject to Rome, which founded the colony of Cosa on Vulcian territory in 283 B.C. Just where the city was located was common knowledge from the Middle Ages on. The story told by 19th-century archaeologists of how it was rediscovered is therefore nothing but a fable. According to this story, in 1828, while a peasant was ploughing his fields, the ground suddenly gave way under one of his oxen, revealing an Etruscan tomb. Actually there had already been excavations in the necropolis in the 18th century. Looting had been so open and shameless that the papal government intervened in 1802 with a law aimed at restraining such systematic plunder. More regular excavations were begun in 1825 by the Candelori brothers; in 1828 began the largescale excavations by the Prince of Canino. G. Dennis and others reported the barbarous destruction of objects lacking in commercial value by those in charge of the excavations for the Princess of Canino. Vandalous looting of this extremely rich necropolis has enriched museums all over the world, but the lack of controlled excavation has destroyed any possibility of studying and dating the various types of tomb and the materials found in them. Besides, the necropolis had already been plundered in antiquity. Only the excavations directed by Gsell in the second half of the 19th century give us an idea of Vulci's culture. Excavations carried out in the past 50 years have provided us with much information which helps us to know this rich city better.

Vulci was situated on a rather low flat hill (75m. above sea level). On the north-east, where the acropolis must have been, and to the east the land drops off steeply. The other sides have no natural defences. Remains of city walls, built of large tufa blocks, do not seem to be earlier than the 4th century B.C. The wall may have been limited to the weaker spots. There were four gates—north, west, south and east. Near the north gate was a cult place, perhaps a temple, of which only the votive deposit has been found, providing a date of from the first half of the second century B.C. to the end of the 1st century A.D. A small temple dedicated to Heracles, near the East gate, had votive offerings dating from the second half of the 1st century B.C. to the end of the 1st century A.D. These cults, the buildings recently excavated within the city walls (baths, a temple, shops) and the roads all belong to the Roman period. So far we have been unable to find the remains of

the Etruscan city, which must have been on the same site as the Roman one, and our knowledge of the Etruscan city is limited to the cemeteries (see map, p. 91).

There are two cemeteries to the north of Vulci, one at Osteria and the other between the acropolis and the bridge of the Abbadia. To the east, the left bank of the river Fiora is all one great necropolis with various names: Cavalupo, Ponte Rotto-which may be the richest and earliest-the Polledrara. Tombs have also been found at the Ponte Sodo, and south and west of Vulci. They began in Villanovan times, except those to the west of the city, which are very late. The pozzetto tombs may be later than those of Tarquinia and, in the older Villanovan period, they are less rich, but this may be due to the barbarous destruction carried out in the 19th century. The latest cinerary urns often differ from those usually found : some have a round body and a vertical handle. The cover may be shaped like a disc or may be an impasto helmet which ends above like the roof of a hut, or is surrounded by projecting points. A hut urn has a platform in front of the door and large acroteria. Another hut urn in hammered bronze has bronze rings along the outer edge of a sharply overhanging roof. It is decorated in repoussé with studs, lines and dots. A late pozzo tomb in the Cavalupo necropolis had an ossuary in hammered bronze, a bronze flask worked in repoussé and a sword with two figurines on the sheath, one male, the other female. At Osteria, a bronze figurine of a warrior, imported from Sardinia, was found in a pozzo tomb, with a stone receptacle. Up to now the only Etruscan cities where nuragic objects have been found are Vulci, Populonia, Vetulonia, and Graviscae.

The 7th-century fossa tombs are contemporary with the late pozzetto tombs. The inhumation rite prevailed but cremation in bronze ash urns continued down to the chamber tombs. A chamber tomb from the first half of the 7th century B.C., the Tomb of the Bronze Chariot (Tomba del Carro di Bronzo), in the necropolis of Osteria, had a rich array of bronzes, impasto vases and a chariot in hammered bronze decorated in repoussé. The trench tombs contained Italo-Geometric and impasto vases, numerous bronzes (among which was a so-called Vetulonian 'candelabrum'), Greek Proto-Corinthian and Corinthian vases and red and black bucchero ware. The later trench tombs were covered with tufa slabs. Fossa tombs continued to be used in the 6th and ς th centuries, alongside the chamber tombs. Some Attic blackfigure vases of the mid-6th century were in the Tomb of the Warrior

VULCI; STATONIA; THE VALLEY OF THE RIVER FIORA

(also called the Avvolta tomb), a chamber tomb which had stone slabs all around the walls.

Up to the close of the 7th century the quality of the objects produced in Vulci was no higher than that in the other cities of southern Etruria. Bucchero ware was good, shiny and thin, but not up to the best of the Caeretan production. There were bronzes, but the Tomb of the Bronze Chariot itself reveals that craftsmanship was less accurate than elsewhere. The jewellery was beautiful, but not as opulent and splendid as that of Caere, Praeneste and Vetulonia. The gold fibula found in a tomb at Ponte Sodo, now in Munich, is not as elegant as a similar one from the Regolini-Galassi tomb; a lovely pendant completely covered with granulation, also in Munich, recalls the bracelets from Tarquinia but it is simpler; a fibula with small lions in the round—similar to the one from Marsiliana d'Albegna-is not as rich or sumptuous as Praenestine goldwork. During the 7th and very early 6th century B.C. Vulci imported less than Caere. The oldest and finest pottery-Proto-Corinthian vases and Attic vases, amphoras full of oil, an amphora by the Netos painter-imported to Etruria arrived at Caere.

At the beginning of the 6th century B.C. Vulci became one of the most important centres for art in Etruria as well as one of the richest. The tombs contained magnificent imported objects and a wealth of jewellery —bezel rings, necklaces, and, in later centuries, gold laminae worked in repoussé, bullae, gold diadems. Even if all this jewellery was not made in Vulci it is still evidence of the wealth of the town.

Commerce flourished. The best vases painted in Athens between 575 and 450 B.C., both black- and red-figure ware, were found at Vulci. Ceramics also arrived from eastern Greece and from the islands. No other city has given us such quantities of Greek pottery and of such high quality as Vulci. Nineteenth-century excavators had already noted this. Dennis assures us that for every four Attic vases found at Tarquinia, Vulci had 45. After 450 B.C. importation from Attica ceased both in Vulci and in Etruria. Athenian vases took to the Adriatic and were sent to Adria, and especially to Spina and Bologna.

The chamber tombs of Vulci are generally simpler than those of Caere and Tarquinia, and are not decorated. This does not mean they were poorer—on the contrary, chamber tombs and especially archaic ones belong to the period when Vulci was at her zenith—it only proves that burial customs differed. The ceiling is often vaulted, only rarely gabled. A tomb discovered in 1830 in the north necropolis,

almost beneath the city, the Tomb of the Sun and the Moon (Tomba del Sole e della Luna) was exceptional in that the ceilings of the various chambers were carved from the rock in imitation of beams and listels, and in one of the chambers the ceiling has a fan-pattern similar to one in Caere and one in San Giuliano. Two late tombs were painted. The entrance is normally closed by blocks of tufa. One was closed by a nenfro slab similar to those found in Tarquinia (see Tarquinia, p. 81) and must have been imported. Vulci has its own characteristic type of chamber tomb. In the 19th century archaeologists improperly called it a cassone, a term easily confused with that used for the trench tombs lined with limestone slabs. The sloping corridor led into an antechamber open to the sky, something like a courtyard. Several side chambers completely hewn out of the rock, with a ceiling, opened on to this antechamber. There are many of these chamber tombs with unroofed vestibule from the 6th century to around the middle of the 5th century B.C., when they stopped being made. This type is also found near Vulci, at Pescia Romana, Montalto di Castro, Tuscania, Castro.

On the whole, the tombs of Vulci were not covered by tumuli, although unless limited by a wall these could also have been destroyed by farming activities. Nineteenth-century archaeologists stressed the difference between the cemeteries of Vulci, uniformly level, and those of Tarquinia and Caere, where the sepulchral mounds gave the landscape a rugged hilly aspect. Only three tumuli are known at Vulci—a very large one, the Cucumella, and two smaller ones, the Cucumelletta and the Rotonda. The Cucumella was excavated at various times. Several chamber tombs appear to have been found in the excavation of 1829 but what with contradictory and inexact reports and hypothetical, often imaginary, reconstructions at variance with each other, the monument has become quite incomprehensible.

The late chamber tombs of the necropolis of Cavalupo (from the end of the 4th to the 1st century B.C.) were carved into the steep cliff that rises over the left bank of the Fiora river, in front of the old city. They are located at various heights, and are often one above the other. Each has a long corridor leading to a central antechamber with a number of chambers around it. Smaller side rooms also open on the corridor. Tombs with a vaulted ceiling and a chimney-like opening (as in the Mercareccia tomb at Tarquinia), which continues up through the ground and is closed at the top by a stone slab, are not unusual at Cavalupo. According to 19th-century excavators real or fantastic animals carved in the round were set over these late tombs.

The abundance of funeral monuments set over the tombs is typically Vulcian. Sphinxes, griffins, lions, men on horseback and horses, pilasters, hippocamps in nenfro and tufa, dating from the 6th century B.C. to Roman times, have been found in this large plundered necropolis. They were all stray finds and fragmentary; they are particularly numerous at the Ponte Rotto. While they may have been the guardians and protectors of rich tombs, it is more likely that they were simply markers. Sphinxes and griffins also came to light during the excavation of the Cucumella, but we do not know where they were placed originally.

The centaur at the Villa Giulia Museum in Rome (Pl. 43c) was a casual find in a tomb in the necropolis. It is one of the most archaic sculptures of Vulci; stylistically it follows in the tracks of the Greek Daedalic sculpture of the 7th century B.C., which continued in Italy down to the end of the 6th century B.C. The figure resembles the Greek centaur type of statue and, seen from the front, looks like a Greek kouros—a nude standing youth with his arms lying close to his sides—and might be compared to the statues of Cleobis and Biton at Delphi. While close to them in style and facial features, the Vulcian centaur is more massive and heavier, with softer more swollen forms. His eyes are typically Etruscan.

In 1839 a female statue in marble (Pl. 43a) was found in the tomb of the Polledrara (known also as the Grotto of Isis or Tomb of Isis from a plastic vase believed to represent the Egyptian goddess). She has always been considered Daedalic. Contacts with the Greek Daedalic style seem to have been strong. The low forehead, the flat skull, the squarish face which seems cut into the face of a cube, the large triangular eyes, are typical of Daedalic sculpture. Her rather stiff pose and severe features make the Vulci figure as monumental and imposing as the Daedalic statuettes. The long vertical lines of the cloak make the figure seem taller and more perpendicular. But the feeling for volume and solidity, emphasized by the tightly clinging clothing, the depth of the skull itself, the way the hair curves around the forehead, the shape of the long curls (unusual for Greece prior to 600 B.C.) which fall to her bosom leaving her ears free, all show that Daedalic formulae are a thing of the past. Unlike the Daedalic style which builds up the figure by setting one block upon another and which sharply separates the bust from the rest of the body by a wide belt, here the sculptor has

eliminated this break and has used the cloak as a connecting element between the upper and lower parts of the body. The figure is conceived as a single mass and the eye moves freely and uninterruptedly over the forms. Some of the characteristic features of the statuette—the large flat triangular nose, the high cheekbones, the two lines which slant down from the nose to the corners of the wide slit of the mouth with its thin, tight, protruding lips—are almost always found in 6thcentury sculpture under Daedalic influence, in Veii, in Chiusi, that is, wherever Vulci's influence arrived. But it is a stylistic formula, or

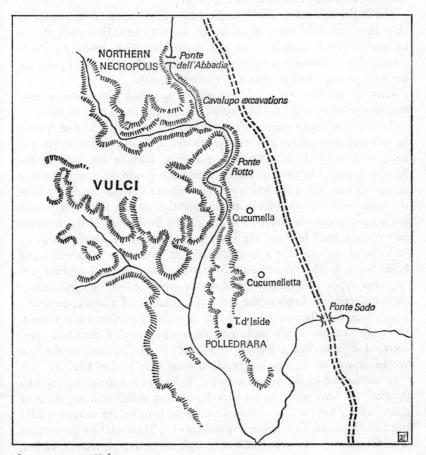

The cemeteries at Vulci

rather a mannerism, that was not invented at Vulci. It appears in the heads of the metopes of Temple C at Selinunte (for example the metope with a Gorgon, Athena and Perseus), which are later than the Polledrara statuette. We find it in the Campanian antefixes with the head of a woman, from Capua and from the temple of the goddess Marica at the mouth of the Garigliano. These are earlier than the statuette from Vulci and may have influenced it. The mantle she wears falls straight down the front of the figure in two parallel folds; since this feature first appears in Greek sculpture and pottery between 560 and 540 B.C.

The Polledrara tomb also had the bust of a woman. It was made of thin hammered bronze; sphyrelaton, as the Greeks called such statues of sheet metal hammered over a wooden core. The closest parallel is a sphyrelaton from the temple of Hera at Samos, but the Vulci piece has been so greatly restored that it is difficult to date.

After the middle of the 6th century the so-called Ionian sculpturethat of the islands and of the Greek cities on the coast of Asia Minorinfluenced Vulci and other Etruscan centres. Many sepulchral sculptures in tufa belong to this current: a youth riding a hippocamp (530-520 B.C.) and many lions. The best examples include the one in the Archaeological Museum of Florence and the group to which the lion in the Vatican (Pl. 43d) belongs. The sculptor has not tried to model the muscles: they are merely drawn. But the Vatican lion differs from his Asiatic Greek counterparts in the plastic modelling of the juncture between the back legs and the body and of the mane which stands up in front of the ears like a triangular collar, as it does in Oriental and Italic lions. In the Etrusco-Roman period, from the 3rd century B.C. on, new types of funerary monuments were added: winged female demons, sepulchral cippi in the form of a cube, or of a house, aediculae which may have been used on tombs as votive gifts (we are not sure). We only have their tufa pediments decorated in relief with two symmetrical figures, but a few small models in clay, found in the late votive deposit of the north gate, show what they looked like.

From the end of the 6th century on, Vulci had a flourishing production of cast bronzes. The rod tripods, so very different from those of Caere which were made of thin hammered bronze, are unmistakable: most of those we have were found in Vulci. Their earliest prototypes were found in southern Italy. Close in style to the tripods are candelabra, censers, statuettes of votaries, helmets, bronze vases of which often

only the handles have survived. These 6th- and 5th-century pieces may not be the Etruscan bronzes (tyrrhena sigilla) admired by the ancients. Nevertheless, from the late 6th century onwards Vulcian bronzes were exported all over Italy, to various parts of Central Europe and Greece as well as to Etruscan cities and sanctuaries. A crater handle now in the Louvre (Pl. 46a) with two horsemen, perhaps the Dioscuri (the times clinier, as they are called in two votive inscriptions at Tarquinia) belongs to the production known as 'Vulcian'. A similar handle was found at Spina, at the mouth of the Po; a horseman identical with those on the handle is in Volterra. The Vulcian handle is an imitation of those on the fine bronze craters found in southern Italy, Yugoslavia, northern France, and which some attribute to Taranto, others to Reggio, others, more correctly, to Sparta.

Whether Vulci or Tarquinii produced the group of black-figure vases dating from the second half of the 6th century B.C. and erroneously called 'Pontic' (Pl. 47) is open to question. True, Pontic vases were influenced by Ionian vase painting, but they were painted in one of the large centres of southern Etruria. The problem is which one, since in style and motifs they are linked both to Tarquinian painting prior to 500 B.C. and to the bronzes attributed to Vulci. From the middle of the 6th to the middle of the 5th century B.C. the two cities were very close artistically. Their decorative repertory, the same found on Pontic vases, is similar. For example, the frieze of lotus flowers and palmettes, with the full palmette which eventually can be traced back to those on Clazomenian ware, appears in the Tarquinian tombs, in the bronzes from Vulci and on the Pontic vases. The stylization of the lion's mane is also identical in the painted tombs of Tarquinii, the bronzes and sculpture of Vulci and the Pontic vases. At times the nature of the artistic bonds between Vulci and Tarquinii suggests extremely close contacts. The lovely dancer holding a censer (Pl. 44c; London, British Museum) was made in Vulci, but she is a three-dimensional version of the dancers painted on the walls of Tarquinian tombs. The profile of the youth (Pl. 44b) on the censer from Vulci (Vatican Museums) is identical with that of the boy holding a folding chair in the Tomb of the Augurs and that of the young flute player in the Tomb of the Baron in Tarquinii. If provenance is considered a determining factor-and generally Etruscan vases are found prevalently where they were madethe Pontic vases must be attributed to Vulci, for by far the most were found in the tombs there.

VULCI; STATONIA; THE VALLEY OF THE RIVER FIORA

Etruscan imitations of Corinthian vases with friezes of walking animals were made to a large extent at Vulci. But it is still hard to localize there the many black-figure vases painted by the Micali painter and his school between 520 and the early decades of the 5th century B.C. Some of his decorative motifs appear in the Tarquinian tombs, but the figures on the more carefully painted vases have the profile of the figures on some of the Caeretan hydriae. But the fact that most of the vases by this painter were found in tombs at Vulci and that some of his mannerisms in the stylization of dresses and cloaks, which form a girdle around the waist, are found in the small Vulci bronzes (Pl. 44c) tips the scales in favour of Vulci.

Vulci as the point of origin for these black-figure vases of the 6th century is also supported by the fact that pottery workshops existed in Vulci in the centuries that followed. The earliest and best of the pseudo-red-figure ware with decoration in superposed colour (the figures are painted in red over the black background) also seem to have been made in Vulci. One of the earliest red-figure Etruscan vases, a cup with the name Avles Vpinas was probably painted at Vulci around 450 B.C. It seems quite probable that the series of vases at-tributed to Vulci for the 4th century B.C. were really made there. They include a crater of the Argonaut group (Pl. 48), as beautiful in inspiration as it is careless and mediocre technically, and a fine red-figure cup in the Vatican (Pl. 49), with details picked out in gold, on which Zeus is carrying off a maiden. The vases of the Vanth Group, with Underworld subjects, found in Orvieto, would seem to come from a Vulcian workshop.

Bucchero workshops also flourished at Vulci. It was a leading centre for thin-walled bucchero (bucchero sottile) and shapes and decoration were sober and elegant. Two extraordinary pieces from Orvieto, a footless kantharos with high ribbon handles, so thin as to seem to be made of sheet bronze, and an askos in the shape of a siren, may have been made at Vulci. Among the typical Vulcian shapes are chalices with a high foot and chalices with high ribbon handles.

Two late tombs—the Campanari tomb in the north necropolis, and the François tomb—are unusual in that they have painted decoration. The late Campanari tomb, no longer extant, is known through inaccurate descriptions and drawings of the 19th century. A demon seems to have been painted outside the entrance door, as in other late tombs (Tarquinia, Chiusi, Orvieto). The back wall had a man seated

on a throne and a woman standing next to him: perhaps Hades and Persephone, or the deceased and his wife. A procession may have been painted next to them and on the other walls. The tomb had a central column with an acanthus leaf capital and human heads. Similar capitals with women's heads were found in other cemeteries of Vulci. Judging from their decoration they may be as late as the 1st century B.C.

The second painted tomb, the famous François tomb, has been variously dated from the 4th to the 1st century B.C. I judge it to belong to the second half of the 3rd century B.C. but the Greek models which inspired single figures may in some cases go back to the 4th century B.C. The tomb is cut into the north-west slope of the Fiora, in the necropolis of Ponte Rotto, and merits special attention. Only the antechamber is decorated with figured scenes. The decorative layout differs from that of Tarquinia in that the frieze has no unity of subject. This may depend not so much on a different decorative system as on the many doors in the walls leading to the various burial chambers. The figures in the spaces between the doors are either single or in pairs. The scenes are unrelated. In general the subject is mythological and despite the obvious influence of Greek models of various periods, the individual figures, technically excellent, are cold, boring and contrived. Only the group of Vel Saties and his dwarf Arnza give us an idea of what the painter is capable of when he is not forced to follow schemes and models he does not feel (Pls. 49b, 50, 51).

The walls of the central chamber, facing the entrance, offer a larger surface and the possibility of more complex scenes. On the right wall the painter depicted the historical scene with the Vibenna brothers and Mastarna, which has already been discussed (p. 13, Pl. 1): this painting is very interesting historically but artistically monotonous. The four groups of two warriors each are completely unrelated one to the other. On the left wall is a mythological scene: Achilles sacrificing the Trojan prisoners to the shadow of Patrocles (Pls. 49b, 50, 51). This painting is remarkable for its fine composition and the beauty of single figures. Here the painter had a model: a painting which was also used for six other works-five Etruscan ones and a sixth one at Praeneste, dating between the middle of the 4th and the 2nd century B.C. This model-painting was probably in one of the Etruscan cities, since neither vases nor reliefs from Greece or southern Italy have been found which have the same subject (a crater made in south Italy, at Paestum, which has been compared to the François tomb, must be excluded since

VULCI; STATONIA; THE VALLEY OF THE RIVER FIORA

the subject is not the same). But in Etruria (and Praeneste falls within the sphere of Etruscan influence) we have seven works, all of which depend more or less closely on the same model. This painting, which was probably famous, must have been in a neighbouring city. The original must have been extremely fine to judge from the François tomb, which thanks to its size and to the skill of the painter best succeeds in giving us an idea of what it was like. The painter of the François tomb seems to have managed to keep the original inspiration, the skilful composition, the beauty of some figures and the pathos of others almost intact. Opinion varies as to whether the two demons, Charu and the beautiful winged girl, were in the original or were added here by the painter. They are as fine as the best of the other figures. Winged female figures are frequent in Etruscan art from the 4th century on. In paintings, sarcophagi and urns they accompany the deceased in their journey to the Underworld, or are seated at the foot of the couch on which the banqueting figure is reclining. In some cases their name is written next to the figure, in the François tomb her name is 'Vanth'. They are infernal deities, difficult though it may be to believe that these beautiful and benevolent-looking creatures could be the companions of the scowling horrid male demons. They appear often in the decorative repertory of Etruscan urns and sarcophagi. The sculptor of a sarcophagus from Vulci, which is now in Copenhagen, used the motif with considerable originality.

The number of sarcophagi in Vulci, almost all in nenfro, is remarkable. There are not as many as in Tarquinia, but they are of higher quality. A local school, active from the 4th to the 1st century B.C., may be inferred. Three sarcophagi, all from the necropolis of Ponte Rotto, speak for the originality of this school. One is now in Copenhagen, the other two are in Boston. They may be considered the best of all Etruscan sarcophagi. The one in Copenhagen is unique. On the front slope of the gabled lid a winged girl is shown reclining, like the figures of the deceased, but she is carved in sunk relief. A cloak covers the lower part of her body and a dove has just flown to her right leg. Her large beautiful open wings are drawn rather than sculpted on the other side of the lid. The chest of the sarcophagus is also carved in sunk relief with processions and animals.

The two sarcophagi in Boston are also very original. They are known as the sarcophagi of the 'husband and wife' since the figures of the couple are shown on the lid, not seated on a banquet couch as in the

painted tombs and as was standard for sarcophagi after the 4th century, but lying down. Together they sleep the sleep of death (Pl. 53). The sarcophagus itself, in nenfro, has a scene of farewell on the front and on the ends, with respectively two women in a wagon and a man getting into a chariot (Pl. 52). The quality is very fine. The man on the lid of the second sarcophagus, which is in marble, is bearded. The reliefs on the chest—battles between Amazons and horsemen on the front and back and animal fights on the ends—are well done, but not as fine, and the composition is looser. All three sarcophagi may belong to the early 3rd century B.C.

The earliest terracotta architectural decorations found at Vulci are from the late 6th century. There are so few of them because excavations were uncontrolled and not because Vulci had no temples or important buildings. G. Dennis wrote that more terracotta statues have come from the necropolis of Vulci than from any other necropolis—a strange statement, for we know of no terracotta statues from Vulci. The few terracottas found in 1879 in the necropolis of Ponte Rotto, between the Cucumella and the Fiora (Florence, Archaeological Museum) and the fragments from the excavations of 1835 (Vatican Museums) are too meagre, too insignificant, to justify Dennis's statement. A votive deposit, recently excavated, has yielded small terracotta models of colonnades and buildings of the Etrusco-Roman period.

After its defeat in 280 B.C. and its submission to Rome, Vulci must have gone downhill rapidly for Livy does not mention it among the Etruscan cities which sent aid to Scipio in 205 B.C. Pliny still lists Vulci among the centres of the seventh region of Augustus. Strabo, on the other hand, makes no mention of it at the beginning of the 1st century A.D.—perhaps it is one of those centres of the interior which he mentions as in decadence or as having disappeared. It is not mentioned in the Itinerari romani, which means that the road along the valley of the Fiora (see above) was no longer so important in the early centuries of the Christian era as it was in Etruscan times, when local Vulcian production and imports took this way to reach inner Etruria. Still the necropolises of the 3rd to 1st centuries B.C. have yielded material that denotes something beyond simple prosperity.

Quite a number of inhabited centres, none of them large or important, flourished in the vicinity of Vulci. Attic and Corinthian ceramics, Etruscan bucchero ware and painted vases, probably imported from Vulci, were found at Montalto di Castro, Canino, Pescia Romana and, in the upper valley of the Fiora at Castro, Poggio Buco, Pitigliano, Sovana. These small sites are naturally fortified, situated as they are on a tongue of land, where two small streams met that had cut deep narrow gorges. These centres lack the wealth of imported material of the coastal cities, but they are interesting. Etruscan and Roman chamber and fossa tombs (generally ruined) are scattered throughout the area.

Pliny mentions the names of urban centres for this area, but they cannot always be identified with the sites revealed by excavations. Silver coins with the inscription thezi and thezle have been found in the territory of Vulci but we do not know to which Etruscan city they belong.

At Sovana, in the valley of the Fiora, the tombs belong to the group of so-called rock-tombs (p. 100). In the same valley, but closer to Vulci, a small city existed on a triangular plateau with steep slopes, bounded by the Fiora and the torrents Bavoso and Rubbiano, in a locality known as 'Le Sparne'. It was naturally fortified, except to the west, towards the necropolis, where a ditch was dug and reinforced by an embankment, thus separating the city from the necropolis. The city, generally known as Poggio Buco from the name of the necropolis area, was very small-about three kilometres in circuit. Several terracotta plaques in relief (6th-5th centuries B.C.) belonged to a temple of which only the precinct has been found. A few statuettes and votive terracottas from the end of the 3rd century and later come from there. The architectural plaques may be the work of a local craftsman. Together with obvious late Ionian influences, they reveal the stylistic time lag typical of provincial centres. The plaque with griffins and deer is unique in southern Etruria (Pl. 54a).

The cemetery of Poggio Buco gives us the history of the town from its beginning to its disappearance. Like other small towns in the hinterland of Tarquinia and Vulci, its fortunes prospered during the archaic period, from well into the 7th century to the end of the 6th century B.C., after which it was abandoned, or almost so, for about two centuries. Life began again in the second half of the 3rd century B.C. with the Roman conquest. The tombs of the 3rd to the 1st century B.C. recall those of Chiusi: the corridors have lateral loculi sealed off by tiles. Archaic tombs had been plundered in antiquity, their bronzes had disappeared, but the pottery, being of little interest to the ancients, had fortunately survived. Thanks to this we can form a picture of the centre and of its

activities. The simplest pottery was made locally. The more elaborate, or non-Etruscan ware—a Proto-Corinthian cup, a few Corinthian and Attic vases, the Etrusco-Corinthian ware—all came from Vulci. Some of the heavy bucchero, of Clusine type, prove that communications with Clusium, via the upper valley of the Fiora, were almost as easy as those with Vulci.

It has been suggested that the town at Poggio Buco was the ancient 'Statonia', mentioned by Pliny and Seneca for its stone quarries. Some acorn-shaped missiles, used in antiquity as ammunition, inscribed with the name 'Statnes', were found in the city. The name has been interpreted as the Etruscan for Statonia. Other scholars however place Statonia near the Lake of Mezzano, which they identify with the 'Lacus Statoniensis mentioned by Pliny and by Seneca. For others however, the Lacus Statoniensis is the lake of Bolsena, and Statonia was somewhere on the shores of this lake. In this case the acorn-shaped missiles would prove only that Statonia had waged war with the city at Poggio Buco. And in support of this theory they cite the finding of an acorn with the same inscription at Sovana.

A smaller town, well fortified by nature, was at Pitigliano, between Poggio Buco and Sovana. The tombs, which date from the end of the 7th to the early 5th century B.C., are hollowed in the cliffs which drop sharply to the river. Tomb furniture is similar to that of Poggio Buco. Here too, after a period of sharp decline, life began again in the 1st century A.D.

The necropolis of an unidentified Etruscan centre (7th-6th centuries B.C. to the Roman period) has been excavated in the past few years in the proximity of the hill which was the site of Castro until 1649. It lies about 20 kilometres north of Vulci, on the river Olpeta, which is a tributary of the Fiora. The chamber tombs, which had been cut into the tufa, open onto a square guarded by sphinxes, winged lions, horses and a ram. A wooden chariot, faced with hammered bronze plaques and with a guard rail in the shape of three arches, was on the floor of one of the chamber tombs. In the corridor were the skeletons of two horses. Some of the bronzes and pottery found in the tombs were locally made, but most were imported. Imports from Vulci are the transitional Proto-Corinthian and Corinthian vases, the Attic vases, the Etrusco-Corinthian ware and some of the buccheros, such as the cups with high foot and high handle. Other buccheros came from Clusium. The corner

SOVANA AND THE REGION OF THE ROCK TOMBS; BISENZIO, TUSCANIA

slab of an altar and the nenfro animals in the round, found in the necropolis, are of local make. They were clearly influenced by those made in Vulci at the end of the 6th and early 5th centuries B.C., but are the work of a local sculptor who transformed his models and saw them primarily as decoration.

We do not know to whom the upper valley of the Fiora belonged. In the archaic period it was influenced artistically and culturally by Vulci, which would lead us to believe that the entire region was under her control. Some however favour Volsinii, but this would be improbable until after the decline of Vulci, in the 3rd century B.C.

Sovana and the Region of the Rock Tombs; Bisenzio; Tuscania

Inner Etruria, east of Tarquinia, has a singular aspect. It is a wild and picturesque region, with wide tufa plateaux cut deeply by the narrow steep valleys of rivers and torrents. Judging from the ancient remains, the region was already inhabited in the Bronze Age (Bisenzio, San Giuliano, Poggio Montano, etc.). There were no large and important cities. The inhabitants were farmers who lived in villages and small groups and not until the late Villanovan or the 7th and 6th centuries B.C. did the historical centres come into being. Naturally fortified places were generally chosen, at the confluences of two streams, so that the site would be inaccessible from two sides. The third side was usually protected by an artificial ditch and, sometimes, by a wall. Similar villages, almost inaccessible, were found in other parts of Etruria as well, for example in the territory of Vulci, Faleri, Capena, at Poggio Buco. But the region east of Tarquinia is distinguished by the singular features of its tombs which have given the region its name: the region of the 'rock tombs'. These tombs are cut into the high, inaccessible cliffs above the streams. They are set at varying heights, one above the other, or in a row, but always higher than the paths they line. Sometimes they continue for considerable distances. What sets them off from other tombs cut into the rock is their monumentality. They are funeral monuments that were not built with blocks of stone above the tombs. They are cut into the cliff and their architectural façade, the mouldings and crowning elements are all of them hewn out of the rock.

These tombs—we might better say the rock monument that crowns

SOUTHERN ETRURIA

them-have different names according to their form. The most usual type in all the rock cemeteries is the cube-tomb (tomba a dado) shaped like a large cube that projects out of the rock. The cube tomb is a 'real' cube tomb (a dado reale) when the cube and its crowning mouldings project out of the cliff on all four faces. We have a 'half-cube' tomb (a mezzo dado) when the back adheres to the cliff wall. We have a 'falsecube' tomb (a dado finto or a dado apparente) when only the façade of the cube is worked out of the rock or delineated on it (Pl. 55). The cubetomb is the earliest type of rock tomb and first appeared at the end of the 7th century B.C. More recent are the aedicule tombs (tombe a edicola), which are somewhat like small shrines. Their frequency varies according to the site and the necropolis. The various types include the 'pediment tomb' (tomba a timpano) crowned by a pediment; the 'pediment tomb with portico' (tomba a timpano con portico) when the façade has a porch between two antae, surmounted by a pediment; the 'temple' tomb (tomba a tempio), when the building has the façade of a temple with its podium, columns, architrave and pediment. The actual tomb, though, where the body was placed, was a chamber tomb, often excavated under the cube or the façade with the entrance also just below the façade. In the earliest tombs (Blera, San Giuliano), however, the cella is excavated within the cube itself and the door of the façade is also the entrance to the tomb.

The monumental façade of the tomb was prepared with great care, sculptured, or rather carved into the soft tufa, sometimes evened off with a layer of stucco (Norchia, Sovana) or carefully polished (Blera). But the burial chambers excavated below the façade were often irregular in plan and carelessly done.

Rock-tombs have been found almost exclusively between the lake of Bolsena and the lake of Bracciano: at San Giovenale, San Giuliano, Blera, Luni sul Mignone, Cerracchio, Poggio Montano, Castel d'Asso, Norchia, La Bicocca, etc. Outside this area rock-tombs are found at Sovana, in the upper valley of the river Fiora. A few isolated rocktombs were found elsewhere. They differ from site to site in small details and peculiarities of style.

Sovana was discovered in 1843 by Ainsley, when other sites with rocktombs were already known. Only a few cuniculi of this ancient town and the sparse remains of walls are left on the site of the modern town, at the confluence of the torrents Calesine and Folonia, which flow

SOVANA AND THE REGION OF THE ROCK TOMBS; BISENZIO, TUSCANIA

about 60m. below the inhabited tufa plateau. The name of the ancient town in Roman times was 'Suana', mentioned by Pliny (III, 8) as a municipium and by Ptolemy. Some scholars say it belonged to Vulci, others to Volsinii. It has cube-tombs, cut out of the high cliff above the torrents; the earliest date from the late 7th or early 6th century B.C. The more complex ones date to the 3rd-2nd centuries B.C. Among these are the Tomb of the Siren—an aedicule tomb preceded by a portico and with the monster Scylla seizing two of the companions of Ulysses carved in the pediment. Other noteworthy tombs are the Grotta Pola with eight columns on the façade, and the Ildebranda Tomb, the only temple-tomb at Sovana. It has a podium with a double staircase, six columns on the façade and three at the sides. The capitals of both tombs have volutes and human heads, like the capital of the Campanari tomb at Vulci. The tufa was stuccoed and smoothed; the architectural elements were painted.

A chamber tomb had a lacunaria ceiling; remains of paintings were on the walls. It is the only painted tomb in the necropolis of Sovana.

A small sanctuary in the centre of the cemetery seems to be unrelated to the surrounding cemetery. It had an altar, and perhaps a small shrine: a goddess whose name we do not know was worshipped there. The terracotta offerings found in the votive deposit—heads, legs, feet and other parts of the human body—seem to show that she was probably a salutary goddess.

The numerous settlements in the region of the rock-tombs, between Lake Bolsena and the lake of Bracciano, do not seem to have had any particular artistic development, even though communications with the Tyrrhenian coast and the Faliscan territory were not difficult. The architecture of the tombs is what primarily interests the visitor. The territory may have attained a higher artistic level than present appearances would lead one to believe in antiquity, but there was so much plundering of the cemeteries that we are seriously hampered in any attempts at forming an opinion of these primarily agricultural towns. We do not know their ancient names. Two Etruscan towns mentioned by Livy (VI, 4), Cortuosa and Contenebra, have not been identified.

It has been said that the region of the rock-tombs was dependent on the culture of Tarquinia. Recent excavations and studies have shown a strong Caeretan influence, particularly from the 7th to the 5th centuries B.C. Caeretan influence may account for the chamber tombs with tumuli, hewn into the tufa on the plateau high up in the hills, while the rocktombs are cut into the steep tufa wall of the valleys below. The cubetombs and some types of chamber tomb also reveal the importance of Caere. But it is impossible to say just how much was due to conquest and how much to artistic and decorative influences, since communications were easy and favoured influences from southern Etruria, while the Faliscan region sent its own pottery.

The Etruscan settlement at San Giuliano has disappeared. It was built on a plateau that drops off sharply and had, it seems, only one entrance. There are ruins of temples at Poggio Castello and Noce. The cemeteries are all along the hills. The most important are at Chiusa di Cima, which is the earliest and has many cube-tombs, and Caiolo. Caiolo also has many portico-tombs, some of them famous: the Tomba Cima, which has remnants of paintings, is divided into three parts by fluted pilasters; the Coccumella di Caiolo has a false vault built of progressively projecting rows of stone blocks. Other tombs have a chamber with a gabled roof and a central beam. There are no temple-tombs at San Giuliano.

San Giovenale is on a highland which was inhabited from the late Bronze Age through the Villanovan and up to the beginning of the 1st century B.C. In the 7th century B.C. the town was of goodly size. The Villanovan huts had been replaced by houses set on either side of a road. In the western part of the acropolis the houses were larger and better preserved. Hundreds of tombs were hewn into the tufa; those of the 7th and 6th centuries B.C. were covered by a tumulus.

Luni, at the point where the river Vesca flows into the Mignone, had iron mines. There are interesting remains of huts and houses. Fragments of Mycenaean pottery have been found.

Another settlement was at Acquarossa, north of Viterbo, where the Roman Ferentum was later to be. The houses were built of wood, or of poles and reeds covered with clay. The roof tiles had a red slip on which horses, deer and birds were painted in white. Some of the flat tiles with raised edges terminate in dragon heads. A building with three rooms and a porch may have been a temple. The terracotta revetment plaques have unfamiliar motifs alternating with wellknown ones such as Hercules and the Nemean lion, Hercules and the bull and dancing satyrs.

An architectural terracotta plaque similar to the ones from Acquarossa comes from a place nearby, Castel d'Asso, a site identified by some

SOVANA AND THE REGION OF THE ROCK TOMBS; BISENZIO, TUSCANIA

scholars with the Castellum Axiae mentioned by Cicero (Pro Caec., 20) as being in Tarquinian territory.

The two 'Doric tombs' at Norchia are quite distinctive: they are similar and have temple façades, with two columns between the antae. A frieze of metopes with human heads and triglyphs runs along the architrave; there are remains of pediment sculptures. The tombs were already in poor condition in the 19th century: half of one of the pediments had fallen down into the valley. The drawings made at the time are in the form of rather imaginative reconstructions. Judging from the description given by Orioli in 1833 they are not earlier than the 2nd century B.C.

Rock sculpture has also been found at San Giuliano and in the upper valley of the Mignone. A rock altar at Grotta Porcina had sculptured decoration.

A few sarcophagi found in this region-at Vetralla, San Giuliano, Norchia, Musarna-stand in a group by themselves. They are decorated with sculptures and all have archaic and provincial features and are rather crudely executed. They were influenced by the sarcophagi of Bolsena, Orvieto and Bomarzo. What is practically a compendium of the various funerary motifs is carved on the chest of a nenfro sarcophagus from Norchia: demons, athletic contests, journey to the Underworld. Two demons are shown hastening towards the centre, a male demon with a hammer and a serpent, and a second demon, possibly female, with two serpents. In the centre is a hippocamp with an odd sort of tail and fins and two boxers with gloves and loincloths. Another sarcophagus has marine monsters. Both in technique and motifs these two sarcophagi are close to a crude provincial one from San Giuliano, that of Vel Thansina. The dead man, lying supine on the sarcophagus, wears a cloak with rather shapeless folds and has a large protruding belly. His hair looks like a close-fitting cap. He is probably the same person shown on the front of the sarcophagusa rider with a paunch mounted on a crudely executed mule. On the left and right are long-robed demons with snakes in their hands: they are similar to those on the sarcophagi of Norchia. Other sarcophagi are even more elementary and crude, the figures on the lids are shapeless masses, like wax figures slowly liquifying.

Not far from Castel d'Asso, near the medieval town of Musarna, was an Etrusco-Roman centre of unknown name. The tombs show it to have begun in the 3rd century B.C. Among the burials found there is

SOUTHERN ETRURIA

that of the Alethna family, which was one of the most important in the region during the second half of the 3rd and the 2nd centuries B.C. On their sarcophagi seven members of the family proudly and ostentatiously listed the magistratures they had held, probably in the town where they lived. One of them, Arnth Alethna, proud of having been praetor in a city as large as Tarquinii, specified this in the inscription (zilath tarchnalthi). Several sarcophagi, funerary cippi and house urns come from Musarna.

Bomarzo is near Bolsena and Orvieto and was influenced by both. A fine sarcophagus (London, British Museum) recalls those of the area of Volsinii in its shape, decorative motifs and technique. It comes from a chamber tomb with decorative paintings: a stylized wave motif runs all around the walls under alternating red and black dolphins. Further up on the back wall are hippocamps and marine monsters. On the left was a demon with a vase and two serpents. Two sarcophagi were on the floor. One, in tufa, was unadorned; the other had the shape of a wooden chest, and a lid like a gabled roof, with tiles, antefixes, acroteria. It is the only example in Etruria of a lid which exactly reproduces a roof. On the fillets at the ends of the front, a female demon and a warrior are carved in flat relief; on those at the back are two demons, one male and one female. A hollowed listel, carved in intaglio, joins the figures.

A Roman centre once stood on the south-west shore of the Lake of Bolsena, near the modern Capodimonte. Pliny (III, 5) called the inhabitants 'Vesentini', but inscriptions say 'Visentini' and the name of the city was therefore 'Visentium'. A rich Etruscan town existed here in Villanovan times. Its Etruscan name is not known, nor was mention of a city on this site ever made by ancient writers. Scholars usually include it in the territory of Tarquinii since Pliny (II, 95) calls the lake of Bolsena 'lacus Tarquiniensis' (lake of Tarquinii) and because modern Bisenzio is situated where the river Marta-Tarquinia's river-leaves the lake. But other ancient writers-Vitruvius, Frontinus, Columella, Strabo—and Pliny himself (XXXVI, 22) call the lake 'lacus Volsiniensis', lake of Volsinii. Still the fact that many bronzes were found in the Villanovan tombs near Visentium may indicate that it belonged to Tarquinii. In the 8th century and at the beginning of the 7th century B.C. Tarquinii was still the most important Etruscan centre for objects in bronze

SOVANA AND THE REGION OF THE ROCK TOMBS; BISENZIO, TUSCANIA

The many rich cemeteries prove that the town was important: Polledrara, San Bernardino, Porto Madonna, Le Bucacce, Olmo Bello and others. The earliest—they are the farthest from Roman Visentium are at Porto Madonna, San Bernardino and Polledrara. The tombs are simple pozzetti, or pozzetti with cylindrical tufa receptacles, occasionally connected at the bottom by tunnels, as in Vulci or Tarquinii; fossa tombs, the earliest with cremation burials, others with a tufa coffin which sometimes held a second coffin in wood; chamber tombs, decorated with red bands. In the cemetery of Palazzetta tombs were placed on two or even three levels, with fossa tombs above the lower pozzo tombs. The skull of a woman who had had her teeth bound in gold was in one of the fossa tombs.

The most beautiful and interesting material comes from the late Villanovan tombs with their fine cast or hammered sheet bronzes and with Italo-Geometric vases, coated with a white slip and painted with a geometric decoration in black and red. These vases were probably imported from Tarquinii: one of the finest pieces, a footed olla with a row of women holding hands, is from a tomb in Bisenzio, from the Bucacce. The Etruscan town at Bisenzio was undoubtedly in touch with Clusium, in northern Etruria. A tomb in the necropolis of Olmo Bello had an impasto vase with a cover in the shape of a schematic human head exactly like the Clusine canopi (pp. 163 f.) and like them was on a high-backed throne. Communications with Clusium were easy thanks to the road which passed along the north shore of the lake of Bolsena. Two silver filigree bracelets came from Olmo Bello. The originality of some of the bronzes-the trolley tray, the situla with figures on the cover—which are unique in Etruria may be due to a pleasing decorative provincialism.

The site continued to be inhabited and later became the Roman town of Visentium. It was luckier than many other small centres in that region which had already fallen into decadence or disappeared by the 1st century A.D., for it managed to remain relatively important and become the seat of a medieval bishopric.

Medieval Toscanella, now known once again by its ancient name of Tuscania, lies north-east of Tarquinia on the river Marta. The ancient Etruscan town, which began at the end of the 7th century B.C., was probably where the medieval centre was; it had various cemeteries. A few ancient walls are also left. Some architectural terracotta plaques of rather poor quality faced the wooden trabeation of a building. They have been dated in the 7th century B.C., but their archaic appearance is due to the crude workmanship of a provincial craftsman who was behind the times. They probably are not prior to the last quarter of the 6th century B.C. The building to which they belonged must have been quite modest in size, and may not have been a temple, since architectural terracottas were also used for civic buildings.

The earliest cemeteries—San Giusto, Sasso Pizzuto, Carcarella, Scalette—have fossa tombs. The 6th-century chamber tombs recall those of Tarquinii in plan: a corridor with side walls that narrow into arches, cut into the tufa and closed by slabs (San Giusto, Sasso Pizzuto, Ara del Tufo). The tomb furniture includes black and red impasto vases, buccheros, many of which were made in Tarquinii, locally made pottery, Italo-Geometric vases, an occasional imported Greek vase, including a Corinthian olpe of c. 600 B.C., and a few Attic cups; a few Etrusco-Corinthian vases were also imported.

In the centuries that followed, chamber tombs had one or more chambers and—as at Tarquinia—a gabled ceiling with a central beam. Sometimes, when several chambers are next to each other, small windows as well as doors were cut into the wall, which divided them from the central hall. The most famous tomb in Tuscania is the 'Grotta della Regina' in the neighbourhood of the small church of the Madonna dell'Olivo. It is very complex and has several levels.

Late chamber tombs had many sarcophagi and urns, some in nenfro or local tufa, most often in terracotta. This development of the sarcophagus industry also sets Tuscania in the Tarquinian sphere of artistic influence. On the whole, the sarcophagi are not beautiful but they are nevertheless interesting. All of them come from local workshops and some even seem to have been made by the same artisan. Those in nenfro are more elegant and ambitious, modelled on those made in Tarquinii. A sarcophagus, which is now in the Vatican depicts the slaughter of the daughters of Niobe on the front. Greek inspiration has been transformed according to Etruscan taste: the avenging gods, Apollo and Artemis, have been replaced by demons. Probably the sculptor had a model for this scene, but the figure on the cover, with his uninteresting heavy drapery and symmetrical parallel folds gives us an exact idea of the limitations of this minor local craftsman when he had no model. Another sarcophagus, similar to the one just mentioned, has a strange scene on the front—preparations for the lapidation

SOVANA AND THE REGION OF THE ROCK TOMBS; BISENZIO, TUSCANIA

of a nude man and a nude woman, behind an altar, in the presence of Mars and Venus.

Many sarcophagi and urns are in terracotta, generally with an unadorned plain chest and with the deceased on the cover. On the whole they are rather mediocre. The coroplast's main interest lay in the head, which he animated with a few swift strokes of the modelling tool. One of the best pieces produced by this school is the urn known as 'Dying Adonis', depicting a youth flung down on the kline while his dog lies underneath next to the footstool.

Two chamber tombs of the Curunas family (late 4th—early 3rd century B.C.) contained important bronzes, including a situla and a crater, both decorated in repoussé, as well as a number of nenfro sarcophagi.

Inscriptions on sarcophagi mention the names of the most important families. In the 2nd century B.C. some of their members held civil or religious offices. It seems unlikely that the modest town of Tuscania could have had all the magistratures listed in the inscriptions. Although no other city is specifically mentioned, some of these may refer to offices held in Tarquinia or other cities in the region.

The famous pair of dice with the numbers one to six written in Etruscan were found in Tuscania. The order of the numbers and which word corresponds to which number is still a matter of debate.

The disastrous earthquake of February 1971 did no damage to the tombs of Tuscania. The material in the local museum came through better than was to be expected.

A charming little bucchero rooster (Pl. 93) was found in the region of the rock-tombs, apparently in Viterbo. It is now at the Metropolitan Museum in New York. On its body is incised the Etruscan alphabet. It dates to the end of the 7th or the beginning of the 6th century B.C.

To whom did this region of rupestral tombs belong in Etruscan times? The answer is not easy. The southern zone, up to the lake of Vico, was, as we have seen, under the influence of Caere and the Faliscan territory. But Bomarzo was strongly influenced by Volsinii and Orvieto. To judge from the sarcophagi, even Vetralla, Norchia and Musarna were dependent on Bomarzo and the Volsinian area. This would cut Tarquinii off from most of inner Etruria, leaving her with not much more than the Valley of the Marta, where Bisenzio and Tuscania were in close contact with Tarquinii. But if we judge from conditions during the Roman empire, which might reflect the situation

SOUTHERN ETRURIA

in Etruscan times (some scholars have no doubts about this), the southern region might be in Tarquinian territory. Probably only the northwestern area, including Ferento, Viterbo and Bomarzo, belonged to Volsinii.

Central Etruria is a region of transition, almost an intermediate belt which has some of the characteristics of south Etruria, but also some features we find only in north Etruria (see pp. 128 ff.). Central Etruria includes the valley of Albegna with the Etruscan necropolis found at Marsiliana, as well as Magliano, Saturnia, and, further east, the northeast shore of the lake of Bolsena, with Volsinii, the settlements in the hills east of the lake, and Orvieto.

The territory between the rivers Fiora and Albegna (Roman Albinia) apparently corresponds to the ager Caletranus, mentioned by Pliny (III, 52) and Livy (XXXIX, 55). Generally this region is thought to have belonged to Vulci, the nearest important city, but topographically the land is closer to north Etruria. The tufa plateaux, volcanic in origin, into which rivers have cut deep picturesque ravines ideal for the construction of easily fortified cities and for the excavation of chamber tombs, have given way to fairly steep rocky hills. Since the lie of the land was so different, there were also fundamental differences in the architecture—the only extant examples are the tombs. The rock is too hard to be easily excavated, but it can be cut into blocks and slabs. Where the land did not lend itself to rock-cut chamber tombs they were 'built' (especially the monumental ones) above the ground with slabs or blocks of local stone. Saturnia, Marsiliana, Orvieto in Central Etruria are the first centres-topographically speaking-in which this new building method appears. From an artistic point of view both southern and northern Etruscan influences are evident.

Saturnia; Marsiliana

When the rich city of Marsiliana d'Albegna was at the height of its Orientalizing culture and received imports from other Etruscan cities, Saturnia—the ancient Aurinia according to Pliny (III, 5, 52)—was but a small agricultural settlement, unimportant and backward. It was situated on a travertine plateau (290m. above sea level), to the left of the Albegna river, isolated and hard to reach. Its ancient walls, which

are preserved to the west and to the east, are in polygonal masonry; there are Roman stretches and medieval ones. The roads were partly cut into the rock. According to Dionysius of Halicarnassus (I, 26) the town was pre-Etruscan, founded by the Pelasgi. Most of the buildings still extant in the city are Roman. The necropolis shows that the settlement began in late Villanovan times. The few late pozzetti (7th century B.C.) are contemporary with the inhumation trench tombs. The interesting biconical ossuaries are covered with a large cup which is not the standard Villanovan inverted one. The cup has above it a large elongated ovoid sphere, reminiscent of a cippus but also of a human head. Though not exactly like the canopic jars of Chiusi (pp. 163 f.), they seem to have been influenced by them, which is not surprising. Communications with Chiusi were easy and only meant reaching the valley of the river Fiora and the road that ran from Vulci to Chiusi (p. 85). An ossuary of this type was also found at Vulci.

The trench tombs were sometimes completely lined and covered with travertine slabs. Two trenches had a gabled roof: the slabs were supported by a wooden beam.

There are two types of chamber tomb: tombs dug into the gravel under the layer of travertine, which served as a ceiling, with the tumulus enclosed by a ring of upright stones, as in the Vetulonian 'circles' (p. 129); and tombs built on the surface of the ground with large upright slabs. They had one or more chambers and were roofed over by large slabs. When the chamber was large, the roof had two covering slabs supported at the centre of the chamber by an upright slab which divided it into two parts. The tumulus had rings of superimposed slabs. Occasionally the tombs built with slabs were dug into the ground for about two-thirds of their height. Tomb furniture was simple: vases of local impasto, a few imported buccheros, including a fine bucchero vase with female heads in relief; Attic red and black figure cups were rare, still rarer Etruscan painted vases.

After the disappearance of Marsiliana, Saturnia became the most important settlement in the valley of the Albegna. Nothing proves that it ever belonged to Vulci. If the tombs known to us really represent all the periods, the city declined in the 5th century, and regained importance only when Rome founded a colony there, in 183 B.C. The tombs, found singly or in small clusters in the Albegna valley, prove that it was thickly populated in antiquity. They were probably the tombs of land-owners who exploited the fertile soil.

SATURNIA; MARSILIANA

An important necropolis near Marsiliana belonged to an unidentified ancient city. 'Caletra' has been proposed as its name, since the site is included within the zone believed to have been the 'agro caletrano', but we do not even know where the city was. Our only evidence for the existence of a settlement is the rich necropolis, which began shortly before the beginning of the 7th century B.C. with cremation burials in late pozzetti or buca tombs, contemporary with the trench tombs. The most recent burials were chamber tombs built of stone blocks, but so ruined that the details of their construction and mode of covering are often doubtful. They were so rifled that very little can be said about the funerary furniture. In the first half of the 6th century B.C. the cemetery stopped being used. As at Vetulonia, the city disappeared while it was still at its height. Indeed, the latest tombs were among the richest ones.

Marsiliana had many points of contact with its important neighbour to the north, Vetulonia. It may also have been in close touch with Rusellae (now Roselle), which is nearer, but only the excavation of Rusellae and its cemeteries will throw some light on the question. A specific type of tomb, frequent in Marsiliana, consisting of trench tombs enclosed by circles of stones, has so far been found only here and at Vetulonia. These 'ring' trenches (fosse 'con circolo'), or better, the 'circles' ('circoli'), are trenches dug into the earth and circumscribed or bounded by a large ring of travertine slabs set upright. These may originally have enclosed the tumulus raised over the tomb. Exceptionally these circle-graves have more than one trench. The body was placed on a layer of pebbles or sand, or on boards. In the Perazzeta Circle it had been placed on an iron bed. The sides of the trench might be faced with upright slabs of alberese (a kind of limestone), as at Saturnia. In one trench the body had been placed in a hollowed-out block of stone. As in Vetulonia, the circle-graves are the richest tombs. Some, such as the Circle of the Ivories and the Circle of the Fibula at Banditella. or the Perazzeta Circle, were fantastically rich, although never quite as fabulous as the tombs of southern Etruria. While the material at Marsiliana with its fine ivories, gold jewellery, bronzes, is rich, it consists of everyday objects of personal use, similar in this to the material in Vetulonia and Populonia. Many of the tombs contained a chariot and the Circle of Perazzeta had two.

A study of living conditions in the valley of the Albegna and of the funeral accessories found in the tombs at Marsiliana (about 100 tombs) raises various questions. Why did this city come into being? What

made it so prosperous? Why did it fall into decadence and why was it abandoned? Was it an independent city, or was it dependent on Vulci, or Rusellae, or Vetulonia? Were the rich objects found in the tombs made locally or were they imported? If they were local products Marsiliana would occupy an important place in Etruscan production of the 7th century B.C. True, these objects seldom go beyond good craftsmanship, but they are frequently striking and in excellent taste.

It is not always possible to answer all these questions. The site of the Etruscan city has been conjectured to be where the castle of Marsiliana now stands, on the torrent Elsa, a left hand tributary of the Albegna river. Although A. Minto, who excavated Marsiliana, is sure that the group of hills of which it is a part constitute a natural fortress, the position of Marsiliana and the fact that it is only 120m. above sea level are not enough to make it an important fortification. Its position in the valley of the Albegna is that of an Etruscan farm settlement and it probably started as one and seems never to have changed. There were no mines to exploit. Those on Mount Amiata were too far away and mercury was of little importance in the 7th century B.C. The really important metal was copper. There was iron a few kilometres away at Magliano, but it seems to have been exploited only in Etrusco-Roman times. There is nothing to show that Marsiliana had any maritime trade and used the mouth of the Albegna as a port. Only communications with southern Etruria, with Rusellae and Vetulonia, presented no problems.

With reference to the funerary accessories, it is hard to say if the numerous impasto vases and the few buccheros were made locally or not. They probably were, for even small centres saw to their own daily needs in the way of everyday pottery and the ware found at Marsiliana is, with few exceptions, of this type. A large footed jar in impasto decorated with horses in a low flat relief was imported. I would judge it to be an imitation of the Caeretan buccheros. The unguent vases, which imitate those made in Corinth in the 7th century B.C., were also imported. Exceedingly few tombs in Marsiliana had Greek vases which might have served as models. They probably came from a coastal city where such Greek vases arrived. Some of the bronzes andirons, spits, etc.—may have been made in Marsiliana, but the finer, more complex pieces, the jewellery and perhaps the ivories, were imported.

Among the bronzes, the censers (Pl. 57) and the so-called 'candelabra'

SATURNIA; MARSILIANA

(pp. 133, 257) came from Vetulonia. So did a fragmentary handle shaped like the bust of a man with a crown of large leaves on his head; he raises his arms to support the semicircular handle. It was made in the same workshop as the sporadic handle found at Fabbrecce, in Umbria. The Fabbrecce piece (Pl. 64) is more elaborate, but similar in type: a male half-figure, with a wreath of large leaves on his head and with upraised arms, holds the two ends of a handle on which dogs alternate with lions which have a human leg, or arm, issuing from their jaws. The best parallels are with handles found at Vetulonia, and their range of diffusion seems to indicate Vetulonia as the place of origin.

The jewellery found in Marsiliana was not made locally. Some of the gold fibulas and the filigree bracelets are from Vetulonia. The duality of influences—from both the north and the south—to which Marsiliana was subject is most evident in this field. Side by side with the Vetulonian filigree bracelets we find two rich brooches similar to those from Praeneste and the rich 'Corsini fibula' (Pl. 58) with decoration in the round along the bow and long pin, very like one from Vulci and typically south Etruscan. It is uncertain where a fibula with an undulating bow, decorated in filigree and granulation, that was found in the Perazzeta Circle, is from. It resembles both a fibula from Vetulonia and one from Caere.

The ivories from Marsiliana are difficult to classify. Although they were found in three different tombs, they form a fairly close group. Most of them, and probably all of them, were made in Etruria. Only one ivory, a nude female figure from the Circle of the Fibula, is doubtful. She clasps one breast with her left hand and with her right holds a vase under her other breast. A sheet of gold foil was wrapped around her shoulders. Since she is the only piece of the kind in Etruria, one would be tempted to think she had been imported from the East, but the long braid down her back is frequent in Etruria in the 7th and first half of the 6th century and rarer in the East.

The other ivories were unquestionably carved in Etruria, but just where is a problem. The motif on a small disc—two nice dogs, recognizable by the collar around their necks, curled round a central hole—is unknown elsewhere, either in or outside Etruria. But it must have been a favourite motif in Marsiliana, for a disc with a crouching dog also served as a terminal piece of the ivory handle of a flabellum (fan). At the other end of the same handle was another disc (0.7m. in diameter), decorated in high relief with an unusual motif (Pl. 58). In

the centre, along the axis, crouches an animal with long pointed ears, curled tail, and long undulating rope-like mane. It resembles a dog, but it is clearly supposed to be a lion. In fact it is flanked on either side by supine nude youths in a rather contorted position. Their legs converge. Each youth has sunk a dagger into the sides of the lion. The craftsman had some difficulty in fitting the group into a circle. Seen from above—as we do now—all three look dead, but to the person who held the fan upright by the handle, the two youths seemed to be standing and victorious. The composition is naive, childish, but effective. It is just this ingenuity of vision and composition which marks the work as Etruscan and not oriental. But where it was made is uncertain.

The closest parallel is an ivory from Praeneste, from the Barberini tomb. A reclining lion has two dead (?) men under his forepaws. Their right hands can be seen grasping the locks of his mane. Another young man, presumably dead, is lying on the lion's back. His hair is incised exactly like the mane of the Marsiliana lion. But the Barberini ivory is by a much more skilful master, a master who had seen oriental ivories and objects as well as reproductions of lions. Some scholars have even judged the piece to be an Eastern import. That they are wrong has been confirmed by Professor K. Bittel, for the youth wears an Italic belt instead of the rectangular Assyrian girdle. Nor would an Easterner have represented the triple slaughter in such a naive way. The dead man lying so peacefully on the back of the lion is the product of the imagination of an Etruscan who lived where lions did not exist.

A similar massacre, of animals this time, more naive still and cruder, is represented on a fragmentary lid from the Circle of the Fibula. A reclining lion, with the same wavy mane and long ears as the lion on the disc, has killed a small antelope which is flung over his back. He is sinking his fangs into an animal as large as he is, perhaps a dog, since it wears the standard collar of slanted lines. With his hind legs the lion defends himself against a large bull. There are also other unidentifiable animals. Like the Barberini ivory, the lion here has a dead creature on his back and other victims under his paws. But his victims are animals, not men. The artisan may have been the same man who carved the small disc with the dogs, and the flabellum handle. The crude work, the rather un-lionlike lions, seem to indicate a craftsman from northern Etruria, influenced by Caere, where the Barberini ivories were probably made.

Two lid handles in ivory can also be compared with the Caeretan

SATURNIA; MARSILIANA

material from Praeneste. Each handle consists of a lion with the lower half of a human body dangling from his jaws. They are versions in ivory of bronze furniture finials such as those in the Barberini tomb in Praeneste.

The famous ivory pyxis (box) from Marsiliana recalls the censers from Vetulonia in shape and in the lotus flower attached to the lid. It was carved by a craftsman familiar with Vetulonian censers. The decoration is arranged in two zones, as on the much simpler bronze models. There are rows of animals, some of which are fighting. Here too there is an ingenuity not found in southern Etruria. Note the prostrate man suspended in mid-air between a lion which attacks him and a sphinx; or the strange ram; or on the lid, decorated in flat relief, the fish used as a filler ornament above a four-footed creature. The comb from the same Circle of the Ivories clearly shows that the craftsman was Etruscan—a lion has a long volute issuing from his jaws, a motif which, whatever its origin, has been found only in Etruria.

Mention must be made of an ivory tablet (Pl. 94) with the archaic Etruscan alphabet incised along the margin, not so much because of its artistic value but because of its intrinsic interest. It is a writing tablet of the kind that was coated with wax and written on with a stylus: the writing was cancelled by passing a piece of hot metal over the wax. Comparisons both in shape and material exist only with the East. No other tablet like this has been found in Italy. But none of the Eastern tablets are just like it either. The main difference is in size. The Eastern tablets are much larger and served a practical purpose-they were meant to be written on. The Marsiliana tablet could not normally have been used, for it is too small (0.088m. in length) and there is room for no more than a few words. It is a miniature tablet. Why then should a tablet which the dead man could not have used in life be put into the tomb with him? There are two quite plausible explanations. Writing in Etruria was just at its beginnings and the tablet testifies to these beginnings in Marsiliana. The dead man wanted to show that he knew how to write and the tablet was a public testimony of his learning. The second explanation is simpler and does not exclude the first. The alphabet incised along the edge was a 'model' alphabet, a 'reference book' or primer, which suggested the shapes of the letters to the person writing, who might not be on too familiar terms with all the letters. The alphabet was incised on an object that had to do with writing. In other parts of Etruria alphabets were found engraved on vases which

might have been the equivalent of an inkpot, containing the coloured liquid used to write on papyrus. Anyone who forgot a letter while he was writing had only to turn the alphabet inkpot to the right place.

When the tablet was discovered it was dated to the 8th century B.C., a date that has often been repeated. In a 1957 issue of Historia which has a summary of the present state of Etruscan studies, Professor Oltzscha still gives this date. But the Marsiliana tablet has no stylistic characteristics which might date it. This can be done on the basis of the letters and their form: using this method M. Guarducci places it in the first half of the 7th century. Or it can be dated on the basis of the other objects from the tomb in which it was found, especially the ivories. Judging by these, Miss Jeffery dated it to the second quarter of the 7th century B.C., but this is too early a date for these ivories.

The tomb where it was found, the Circle of the Ivories, had three burials in a single trench, and therefore three distinct groups of tomb furniture, but the groups do not seem to vary greatly in time. Some of the ivories even seem to be by the same craftsman. Similarities with one of the Barberini ivories would lower their date to quite late in the second half of the 7th century B.C. But there was also an Etrusco-Corinthian alabastron in the tomb: alabaster began to be used in Corinth around 620 B.C., while Etruscan imitations are not earlier than the last years of the 7th century. So that even if the alabastron belongs to the most recent deposit and the tablet to the earliest, neither the ivories nor the tablet could date back to long before 630–620 B.C. The Marsiliana alphabet would then be contemporary, or almost so, with the group of archaic alphabets—Regolini-Galassi tomb, the alphabets of Viterbo and of Formello.

The cause of Marsiliana's disappearance could only have been a war which destroyed the city and scattered its inhabitants. There may be a relationship between the disappearance of Marsiliana and the formation of an Etruscan centre at Magliano, a few kilometres north of the river Albegna. Marsiliana came to an end not much later than 600 B.C. and the new centre dates from the beginning of the 6th century B.C. The inhabitants of the destroyed city could have moved to Magliano where the famous 'lead of Magliano', a long spiral inscription incised on both sides of a lead tablet, was found. As far as we can gather both Marsiliana and Vetulonia seem to have disappeared more or less at the same time. Their wealthy neighbour, the city of Rusellae, may have been the cause, but we have no proof.

THE LAKE OF BOLSENA; VOLSINII; ORVIETO

The new Etruscan town at Magliano seems to have been inhabited without interruptions. The Romans founded the colony of Heba there. From the 3rd century B.C. on, one of Heba's resources was the working of the local iron mines.

The Lake of Bolsena; Volsinii; Orvieto

In antiquity the region around Lake Bolsena was relatively densely populated. The lake is now 8 to 10 metres higher than it used to be in prehistoric times. The coast line has changed, particularly on the west and on the south; the island of Marta was once connected to the mainland. South of Bolsena, at the Gran Carro, the lake has covered a Villanovan settlement. A road can still be seen going straight into the lake, the remains of ancient pile dwellings were found along the east and north shores and the lake was full of fish (Columella, I, 10). The western shore with Visentium, modern Bisenzio, almost certainly belonged to Tarquinii (p. 70). This is obviously why Pliny calls it 'Tarquinian lake' (II, 95). But Pliny himself (XXXVI, 22) and others also called it the 'Volsinian lake'.

Hut foundations east of the lake, at Capriola, date back to the Bronze Age. The cemetery of a late Villanovan settlement, dating to around 700 B.C., has also been found.

The most important site, east of the lake, is La Civita, situated on a naturally fortified hill. It had the remains of a settlement of the 6th–4th century B.C., surrounded by a wall built of irregular blocks. Outside the wall was a building which has been identified as a temple: a large hall with rudimentary bases for columns or piers which supported the roof. The walls were built with a rather unusual technique—rows of stones and tufa blocks alternating in chessboard fashion. The building was destroyed by fire in the first half of the 4th century B.C. In the 19th century plundered tombs were found in various spots in the neighbourhood.

On the hills above Bolsena the excavations of the French School, begun in 1946, have brought to light the remains of an Etruscan city which continued to exist in Roman times. Not much is left of the Etruscan town. Its acropolis was at Mozzetta di Viètena (622m. above sea level). The town was built on terraces with a total difference in level of about 300 metres. A city wall of squared blocks was built in

the 4th century B.C.; the weakest points had a double wall, that is, two parallel walls joined by transverse sections of wall, a technique we find in south Italy, but not elsewhere in Etruria. Above the lake, near the castle of Boisena, the wall is built of regular blocks of stone, inscribed with various signs and letters. A cult building (3rd century B.C.) has come to light within the city walls, at Poggio Casetta. It was wrongly interpreted at first as a tripartite temple. It has a small enclosure ($17.20 \times 13.40m$.) and a single cella ($8.00 \times 6.60m$.) set against the back wall. Various terracotta statuettes of gods, worked in the round— Minerva, Cilens (Florence, Archaeological Museum)—came to light here, but a reconstruction of the decoration (frieze or pediment) to which they belonged is impossible. Nor do we know which divinity was worshipped in the cult enclosure.

The cemeteries—Poggio Sala, Viètena, Poggio Pesce, Barano stretch out all around the Etruscan city. The earliest tombs, and consequently the town, belong to the end of the 7th century B.C. Buccheros and bronzes were found in the necropolis of Barano, which is the only cemetery in which the early tombs were not re-used in Roman times. The other cemeteries had late tomb furniture, belonging to the Etrusco-Roman period: the tombs are said to be older, but were re-used. On the whole, what has come to light is poor, but this may be because of plundering. It is impossible to realize how important and wealthy this Etruscan centre was.

Another cult enclosure within the walls was excavated in 1905 by Gabrici on a plateau at Pozzarello. He and others identified it with the temple of Nortia, an Etruscan goddess particularly venerated at Volsinii according to ancient sources. But a votive inscription on a cippus found in the Pozzarello enclosure mentions the god Selvans sanchuneta. It therefore seems likely that it was not Nortia, but Selvans, as a god of boundaries, who was worshipped there. The cult began in Etruscan times and continued in the Roman period. Latin inscriptions from Volsinii have been interpreted as dedications to the goddess Nortia, but there is no proof that hers was the name meant. An inscription found further down in the valley testifies to the cult of Silvanus. Inscriptions on tiles prove the existence of buildings sacred to Fufluns and to Apollo.

The Roman town was not on the same site as the Etruscan settlement, but further down towards the lake: Latin inscriptions prove that the name of this Roman city was Volsinii. We do not know the name of the earlier Etruscan centre. There are no Roman ruins in this Etruscan town and it seems to have been completely deserted after being conquered by Rome.

Recent excavations have shown that the so-called Volsinian vases, decorated in relief and often gilded or silvered made in the 4th and 3rd centuries B.C., come from a workshop in Roman Volsinii.

Somewhere in this region, between Lake Bolsena and the Tiber, was an Etruscan city, described in our sources as ancient and extremely rich. Latin writers called it Volsinii. Zonara tells us (VIII, 7) that it was surrounded by powerful walls. Actually we have more information about this Etruscan 'Volsinii' than we have about other Etruscan cities. Its ancient name is given by the inscriptions on coins-'Velsu', 'Velznani', 'Velsna'-and is confirmed by the adjective 'Velznach' ('of Volsinii') which follows the name of Laris Papathnas in the François tomb in Vulci. Ancient sources, especially Livy, mention some wars fought by Etruscan Volsinii against Rome: in 392, 310, 295 and 280 B.C. Some scholars consider the first two wars anticipations of the one in 295 B.C., since for 295 B.C. Livy simply repeats the events he had divided between 392 and 310 B.C. No doubts exist about events in 295 and 280 B.C. for the Fasti Triumphales tell us that in 294 B.C. M. Attilius Regulus triumphed over the Volsinians and so did Ti. Coruncanius in 280 B.C. But it was not until 265 B.C. that Rome, taking advantage of the city's internal struggles and dissensions, definitely conquered Volsinii. The Fasti Triumphales mention the triumph of M. Fulvius Flaccus in 264 B.C. Following the conquest, the Romans took 2,000 bronze statues to Rome. Zonara (VIII, 7) says that the city was destroyed and its inhabitants transferred elsewhere. Roman Volsinii, we know, was on the lake of Bolsena. Where was Etruscan Volsinii?

Various places have been identified with Etruscan Volsinii. Up to 1946 the favourite hypothesis was the one identifying it with Orvieto. After the recent French excavations at Bolsena, many feel inclined to identify it with the Etruscan city above Bolsena. But the new excavations have provided no corroborating evidence on the basis of which Roman Volsinii could be identified with the Etruscan city. At Bolsena, contrary to Zonara's reference to 'a removal' (or transferral), the Etruscan and the Roman town are within the same city walls.

These walls prove that when they were built, in the 4th century B.C., the town included that part which was later to be occupied by

Roman Volsinii and that there was no 'removal'. The existence of the Roman city within such a limited area may be due to the fact, quite usual for Etruscan cities, that the Roman city occupied only a small part of the area enclosed by the Etruscan walls.

Volsinii is often mentioned by modern scholars as an important religious centre. Two cults have traditionally been connected with this town: that of the goddess Nortia and that of the god Vertumnus. We know that Nortia had a temple at Volsinii and that nails were driven into it yearly to record the number of years (Livy, VII, 3). We know nothing about the cult itself. When the sanctuary excavated by Gabrici was discovered in 1905 at Pozzarello, its identification with that of Nortia was proposed. But this, as well as the characteristics attributed to the goddess by modern scholars, are purely hypothetical.

Another god of Volsinii was Vertumnus or Vortumnus. According to Varro (De lingua latina, V, 46) he was the main god in Etruria, and was brought to Rome by the companions of Caele Vibenna. There was an ancient statue of him in the Vicus Tuscus. So far, no trace of an Etruscan cult to this god has been found. Some believe that Vertumnus was the Etruscan god Tinia, held in high esteem particularly in Bolsena, Orvieto, and the region around Viterbo, to judge from the votive cippi with the inscription tinia tinscvil (gift, offering to Tinia) found in various places. Others identify Vertumnus with the god of the 'fanum Voltumnae', the sanctuary of Voltumna, often mentioned by Livy in his account of the war between Rome and Veii. The sanctuary was probably in southern Etruria. The oft-repeated hypothesis that it was at Volsinii is recent and as yet unfounded.

After the Roman conquest Volsinii began to decline. We can deduce as much from the passage in which Livy lists the Etruscan cities (XXVIII, 45) which sent voluntary contributions to Scipio in 205 B.C.: there is no mention of Volsinii. Yet for Strabo it was still an important city at the time of Augustus.

The other city with which Etruscan Volsinii has been identified is as was said above—Orvieto. Other scholars, however, considered Orvieto to have been Salpinum, mentioned by Livy (XXXI ff.) as an ally of Volsinii, while others identify it with the sanctuary of Voltumna. G. Baffioni has shown that the name Salpinum is an erudite hypothesis. Livy's text probably had 'Capena'. Nor is there any basis for an identification of Orvieto with the sanctuary of Voltumna. The only fact we know is that the Etruscan city which preceded the medieval urbs vetus was very rich and powerful. The site recalls that of the cities of southern Etruria. It stands on an isolated tufa plateau, whose cliffs rise almost perpendicularly 40 to 45 metres above the valley of the river Paglia. The only entrance which unquestionably existed in antiquity is to the south-west—the Via della Cava, near Porta Maggiore—where an ancient road cuts the rock. In 1965 part of a wall—probably the city wall—was found here.

The city lies at the point where the river Paglia runs into the Tiber. In antiquity both rivers were navigable up to Orvieto and beyond. This was a factor in the wealth of the city: it made communications with the Faliscan territory and with Chiusi easy. Lake Bolsena and the valley of the Fiora facilitated those with Vulci and the coast. To the south of the lake a route led to Tarquinia and Caere. Eastwards contacts with the territory east of the Trasimene Lake and with Umbria were unhampered. It was from these cities that Orvieto received artistic stimulation and imported and exported local and foreign products. At the same time it was a point of passage for Italic ideas and products on their way to Etruria. Pallottino has noticed that many names in funeral inscriptions at Orvieto are Italic, the names of foreigners who settled there and prospered. One must also remember that at Orvieto, in the Tomba Golini I (second half of the 4th century B.C.) we find the earliest mention of an Umbrian magistrature, the moru, which was later also mentioned in inscriptions elsewhere in Etruria. And it may not be chance that the inscriptions referring to a maru are almost all aligned between Orvieto and Tarquinia.

It has been said that there was no Villanovan phase in Orvieto, but recently Villanovan fragments have been found—enough of them to show that even then the cliff on which the city now stands was inhabited. The cemetery of Cannicella, south—west of the city, indicates that the settlement was of a good size at the end of the 7th century.

The tombs of Orvieto are all around the cliff on which the city stands. Two cemeteries are important, Cannicella and the necropolis of Crocifisso del Tufo. Although plundered since antiquity they show Orvieto to have been a flourishing city from the early 6th to the end of the 4th centuries B.C.

The necropolis of Crocifisso del Tufo, north-west of the city, is singularly interesting and unique among Etruscan cemeteries. The tombs are arranged side by side along intersecting streets which follow an established plan. At one crossing there was a tall parallelepiped

pilaster. The tombs are built of carefully squared stones and resemble each other in plan and façade. Each tomb has a small chamber, generally meant for two people; tombs with two chambers are exceptional. The ceiling consists of rows of blocks which jut out to form a false pointed vault. On top of the tumulus which covered each tomb were one or more cippi, cylindrical, pine-cone or spherical in shape. Each tomb had its inscription sculpted on the architrave of the door or on a cippus. Orvieto has more archaic funeral inscriptions than any other town and more seems to have been written there in the last decades of the 6th and in the 5th centuries than elsewhere. Simple tufa sarcophagi containing inhumation burials or cassetta tombs made of slabs with a cremation burial were sometimes set in the space between two chamber tombs. One group of tombs in this necropolis was excavated in 1872 and in 1876. Systematic excavation was again begun recently, in 1960.

Cannicella, south-east of Orvieto, is somewhat more archaic. It spreads out on successive terraces and has fossa tombs and chamber tombs dug into the tufa, or built up. The funeral cippi are in trachyte, or serpentine, set into bases of nenfro with a moulding. Here too there are numerous inscriptions. A tomb with a chimney-like opening in the ceiling which leads to the outside, of a type frequent in Civita Castellana, Caere and Vulci, and of which there are two examples at Tarquinia, confirms Orvieto's relations with these cities. The remains of buildings, four stone altars, a nude female statue in marble, probably a goddess (second half of the 6th century), the remains of a votive deposit, were found on an artificial terrace at Cannicella. In front was a square pond to which water ran through a small channel. It is rare to find a nude female statue in Etruria, where such figures first seem to appear in Hellenistic times. All around were small votive bronzes and terracottas, fragments of roof tiles of a building destroyed by fire.

To the north, the border between Orvieto and Chiusi was probably the river Paglia, to the east it is impossible to say whether or not Orvieto's territory stopped at the Tiber.

Orvieto and Falerii both pride themselves on having the remains of various temples. There are no indications who was worshipped in them, except for the cult of Tinia in Orvieto indicated by cippi with votive inscriptions found in the city.

A beautiful terracotta head of a satyr (Pl. 59) comes from San Giovanni Evangelista. It recalls the centaur in one of the Parthenon metopes who is grimacing with pain because a god has put a finger in his eye. It almost seems as if the Etruscan sculptor had been directly inspired by the Parthenon sculpture. His satyr almost repeats the painful grimace, showing his teeth through parted lips. But in this antefix from Orvieto there is no reason for the expression—it is nothing but a mannerism used to make the piece more effective.

Heads in terracotta found in the Via S. Leonardo (Pl. 59a) were attributed to the pediment of a temple. The modelling is excellent soft and skilful—but the heads are cold, monotonous, lifeless. The Greek models on which they are based are of the mid-4th century B.C., but these terracottas impress one not as being classical but rather classicistic and archaicizing. The bearded male head recalls the head on the coins which reproduce the chryselephantine colossus which Hadrian had erected in the Olympeion at Athens. They therefore probably date to the first century B.C., like the antefixae with which they were found.

The Belvedere temple had three cellae. We still have the high base, the foundations and the entrance stairway, as well as the figures which decorated the pediment, although in fragmentary state. They are less carefully done, not as finished, but much more beautiful with their contrasts of light and shade brought out by the swift strokes of the modelling tool. The old wrinkled man (Pl. 60a) fingering his beard is full of life and much more pleasing than the dignified figures from the Via S. Leonardo. A few unevenly spaced teeth can be seen through his wide half-open mouth. A Gorgon head acroterion (Pl. 59d) already betrays the weariness of an overworked motif. The Gorgon is no longer that monstrous horrid creature capable of petrifying anyone who looks at her, as she was in 6th-century Greece and Etruria. She is almost a 'beautiful' Gorgon of the kind the Greeks had in the 5th century B.C. But in his effort to increase the effect, the sculptor has transformed the Greek type into an overly plastic mask. The lines and surfaces of the human face have been broken, distorted, deformed in an attempt to increase the expressive violence and to transmit fear and horror.

A. Andren has noted that the same matrixes were used in making the decorations of the various temples.

Sculpture in nenfro, or limestone, is rare and was used solely for funeral purposes. There are a few cippi of various kinds decorated in relief—parallelepiped pilasters, or spherical cippi (Pl. 6ob) transformed into the heads of warriors, of which the finest and best-known is the one in the Archaeological Museum in Florence.

Several good stone sarcophagi come from Orvieto and the surrounding area, but they may have been made in Bolsena, since they are from the environs and not from the city itself. The quality is good and they have features in common. They were all made in the same workshop, which might have been in either of the two cities, or even at Vulci. They all have the same type of shape: a wooden chest with a gabled lid and a decoration in flat relief carved into the surface of the chest. The sarcophagus now in Florence is quite simple, with nothing but plastic decoration on the lid (winged griffins and lions). Other sarcophagi have male and female demons in flat relief on the large lateral mouldings of the chest; the sarcophagus from Bomarzo also has a warrior.

In the hills south of Orvieto, at Settecamini, a group of chamber tombs cut into the tufa were found in 1863. More detailed information as well as drawings made immediately after their discovery, when the paintings were not nearly as ruined as they are now, are available for two of them, the Tomba Golini I ('the Velii') and the Tomba Golini II ('the Chariots'). Both are square chamber tombs. The Tomba Golini I (late 4th century B.C.—Pls. 61, 62a) is divided into two chambers by a tufa partition which goes from the back wall to halfway down the middle of the chamber. The plan is reminiscent of early Clusine chamber tombs, of the tombs of the Valdelsa and, in central Etruria. of some tombs of Heba in the territory of Magliano. The subject of the two tombs at Orvieto is the same, but details vary. The dead man arrives in the afterworld and relatives and ancestors await him at a banquet. There may very well be Tarquinian influence in the subject matter, but the earliest Tarquinian tomb with the afterworld (Tomb of Orcus) is later than the ones in Orvieto and treats the subject differently. Like the great Apulian amphoras, the Tarquinian afterworld is peopled by the heroes of Greek Hades. The afterworld in Orvieto has no Greek heroes-the only concessions to Greek ideas are the figures of Hades and Persephone. This is the afterworld of the Etruscans, concrete, readily understandable, free from futile fantasies. It is, in brief, the continuation of life on earth. The Golini I tomb is more provincial, but is spontaneous. It is also interesting for the glimpses it gives of Etruscan family life and the house of a rich man.

The central partition separates the servants from the masters. To the left of the entrance the animals slaughtered for the banquet are hung on beams: an ox—next to him on the floor is his head with its large

staring eyes—a fawn, a hare, birds. It is a still life study, impressive and alive. Two thousand years later a great painter, Rembrandt, was to turn to the same subject in his 'Quartered Ox' in the Louvre. His painting was criticized, condemned as vulgar and unworthy of being in a museum. It is not surprising therefore that a 'History of Etruscan Art' should say that the Orvieto tomb displays 'various accents of unprejudiced vulgarity'. The Etruscan painter—a provincial artist—lacks the freshness of touch and chiaroscuro of a Rembrandt, he is cruder and brutal, but he has felt untuitively that real life can be the subject of a painting. The larder well stocked with meat is typically Italic: the Greeks ate primarily fish (Pl. 61c).

In the left-hand compartment of the tomb the servants are busy preparing the food. The flute player, entertaining the servants, testifies to an Etruscan custom (Athenaeus, XII, 518b). The marked realism of this lively scene is quite Etruscan and without precedent. A lone monkey has climbed a pole. In the right-hand compartment is the banquet presided over by the gods of the Underworld. The cup-bearer (Pl. 62a) stands next to the table with its vases of wine, ready to pour for the guests. Next to this scene were the banqueting guests (now almost completely gone). On a stool, in front of a couch, are a horned animal and a boy. To the right of the entrance door the dead man is shown arriving in a chariot drawn by two horses and accompanied by a winged female demon.

The second painted tomb, Golini II, is simpler, lacks unity, and is also greatly dilapidated. The entrance was guarded by snakes. Two deceased are shown arriving, one to the right and one to the left of the door. The one on the left wears a pointed hat, like those usually worn by the haruspex. On the other walls are trumpet and lituus players, warriors with shields, banqueting couples. Not many details are still visible: a female head and a dove, one of the domestic animals of the Etruscans, on a stool next to a couch (Pl. 62b, c).

A third painted tomb was found at Poggio Rubello, near Porano, the tomb of the Hescana family. It has a banquet and a procession (?) with rather unrelated figures. It is provincial and later (2nd century B.C.).

Greek vases, found in the tombs, testify to contacts between Orvieto and the coastal cities. Corinthian vases are exceedingly rare, while Etruscan imitations are frequent. Some of the Greek vases, in the Faina Collection, thought to have come from Orvieto, are from Vulci.

It is therefore uncertain whether a fine Corinthian crater with a narrative scene (570-560 B.C.) was really found in Orvieto. If it had been, that would make it the only Corinthian crater found outside south Etruria. Attic black-figure and red-figure vases are frequent: the earliest belong to the second quarter of the 6th century B.C. A few black-figure vases made in southern Etruria also reached Orvieto, such as a Pontic vase and some vases by the Micali painter. Orvieto imported red-figure Etruscan vases from Vulci, Falerii and Clusium. At the beginning of the 5th century B.C., Orvieto had its own workshop of black-figure vases, in which one or two painters were active. There may also have been a red-figure workshop: I am tempted to attribute a group of vases of the late 4th century found only at Orvieto and at Chiusi to such a workshop. This is the 'Vanth Group', with characteristic underworld scenes, a group that has usually been considered Vulcentian. In either case, it was a short-lived affair, limited to one or two painters. A bucchero workshop produced ware of exceptional interest and beauty, as G. Camporeale has proved.

5 NORTHERN ETRURIA

Vetulonia; Rusellae (Roselle)

Vetulonia is mentioned for the first time by Dionysius of Halicarnassus (III, 51). According to him it helped the Latins, together with other north Etruscan cities-Clusium, Arezzo, Volaterrae, Rusellae-against Tarquinius Priscus, king of Rome, around the end of the 7th or the beginning of the 6th century B.C. This passage is rather suspicious, not because Vetulonia might not have been strong enough to fight Rome, but because the other Etruscan cities mentioned, except for Clusium and Rusellae, either did not exist (like Arezzo) or were small towns, like Volaterrae. Moreover all of them, including Vetulonia, were too far from Rome to make any aid to the Latins likely. Silius Italicus (VIII, 483 ff.) also refers to the archaic period when he says that Vetulonia gave Rome the symbols of power: the fasces (a double axe with eight rods of iron) of the lictors, the ivory sella curulis (curule chair) and the toga edged with purple. This statement too is strange. Examples of the sella curulis were found in places that have nothing in common with Vetulonia. An ivory seat and several in wood-the bronze feet which assured their stability have been found-were in tombs in Bologna. One ivory sella curulis was in a tomb at Quinto Fiorentino, north of the Arno. From the 6th century on they appear in paintings and reliefs. It is true that a fasces was found in Vetulonia in the Tomb of the Lictor-doubts expressed by various scholars are ungrounded-but it seems odd that one of the cities farthest from Rome, a city moreover which disappeared in the 6th century B.C., should have influenced archaic Rome. Strabo (V, 220) attributes the introduction of these symbols to Tarquinii; his statement seems more likely to be true.

In the 3rd century B.C. Vetulonia was once again an important city, then it definitely disappeared. In the Renaissance there was a reawakened interest in the city, of which only the name was known. It was sought for throughout the Maremma, from the river Cecina to Vulci and the Ciminian Hills, and identified with any number of anonymous ruins, fitting more or less the latitude and longitude given by the Greek geographer Ptolemy and medieval documents, which mentioned a hill and a castle of Vitolonia, or Vitulonnio. At the end of

NORTHERN ETRURIA

the 19th century Isidoro Falchi identified the remains of the city at Colonna di Buriano, in the province of Grosseto, and excavated its important necropolis. Criticism and bitter controversy resulted from this claim, but it is generally accepted.

The Etruscan name of the city is given in a large number of bronze coins of the 3rd century B.C. inscribed 'Vatl', found in Vetulonia. Scholars do not however all agree concerning coins with a triple inscription 'Cha, Vetalu, Pupluna'.

The city (see map, p. 131) was on the right of the river Ombrone, the 'Umbro' of antiquity. A few remains on the hill of Colonna—which has changed its name back to Vetulonia—and on two hills to the north-west belong primarily to the Roman period and in part to Etrusco-Roman times. Only the large cemeteries show that Vetulonia was inhabited from early Villanovan times to the 6th century B.C. There may possibly have been two inhabited centres in the 8th century, corresponding to two groups of tombs, Poggio alla Guardia and Poggio alle Birbe in the east, and Colle Baroncio in the north-west. In the 7th century there was only one town and it was probably where Vetulonia was in the 3rd century B.C.

The earliest burials—the cremation pozzetti at Poggio alla Guardia with biconical or globular ash urns and hut urns—contained rather poor and simple equipment. The pozzetti were covered by a large shield-shaped stone. J. Falchi and other scholars have described a special type of pozzetto tomb found at Vetulonia, the so-called ripostigli stranieri, ('foreign deposits'), belonging to the second half of the 8th century B.C. These were pozzetto tombs with funeral equipment but no ashes or ash urn. By comparison to the simple accessories of archaic Villanovan tombs, the richer objects in these late pozzetti led at first to the belief that the material had been imported by foreigners who had settled in Vetulonia. Now we know they were normal pozzetti with a cinerary urn which had simply not been recognized as such since its form was different from the usual. The contents of the ripostigli are not exotic but are the same as those found in the fossa tombs which also began in the second half of the 8th century B.C. In Vetulonia the late pozzetto tombs (rarely the fossa tombs) are often grouped within a ring of stones, set upright in the earth about a metre or so apart. These are the so-called 'interrupted circles' characteristic of Vetulonia. They are on the outskirts of the archaic Villanovan cemetery.

The 'continuous circle' tombs are later (7th century B.C.). They have

VETULONIA; RUSELLAE (ROSELLE)

one or more fossa tombs, surrounded by a ring of white stones set upright next to each other. Some 'circles' have a diameter of as much as 30m. and probably marked the edges of a tumulus which has been obliterated in the process of tilling the land. As at Marsiliana, the circle-tombs of the 7th century B.C. abounded in bronzes and goldwork and compare favourably in riches with the princely tombs of Caere and Praeneste. We must repeat for Vetulonia what was said for Marsiliana: tomb-furniture is exceedingly rich, but simpler in taste, more intimate, and completely lacks the rather showy baroque quality of pieces from Praeneste or Caere. In taste Marsiliana and Vetulonia are alike, but a good part of the fine material found in Vetulonian tombs was made there, while Marsiliana probably imported it. The richest and best-known 'circles' are the Circle of Bes and the Circle of the Bracelets (Circolo dei Monili)-both 7th century B.C.-and the later circles delle Pellicce, del Duce, degli Acquastrini and del Littore, some of which are 6th-century.

The few monumental chamber tombs, built in masonry, belong to a later phase. They have a corridor leading to a square chamber roofed by a false dome which rests on the corner corbelling (Tomba della Pietrera, del Diavolino, di Pozzo dell'Abate). They are built of blocks of local and imported stone, and were covered by a tumulus. A recently excavated constructed tomb is unique at Vetulonia and in north Etruria. It is a square chamber tomb, built of stone slabs laid horizontally. It has a framework of vertical wooden beams—one in each corner and one in the middle of each wall—driven into the ground. Horizontal beams probably connected the vertical ones at the top of the walls. The roof was probably gabled. A tumulus covered the tomb.

In the Tomba del Figulo ('the Potter') at the Migliarino, on the outskirts of the explored cemetery, several Corinthian plastic vases were found. Two fragments of Attic black-figure vases were brought to light in the excavation of the Tomba della Pietrera, a few other sporadic fragments have turned up recently. The Tomb of the Prince (Tombadel Duce) had some linear Proto-Corinthian cups of late type, with rays around the base. Etrusco-Corinthian aryballoi with linear decoration are plentiful, while those with animal friezes are absent. This may be because Vetulonia was no longer important by the time the Etrusco-Corinthian workshops began producing them. There are some bucchero vases of a Caeretan workshop, such as the inscribed cup of the Tomba del Duce (Pl. 10c).

NORTHERN ETRURIA

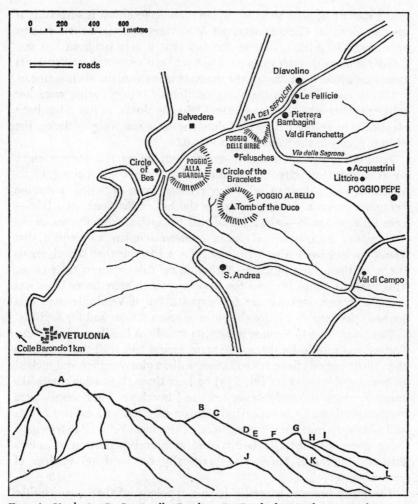

Key: A. Vetulonia; B. Poggio alla Guardia; C. Circolo dei Monili; D. Tomba del Duce; E. Circolo del Diavolo; F. Poggio alle Birbe; G. Pietrera; H. Spianata delle Pellicie; I. Diavolino; J. S. Andrea; K. Acquastrini e Sagrona; L. Poggio Pepe.

Vetulonia

The scarcity of Attic and Corinthian vases at Vetulonia is surprising if we consider that Clusium received Attic vases ever since their earliest appearance in Etruria, despite the fact that it was far from the sea. Either tombs with such vases have not yet been excavated, or Vetulonia must needs have been outside the main trade routes of the Mediterranean.

This is one of the problems in Vetulonia's history: what were her relations with other Etruscan cities? Was Vetulonia, as has often been claimed a maritime city? What does the only surviving evidence, the objects found in the tombs, say about it?

Vetulonia is now about 15 kilometres from the sea. It is never referred to as a maritime city in antiquity. But some coins belonging to Vetulonia and a Roman relief from Caere, both depicting a marine being, moreover the existence below the hill of Vetulonia of a lake— Lake Prile or Aprile—which could still be reached from the sea in the 1st century B.C., have led some modern scholars to deduce that Vetulonia had her harbour in Lake Prile, a harbour that was closer to the town than those of Caere, Tarquinia or Vulci were to their cities. This harbour could be used for imports, which were fewer than was thought at first, and for her few exports. But if Vetulonia used this harbour she used it only for the cities of south Etruria and for Sardinia.

Tomb-furniture in Vetulonia consists mostly of locally made objects. Pottery was mostly local impasto ware, coarse and with thick walls in the archaic period; finer, with thinner walls, a glossy surface and incised or impressed decoration (Pl. $6\,3b$) in later times. It is a bucchero-like impasto which at Vetulonia replaced real bucchero. Some shapes were very original, with ribbon or lotus-flower handles, well defined angles and ribbing in imitation of metal vases. These local Vetulonian bucchero vases never attained the beauty and technical perfection of south Etruscan bucchero. There was practically no local production of painted vases.

The many bronzes generally have a typology of their own, unlike the bronzes of south Etruria. The impression left after a visit to the Archaeological Museum in Florence is that of quantities of bronzes, but, at the same time of a very austere decoration. There is no superfluous ostentation; no repoussé decoration with rows of animals, real or imaginary such as we find in other Etruscan centres. The walls of the vases are plain; decoration is limited to the characteristic handles cast in the form of animal protomes, human figures or lotus flowers. Occasional objects in repoussé bronze or silver are generally imported;

NORTHERN ETRURIA

the silver chest from the Tomba del Duce (Pl. 66) is such an import. We marvel at the surfeit of cast bronzes found in tombs like the Circle of the Trident. Some of the objects—such as the so-called trident and the lictor's fasces—are unique in Etruria. Others are frequent in Vetulonia and rarely found elsewhere. This would indicate that objects such as the tripods with hemispheric basin and rod feet decorated with horses or riders were made locally. In the rest of Etruria tripods generally have ribbon feet (a few examples of these were also found in Vetulonia).

A bronze handle (Pl. 64a) found at Fabbrecce in Umbria and another fragmentary handle from Marsiliana were made in Vetulonia, where two simpler specimens were found. The handle from Fabbrecce is very elaborate, with a human figure, bull protoma, a dog and lions. The cylindrical censers (Pl. 57) with perforated walls, lotus flowers on the lid, and articulated handle, as well as the vases with a spherical

The cylindrical censers (Pl. 57) with perforated walls, lotus flowers on the lid, and articulated handle, as well as the vases with a spherical body, high base in the form of a truncated cone, and rod-shaped handles decorated with protomes and lotus flowers, are Vetulonian. A censer from a fossa tomb in the Circolo della Franchetta differs from the norm: above the flower on the lid a human half-figure raises its arms to hold the usual handle. The so-called 'candelabra' (Pl. 64b), topped by figurines or flowers, with lateral branches, were made at Vetulonia. They were used to hang cups and pitchers and not, as the name would indicate, candles.

Imported bronzes and pottery are found at Vetulonia, but they were limited to particularly rich tombs, proof that they were imported to please some wealthy family. The two great cauldrons in the Circle of the Cauldrons, decorated around the rim with lion and griffin protomes and winged human figures, were imported from the East (probably via one of the south Etruscan cities). A bronze food-tray with wheels, similar to the Etrusco-Latian ones, came from south Etruria. Many imported objects were in the 4th and 5th trench of the rich Tomb of the Prince. The lamp, in the shape of a small boat, like the ones from the Tomb of the Three Boats (Tomba delle Tre Navicelle), came from Sardinia. It resembles them in shape, decoration and size, but is more elaborate than usual. Other imported objects include the bronze chest covered with a repoussé sheet of silver (Pl. 66), which may have been made in Caere; a silver cup with incised decorations; possibly the two tripods with ribbon feet; the Proto-Corinthian cups mentioned previously; a group of Caeretan buccheros, among which is the remarkable cup with an inscription around its foot (Pl. 10C). The bronze shield in the second fossa may also have been imported, since similar pieces come mostly from south Etruria. The scarabs, the amber, and the small idols are imports: scarabs were common commercial ware throughout the Mediterranean area and it is not surprising to find them in Vetulonia. As for the amber, more seems to have been found at Vetulonia—where we already find it in the Villanovan pozzetti—than in any other Etruscan city. It may have come from northern Europe, in its natural state, and was then worked in Vetulonia itself. It was used for fibulae, necklaces, figurines, etc. It was less usual during the 7th century and became rare around 600 B.C.

The many rich pieces of gold jewellery were made locally. In this field too Vetulonia differed from south Etruria. The technique is the same, but was applied differently. Solid cast pieces are rare and only occur for very small objects, such as fibulae. Repoussé, granulation and filigree were used. Granulation done with tiny globules of gold was used for geometrical designs: circles, filled with small granulated triangles, alternating with plain ones, are characteristic and were mostly used for silver and gold fibulae. While filigree seems to be rare in south Etruria it conforms very well to the severe taste of Vetulonia. Bands of gold are joined by gold wire, forming an undulating or meander-like openwork pattern. Bracelets—their shape differs from those in south Etruria—were preferably done in this technique (Pl. 64c).

Granulation at Vetulonia had a special character: the pulviscolo technique. Sphinxes, lions, horses, etc. which ornamented the plain gold surface were done in a granulation so minute as to look like a solid mass of gold dust, with no modelling or details. In south Etruria granulation was plastic and three-dimensional. Vetulonia preferred a linear, geometric decoration: decorative effects were based on the contrast between the shiny, smooth surface of the gold and the opaque area covered by pulviscolo. The animals, either running or set in a heraldic motif, which we find on the beautiful pulviscolo jewellery from the Tomb of the Lictor and the Costiaccia Bambagini, recall those painted on geometric vases from South Etruria. They are so similar on different jewels that they may have been the work of the same goldsmith.

The jewellery of Vetulonia was made by technically skilled goldsmiths with good taste. It is never too ornate or heavy. It presents one unsolved problem: what was the relationship between the jewellery of Vetulonia and that of south Etruria? Did goldsmiths emigrate to Vetulonia from south Etruria, or from some other place in the Mediterranean, since no precedents were found in Vetulonia for the fine jewels found in some of the tombs? True, some fibulae have simpler, less evolved motifs, but there is no reason why they should be earlier than finer pieces. Technically they are as fine as their more magnificent brothers; they may be fibulae meant for the less wealthy.

It has been argued—as by L. Pareti—that Vetulonian goldwork, with its simple, geometric taste, represents an earlier phase of the more plastic south Etruscan production. But these differences are not simply a matter of chronology. The fossa tombs in the tumulus of the Pietrera and those of the Circolo delle Migliarine with their gold jewellery may be dated to the end of the 7th or early 6th century B.C. They are not earlier than south Etruscan jewellery. There is therefore no progression from the simple to the complex, from a geometric to a baroque style, but it is a contemporary production which reflects the differences between north and south Etruria.

Bronze statuettes are rare in Vetulonia. One of the reasons is that the city no longer existed in the 6th century when figurines began to be widespread in Etruria. Those we have were only meant to be decorative. They were used as terminals for candelabra or decorated the handles or feet of a vessel. They are often very pleasant and so well adapted to the object for which they were made that we cannot help but appreciate them as ornaments. The girl on the candelabrum from the Tomb of the Prince; the maiden with an amphora on that from the second Circolo delle Pellicce (Pl. 64b), a nude girl whose gesture is identical with that adopted centuries later by Venus; the strange long-necked human protomes from the Circolo degli Acquastrini; the human half-figures supporting handles; the horsemen on the tripods, as well as other figurines, are all very fine decoration and nothing more.

A sandstone stele with a warrior armed with a double axe, in the Circolo della Stele, is inscribed Aule Feluske. Philologists and epigraphists have not yet given a satisfactory translation. If this stele really belongs to the second half of the 7th century, then it would be the earliest known example of the sepulchral stele which is characteristic of north Etruria.

The only sculpture in Vetulonia consists of some fragmentary figures about which much has been said. They are important because they are the earliest attempt at large-sized stone sculpture in the round in

VETULONIA; RUSELLAE (ROSELLE)

Etruria. They were found in the excavation of the Tumulo della Pietrera: some fragments were in the two chambers of the tumulus, other fragments near it. We have been unable to connect them convincingly with any particular school. Scholars have related them to eastern sculpture, to Greek Daedalic sculpture of the 7th century, to sculpture from other centres in north Etruria, to the female heads in Vetulonian goldwork, to the pediment of the temple of Artemis at Corfu. Comparisons with Greek sculpture only stress the fact that no satisfactory parallels exist. This is understandable, for Vetulonia had no direct contacts with Greece. The costumes, hair-dress and gestures of these figures are found only in Etruria and reflect Etruscan customs. The posture of the female statues is interesting, because we find it in scenes of mourning and exposition of the dead. According to a recent hypothesis of G. Camporeale's they imitate the supporting figurines of the footed ivory or bucchero cups with pedestal.

Contacts and trade relations between Vetulonia and other Etruscan cities moved along several routes. One road undoubtedly went to Marsiliana and Saturnia, for Vetulonia regularly sent its products to Marsiliana. Communications with Chiusi and Umbria were via the valley of the river Ombrone, Castelluccio di Pienza and the pass of the Foce: Vetulonian bronzes, including a censer, were imitated at Chiusi. Another road went to Populonia, along the valleys of the rivers Cornia and Cecina, branched off to Volterra on one side, and on the other reached north Italy and Bologna (pp. 136 ff.), via Monteriggioni, Castellina in Chianti, the Arno ford at Florence, and the valleys of the rivers Ombrone and Reno. Along this road a Vetulonian gold fibula arrived at Bologna; amber from northern Europe came to Vetulonia; two ciste a cordoni (ribbed terracotta pails) and the terracotta capeduncola (a small cup with a curved handle ending in a flat spatula) from the Circle of the Trident arrived from Bologna. And it is also probably the route (or one of them) via which the funerary stele spread in north Etruria.

It is hard to tell whether trade with south Etruria, especially Caere, took place by land or by sea.

Vetulonia exported less than did other Etruscan cities. A few censers arrived at Caere, Marsiliana, Populonia, and probably also Clusium, where an imitation was found. A bronze pyxis in the shape of a Vetulonian censer, found in a tumulus in Alsace (now at the Museum in Colmar), was not made in Vetulonia. It may be an imitation made in

Clusium, for the relief frieze of animals on the cover recalls the decoration on the bucchero pesante of Clusium. Vetulonian tripods with rod feet and horsemen reached southern Etruria. But, with the exception of Marsiliana, to which Vetulonia regularly sent its products, export as well as import seems to have been intermittent. Vetulonia had a harbour, but does not seem to have used it before the second half of the 8th century B.C. and even then, if we judge from the limited importation, only occasionally. Vetulonia was in maritime contact with Sardinia. The Sardinian boats mentioned above arrived that way.

If commerce was so limited in Vetulonia, how can we explain the changes which took place during the second half of the 8th century B.C., from the humble contents of the archaic pozzetti to the relative wealth of the ripostigli stranieri, to the later pozzetti, and finally to the unquestionable wealth of the circle graves of the Orientalizing period? The answer may be found in the tombs themselves. There are practically no metals in the archaic Villanovan burials, with the exception of one or two bronze fibulae, a semi-lunar razor, an iron spear point. A comparison with Tarquinian bronzes of the same period stresses this fact. But after 750 B.C. metals, including gold and silver, were plentiful. The new economic factor upon which this sudden prosperity was based was metal. The objects in the tombs seem to indicate that the mines of Massa Marittima, near Vetulonia, were discovered about this time. This alone can explain the frequency, the outright profusion of bronze objects, a profusion which strikes anyone who visits the rooms dedicated to Vetulonia in the Archaeological Museum in Florence.

Then why, with such a wealth of bronzes, did Vetulonia disappear? The answer, given by some scholars, that the rise of the neighbouring industrial iron centre of Populonia was responsible, cannot be accepted. Even if the iron industry had been well developed in the 6th century B.C. at Populonia—but it was not (p. 143)—why this should have destroyed the copper industry in Vetulonia is incomprehensible. Both metals were essential. Moreover the tombs would have revealed a gradual impoverishment in their accessories.

If the mines of Massa Marittima belonged to Vetulonia, then the modest villages excavated by D. Levi around the lake of the Accesa, south of Massa Marittima, must also have been Vetulonian. This would be our only indication as to the extent of Vetulonia's territory.

The ruins of Rusellae (modern Roselle) lie 15 kilometres in a direct

VETULONIA; RUSELLAE (ROSELLE)

line south-east of Vetulonia. The hill on which the city rose dominates the marsh of Castiglione. Lake Prile was its harbour, as it was that of Vetulonia. Both ancient sources and chance finds seem to prove that Rusellae was an important settlement, but it was never properly excavated until quite recently. In recent years the German Archaeological Institute studied the walls of the city, which consist of an earthen rampart reinforced by a wall, and the city itself is being excavated by the Istituto di Studi Etruschi ed Italici. What we know seems to indicate not only that Rusellae was a rich city, but that it was in closer contact with the culture of south Etruria and the Mediterranean than Vetulonia. She received Corinthian and Etrusco-Corinthian vases, Ionian ceramics, Attic vases of the second half of the 6th and of the 5th century, Etruscan black-figure pottery, fine Caeretan buccheros with animal friezes in relief. Caeretan bucchero was also imitated locally. Remains of 7th-century buildings were found, with massive walls of unbaked bricks covered by plaster. Architectural terracottas date from the 6th century B.C. to Hellenistic times. Some were made from south Etruscan moulds (revetment plaques with a banquet scene), but the later pieces would seem to indicate a local production. A fine archaic stone stele with a male figure in flat relief-unfortunately fragmentary-show that in this Rusellae follows north Etruria. It is as yet uncertain whether it was inhabited in Villanovan times. There was a small Villanovan cemetery at Nomadelfia, three kilometres from Rusellae.

Future excavations will give us a clearer idea both of the the city and of its importance. It is to be hoped that they will throw some light on relations with Vetulonia.

The key to the mystery of Vetulonia's disappearance may lie in Rusellae. It seems unlikely that two rich cities, much too close to each other to exist without quarrelling, both using the same harbour, could coexist as independent cities. They were rivals both on land and on sea. Excavations will tell us, we hope, whether Rusellae is as ancient as Vetulonia, and whether they were rivals as far back as the 8th century, or whether Rusellae came into being later, in the 7th century, perhaps as an offshoot of Vetulonia, which it replaced in the 6th century. The disappearance of Vetulonia, with no forewarning signs of decadence, could be due to conquest and consequent destruction by Rusellae.

The suggestion made many years ago that the inhabitants of Vetulonia moved north to Poggio di Castiglione in the 6th century B.C. has

recently been proposed anew. But excavations carried out on the site, not far from the lake of the Accesa, between Vetulonia and Massa Marittima, from 1928 to 1931, only revealed traces of a late Etrusco-Roman settlement.

From the 6th to the 3rd centuries B.C. Vetulonia was practically deserted. Sheets of gold foil with a head wearing a wreath, seen in profile, the few sporadic fragments of Attic vases mentioned above and a bronze kottabos (stand used in a game), dating to the 4th century, with a silene holding the plate, are all we have from this period. The kottabos was found in a recess hewn into the rock within the 3rd-century citywalls. Excavations, which have recently been taken up anew, may possibly throw some light on the Etrusco-Roman period.

At the end of the 4th or the beginning of the 3rd century B.C., when northern Etruria passed under Roman control, Vetulonia once more appeared as an Etruscan city. It was important enough to have its own coinage and a city wall which enclosed three hills. To this period belong the brimmed bronze helmets—more than a hundred—found in a second recess near the one which contained the kottabos. The helmets had been broken and flattened to render them unserviceable. The recent discovery of a sandstone slab with the Etruscan alphabet (late 3rd century B.C.) is important.

What little remains of shops, paved roads, a few architectural terracottas of the 3rd century and probably the city walls (their 5th-century date is only hypothetical) belong to the Roman period. Vetulonia was never again as important.

The fact that there is no mention of Vetulonia among the Etruscan cities which sent aid to Scipio in 205 B.C., while Rusellae supplied fir trees and grain, is indicative. It is surprising to find the city personified as a maritime centre on the base of the monument erected at Caere in the 1st century A.D. by the Emperor Claudius. Vetulonia, represented as a young man with an oar on his shoulder, is shown together with Vulci and Tarquinia. It is almost as if the base evoked the glories of the past instead of being a statement of the actual conditions in Etruria, for Vulci was also in decline.

Rusellae, however, seems to have been as rich as it was in archaic times. In the 4th and 3rd centuries it imported Caeretan and Faliscan pottery as well as Calenian and Megarian vases. In the 1st century B.C. Lake Prile was still navigable, so that Rusellae could trade with other cities. It was still important in the empire as shown by the fact that it became an episcopal seat in the 4th century A.D., incorporating Vetulonia and Populonia.

Populonia

Strabo (V, 2, 6) wrote that Populonia was the only Etruscan city situated on the sea. This was unusual for an Etruscan city and was noted by ancient writers. In Roman times it consisted of two districts—the upper town, no longer inhabited in the 1st century A.D., was on the hill, where the castle and the town are now and it probably corresponded to the Etruscan city. The harbour district, which came into being as an industrial centre when the iron industry was developed, was at the foot of the hill along the coast. It was inhabited in Roman times. It spread out around the port, where the archaic Etruscan cemetery had been.

The Etruscan name of the city is known from coins as 'Pupluna', 'Pufluna' and 'Fufluna'. It is the only Etruscan city that had a relatively ancient coinage, thanks probably to its commerce in iron (p. 145).

In his commentary on Virgil's Aeneid (X, 172) Servius wrote that Populonia was not as old as other Etruscan cities. According to him, it was founded either by people from Corsica, or by the Volterrani, or it was conquered by the Volterrani who then drove out the Corsicans. Excavations do not confirm the information given by Servius. The earliest cemeteries are clearly Villanovan, like those of other cities on the coast of Etruria, and exclude a Corsican foundation. Nor can Volterra have founded Populonia, for its tombs are later and differ both in their characteristics and in the tomb furniture. Conquest by Volterra in the 7th or even in the 6th century B.C. also seems out of the question, for Populonia was by then densely populated, as far as we can judge from her graves, as well as rich and powerful, while Volterra was still a modest settlement. Moreover neither tombs nor tomb furniture are similar. Volterra was an agricultural centre and kept far from the sea. The only proof for a possible Volterran occupation around the late 7th-early 6th century might be the fact that Dionysius of Halicarnassus (III, 51) makes no mention whatsoever of Populonia when he lists the cities of north Etruria that had aided the Latins. Populonia would not have been mentioned if it belonged to Volterra. But this war is as legendary as the help given by Populonia to Aeneas (Virgil, Aen. X, 172): the silence concerning Populonia is no proof.

Tomb furniture of the 7th, 6th and 5th centuries shows that Volterra did not exploit the mines in the Cecina valley until later, for metals are rare. It also proves that contacts with south Etruria, Greece and the Atlantic coast were almost non-existent. Populonia on the other hand exploited minerals and traded with the cities of Etruria, with Sardinia and the Mediterranean world in the 7th and 6th centuries B.C. There is no evidence for the double foundation suggested by Altheim—an early one by Corsica, a later one by Volterra.

There are two groups of Villanovan cemeteries at Populonia-at the foot of the hill and around the port; one was at San Cerbone, just below the hill, where the industrial sector was in Roman times, the other was further north, at the Piano and Poggio delle Granate (see map, p. 145). They are far enough apart to suggest that they may have belonged to two different settlements which later fused into a single village. The tombs are simple and the material found in them is that of an agricultural population. There are objects in bronze and in terracotta. The fact that there is practically no iron should be noted. Almost the only metal used for weapons and personal objects is bronze. The semilunar razors, the bronze belts, are frequent in contemporary cemeteries of south Etruria, but are rarely found in the tombs of Populonia. Although they are comparatively frequent in the Faliscan territory and in Tarquinia, the bronze belts are unusual in north Etruria. The imported material in the Villanovan tombs consists of a few beads in amber and glass paste. The pozzetti are mixed with later tombs, both fossa tombs and chambers. The fossa tombs are sometimes lined with sandstone slabs which, together with the covering slabs, form a real coffin. The chamber tombs seem to begin in the early 7th century. The simpler ones are on the Piano and the Poggio delle Granate. The chambers are small, elliptical or sometimes circular, with an entrance corridor and a false dome. They are covered by a tumulus. Some scholars believe that they are simple and small because they are early and preparatory to the monumental and more complex tombs of the San Cerbone cemetery. Others however consider them to be late, poor and crude imitations of the monumental tombs.

The chamber-tombs of San Cerbone, Porcareccia and Costone della Fredda are larger and architecturally more interesting, with rich tomb furniture. The chambers are square, built of dressed blocks and covered by a false dome of limestone slabs. The tumulus is limited by a circular drum, built of stone blocks, in which the entrance

POPULONIA

corridor opened and from which it occasionally projects. The drum is characteristic of the tumuli of Populonia. It is crowned above by projecting slabs of limestone, which slant downwards. There was a limestone pavement round the base of the drum—also slanting outwards so as to collect and lead off the rainwater. From the middle of the 6th to the middle of the 5th century B.C. chamber tombs changed : we find small aedicule-tombs with a rectangular ground plan (Pl. 67a). They were built of blocks of limestone, had a gabled roof and sometimes wooden parts protected by terracotta revetments as if they were small temples. In this period tombs were marked by undecorated sandstone steles, crowned by a palmette. They are characteristic of Populonia and are not found in other parts of Etruria.

Tomb furniture in the earliest chamber tombs is still Villanovan in type. Later tombs had very rich material. In the 7th and 6th centuries B.C. there were a good many imported objects as well as objects of everyday use and personal ornaments-spirals, pendants, fibulae, offensive and defensive weapons, impasto pottery. There were cups in bucchero sottile, on a high foot with one or two wide ribbon handles. probably imported from Caere. A few heavier-looking bucchero cups of less elegant shape may be local imitations, but this is doubtful. So little bucchero was found in Populonia that the existence of a local workshop is uncertain. Imports from Greece include some Proto-Corinthian pyxides and an aryballos dating to 630–620 B.C.; Corinthian pottery, which is more plentiful in Populonia than in any other city of northern Etruria; black-figure and red-figure Attic vases and Ionian vases. Greek vases may have arrived directly from Greece, or may have reached Populonia via southern Etruria. They are not as fine as those found in Vulci, or Tarquinia, but the two beautiful red-figure hydriae by the Meidias Painter (Florence, Museo Archeologico) came to Populonia in the second half of the 5th century, that is when Attic vases had stopped coming to Etruria. Populonia also imported Etruscan imitations of Corinthian vases from south Etruria. The ivory horn from the Grande Tumulo dei Carri is imported, so is some of the jewellery. The shape of the horn and the decoration incised on the bands of gold around it can best be compared with objects from Latian Etruria. The votive bronze quivers and a lamp shaped like a small boat, similar to those found in Vetulonia and Graviscae, are from Sardinia.

Many fine bronzes found in Populonia, particularly the decorative cast and hammered bronzes, were made locally. Some of them, like the

flabelli (fans) from the Tomb of the Flabelli and the decoration of the two chariots, found in the Grande Tumulo dei Carri, are unique, or almost. The chariots are particularly interesting. They were covered with a sheathing of bronze with animals and hunting scenes in iron inlaid into the bronze. Their importance lies not so much in the decoration itself, but in the value set upon iron, used here as a precious metal in comparison to the bronze. I know three other examples of this technique: the two buckles from Poggio Civitate, near Siena, and a lion protome from Praeneste. Iron, which is almost absent from the earliest chamber-tombs, was still a rare and precious material at Populonia, in the 7th century B.C., when the chariots were made. This leads to the conclusion that Populonia's prosperity in the 7th century B.C. and the wealth of objects found in some of the tombs are not due to the iron industry, as is generally said. The large amount of bronze seems to indicate that Populonia derived its riches from the possession of the copper mines in the nearby ore fields of Campiglia. Copper transformed the Villanovan agricultural centre into a rich industrial city and gave its citizens the means to acquire imported goods and to own the many bronze objects found in 7th and 6th century tombs. Although ancient writers mention Populonia only in connection with the commerce of iron, mined on Elba, iron did not play an important part in the economy of the city until later.

One fact has not been sufficiently stressed. While the rich supply of copper gave Populonia its wealth and favoured a local production of bronzes, its use was limited mainly to objects of everyday use—vessels of various shapes, candelabra, censers, helmets, greaves, etc.—its use was mainly industrial and commercial in character. There was no sandstone or limestone sculpture in Populonia: the palmette-stelae of the 6th and 5th centuries are the work of stonemasons. There is nothing to show that Populonia exported locally made products. Jewellery, including a fine gold ring (Pl. 67) with an oval bezel with Hercules struggling with a three-bodied monster (late 6th century B.C.) was imported. The Apollo from Piombino (at the Louvre) found in the sea near Populonia is not Etruscan. I can find no group of bronzes of high artistic level which can be related to the city (the fine small bronze of Ajax falling on his sword is isolated and was probably imported from some centre which had more of an artistic tradition). Even the 7th-century bronzes, which are technically good, fall into the category of decorative arts. No paintings or architectural terracottas have been

POPULONIA

found, except for modest antefixes produced in series. As far as we know Populonia has no painted vases of her own.

Although the north Etruscan cities—Clusium, Perusia and Volaterrae produced a considerable amount of sculpted urns from the 3rd to the 1st centuries B.C., Populonia neither made nor imported them. It was a city of businessmen, too taken up with their industries to find time to further local art. But they made up for this by importing pottery from Greece. The great number of fragments of black-figure and red-figure vases indicate that trade with Attica was lively. It also lasted longer. Populonia is the only Etruscan centre where two Attic vases of the second half of the 5th century B.C. have been found.

Populonia's industrial activity greatly helped the importation of products from overseas, but also caused the destruction of tombs and tomb furniture. This happened when the lower city became the centre where iron ore was worked.

When Diodorus (V, 13, 1) wrote about the island of Elba and its iron mines, he did not mention Populonia. But other ancient authors (Servius, Strabo) state that the iron from Elba could not be smelted on the island and had to be transported to Populonia for a preliminary treatment before being sent elsewhere. Smelting was done around the harbour where the pre-4th-century cemetery was. The slag was piled high on the tombs: it preserved, but also crushed them, destroyed dome or roof, fused tomb furniture and made plundering easy in antiquity: there is little jewellery left in them. Since late 5th-century B.C. tombs were found under the slab, the smelting of iron must have begun around 400 B.C.

On the other hand the buried tombs have again come to light thanks to that same iron industry. Smelting methods were imperfect in antiquity and modern industry decided to recuperate the considerable quantity of iron which the slag still contained. In 1920 a company began to exploit the old slag; many ancient tombs were and still are being discovered.

Very little is left of Etruscan Populonia. It was on a hill, (284m. above sea level), which drops off abruptly to the sea and descends gradually towards the harbour. The upper city was surrounded by a wall: the sections to the south and south-west are best preserved. It had a good natural harbour, Porto Baratti. Rutilius Namatianus mentions its tunny fishing and Pliny (XIV, 9) refers to a statue of Jupiter made from the trunk of a vine, probably in one of the temples of

the city. In 282 B.C. Populonia was besieged during the war between Rome and the Gauls; in 80 B.C., in the war between Marius and Sulla, it sustained a siege from the army of Sulla. When Rutilius Namatianus visited the city in 416 A.D. only a few houses and the temples were on the hill. The Roman town was below at Porto Baratti, where remains of buildings, thermae and mosaics were found.

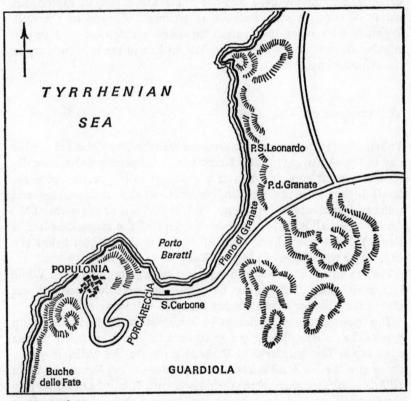

Populonia and its cemeteries

Iron saved Populonia from the general depression which hit the industrial cities of south Etruria in the 5th century. In the 4th century a period of activity and prosperity set in which stopped only after the siege of Sulla. Foreign coins found in the excavations and Populonia's own coins—they are the richest and oldest coinage in all Etruria—speak clearly for its wealth and trade.

VOLTERRA (ANCIENTO VLATERRAE)

Why then had Populonia fallen so low by the time of Rutilius Namatianus' visit in 416 A.D.? The reason is not, I believe, hard to find: iron mines were exploited all over the Roman empire and the discovery of iron mines in Carinthia probably dealt Populonia a hard blow. In the first century A.D. Strabo sang the praises of these mines and the excellent quality of the iron mined there. The house of an iron exporter has recently been excavated near Klagenfurt, in Austria, the owner of which was in the habit of writing his orders on the wall. Together with other information he noted a shipment of a certain number of iron axes to Populonia. The decline of the iron industry in the Etruscan city is obvious.

Volterra (ancient Volaterrae)

Volterra (see map, p. 153), the Etruscan 'Velathri', hypothetical mother city of Populonia, is typically Etruscan in its picturesque and naturally fortified site. It spreads out over a group of hills (531m. above sea level) higher than the surrounding ones, so that it dominates and watches over the roads to the sea (Val di Cecina), to the plain of the Arno (valle dell'Era), to the south (valleys of the rivers Cecina and Cornia). These natural communication routes all met just below the city, where the village of Saline di Volterra stands today.

Then as now, Volterra is far away from other important cities. While this was useful in antiquity as far as enemies were concerned, it was also responsible for a considerable lag in its culture and art.

The striking ravines known as Le Balze, which have swallowed up part of the ancient plateau and its surrounding walls, give it a unique appearance. The only evident Etruscan ruins are the walls, of which many stretches still exist. The two city gates—Porta Diana and Porta all'Arco—are Etruscan only in their lower part. The three heads set into the Porta all'Arco (Pl. 69a), at the keystone and at the springing of the arch, are characteristic. They may be the heads of the protecting divinities of Volterra but their features are too worn to be recognizable. The Porta all'Arco was reproduced on a small alabaster urn, where it symbolized the gate of Thebes. When the walls were built, not prior to the late 5th century, the archaic cemetery at Piano della Guerruccia, near the balze of S. Giusto, had necessarily to be included. It stopped being used as a cemetery, for the dead were never buried within the

city walls. In the 18th century the inner walls, built around the acropolis to provide a last stronghold in case the enemy succeeded in entering the city, were still partly preserved.

The ruins of a late temple were excavated in 1926 on the acropolis, where the fortress now stands. Various terracottas may have formed part of the temple decoration. Other architectural terracottas in the Museo Guernacci may have belonged to private buildings.

Ancient writers rarely mention Volterra. Servius (ad Aen. X, 172) names it when he relates the three ancient traditions on the founding of Populonia (p. 140.) Dionysius of Halicarnassus (III, 51) states that Volterra, Arezzo, Clusium, Vetulonia and Rusellae helped the Latins against Tarquinius Priscus. But neither Livy nor anyone else mention this aid when they describe the wars of Tarquinius Priscus. This was at the end of the 7th century: it seems unlikely that the city, then a small centre, should have been involved in a war way off at the other end of Etruria.

The Fasti triumphales mention the triumph of the Consul Cn. Fulvius over the Samnites and the Etruscans in 298 B.C. Livy narrates (X, 12) how the Etruscans were attacked and conquered near Volterra, not by Fulvius but by the other consul, L. Cornelius Scipio. After having defeated the Etruscans, the consul, according to Livy, made his way back to Faliscan territory, to Falerii where he had his camp, and then devastated the Samnite country. It is hard to understand just why the consul should have gone to the part of Etruria farthest away both from Falerii where he was stationed and from the Samnites who were the main enemy. This meant crossing a wide stretch—at least 10 days' march—of uneven difficult land, which was enemy country since Rome had at that time conquered only south Etruria. Livy evidently mistook the name of the city just as he had mistaken the name of the consul: Volsinii, for example, would have been more likely than Volterra.

In 205 B.C. Volterra was already in the Roman orbit. The Volterrans (Livy, XXVIII, 45) sent aid in the war against Hannibal: grain and fittings for ships. Neither Livy's periodae nor the Fasti triumphali mention wars against Volterra. Nor as far as that goes does northern Etruria really seem to have waged war against Rome. This was probably the reason behind the prosperity enjoyed by the region from the 4th century on.

Volterra had three cemeteries. The north cemetery extends from S.

VOLTERRA (ANCIENT VOLATERRAE)

Chiara to the Badia and to Montebradoni. The east cemetery is at Portone; the cemetery at Ulimeto is to the south-east.

The Villanovan cemetery is to the north of the town along the road to the Val d'Era and Pisa. The tombs date from Villanovan times to the Roman period. The southern section, the Guerruccia, was included within the city walls when these were built (p. 146) and no new tombs were added. It has the usual pozzetto and dolio tombs: the latter have a large terracotta jar (dolio), containing the cinerary urn and the tomb furniture. A new type, for Etruria, are the cassetta tombs—small rectangular trenches lined with six stone slabs and containing the ossuary and such objects as were given to the dead. They are standard for the so-called 'Golasecca' civilization in northern Italy and fairly frequent in the Villanovan of Bologna, from which those at Volterra may have derived. Fossa inhumation tombs were interspersed among the cremation tombs.

At first glance the material in the cremation tombs looks simple and archaic. Actually most of these tombs are later than they appear to be. In one and the same grave are archaic objects mixed with more recent ones. A tomb in the north cemetery at Montebradoni had a fibula ad arco ritorto ('with a twisted bow') of the late 9th or early 8th century B.C. together with a hemispherical bronze cup of the kind found in the Tomb of the Warrior in Tarquinia, and, much nearer to Volterra, in the Tomb of the Trident in Vetulonia, of the second half of the 7th century B.C.

Dolio tombs and cremation were still being used in 6th-century Volterra. A biconical ash urn from a dolio tomb had a bucchero cover with animals in relief; the cover is an imitation of Caeretan buccheros, made in Rusellae and certainly not prior to the beginning of the 6th century B.C. This time lag is the reason why tombs with Orientalizing material were never found. From Villanovan tombs one goes straight to 6th-century tombs. Many tombs were probably also completely destroyed. The collection of fibulae in the Museo Guarnacci at Volterra proves it although not all the fibulae may have come from the city. Even so, the Volterran Villanovan seems poor. Although metals existed to the south and west, Volterra made little use of them in this period.

Two small tombs are similar to those in Populonia and Vetulonia. They are built of dressed blocks and had a false dome that rested on the corbelling at the corners. They cannot be dated since the tomb furniture

has disappeared. The chamber tombs at the Guerruccia were used in the 6th and 5th centuries B.C. but a few were found in the later cemetery at Portone, where the fragments of the only black-figure Attic vase, and at the Badia, where another Attic vase, a red-figure crater, came to light. A bronze (the handle of a crater) made in Vulci, may be dated to the end of the 6th or the beginning of the 5th century. Notwithstanding its archaic aspect, the stele of Avile Tite from the necropolis of Portone also dates to this period.

The earliest examples of funerary sculpture—four stelae and one cippus—are from the end of the 6th and the 5th century B.C. The stelae are flat, rectangular with a rounded top; they are framed by a flat band on which runs the inscription. Inside this frame, in low relief, is the figure of the deceased. These stelae were influenced by Vetulonia and especially by Rusellae: on the stele from Pomarance and on that of Avile Tite (Aulus Titus—Pl. 69b) the dead man holds a triangular dagger similar to the one on the Rusellae stele. Their archaic appearance, which has misled people into dating them too early, is due to the material (tufa) and to their having been made in a centre which does not at the time seem to have been in direct contact with Greece.

From the 4th century on there are evident signs of Volterra's wealth and prosperity. The earliest indication is the building of the city wall. But it is most obvious in the many rich tombs (Pl. 70a) of this period at La Badia, Portone, and San Girolamo, the three large cemeteries which extend over an area of several kilometres. The tombs consist of a single large chamber hewn out of the tufa, circular or square, with tiers of benches round the walls and with a central pillar. One of them had a winged demon in relief near the entrance, similar to those painted near the doors of late tombs in Tarquinia and Orvieto. Other tombs had a vestibule and small circular chambers opening off it. One tomb is in the form of a Latin cross with four square chambers. Despite the fact that most of these tombs were looted in antiquity they still had fine vases in bronze, glass, and terracotta, coins, and above all the characteristic ash urns in tufa, terracotta and alabaster.

So little is known about Volterra's production that it is difficult to judge a fine archaic marble head found there and recently published. So is the statue of a woman, headless, with an Etruscan inscription on her arm and holding a child.

From the 4th century on-perhaps even before-chamber tombs

VOLTERRA (ANCIENT VOLATERRAE)

were marked on the outside by a mound of earth, by stelae or cippi. Cippi were either square, shaped like a pine-cone or spherical, with a cubic base which sometimes had rams' heads at the corners. One chamber tomb had lions on either side of the door. A fragmentary stele with two figures was found in the necropolis of Ulimeto.

On some of the Volterran urns the dead man is shown taking leave of his relatives in front of a sepulchral monument, square, or circular, or with an oval base, and having one to three pyramids, cones, or cippi on top. Some tombs, found in 1832 in the Portone necropolis, resembled these monuments. They had a square base on which was a conical structure of carefully dressed stones. Underneath was a chamber tomb excavated in the tufa, with small alabaster urns and therefore not earlier than the 3rd or 2nd century B.C.

Volterra unquestionably had a local workshop of red-figure vases in the second half of the 4th century B.C. They were mainly large craters (Pl. 70b, c) with a wide high neck: they were found in various parts of north Etruria as well as at Volterra. The finest ones were exported to Perugia. This group of vases, produced by a workshop in which various painters collaborated, is stylistically close to a group of cups which is generally attributed to Clusium, so close in fact that no clear distinction can be made. It has been suggested that Clusine potters settled in Volterra where they continued their craft. Recently some scholars—and it looks as if they were right—have attributed both groups to Volterra; this town exported these vases to other Etruscan cities and to the Po Valley.

Only two sarcophagi have been found. Both are of tufa and belong to the same tomb. Typical for the last period of Etruscan Volterra are the figured ash urns which were also exported to other centres of north Etruria. The finest examples have the rectangular chest decorated on three sides. The cover may be gabled, or, more often, has the figure of the dead man or woman richly ornamented, in a semi-reclining pose, as if at a banquet. The few early urns are of tufa and look like a wooden chest, with four feet and a gabled lid. Some have ornamental motifs either painted or carved in sunk relief on the chest and on the lid: they probably date to the 4th century B.C. Other urns have narrative scenes, in low relief, with few figures filling the field, as on the front of an urn with a representation of the journey to the Underworld. The composition on these early urns is close to Greek reliefs. They seem to antedate the great mass of urns of the 3rd to 1st centuries B.C.

Late urns are of tufa, but more often of local alabaster, which was very popular since it was easy to work and striking effects could be achieved with a minimum of effort. It was first used in the second half of the 3rd century B.C. and was the standard material for mythological subjects. Most cinerary urns are mass-produced and often repeat each other monotonously. Good pieces are few: mostly they are the 'models' which we mentioned before (see pp. 35 ff.) and which were occasionally misinterpreted by the copyists. But some urns were made by excellent, technically able, creative artists. Many of these urns have scenes inspired by Greek myth, others throw light on everyday life and religious beliefs of ancient Etruria.

The relief on late alabaster urns is often so high as to be almost in the round. The scene is framed by a projecting moulding at the bottom and often also at the top. Frequently there are pilasters, columns, or figures at the corners, so that the persons seem to move within a closed space. The projecting moulding is often decorated with alternating triglyphs and rosettes, or has an Ionian frieze of ovuli or drooping leaves. One unusual urn in tufa has the shape of a capital.

Narrative, and even mythological scenes, have a surprising number of male and female demons. Occasionally they even take the place of a Greek god. No other Etruscan centre made such frequent use of infernal demons. But we only find them on funerary urns or sarcophagi. On Volterran vases painters practically excluded them from their repertory, in sharp contrast with their fellow craftsmen in south Etruria.

The rarity of bronzes and the almost total lack of Greek vases, both Corinthian and Attic, in Villanovan and archaic tombs prior to the end of the 5th century B.C., is striking. True, many tombs were plundered in antiquity, but pottery had no commercial value at that time: tombrobbers did not care about it, they were after the jewellery. The lack of bronzes is all the stranger since the copper mines of the valley of the Cecina were so close to Volterra. While we can easily understand that an agricultural city, such as Volterra was, should have taken no pains to exploit them in Villanovan times, it is surprising that they should have gone unnoticed in the 7th century, when the Etruscan cities were vying with each other in the race for metals and tombs were full of bronze objects. Volterra's indifference is completely incomprehensible. Even the settlements in the Cecina valley, where the metals were, seem to have depended on the ore. The tombs—isolated or in small groups such as the pozzetto and chamber tombs of Cerreta near Montecatini in

VOLTERRA (ANCIENT VOLATERRAE)

the Val di Cecina from the 7th and 6th centuries, the ossuary from Montescudaio (c. 600 B.C.), the rare tombs of Lustignano and Serrazzano, tombs that date from the late Villanovan to the 2nd and 1st centuries B.C., the two fine monumental tombs with circular ground plan and a false dome (Pl. 71a) at Casalmarittimo and Casaglia from the 6th century, the stele of Pomarance from the late 6th century—all clearly testify to the existence of rich farmsteads, such as those near the Arno or in the Val di Chiana.

The valley of the river Cecina was the shortest and easiest way from Volterra to the sea, but there are no tombs either singly or in groups along or near the coast. Stray finds and tombs are on the hills; the circular theles tomb at Casale Marittimo is about 9 kilometres from the sea and is the nearest to the coast; Bibbona, where a votive deposit was found, had a handsome bronze buck, and is also in the hills; other settlements are much further inland. The finds are isolated and none of them indicates the existence of a village. It almost looks as if the settlements around Volterra purposely avoided the sea. The rarity of imported objects in Volterra in early times also emphasizes this aspect: it was a city with no outlet to the sea.

This statement may seem strange, for ancient writers did not exclude the possibility of Volterra arriving at the sea. Strabo says that part of the coast was Volterran and according to Servius Volterra owned the port of Populonia. After the second century B.C. Volterra undoubtedly did reach the sea and had ports there. Vada, on the coast, was one, not only because of the adjective attached to its name in Roman times (Vada Volaterrana), but for the characteristic Volterran small tufa or alabaster urns found in the necropolis. There may also have been a dock at the mouth of the Cecina river, where the town of that name now lies. The ship on which Rutilius Namatianus was a passenger stopped there in the 5th century A.D. The villa of Albinus Caecina was there and tombs of the 3rd to 1st centuries B.C. have been found. But there are no settlements along the coast for the oldest periods. San Vincenzo di Campiglia, which has a few early finds (end of the 6th century), belonged to Populonia. There were some small centres further north, but they were in the hills, like Casalmarittimo.

Castiglioncello, on the coast north of Vada, has a small natural bay, large enough for the ships of the time. About 300 tombs have been found there, but none are earlier than the 3rd to 2nd century B.C. While the material in the tombs is Volterran in type, the tombs

themselves seem to have been of the cassetta type common north of the Arno. There has been talk of Villanovan tombs at Quercianella, but the Villanovan cinerary urns supposed to have been found there are hoaxes sold to private collectors by dishonest individuals.

Some scholars have suggested that Populonia might have been Volterra's port in the 6th and ζ th centuries. But the finds of the two cities involved make this impossible. At that time Attic, Corinthian and Ionian vases were arriving in Populonia from Greece, and jewellery and other objects from south Etruria. If Populonia had been Volterra's port, at least part of this imported material would have reached her and this was not the case. Only three Greek vases were found at Volterra; there was no Etruscan black-figure ware. Some gold a baule earrings may have been imported and a bronze crater made in Vulci, of which we still have the handle decoration, certainly was: they are insufficient to prove maritime commerce.

Volaterrae and its cemeteries

And yet, although there is no tangible proof of Volterra's importance prior to the late 5th century and although archaic finds are rare and not rich, especially when compared with the wealth of later tombs, from the 7th century on Volterra had influence and her commerce expanded and developed. But not towards the sea or the mines, but eastwards in the Arno valley.

Tombs, both singly and in groups, indicate that the territory south and north of the Arno was inhabited in Villanovan times. It is hard to decide whether the area was independent or whether it belonged to a city, and in that case to which one. There is no evidence for any cultural or political influence on the part of Volterra until after the 5th century. But the area was inhabited before that, and formed a cultural unity bound to that city.

Finds have given us a general idea of the road which already existed at the end of the 7th century and was still used by the Romans. Starting in Volterra, it joined a road that came from Vetulonia and Populonia along the river Cornia (p. 136), cut through the Valdelsa—note the villages of Càsole, Colle, and the most important, Monteriggioni crossed the Chianti zone, touching Castellina in Chianti with its tombs, its tumulus, and probably also a settlement; Cetamura; Panzano, where a stele was found; Fonterutuli. At Florence it crossed the Arno and joined the road that came from Clusium. It probably followed the curve of the Apennines. Via the valleys of the Ombrone and the Reno it crossed the Apennines and reached Marzabotto, Casalecchio, Bologna and the Po valley.

Settlements and tombs found along this road have imports from south Etruria, but Volterra's influence is also evident. Tombs found in the' Valdelsa date from late Villanovan to Roman times: Monteriggioni seems to have been an important centre and various imports have been found there. A bucchero cup with an inscription around its foot, similar to the cup in the Tomba del Duce in Vetulonia (Pl. 10C), was in a tomb. The cup came from Caere and its inscription was also incised there. Some bucchero ram protomes which decorated a pyxis are also from Caere. A censer in hammered bronze is similar to others from Tarquinia, Falerii, and Bologna. An impasto vase with a relief decoration of meanders, from a tomb in Monteriggioni, is very near to vases from Volterra, and to the ash urn from Montescudaio, made in Volterra. In the 3rd century tomb furniture in the Valdelsa is typically Volterran. Both in their structure and plan the chamber tombs with a false vault

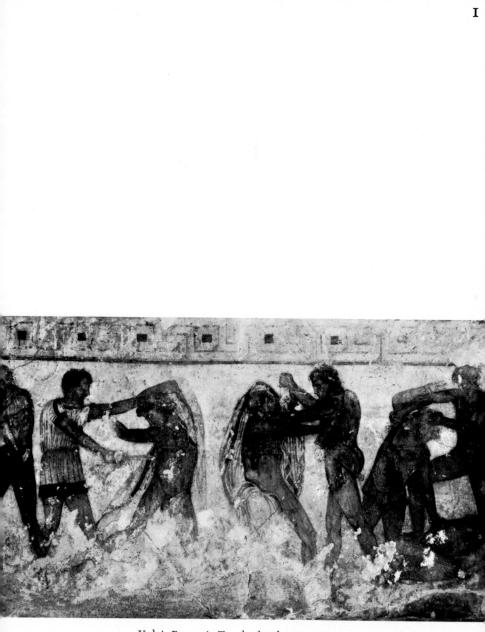

Vulci, François Tomb: battle scenes

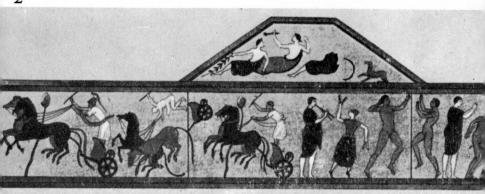

a. Chuisi, Tomb of the Deposito de'Dei: chariot race and athletic games (drawing) b. Oinochoe with trefoil mouth, from Veii c. Bronze bowl with three feet, from Praeneste

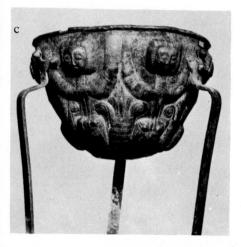

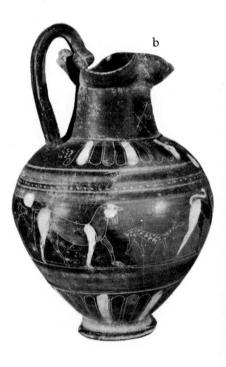

a

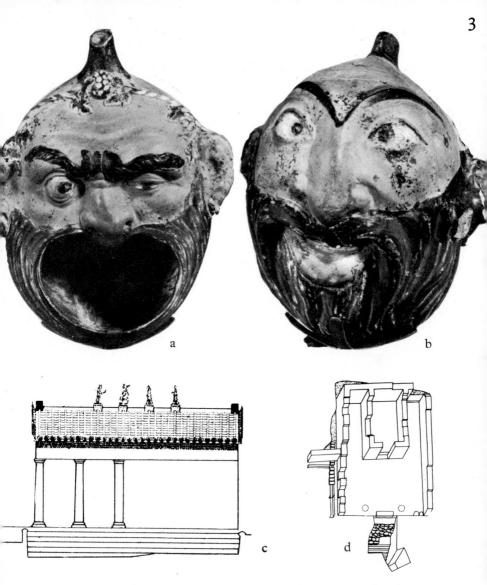

a.-b. Askos in the form of two caricature heads c. Reconstruction of the Portonaccio Temple, Veii

- d. Axonometric view of the temple at Fiesole
- e. Terracotta revetment plaque of a temple, from Velletri

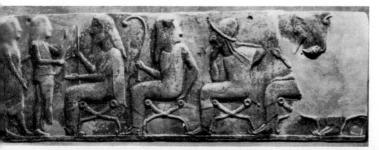

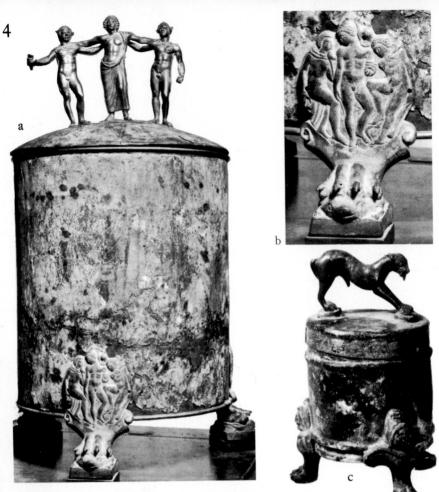

a. The Ficoroni cist, from Praeneste b. Foot of the Ficoroni cist c. Bronze cist d. Detail of a bronze cist with an abduction scene, from Praeneste

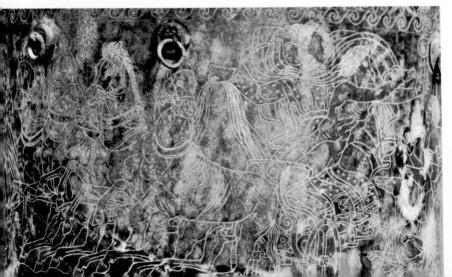

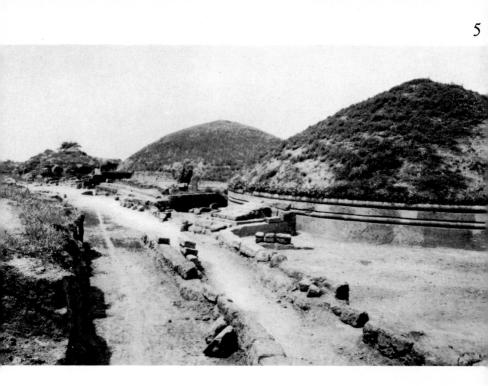

a. Caere, tumuli in the Banditaccia cemetery b. Caere, Tomb of the Seats and Shields

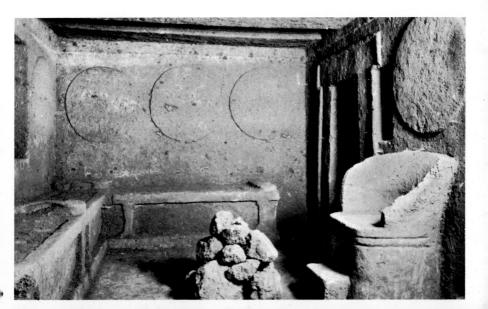

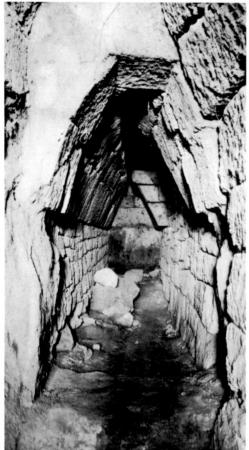

a. Caere, interior of the Regolini-Galassi Tomb b. Detail of one of the 'Campana plaques', from Caere c. Caere, Tomb of the Sarcophagi

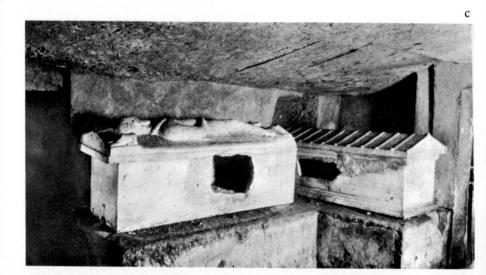

a

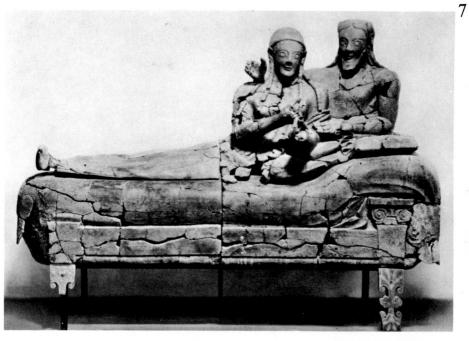

a. Terracotta sarcophagus, from Caere b. Detail of the two figures on the sarcophagus

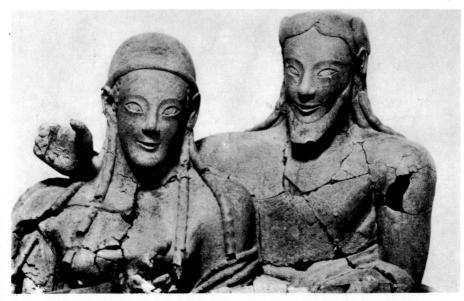

b

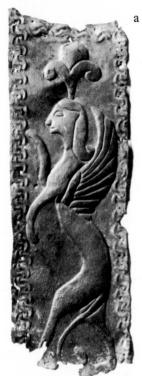

b

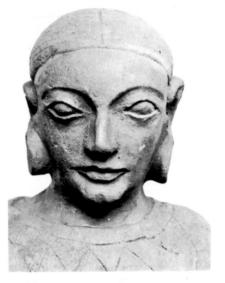

d

a. Repoussé bronze plaque found in a tomb in Caere
b. Profile of the figure of the woman on the terracotta sarcophagus from Caere (see Pl. 7)
c. Cover of a small clay ash urn, from Caere
d. Head of a terracotta statuette of a woman, from Caere

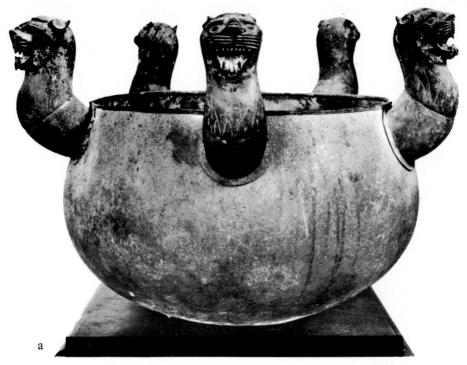

a. Hammered bronze cauldron (lebete), from Caere b–c. Bucchero pyxides, from the Sorbo cemetery at Caere

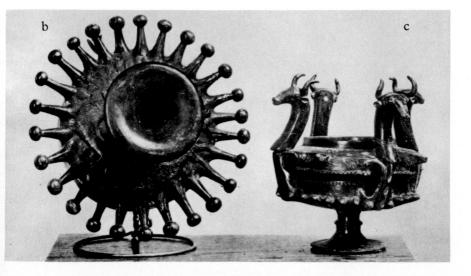

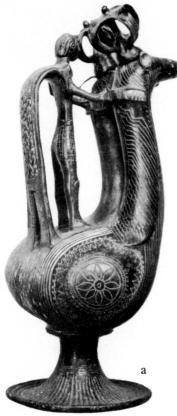

a. Vase in bucchero sottile, from Caere

b. Pitcher in bucchero sottile, from Caere

c. Cup in bucchero sottile, from Vetulonia

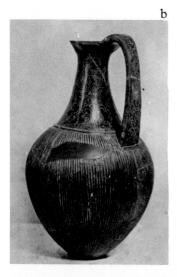

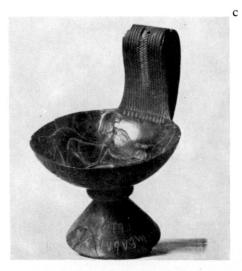

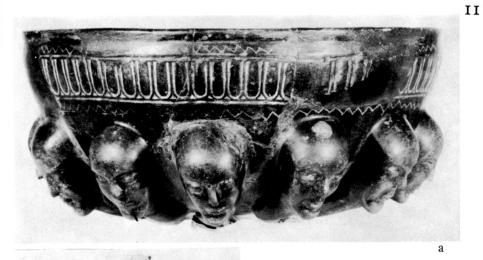

b

1

a. Cup in bucchero sottile, from theTomb of the Painted Lions, Caereb. Globular cauldron (lebete) in impastowith a tall conical support

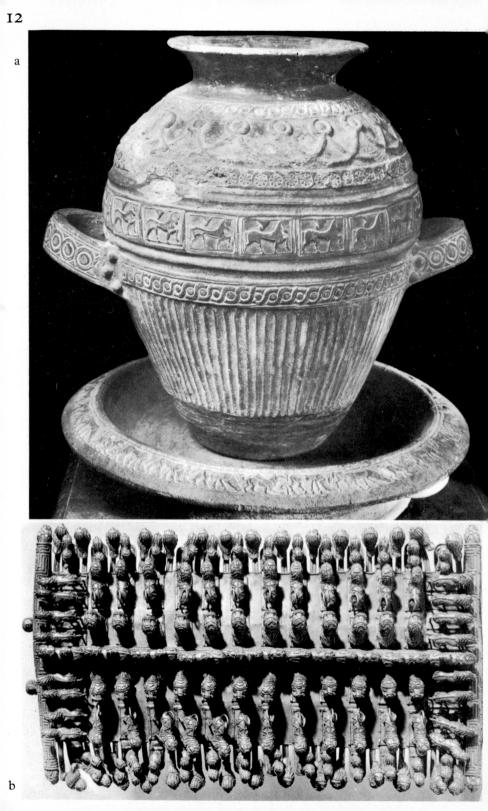

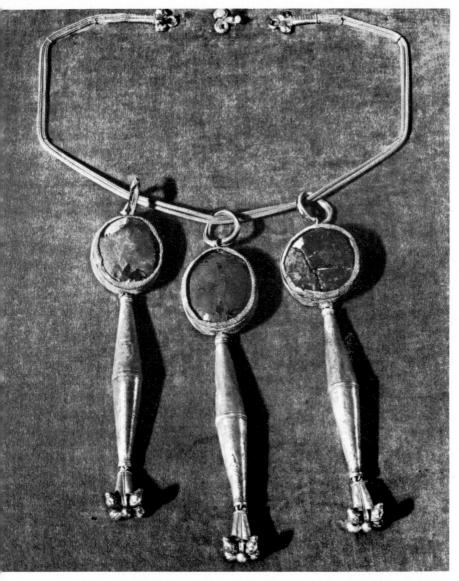

Gold necklace with amber pendants, from Caere

Dolio and plate, in red impasto, perhaps from Caere
Gold brooch with animals in he round, from Praeneste

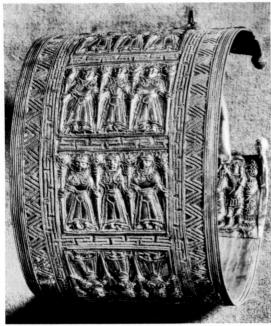

a

- a. Gold bracelet worked in repoussé and granulation, found at Caere
 b. Detail of the preceding bracelet
 c. Gold ring from Caere
 d. Gold a baule (cylinder) earring
 e. Gold a baule earring, from Caere

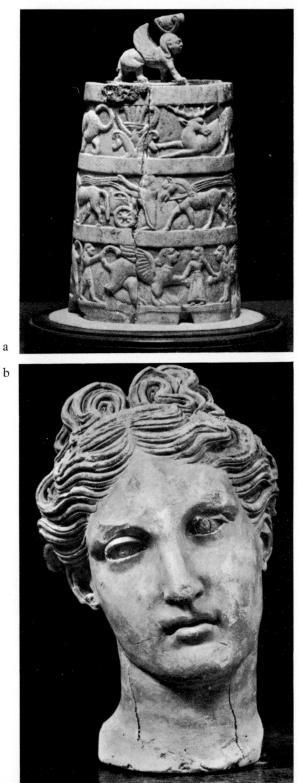

a

a. Ivory pyxis, from the Sorbo cemetery at Cerveteri (Caere) b. Terracotta head of a woman

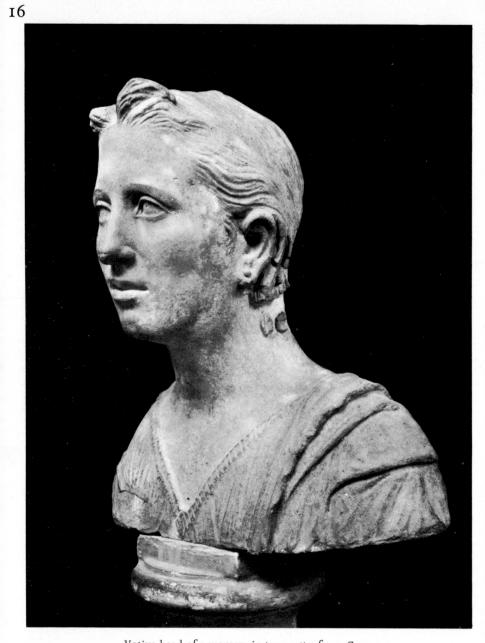

Votive head of a woman, in terracotta, from Caere

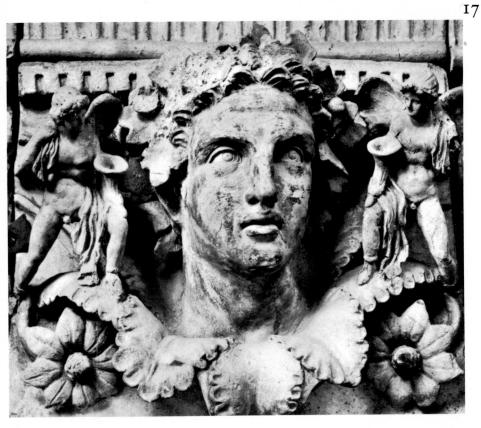

a

- a. Terracotta plaque for temple decoration, from Caere b. Limestone sarcophagus from the Tomb of the Sarcophagi in Caere

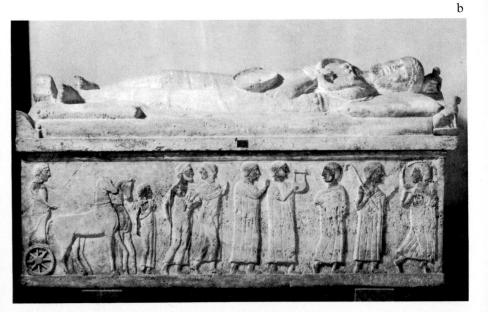

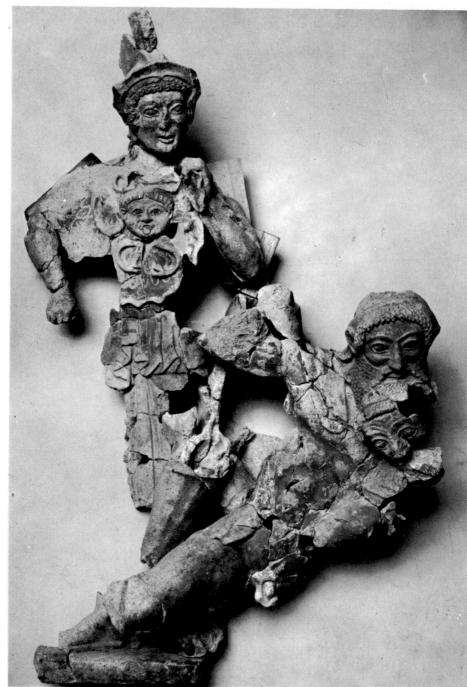

Terracotta group in high relief, from Temple A at Pyrgi

Veii, Ponte Sodo

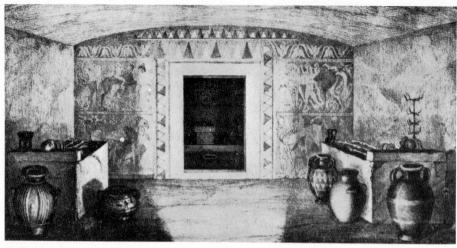

a

a. The Campana Tomb in the necropolis of Monte Michele, at Veii (drawing)b. The two right-hand panels in the Campana Tomb, Veiic. Terracotta antefix with the head of a woman, from Veii

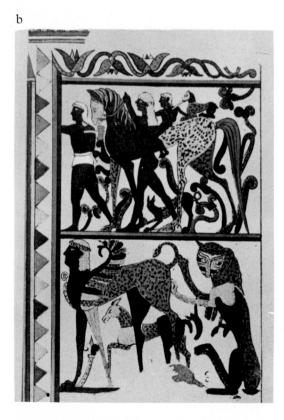

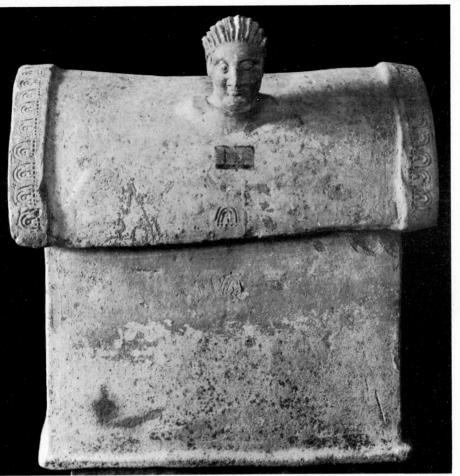

a. Ash urn in terracotta with a semi-cylindrical lid, from which the head of a man projects b-c. Detail of the head

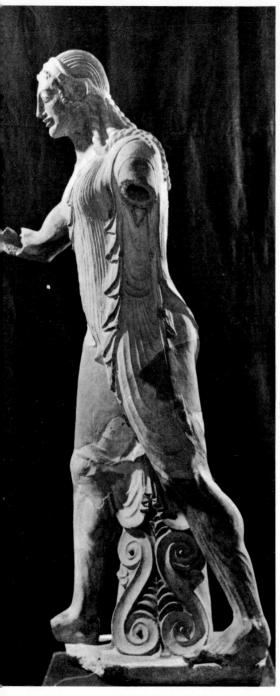

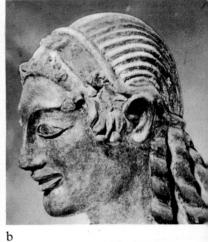

c

a

a. Terracotta statue of Apollo, from the Sanctuary of Minerva at Veii b-c. Detail of the head of Apollo

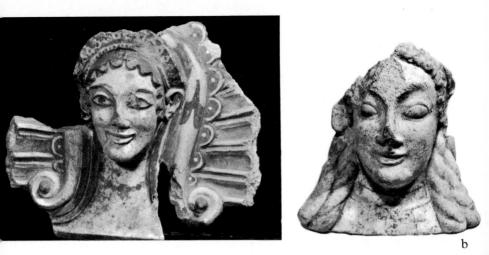

a. Terracotta antefix with the head of a woman, from the temple of Minerva at Veii

- b. Terracotta antefix with the head of a woman, from Veii c. Terracotta head of a woman, from the Sanctuary of Minerva, at Veii d. Terracotta statuette of a youth, from Veii

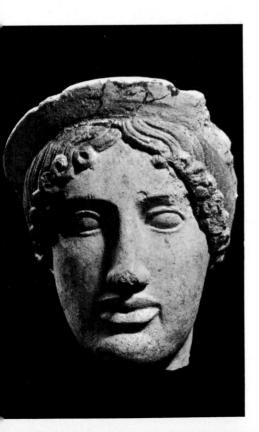

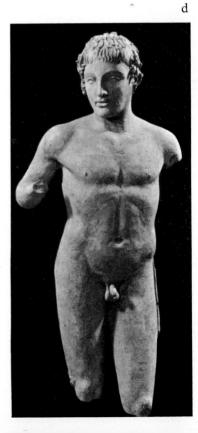

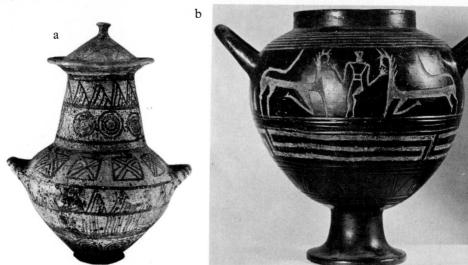

- a. Impasto ash urn, from Falerii b. Footed globular crater, in impasto c. Painted terracotta slab, from the temple of Celle, at Falerii

24

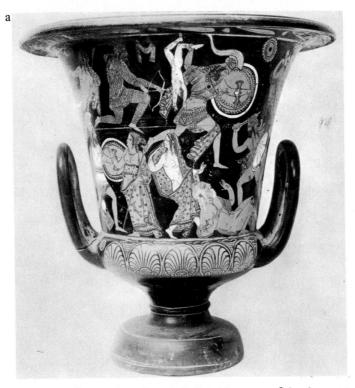

a. Faliscan red-figure crater, from Falerii, with scenes of the destruction of Troy

b. Red-figure stamnos, from Castel Campanile: satyrs and maenads

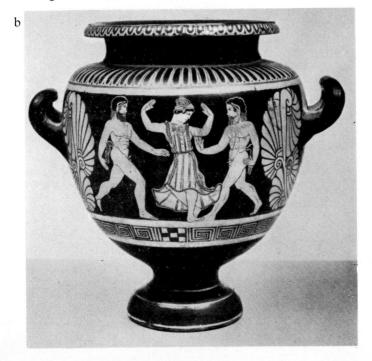

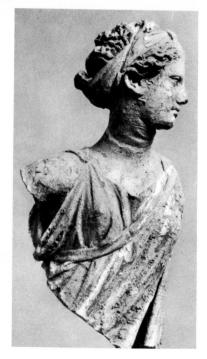

a. Terracotta antefix (Diana?) from the Scasato temple, Falerii b. Male bust in terracotta (Apollo?) from the Scasato temple, Falerii

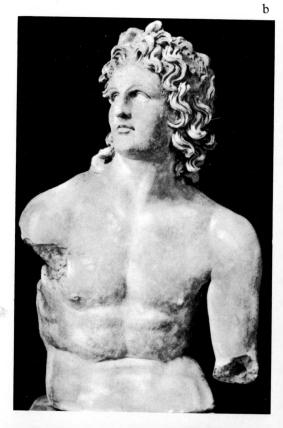

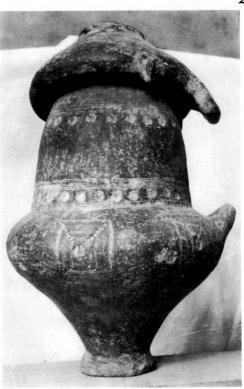

b

- a. Hut-urn, from Poggio di Selciatello, Tarquinia b. Biconical Villanovan ash urn, from Poggio di Selciatello, Tarquinia c. Impasto vases (ɑskoi), Tarquinia

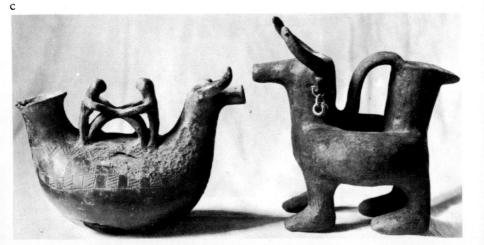

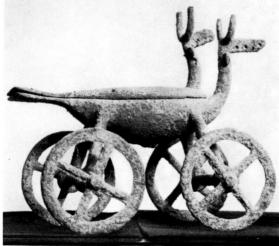

a. Perfume stand in bronze from the necropolis of Monterozzi, Tarquinia b. Gold bracelets decorated in repoussé and granulation, from Tarquinia c. Round shield in thin bronze plate, found in the Regolini-Galassi tomb in Caere

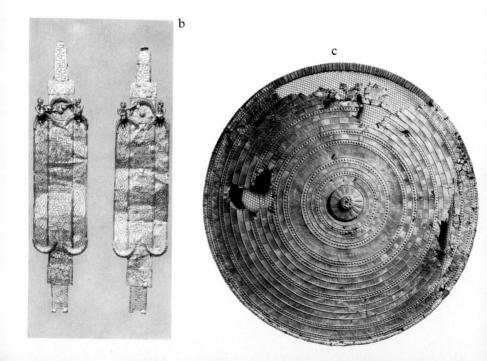

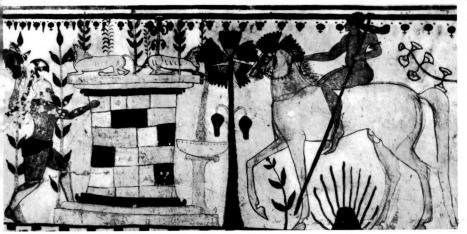

- a. Tarquinia: detail of the Tomb of the Bulls b. The bull above one of the doors of the Tomb of the Bulls in Tarquinia c. Achelous above the other door of the same tomb

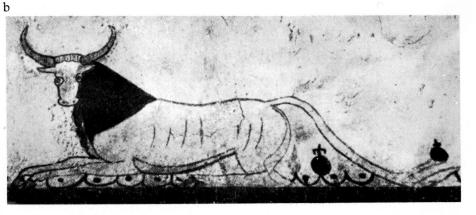

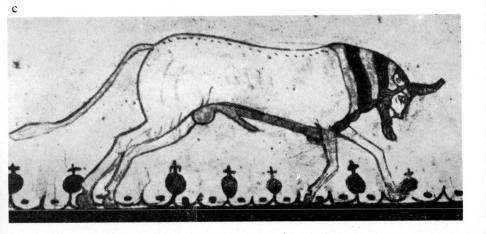

a. Detail of the Tomb of Hunting and Fishing, Tarquinia b. The back wall of the Tomb of Hunting and Fishing

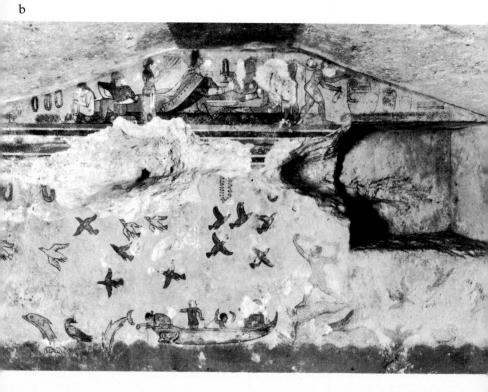

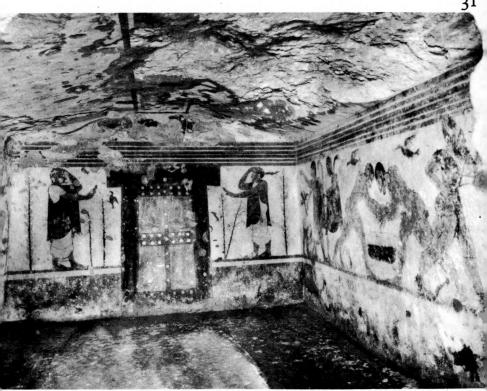

a. The Tomb of the Augurs, Tarquinia b. Wrestlers on the right wall of the Tomb of the Augurs

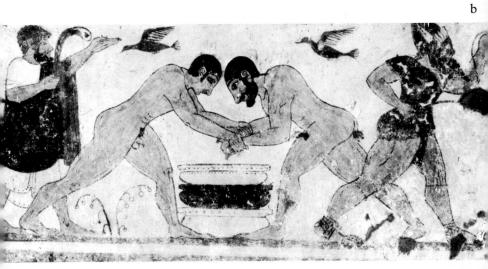

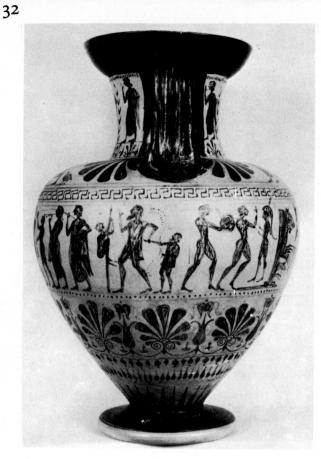

а

a. Black-figure amphora, by the Micali Painter, from Vulci b. A judge and two servants from the Tomb of the Augurs, Tarquinia

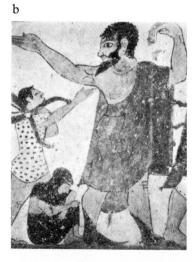

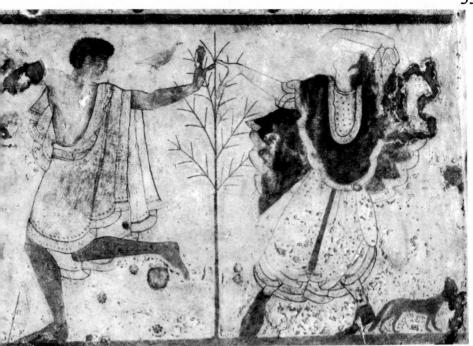

a

a. Tomb of the Triclinium, Tarquinia: two dancers on the right wall b. Detail of the woman dancer

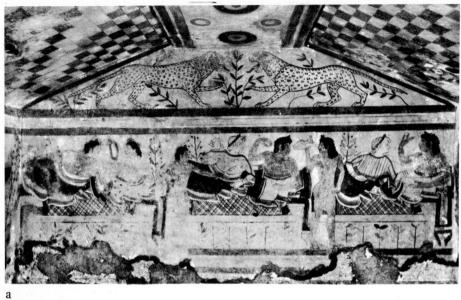

a. Tomb of the Leopards, Tarquinia: the banquet on the back wall b. Double flute player on the right wall

b

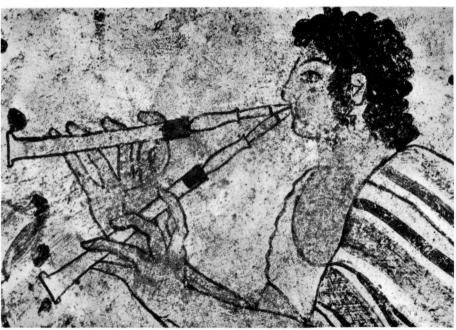

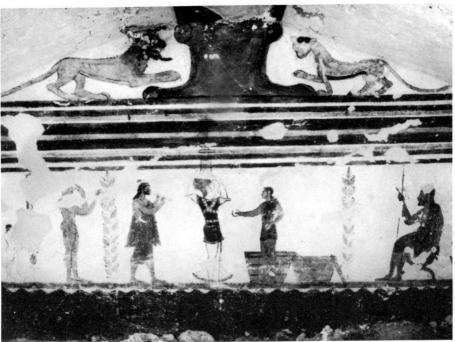

Tarquinia, Tomb of the Jugglers: a. back wall b. right wall

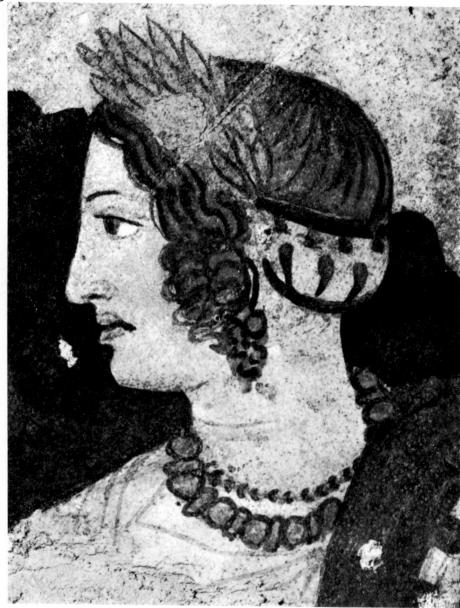

Tomb of Orcus, Tarquinia : head of a woman of the Velcha family

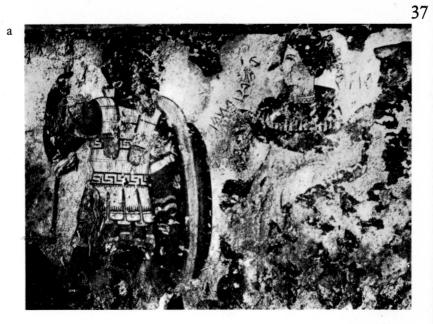

a. Tomb of Orcus, Tarquinia: Persephone, Hades and Geryon. Detail of the head of Hades b., and of Persephone c.

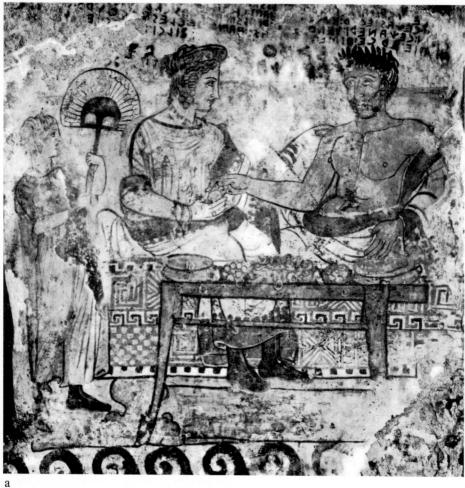

a. Tomb of the Shields, Tarquinia: two banqueters b. Nenfro slab divided into panels, from Tarquinia

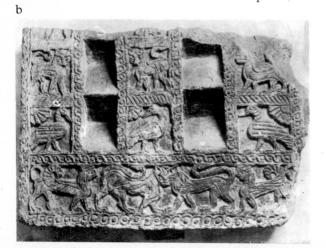

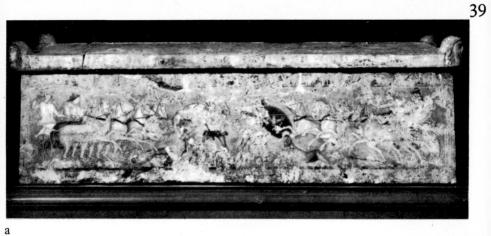

Sarcophagus of the Amazons, from Tarquinia: a. One of the long sides with a battle scene between Amazons and Greeks; b. Detail with two Greeks and an Amazon; c. Detail of a chariot with two Amazons.

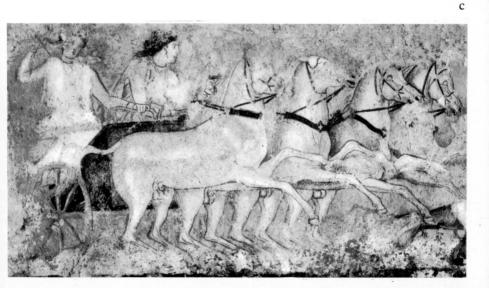

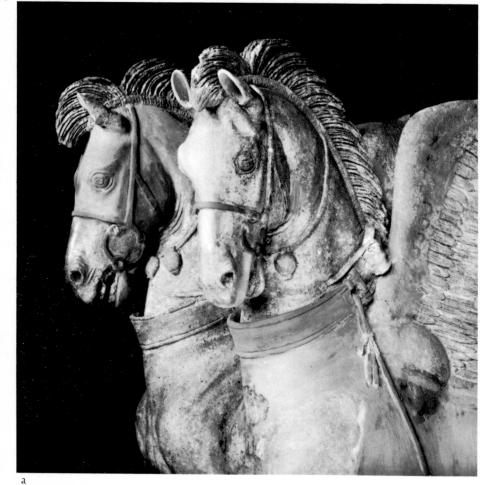

a.Winged horses in terracotta, from Tarquinia, from a pediment decoration b. Lid of a limestone sarcophagus, perhaps from the Tomb of the Triclinium, in Tarquinia

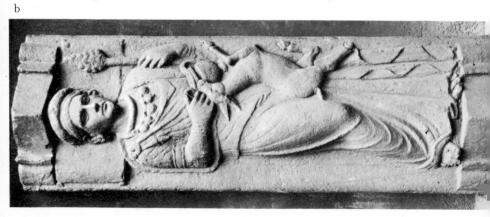

a. Gold foil disc, found at Vulci b. Gold fibula with serpentine bow, from Vulci c.-d. Gold bullae, from Vulci e. Bronze mirror decorated in relief, from Vulci

b

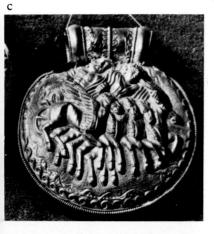

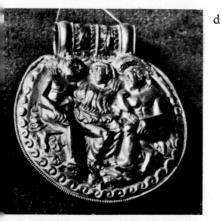

e

41

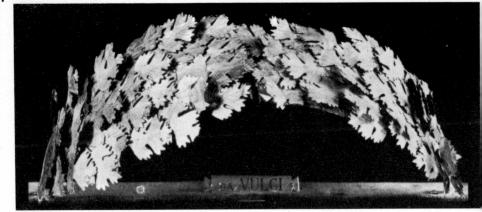

a. Wreath of oak leaves in gold foil, from Vulci b. Gold earring, perhaps from Vulci c. Gold earring, from Todi

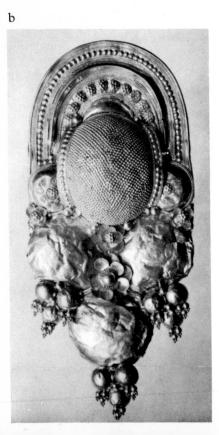

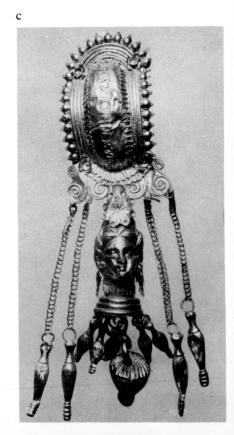

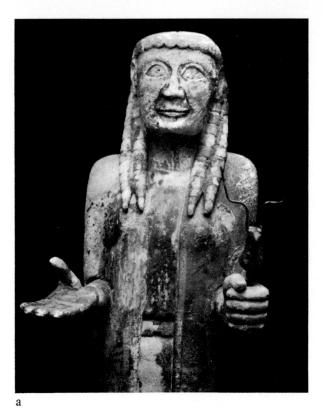

a. Alabaster statue of a woman, from the Cave of Isis, Vulci b. Nenfro cippus, originally square in cross section with carvings on three or four sides, from Vulci c. Centaur in nenfro, from Vulci d. Lion in nenfro, from the cemeteries of Vulci

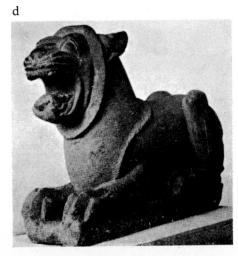

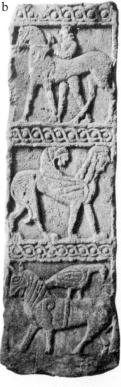

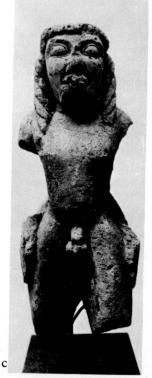

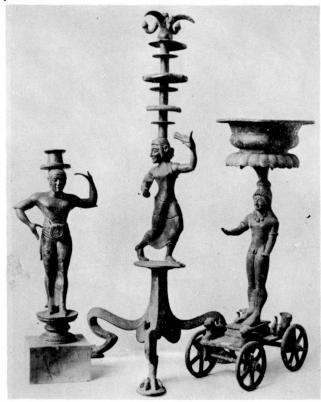

a. Bronzes of the so-called 'Vulci' group: two candelabra with figurines, 'trolley' censer
b. Bronze base of a candelabrum from Vulci
c. Bronze base of a candelabrum: a dancer

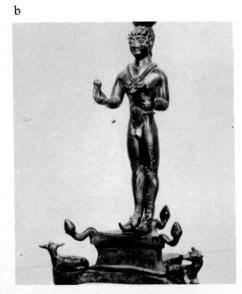

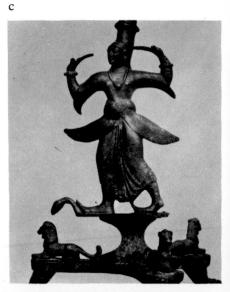

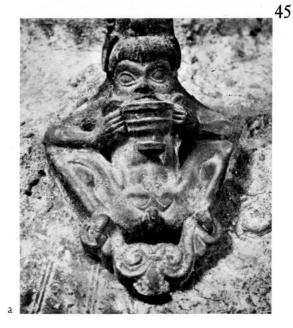

a. Bronze handle of a vase, with a drinking satyr b. Detail of a tripod in bronze similar to the one in Pl. 46b: Hercules and Achelous

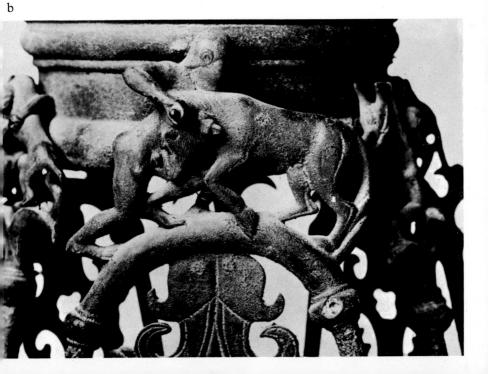

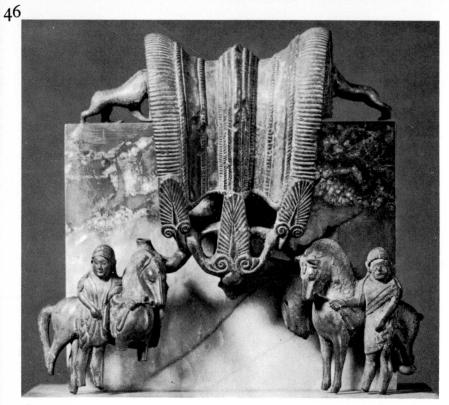

b

a

a. Handle of a bronze crater, of the 'Vulci' group b. Cast bronze tripod, from Vulci

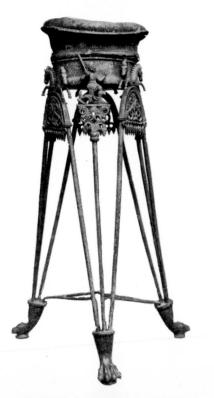

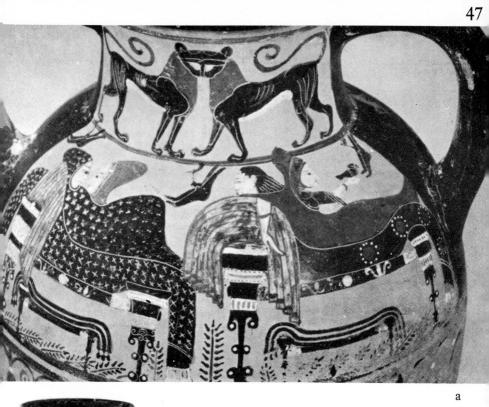

a. Detail of a 'Pontic' amphora by the Paris Painter b.'Pontic' amphora by the Paris Painter

c. Fighting animals: amphora from the workshop of the Paris Painter

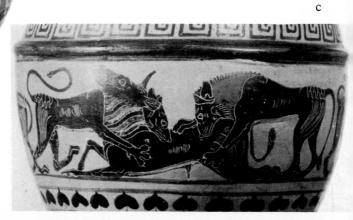

b

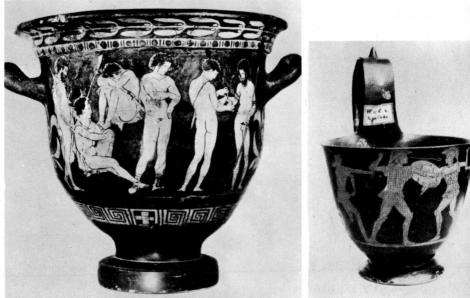

a

a. Etruscan red-figure crater b. Detail of the preceding crater c. 'Superposed colour' red-figure cup, from Vulci

с

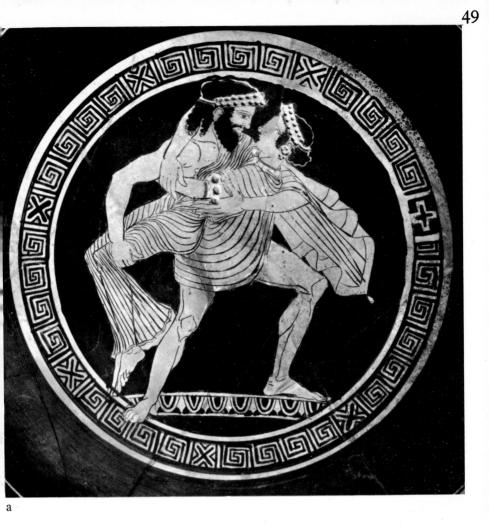

a. Red-figure cup, from Vulci: a god abducting a woman b. François Tomb, Vulci: Achilles killing the Trojan prisoners

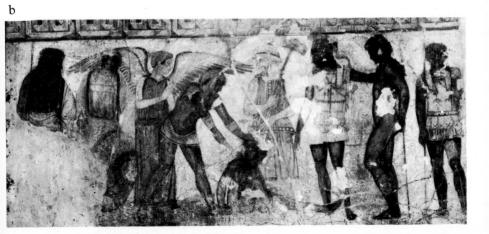

François Tomb, Vulci: head of Charu

François Tomb, Vulci: a. Head of a Trojan prisoner b. Head of Vanth

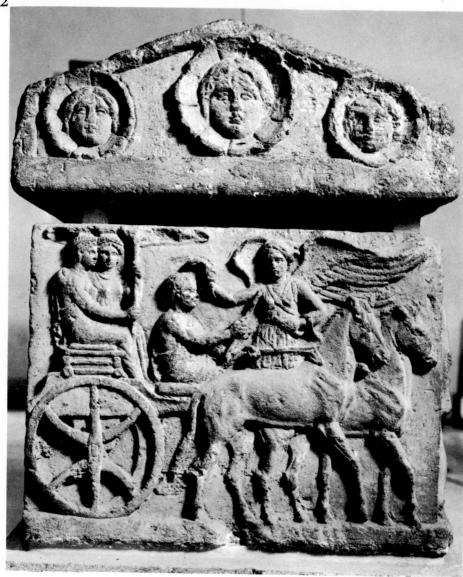

End wall of a peperino sarcophagus, from Vulci

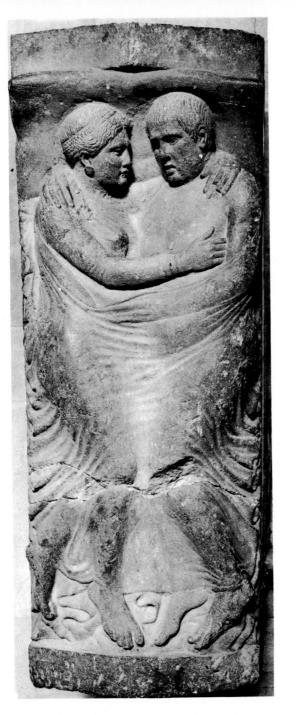

Lid of a sarcophagus in peperino, from Vulci

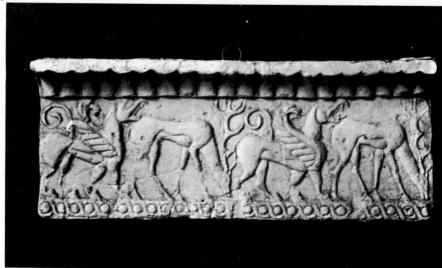

a. Terracotta revetment slab of a temple, found at Poggio Buco b. Terracotta revetment slab of a temple, from Poggio Buco

54

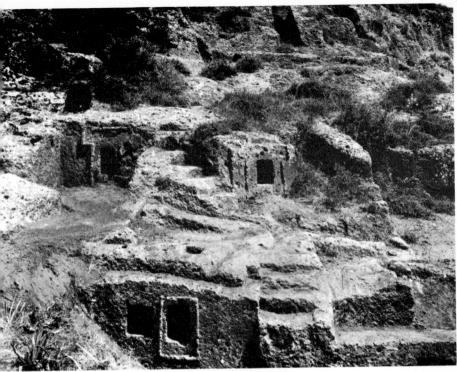

Blera: a. niche tombs and b. 'dado' tomb

b

1

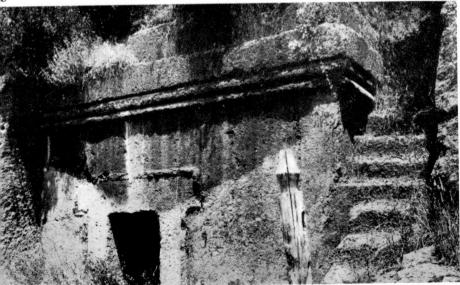

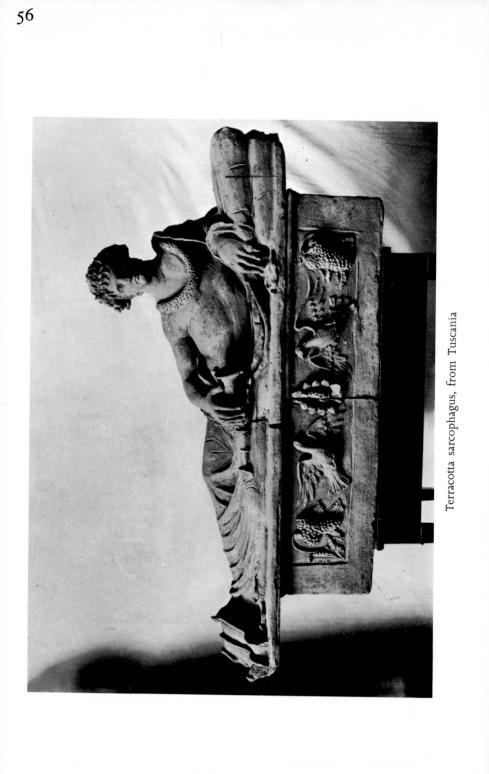

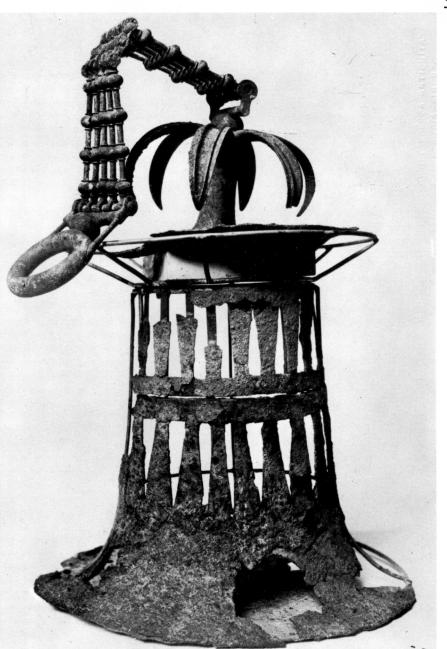

Bronze censer, from the Circle of the Fibula at Marsiliana

The Corsini fibula, from the Circle of the Fibula, Marsiliana. Detail a. and full length b. c. Terminal part of an ivory handle from the Circle of the Ivories, Marsiliana

a a a a a a a

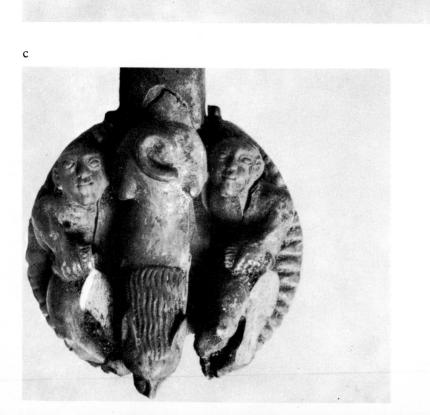

a. Head of a man wearing a diadem, from Orvieto b. Vase in bucchero sottile, with a single handle, from Orvieto

c. Terracotta head of a Silenus, from Orvieto d. Terracotta head of a Gorgon, from Orvieto

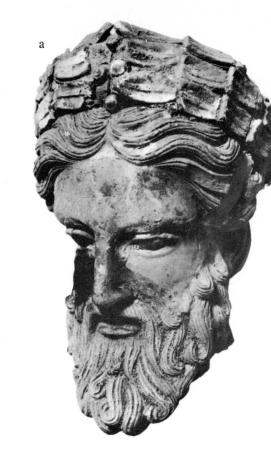

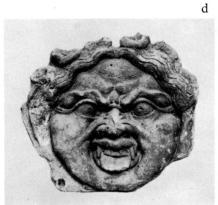

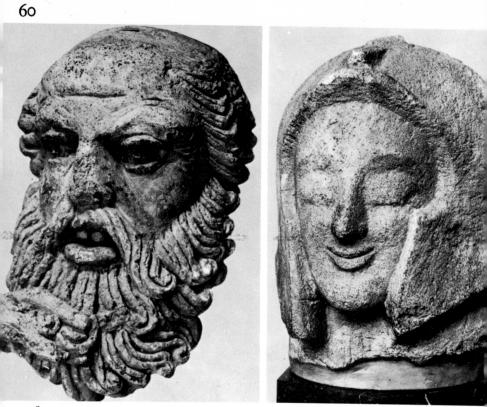

a

a. Terracotta head of an old man, from Orvieto b. Nenfro head of a warrior, from the necropolis of Crocefisso del Tufo, Orvieto

c. One of the four sides of the peperino sarcophagus, from Torre San Severo, Orvieto

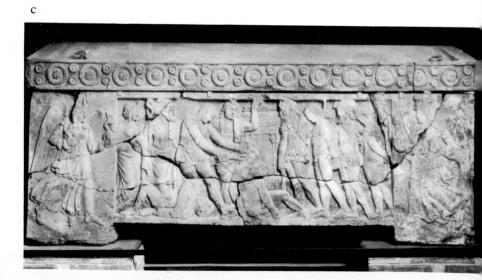

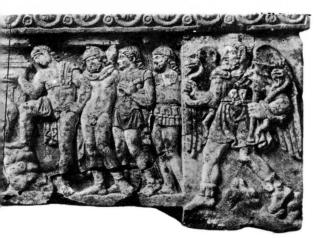

a. Detail of the sarcophagus from Torre San Severo, Orvieto b. Golini I Tomb, banquet in the Underworld c. The larder of the Underworld

a

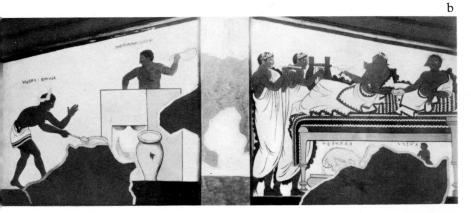

с

8

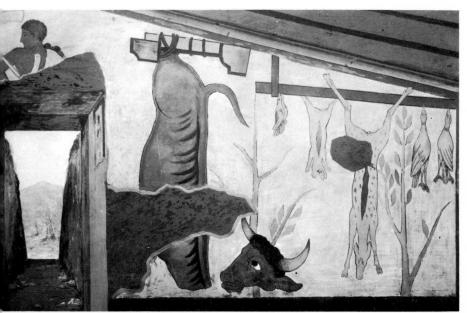

a. Golini I Tomb, Orvieto: the cupbearerb. Golini II Tomb, Orvieto: the dove on the stool of the kline

dove on the stool of the kline c. Head of a banqueter, from the the Golini II Tomb

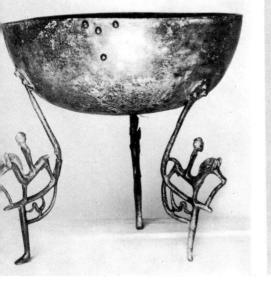

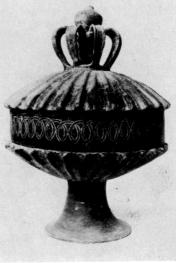

a. Bronze tripod, from Vetulonia b. Footed pyxis, in impasto, from Vetulonia c. Vetulonia, Circle of the Costiaccia Bambagini

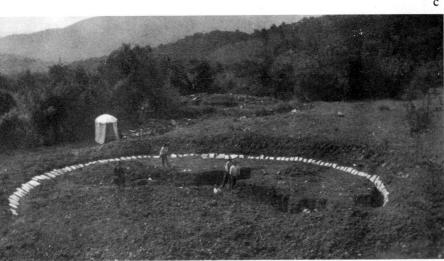

b

с

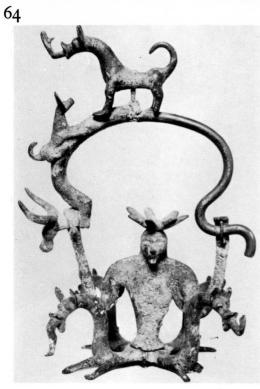

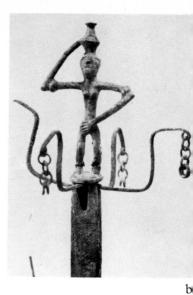

a

a. Bronze handle, found at Fabbrecce, near Città di Castello b. Finial of a bronze 'candelabrum', of 'Vetulonian' type c. Gold filigree bracelet, from the Circle of the Bracelets, Vetulonia

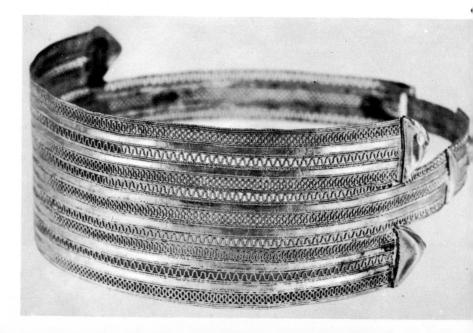

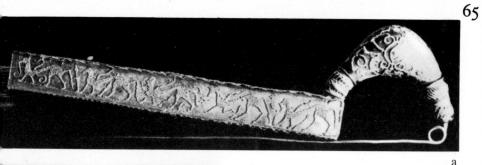

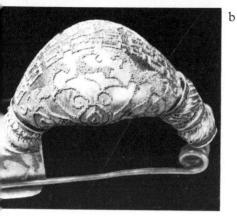

a. Gold leech fibula with a long catch-plate, decorated in the 'pulviscolo' technique, from Vetulonia b. Detail of the preceding fibula c. Leech fibula with a long catchplate, from the Tomb of the Lictor, Vetulonia

d. Detail of the preceding fibula

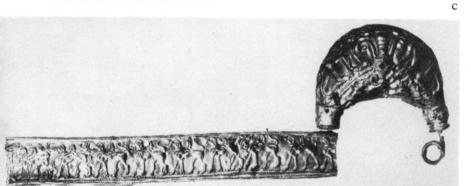

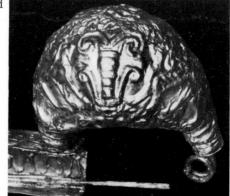

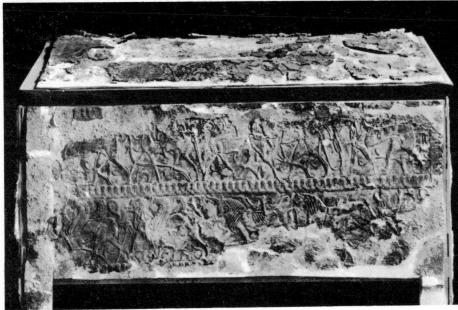

a

a. Urn sheathed in silver, from the Tomba del Duce, Vetulonia b. Detail of the urn

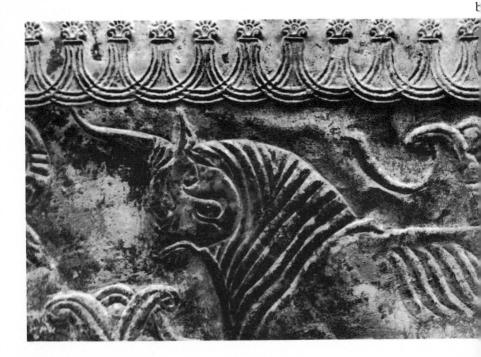

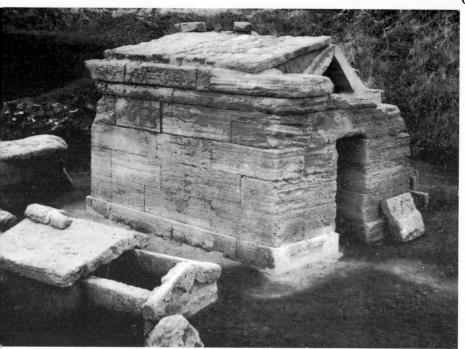

a. Populonia, aedicule tomb b. Gold ring, from Populonia

a

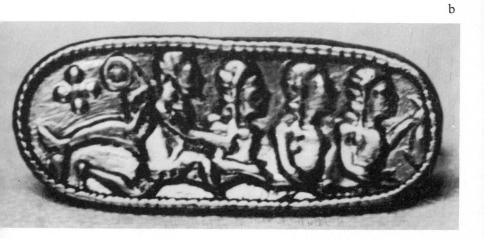

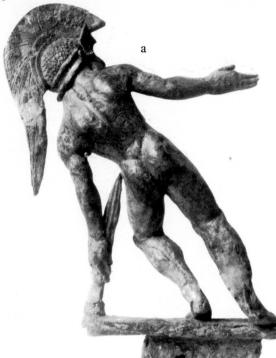

a. Bronze figurine from Populonia: Ajax killing himself b. Bronze mirror, from Populonia

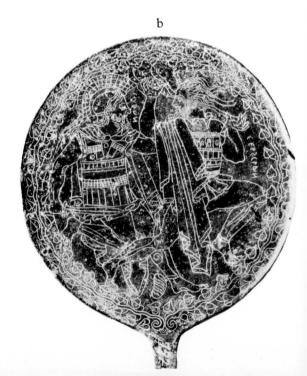

a. The Porta all'Arco, Volterra b. Stele of Avile Tite, from Volterra

a

a. Interior of a Volterran tomb
b. Red figure crater, made in a Volterran workshop: winged female
figure, seated on a dolphin
c. red-figure crater, made in a Volterran workshop: battle between a pygmy
and a crane

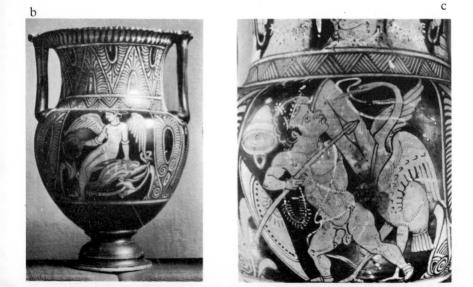

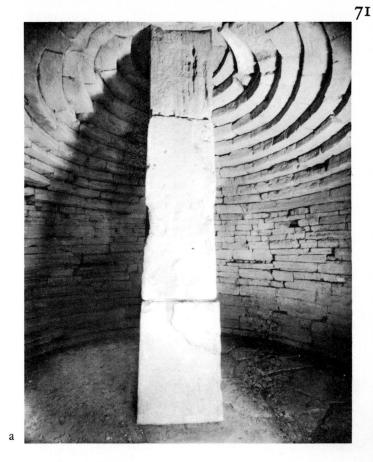

a. Interior of the Tomb of Casal Marittimo (Volterra) b. Relief on a small ash urn in alabaster, from Volterra: Paris recognized as the son of Priam

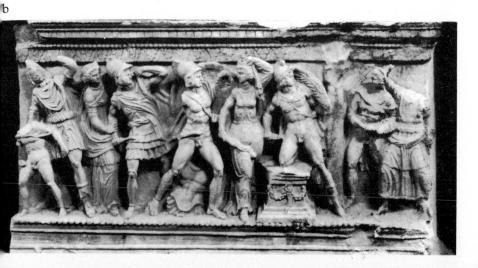

a. Cover of an ash urn, from Montescudaio b. Tumulus of Montecalvario (Chianti): interior of a chamber tomb

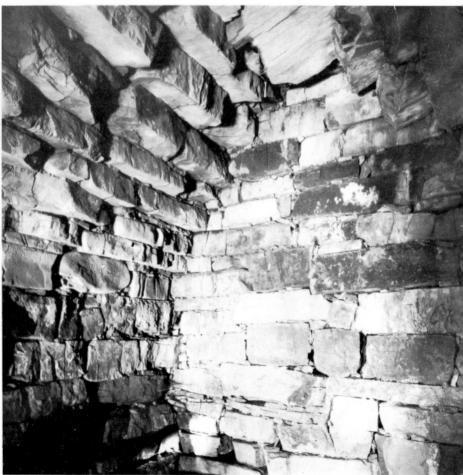

a

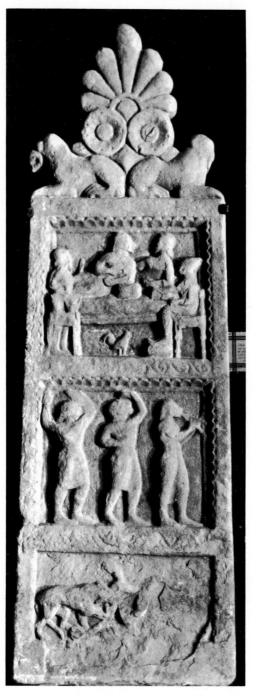

'Fiesole' stele, from Travignoli, near Pontassieve

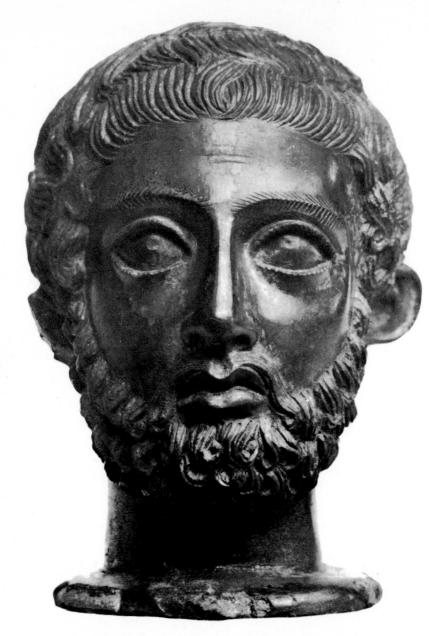

Small bronze head of a man, from Falterona (Casentino)

a. Woman's head on a canopic jar, from Chiusi

b. Canopic jar in impasto, on a seat, from Chiusi (4th cent. B.C.) c. Detail of an ivory pyxis, from a tomb in Chiusi

d. Detail of an ivory situla, from a tomb in Chiusi

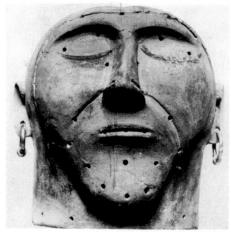

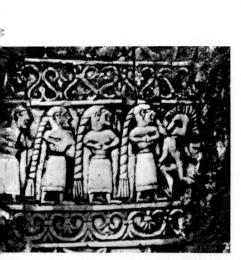

d

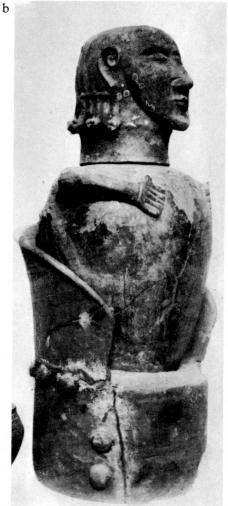

a. Ash urn in pietra fetida, from Chianciano b. Ash urn in pietra fetida, in the shape of a standing man, from Chianciano

c. Cippus in the form of a bust of a woman, from Chiusi

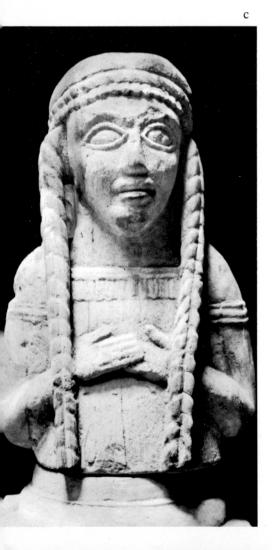

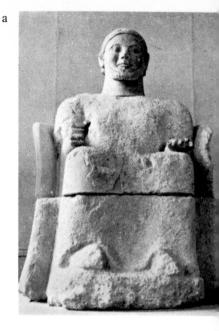

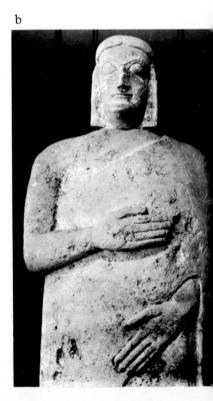

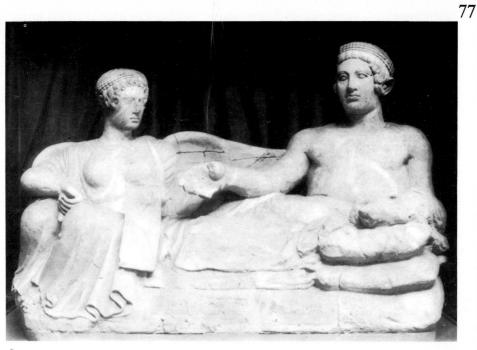

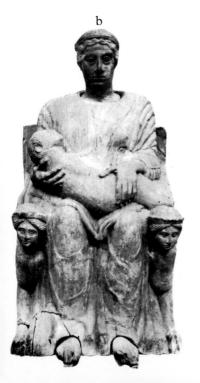

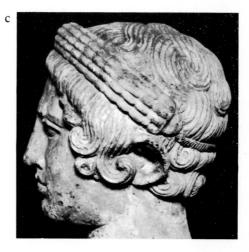

a. Ash urn in pietra fetida from Chianciano, with a detail c. of the head of the man b. Ash urn in pietra fetida, from Chianciano

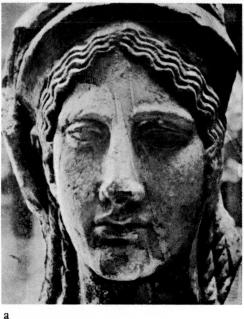

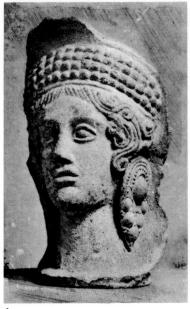

b

- a. Terracotta antefix, perhaps from Chiusib. Fragmentary terracotta antefixc. Athletic games in the Tomb of the Monkey, Chiusi (drawing)

MAMAMAMAMAN

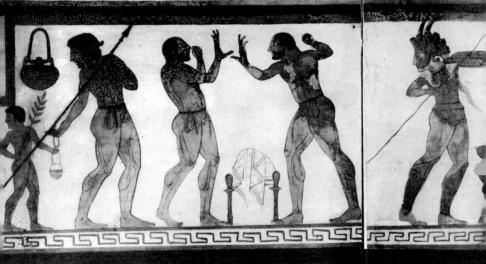

78

с

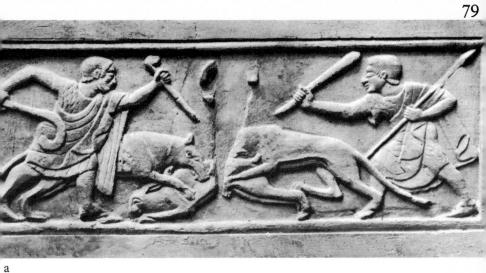

a. Front of a burial urn, from Chiusi b. Quadrangular cippus, fragment, from Chiusi

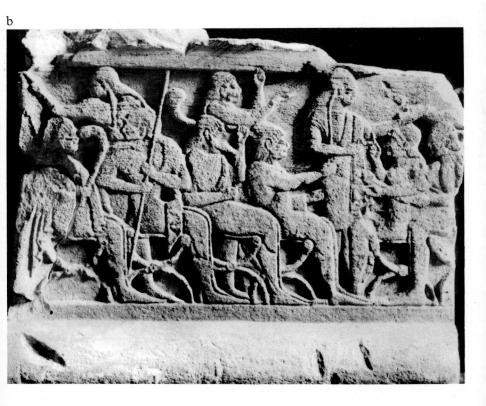

a

a. Sarcophagus in pietra fetida, from the necropolis of the Sperandio,Perugiab. Detail of the same sarcophagus

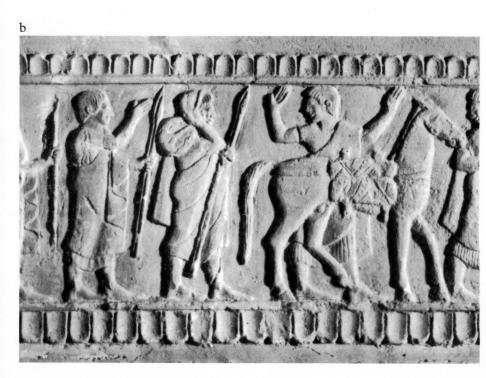

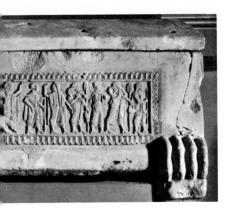

a. Head of Larth Sentinate Caesa, from the tomb of the Pellegrina, Chiusi b. Belief of an urn from Chiusi:

b. Relief of an urn, from Chiusi: the death of Eteocles and Polyneices

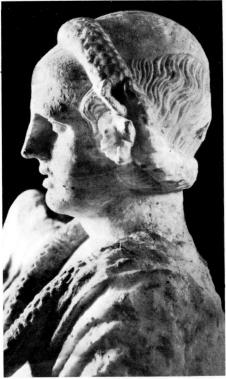

a

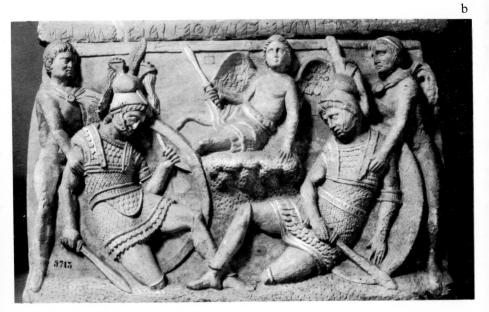

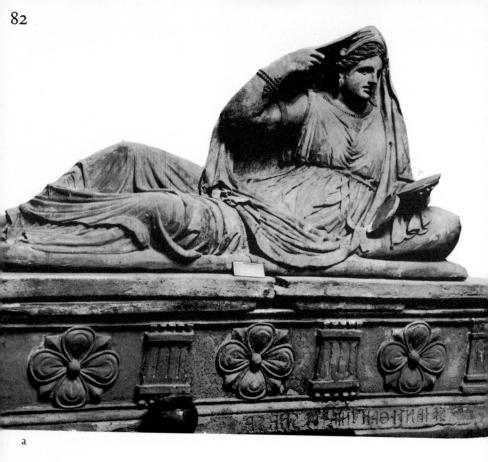

a. Terracotta sarcophagus of Seianti Thanunia Tlesnasa, from Chiusi b. Detail of the preceding

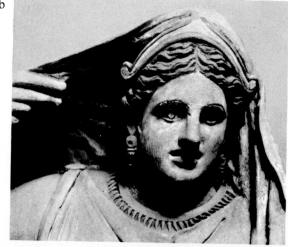

a. Detail of an amphora in bucchero pesante, typical of Chiusi b. Red-figure cup, from Montepulciano: Dionysius and the game of kottabos

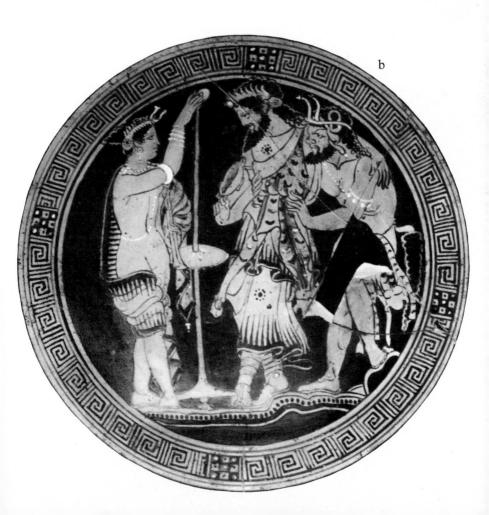

Terracotta revetment slab from a temple, from Arezzo

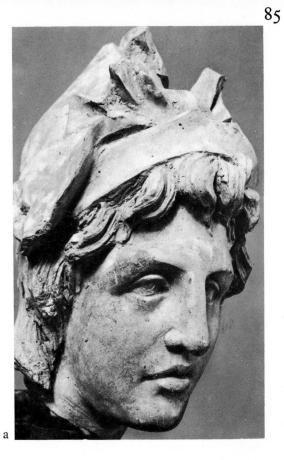

a. Terracotta head of a youth wearing a Phrygian cap, from Arezzo b. Bronze chimera, from Arezzo

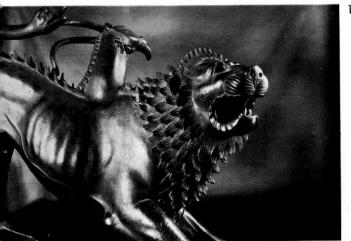

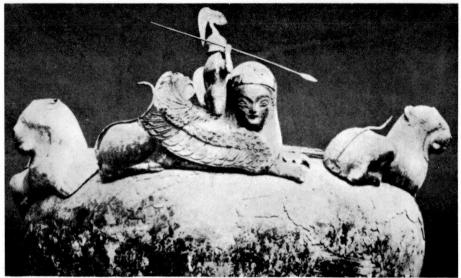

a. Cauldron in hammered bronze, from San Valentino di Marsciano (Perugia) b. Panel of a tripod in hammered bronze, from San Valentino di Marsciano (Perugia)

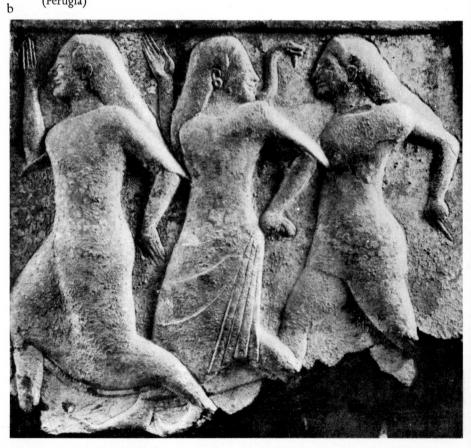

a

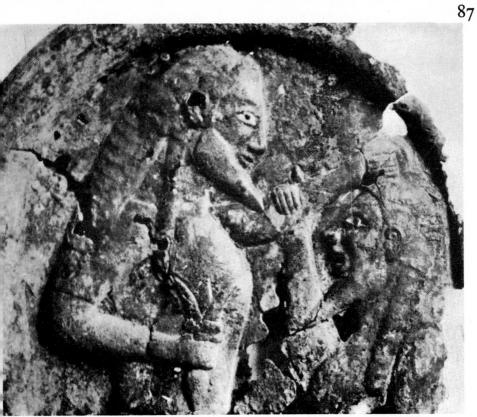

a. Panel in repoussé bronze, from Castel San Mariano, Perugia b. Detail of a panel in repoussé bronze, from Castel San Mariano, Perugia

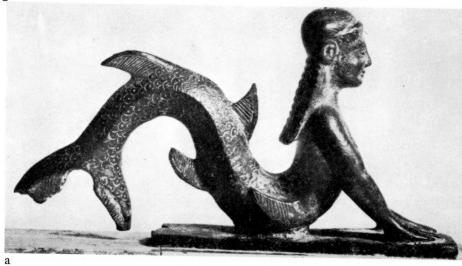

a. Marine being: bronze figurine from Castel San Mariano, Perugia b. Bronze mirror found near Perugia: Perseus with the head of Medusa

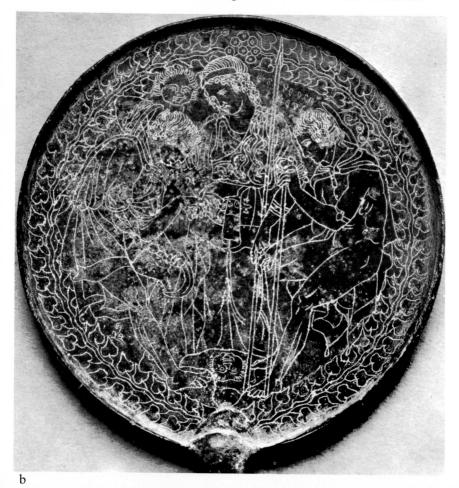

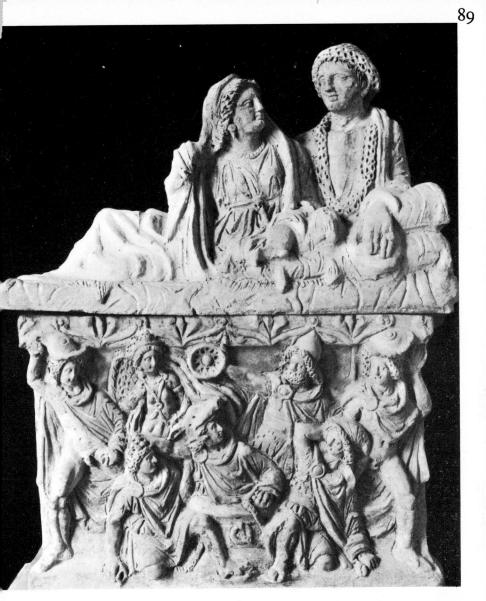

Terracotta urn, from Perugia

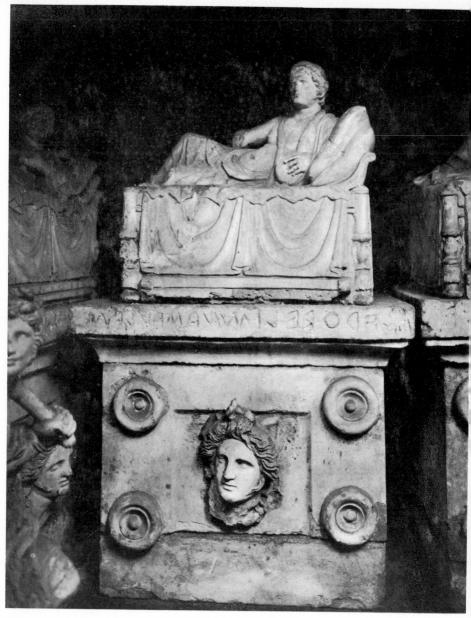

Urn of Larth Velimna, from the tomb of the Volumni, at Palazzone near Perugia

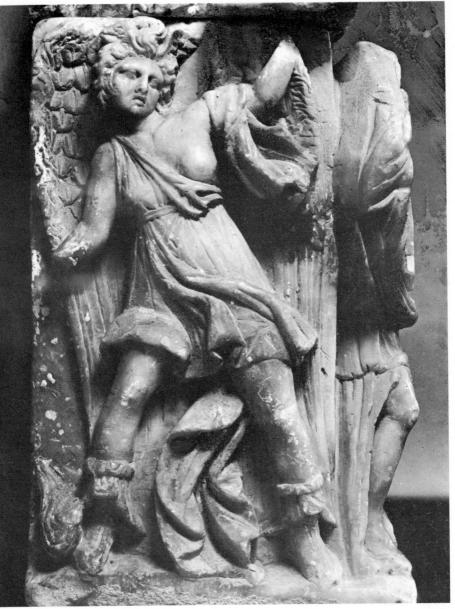

Female demon on an alabaster urn, from Volterra

Black figure oinochoe with a mythological scene

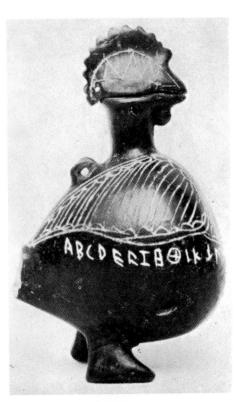

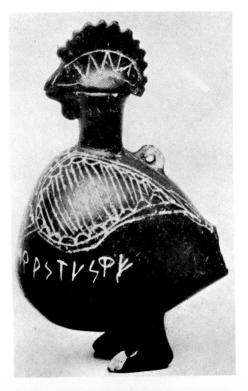

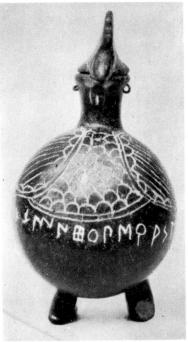

Small vase in bucchero sottile in the shape of a rooster, with an inscription incised after firing (Viterbo alphabet)

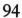

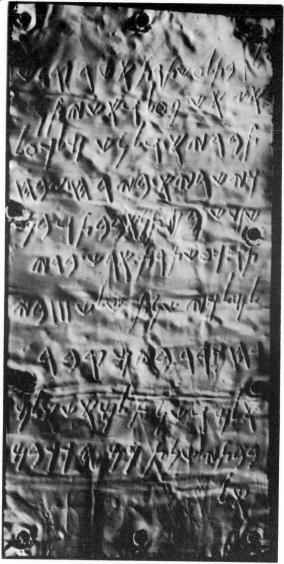

a. Phoenician inscription, found in the temple of Pyrgi b. Miniature writing tablet in ivory, with the alphabet incised in the border, from Marsiliana di Albegna

a

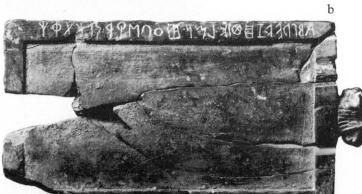

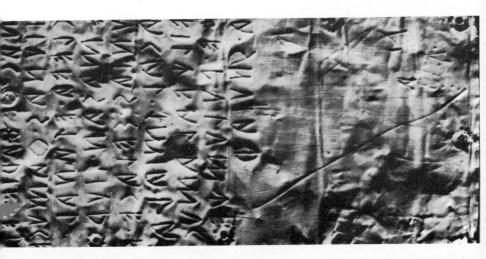

a.-.b. Etruscan inscriptions engraved on sheets of gold foil, found at Pyrgi

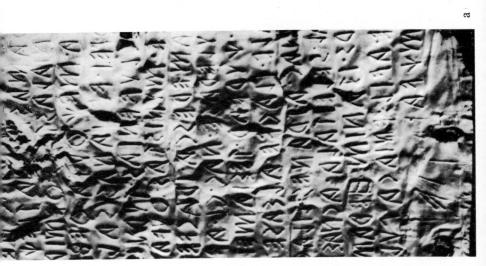

9

The gold sheets from Pyrgi, before being restored

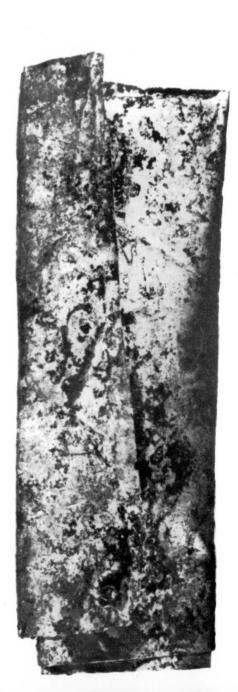

in the famous tumulus in Castellina in Chianti—where traces of a settlement have also recently been discovered—recall those found not far from Cortona, near Clusium. It is hard to say if the predominating influence in Castellina was Clusium or Volterra. Further east, in the vicinity of Florence, Volterran influence is still evident. We can see it in the architecture of the two tombs near Quinto—the well-known one of the 'Mula' and that of the 'Montagnola'—and in a series of characteristic funeral monuments, the Fiesole stelae.

We may be able to say even more regarding Volterra's expansion. It may or may not have influenced a cippus at Marzabotto, whose cubic base has a ram's head at each corner, since similar bases were found in Volterra, but also at Bologna. Nor is it clear whether a rectangular stele from Bologna, rounded at the top, depends on Volterra or on the Fiesole stelae. But the two other funerary stelae in Bologna, with the inscription mi suthi velus kaiknas ('I am the tomb of Vel Kaikna') do depend on Volterra, for 'Kaikna' is Roman 'Caecina', the name of one of Volterra's best known Etruscan families. At least two members of this Volterran family were therefore in Bologna at the end of the 5th century B.C., either as peaceful emigrants in search of wealth, or because their ancestors had arrived with those that conquered Bologna and the Po valley.

Volterra's influence may have spread even further. The only Etruscan inscription in Piedmont, found at Busca, near Pinerolo, is on a limestone slab shaped like a crude stele, rounded at the top as at Volterra. The funerary inscription runs all around it between two incised framing lines, as at Volterra. But this may be simple coincidence. The fact that the horse-shoe stele of Bologna, unknown in the rest of Etruria, is found, even if infrequently, along the road from Bologna to Volterra—at Panzano in Chianti, at Montaione, at Monteriggioni in the Valdelsa—and in Volterra itself between the 5th and 3rd centuries B.C., is significant. In Volterra the fragmentary stele of Laris Hekina from the end of the 5th century B.C. belongs to this type. So does another 3rdcentury stele. In the 2nd century B.C. horseshoe stelae were no longer used in Bologna, but three 2nd-century B.C. horseshoe stelae were found at Castiglioncello, near Volterra.

In the beginning at least, Volterra's expansion was probably of an agricultural nature, as, by the way, was that of Clusium. Volterra was primarily an agricultural centre, as shown in 205 B.C. by the grain it contributed to Scipio's campaign. This explains why metals had not a

great importance for Volterra in the archaic period and why there were few imported objects, especially in the Orientalizing style. Agriculture gave the town a moderate but unfailing prosperity and bloom from the 4th century on. The mines in the valley of the Cecina were probably not exploited until the 4th century B.C.

In the 4th century B.C. the influence of Volterra extended to the Arno and the Val di Chiana. If this area of artistic influence corresponded to political dominion, Volterra's territory would have been one of the most extensive among Etruscan cities.

It is difficult to establish just what Volterra's relationship was with Pisa, the city that appears in the 6th century at the mouth of the Arno. There was probably a road along the valley of the river Era which reached the Arno. This road was undoubtedly important in Villanovan times since Volterra's earliest cemetery extends in that direction. But it was not until the 4th to 3rd centuries, the period of Volterran expansion, that the valley was thickly settled. Chamber tombs with alabaster urns and a Volterran crater have been found there. Only Lari had a few pozzetto tombs dating to the 7th century B.C.

The area near the Arno does not seem to have had important settlements until the 3rd century B.C., but Volterra was probably in contact with Pisa as well as with the Ligurians before this. It is also quite likely that Volterra herself temporarily conquered the area north of the Arno, inhabited by a people whom the Romans called Ligurians (p. 7).

The Territory North of the Arno Florence; Fiesole

The few late Villanovan tombs of the pozzetto and dolio type found in Florence are all that remains of the earliest, or one of the earliest settlements in the Florentine area. This early settlement was probably the result of two facts: a ford across the Arno and the existence of two roads that met there—one from Chiusi, Arezzo and the Val di Chiana, another from Vetulonia, Populonia, and Volterra.

• Our knowledge of the territory north of the Arno has been greatly increased recently. The Etruscans seem to have been spread out through the eastern part, from the river Ombrone to the Apennines, much more than was previously thought. New tombs and new monuments have appeared. A settlement seems to have existed near Artimino, which

Cicero probably mentioned (Ad Att., I, 19) in a passage which has never been taken into account since the editors had 'corrected' the 'Artimino' given in manuscripts to 'Arretium'.

In their architecture two tombs of the late 7th and 6th centuries, the 'Mula' and the 'Montagnola', near Quinto Fiorentino, recall the Volterran ones of Casal Marittimo and Casaglia. They are circular in plan, are built of limestone blocks and have a false dome. La Mula was already known in the Renaissance and has been so transformed that it is impossible to say what it was like. The tomb of the Montagnola is, architecturally, almost intact. It is larger and more imposing than the Volterran tombs and like these has a central pier and a false dome. It is the only Etruscan tholos with two side cellae in addition to the central chamber. What remains of the tomb furniture is interesting, particularly because much of it was imported, a rather unexpected fact in this far corner of Etruria. The incised tridacna shell and possibly the engraved ostrich egg come from the East; other objects-ivory, bone and bronze plaques-are Etruscan and probably not prior to 600 B.C. They seem to have been made in south Etruria—Vulci, Tarquinii, Caere. A fragment of a carved plaque has a hippocamp similar to one on a nenfro slab in Tarquinia. These objects were probably imported via Clusium where ivory objects arrived.

According to a recent hypothesis these imports could have come along the Arno, from Pisa. This is not confirmed by finds, which do not as yet go back earlier than the 5th century B.C. Ancient authors knew nothing either about the origins of the city or its inhabitants. According to Strabo (V, 2, 5) Pisa was founded by the Pisati of the Peloponnese. A Mycenaean foundation has also recently been suggested. Again, there are no proofs. As far as we know it seems to have been a maritime centre. Settlements and villages in the territory around Pisa, north of the Arno, date no further back than the early 6th and 5th centuries. The earliest tombs are of this period.

Recent excavations north of Pisa, at S. Rocchino near Massarosa, have brought to light huts built on piles in the marsh near Massaciuccoli. A few pottery fragments with Etruscan letters have been found. The settlement seems to date from the late 7th to the 5th century B.C. A bucchero cup with an Etruscan inscription is said to have been found in the 19th century at Querceta, near Seravezza, but the provenance is not sure. The same region has cemeteries and isolated tombs, attributed to the 'Ligurians', and dating from the 6th century

THE TERRITORY NORTH OF THE ARNO; FLORENCE; FIESOLE

B.C. on. These are the characteristic 'cassetta' tombs, small fossa tombs lined with stone slabs. According to Livy this area seems to have belonged to Pisa in the 3rd century B.C.

So far what we know seems to exclude the existence of a road that led from Pisa to Florence along the Arno prior to the 3rd century B.C. The tombs along the Arno and close to it are of this date or later. Archaic tombs and settlements are found only along the route from Volterra to Florence (p. 154), far from the river. Nor does the Arno seem to have been used in archaic times for communications or as a route for transmitting artistic influences and importations. Even if the river was navigable beyond Pisa—but Strabo seems to exclude this—no traces of towns or settlements have so far been found along its course from Pisa to the eastern extremity of the plain. The earliest archaic site is Artimino, in that part of the valley we know to have been inhabited by the Etruscans. Its excavation looks quite promising.

Judging from its tombs the Etruscan area north of the Arno, between Artimino and the Apennines, was rich. Next to simple tombs we find chamber tombs with false domes or false vaults, covered by mounds of earth. What is left of the tomb furniture includes imported material from the rest of Etruria. This suggests a problem, which, as yet, has not been solved. In the 2nd century B.C. the Ligurians in the Appenines lived very near the plain inhabited by the Etruscans. There are 'Ligurian' tombs at Monte a Colle near Montecatini, at Piteglio, Caroggio, Montale Agliana, Germinaia, in other words in the foothills of the Apennines, but they are late. An isolated tomb at Marliana, near Pistoia, goes back to the 5th century. What was the relationship between the Ligurians and the Etruscans living in the Arno valley? There is nothing to indicate that the Ligurians were 'bad neighbours' as, according to Strabo, were those near Pisa.

A closely knit group of funerary sculptures comes from the area between the Sieve and the Ombrone rivers, north of the Arno. So far, they are the only proof of a local artistic activity. We find the characteristic rectangular stelae, similar to those of Rusellae, Vetulonia and Volterra, and ovoid or horseshoe stelae. There is also a second type of funeral monument, the cippi. They have different shapes: pilaster, sphere, pine-cone. Cippi were quite usual in south Etruria, but their shapes are generally different and they are undecorated. The pilastershaped cippi of the Arno valley were decorated on all four sides and often crowned by a sphere or a pine-cone.

The earliest stele is that of Larth Ninie, found at Fiesole. It is rectangular and rounded at the top, and resembles the Volterran stele of Avile Tite in shape and in the motif of the warrior with a lance. The full tense line of the breast is also found in Volterra. In his belt Larth Ninie has a hatchet. This is the only time it appears in Etruria as a war weapon. Elsewhere the hatchet was used for hunting, as was the spear, but I do not believe that Larth Ninie was a hunter. The war hatchet is found on the menhir statues of the 'Ligurians' who lived in the valleys of the rivers Magra and Serchio, and in north Italy, for instance, on the Certosa situla. The hatchet carved on the stele of Larth Ninie may be due to the influence of a non-Etruscan people who lived in close contact with the Etruscans and perhaps also to the provincialism of the inhabitants. This stele, the earliest in the area, was dated at around 520-510 B.C. on the basis of comparisons with Caeretan and Greek works. The date will have to be lowered to around 500 B.C.: the whole series of the so-called 'Fiesole stelae' are the work of a local school, which used local materials. There must have been a considerable time lag—they have an obvious tie with Volterra both in shape and decoration as had a stele, now lost, found at Casale, near Castello. On it the dead man had the characteristic dagger found on the stelae of Volterra and Rusellae.

Other Fiesole stelae are later and can be dated in the 5th century. They differ from Volterran pieces in that although rectangular, they are crowned by a palmette and decorated in panels which recall the decoration of the Clusine cippi. Some of the decorative motifs are also reminiscent of Clusium—the banquet, men seated on cross-legged stools, the players on the stele of Antella.

One type of stele, the ovoid horse-shoe stele, has not been found anywhere else. True, many ovoid stelae were found at Bologna and a few at Volterra, but they are rounded above and tapering below, which is just the opposite of the ovoid stelae north of the Arno, which are rounded below and tapering above, where they are crowned by a palmette. This shape is a horseshoe stele turned upside down and seems to be a local development.

The cippi, whatever their shape, seem to be clearly influenced by Orvieto and Clusium.

The territory north of the Arno is where both stelae and cippi underwent their greatest development. This may be due to influences from the Po valley, where the stele was the most usual funeral monument in Bologna. But its origins in our territory go back to Volterra, which seems to have exerted a considerable influence here from 600 B.C. on. Then in the first half of the 5th century Clusine influence began to predominate. Even so, the rare cinerary urns, dating to the 3rd century and later, found in the area are still of Volterran type. It should be noted that the altar in front of the earliest temple in Fiesole (ancient 'Faesulae'), dating to the 3rd century B.C., has a frieze of Ionian ovolo moulding just like those on the Volterran urns.

A few bronzes found in the area may have been made locally.

Tombs were not grouped in cemeteries but were isolated and often quite far apart. Tombs of the 6th and 5th centuries are scattered over a vast area of about 150 square kilometres. Only at Artimino do the tombs seem to have been in groups, but elsewhere they cannot be identified with specific settlements and are the isolated burials characteristic of landowners.

This area between the Arno and the Apennines is the extreme northeastern part of the territory inhabited by the Etruscans. They evidently stopped at the foot of the mountains, just as they had in the Val di Chiana. The tombs, stelae, and occasional bronzes tell us that these peaceful farming people lived a tranquil life on fertile lands, far from each other. The Ligurians who inhabited the Apennines may not have been as fierce as they were three centuries later when the Romans tried to conquer them. Or perhaps the Etruscan expansion on the other side of the Apennines, in the Po valley, was enough to keep them in hand. Peace and safety were essential for the Etruscan road which led along the Ombrone and Reno valleys to Marzabotto and Bologna, and crossed the Apennines. Evidence of contact on the part of Volterra and of the area north of the Arno with the Po valley are found along this road.

In the 5th century stelae and cippi were common in Marzabotto and especially in Bologna. A pine-cone cippus from Marzabotto has a quadrangular base and a ram's head in relief at each corner. Similar cippus bases were found in Bologna, and, in Etruria, at Volterra.

A rectangular stele rounded at the top and with the figure of the dead man in relief is a unique find in Bologna. It belongs to the 5th century B.C. and is completely different from the horseshoe-shaped stelae usual in 5th century Bologna. It recalls the four archaic stelae from Volterra—that of Avile Tite and the ones from Laiatico, Pomarance, and Montaione—but is even closer to the Fiesole stele of Larth Ninie in the hair-style of the figure.

A squarish pilaster-shaped cippus from Marzabotto reveals contacts with the territory north of the Arno both in its form and in the unusual decoration of spirals and palmettes carved in relief above the figure. This kind of decoration appears in the cippi of Settimello and Artimino, but in the round rather than in relief.

Artistic and cultural influences from the Po valley (Etruria Padana) arrived in Etruria in the 5th century via the valleys of the Reno and the Ombrone. It is not chance that a theme often found on Bolognese funerary stelae from the 6th century on, the journey to the Underworld, appears in the territory north of the Arno around the middle of the 5th century B.C. (stele of Sansepolcro). In Chiusi the subject appears on urns and cippi of the first half of the 5th century B.C.; in Tarquinia it is in the Tomba Querciola I of about the middle of the 4th century B.C. But the idea of depicting it on stelae, tomb paintings, sarcophagi, and urns probably came from the Po valley in the 5th century when tradition has it that the Etruscans were there. The Bolognese horseshoe stele, unknown in Etruria prior to the 5th century, reached Etruria about the same time.

The earliest finds in the city of Faesulae (Fiesole) are 3rd century B.C. Recent exploration and excavations have shown that the settlement on the hill of Fiesole is the result of the development which took place throughout Etruria between the 3rd and the 1st centuries B.C. A small unpretentious place of worship on the hill preceded the city; the votive deposit dates perhaps to the 4th century B.C.

One of the earliest buildings in Fiesole is a temple from the beginning of the 3rd century B.C. It has a particular interest, because the walls of the temple are preserved and because of the unusual plan: a single cella and open date (Pl. 3d). It was built on a high basement, with walls on three sides, and was open on the front that had two columns between the side walls. Inside, against the rear wall, was a small rectangular cella for the divinity. A staircase led up to the front.

In the late 7th century the Etruscans settled in the Mugello, north of Florence and Fiesole, between the Arno and the Sieve rivers. Some cippi and stelae were found there. At Poggio di Colle, near Vicchio, a settlement existed from the 7th to the 2nd century B.C. There are chamber tombs with a tumulus.

Chiusi; Arezzo; Cortona; Perugia

The most famous city in north Etruria was Clusium (Chiusi-see map, p. 165), perhaps because one of its kings, Porsenna, is mentioned in the legendary accounts of the history of Rome. We have the Latin name for Chiusi, 'Clusium', and two names for the Etruscan period. Livy (X, 25) called it 'Camars', while some Etruscan inscriptions, one of which is from Chiusi, give the forms 'clevsinas', 'clevinsl', which are thought to give us the ancient name of the city, 'Clevsin'. The explanations of the double name are rather unsatisfactory. Some scholars believe 'Camars' to be the Umbrian name of Chiusi and 'Clevsin' the Etruscan one. Others have suggested the existence of two different cities-'Camars' is the name of modern Chiusi, and 'Clevsin' is an unidentified city in south Etruria. According to some scholars a series of coins inscribed Cha or Ch are Clusine, and so are coins bearing the inscription 'Cha, Vetalu, Pupluna', indicating a political or commercial league between Camars, Vetulonia and Populonia. But other scholars only accept the name of Populonia.

In eastern Etruria, between the Arno and Orvieto, two important centres existed in the Villanovan period, Chiusi and, further south, near the mountain of Cetona, Sarteano.

Both centres have Villanovan cemeteries. North of Chiusi, Poggio Renzo is the earliest Villanovan cemetery and also has the greatest number of pozzetto tombs. West and south-west of Chiusi are the two cemeteries of Fornace and Fonte all'Aia. Sarteano has two Villanovan cemeteries, Solaia and Sferracavalli. On the road to the coast Castelluccio di Pienza also has Villanovan tombs, but is less important. Some scholars believe the Sarteano tombs to be earlier than tombs at Chiusi. True, the Villanovan of Sarteano is simpler, but this may be due to its being more provincial. By the 7th century B.C. Clusium already was the most important city in north-east Etruria, as is proved by the many cemeteries.

Clusium was situated on a hill which dominates the valley of the Clanis (Chiana). Thanks to this situation she was able to develop into an important city. At that time the river Clanis was an affluent of the Tiber and was navigable, providing an easy route to the south. The area was extremely fertile, and famous in antiquity for its products.

The city's wealth was based on agriculture and was therefore not as spectacular as in the cities along the coast, but had more a solid base, without those inevitable ups and downs connected with commerce. Livy (XXVIII, 45, 5) mentioned Clusium's wheat; Dionysius of Halicarnassus (XIII, 10, 11) its wine and oil; Strabo (V, 2, 9) its game and fish. Clusium is the only Etruscan city whose development can be followed down to Roman times.

Its isolated position, and, at the same time, the easy communications with the Tyrrhenian coast, left their mark on the production. Clusium received artistic impulses from abroad via the coastal cities, never directly. The motifs, style and techniques Clusium borrowed and adapted as best it saw fit continued to be used even after they had fallen into disuse in the city of origin. This fact must always be kept in mind in dating Clusium's production. While comparisons with Greece provide the earliest possible date and nothing more, there must be time for the motif, or the style, to arrive in southern Etruria, affirm itself, and then move on to Clusium.

Nothing is left of the Etruscan city which was on the site of modern Chiusi. Its cemeteries, plundered of their finest bronzes and jewellery time and again ever since antiquity, are widespread. They are numerous in the north, towards the Lake of Chiusi and the Val di Chiana, and to the west towards the Val d'Orcia and Monte Amiata. Those to the south of the city are less important and later. Finds antedating the 5th century B.C. are rare on the east, towards Lake Trasimeno. The tombs show a gradual development, without interruptions or sharp breaks, from the earliest pozzetto tombs, to the ziro and chamber tombs. The pozzetto tombs, which are often lined with pebbles, have the usual Villanovan ash urn. No hut urns have been found. Fossa inhumation graves are also missing. Inhumation began late-the earliest examples are in chamber tombs of the 6th century B.C. The ziro tombs are characteristic of Chiusi and the surrounding area. The ash urn was placed inside a large, unglazed terracotta jar of the kind locally called ziro, but tomb furniture was also set outside the ziro. The earliest ziro tombs still have a Villanovan ash urn. In later tombs the urns are of all kinds of shapes and materials: bronze with a ribbon or a cast handle; impasto, with small mobile figures and a large human figure on the lid; ovoid with a human mask in hammered bronze tied to the urn. The characteristic canopic jars (Pl. 75) are also found in ziro and in chamber tombs. They are ash urns with an ovoid body and a cover in the shape of a human head, more or less rudimental. Rudimental modelling is not always a sign that the head is early. In some canopic jars stylization seems to be intentional (Pl. 75a). In reference to the more evolved canopic jars some scholars speak of naturalism and of the beginnings of portraiture. At first sight the more evolved heads really do seem to be portraits; a desire to emphasize individual characteristics seems evident in the bony face with its high cheekbones, the long straight narrow nose, the prominent chin, the thin, tightly closed, protruding lips. But when we are faced with a whole roomful of canopic jars in a museum, when these so-called 'individual features' are seen on every urn, we can only conclude that the heads are not portraits. Sometimes the ash urn, or canopic jar, rests on a chair with a rectangular or semi-circular back, in sheet bronze or impasto, like those carved out of the tufa in the Caeretan tombs. Large bosses on the impasto seats imitate the nail heads of the metal prototypes.

At least one canopic jar was found outside Chiusi—in Bisenzio. The provenance of those supposedly found at Caere is doubtful. The ossuaries from Saturnia, with the cover in the form of an elongated ball, may have been influenced by Clusium.

Objects imported from the cities on the coast and local imitations appear in the ziro tombs of the 7th and 6th centuries and in the chamber tombs. Some fibulae in silver and electrum found at Chiusi and Castelluccio di Pienza came from southern Etruria. No local imitations have so far been found. The gilded silver pail with the inscription Plicasnas (Florence, Museo Archeologico) and the silver plate found with it—which has since disappeared, but Inghirami and Dempster made fairly faithful drawings of it—were made in southern Etruria and imported to Clusium. The rare examples of bucchero sottile and a Caeretan cup with animals in relief, similar to those found at Caere in the Sorbo cemetery, also came from south Etruria (Caere?). The ivory pyxides found in the chamber tombs of La Pania and Fonterotella presumably are also from Caere. They probably date to the first half of the 6th century B.C. At the end of the 6th century Tarquinia sent carved ivory plaques to be used for the decoration of small boxes.

In the 7th century the number of inhabited centres around Clusium increased, but they generally kept near the town. New cemeteries, besides the Villanovan ones, show that the city prospered and expanded. Sarteano and Castelluccio di Pienza also flourished. New settlements arose at Dolciano, north of Clusium, and at Cancelli, to the south.

The extent of Clusium's expansion is also indicated by isolated ziro tombs, often found far from inhabited centres. They seem to indicate an attempt to set up new agricultural settlements on the mountain of Cetona to the south, in the direction of the Trasimeno lake to the east, and at Chianciano to the north. The few impasto vases found at Mezzavia, below Cortona, may come from some such settlement: no traces of a Villanovan cemetery have so far been found there. Siena does not seem to have been an Etruscan centre.

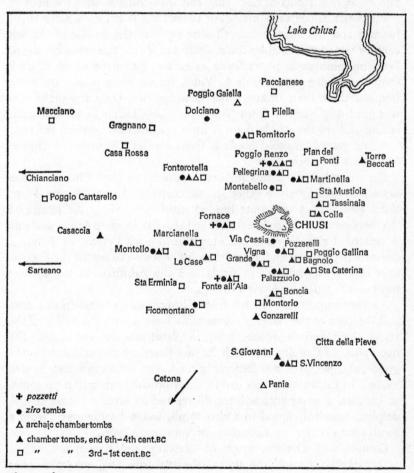

Chiusi and its cemeteries

Greek vases also arrived via maritime Etruria. No Proto-Corinthian, Corinthian or eastern Mediterranean vases were found. But there are many Etrusco-Corinthian vases, often of the simpler type, alabastra and aryballoi, decorated with lines and horizontal bands and used for unguents and perfumes. Some may have been made in Chiusi, others were imported. Attic black-figure and red-figure vases are frequentthe earliest examples date to the second quarter of the 6th century B.C. One of these is the famous crater signed by Clitias and Ergotimus, known as the 'François vase' after the archaeologist who found it at Fonterotella. Greek vases may have arrived via Vulci, since some small bronzes and the most archaic Clusine cippi of the middle of the 6th century were influenced by the sculpture of Vulci. The extensive use of lions or sphinxes in pietra fetida or tufa as guardians of the Clusine tombs may also be traceable to Vulci, for funerary statues are more frequent there than in any other Etruscan city. Only the motif was was probably derived from Vulci, for the Clusine lions are much cruder and on the whole there is little resemblance between the two.

A fine granulated gold fibula is from southern Etruria. No Clusine imitations have been found.

The route by which this imported material reached Clusium is the same route followed by other artistic currents of south Etruria. From Vulci (see above) the route headed north-east, along the course of the Fiora river and passed north of the Lake of Bolsena. At Acquapendente it crossed the Paglia river, reaching Clusium via Cetona, or Sarteano. Imports from Caere and Tarquinian influence—evident in the decoration of the cippi in pietra fetida and the paintings in the Clusine tombs—may also have taken this route.

Another important road led from Clusium to Castelluccio di Pienza and the pass of the Foce: it connected Clusium with the valley of the rivers Orcia and Ombrone, Rusellae, Vetulonia and Populonia. The necropolis of Castelluccio, with its fine jewellery and other imported goods, shows that it was frequently used. Vetulonian influence is also evident in Clusium. An ash urn in sheet bronze with griffin protomes as handles, a cover with a lotus flower and an incense burner (Philadelphia, Museum) found in a ziro tomb, and a bronze pyxis from a tomb near Colmar, are imitations of Vetulonian types.

Contact with Orvieto, south of Clusium, and consequent artistic and trade relations with the city and the intervening region seem to have been relatively unimportant, at least to judge from Clusium's southern

cemeteries which have fewer tombs and are limited to the immediate vicinity of the town.

The 6th century marked the beginning of a period of great artistic activity, which can be followed almost exclusively through its tombs. There were workshops of sculptors, of painters, of bronze workers. Many bases for funerary cippi, sarcophagi, and urns were produced from the second half of the 6th century to the end of the 5th century B.C. The cinerary statues in pietra fetida are contemporary with the cippi but are probably from a different workshop. These male and female figures may be seated or standing. The head closes a cavity hewn out of the chest for the ashes. Modified versions which kept up to date with the new stylistic currents continued to be made from the close of the 6th up to the end of the 4th century B.C. Unfortunately these statues, which are so important for a knowledge of Clusine art, are made of an extremely friable material. In the 19th century when they were found, they were often in fragments and were freely restored. Recent restorations of great interest have revealed that details, heads, and even entire figures, were added and modified. It will not be possible to study Clusine funerary sculpture in the round until the 19th-century additions have been removed.

The earliest urn-statues are in two or more pieces. The body is seen as a cubical mass topped by a powerful head. The massive bull necks are reminiscent of the canopic urns where such necks served a purpose which has been superseded in the statues. The earliest examples show the hair cut at the base of the neck as in the Greek Daedalic statues of the 7th century B.C. and in some Etruscan pieces from the first half of the 6th century. Clusium, with its usual time lag, used the motif here and in small bronzes even after 500 B.C.

The only standing male statue dates to the 5th century B.C. This is the first indication of Attic influence in Clusine sculpture. The head no longer has anything Ionian about it, either in profile or from the front. The carefully carved face is thin, with a long thin nose and the bony structure indicated under the taut skin. The body is still a cylindrical mass and the sculptor has shown no desire to articulate it. It is evidently still under the influence of the characteristic 6th-century B.C. busts found in Clusine cemeteries and placed on undecorated superimposed drums. The male statue is also a column with a bust on top, but the column is monolithic. Although its provenance is Chianciano, it was made in a Clusine workshop.

The statue of a woman with a boy in her lap, seated on a throne supported by two sphinxes (the heads are partly modern) shows just how Clusine production reacted to outside influences. Although the figure follows the new stylistic currents, it harks back to the figures of seated men influenced by Ionian art. It comes from a chamber tomb in Chianciano which was one of the richest centres in Clusine territory. It is rather useless to establish parallels between this statue (and others like it) and the seated statues of the Branchidi at Miletus as well as other Greek statues, when we are dealing with a city like Clusium which had no direct contacts with Greece. But small votive terracottas with one or more enthroned female figures, representing the divinity or the offerer, were frequently used as offerings to various goddesses in southern Etruria—as in many other lands. This is where the sculptors of Clusium probably got their models of a seated woman. They then extended the motif to the male figure, changing it into a representation of the dead man whose ashes were preserved within. A new motif was introduced in the sarcophagus-like urns: the man, half reclining on the banquet couch, had his wife or a winged demon sitting at his feet. The finest example is from Chianciano.

The dignity and severity of these statues and of sarcophagi like the one from Chianciano are near the archaic severe style, but it is always difficult in Etruria, and even more so at Clusium, to decide if and up to what point this was due to a time lag, Dates vary from between the first half of the 5th and the second half of the 4th century B.C. depending on how this problem has been solved.

The quality of later examples is inferior. One of the most recent, the only one in bronze, is an exception. It shows a young man reclining on the banquet couch (Museum, Leningrad). It dates to the end of the 4th or the early 3rd century B.C. Although the piece was found in a tomb in Perugia, it was probably made in Clusium. It is the only large bronze which we can attribute to Clusium. No comparisons exist for other bronzes. Nor are the numerous small bronzes, found in Chiusi and near it, and now in museums, of any help. They date to all periods and may have been made in Clusine workshops.

A terracotta antefix in the Museum at Chiusi (Pl. 78a) was also influenced by Greek archaic severe style. The oval of the face and its severe dignity make it one of the finest pieces in the museum. There is something mysterious about the slanting eyes. Fortunately the shell, which usually frames the head and makes it look heavier, is missing.

So far no other important architectural terracottas have been found. Recent excavations at Murlo (Siena) have brought to light an interesting place of worship, with terracotta sculptures and revetment plaques which are very original and unlike those used in southern Etruria.

For its paintings Clusium turned to Tarquinian motifs and inspiration. The painted tombs, and there are quite a lot, have the usual repertory of 6th- and ς th-century Tarquinian themes—athletic contests, banquets, the dance. It has been said that they are more provincial and un-Greek than Tarquinian paintings. True, they are more provincial, but some of the 'un-Greek' motifs, which had seemed to be limited to Clusium, have been found lately at Tarquinia. The recently discovered Tomb of the Olympic Games at Tarquinia had exploited the motif of the chariot race with the horse that has stumbled sending the charioteer flying (Pl. 2), a motif which until a few years ago had seemed to be specifically Clusine. The Tomb of the Jugglers (Tomba dei Giocolierei, Pl. 35) has also proved that the scene showing a young acrobat dancing before the dead, in the Tomb of the Monkey at Clusium, has a precedent in Tarquinia.

Motifs from Tarquinian painting were also used in the decoration of circular or square bases for funerary cippi, and on the small urns and sarcophagi in pietra fetida. The earliest bases date to the second half of the 6th century, the latest ones to the end of the 5th century B.C., but the best examples are no later than the first half of the century. The flat, extremely low relief is cut into the smooth surface and the details are incised. The colour, which has almost disappeared, made it look very like painting. The composition is carefully worked out and strictly symmetrical, the figures are well related to each other. The strigilated frames around the scenes on urns and sarcophagi recall those of the ivory plaques which decorated wooden boxes. Some reliefs seem to have been inspired by scenes of real life, such as the hunt (Pl. 79a). The athletic contests on the cippi are summaries or extracts of the tomb paintings in Tarquinia and in Chiusi itself and they may actually have been performed in the funeral ceremonies of important persons. The gatherings of men and women and the banquets which frequently accompany the scene of the deceased lying in state reproduce customs which still could be found in the surrounding countryside a hundred years ago: when a person died, his relatives gathered in his house for a banquet at the end of the funeral service.

A fine sarcophagus (early 5th century) found in a chamber tomb in

nearby Perugia, but made in Clusium, differs somewhat for the complexity of the scene, the composition and the subject. That strict symmetry which is characteristic even in works of poor quality is also absent. It may be that the dead man insisted on a martial episode from his own life, for the scene gives us a long procession of marching men, bound prisoners, pack animals, and, at the end of the procession, a pretty group of captured oxen and goats (Pl. 80).

A series of five late tombs (2nd century B.C.) consist of a single rectangular chamber, built of dressed blocks of travertine and covered by a barrel vault. The best known one is the Tomb of the Granduca, north of Chiusi, with folding doors, the two wings of travertine.

The last centuries of Etruscan Clusium are characterized by the production of sarcophagi and ash urns: the rectangular chest is usually decorated in relief; on the cover reclines the figure of the deceased. They are inspired by south Etruria, probably Tarquinia, which was still in close contact with Clusium. Some of the sarcophagi in Tarquinian tombs may even have been done in a Clusine workshop.

This production began in the 3rd century. The deceased is shown half-reclining on the cover of both sarcophagi and urns. His left elbow rests on cushions; he has a patera—a large cup—in his right hand. The urns are miniature sarcophagi. The relief on the chest is close to classic Greek tradition, with an ideal background and figures moving parallel to the background. Relief is never excessive; the symmetrical composition generally avoids the useless, uninteresting filler figures at the sides. The figures are robust and not exaggeratedly tall or intent on finding graceful poses, like those on Volterran urns. Some figures on the covers, such as Larth Sentinate son of Cae (Pl. 81b), or the two Seianti women (Pl. 82), are outstanding. The best period for urns is the second half of the second century. Urns were imported by nearby towns—Montepulciano, Sarteano, and in the Val di Chiana as far as the area around Siena to the west, and beyond the Trasimeno lake to the east.

Bucchero pesante is typical of Clusium, at least from the 6th century on, and perhaps even from the second half of the 7th century B.C. This ware was not produced in Clusium alone but may have been made in other towns in the area, such as Sarteano. There were buccheros a cilindretto (cylinder-decorated), bucchero pesante properly speaking, and undecorated ware. The decoration a cilindretto was done by rolling a cylinder in which the motif was cut on the soft clay and thus impressing

the design into the surface of the bucchero pot. These scenes have no particular meaning and a limited number of figures is monotonously repeated over and over. But there are a few pieces of greater interest. On one bucchero (Pl. 83a) two figures with a sceptre or lance are seated on folding stools in front of a gaming table with some pieces on it. This scene recalls similar ones painted on Attic black-figure vases in the second half of the 6th century: the best known—two Greek heroes playing dice—was painted by Exekias. But something else has been added to the scene on the bucchero—above the table is a cup with two handles of the kind used for wine. When they are thirsty the players will stop and have a drink (Pl. 83a).

The bucchero pesante with its large amphoras, pitchers, or hydriae, with thick walls and spout in the shape of a human or an animal head, plastic decoration on the covers, relief ornamentation on the body, is really heavy, baroque and overly ornate (above all when one is confronted with a whole museum room full of bucchero ware). But if we study small groups it is extremely decorative. These buccheros were ornamental or funerary, for their walls are too porous to contain liquids.

No black-figure pottery was made in Clusium. Some red-figure cups from the 4th century B.C. have been attributed to Clusium but they are contested by Volterra (Pl. 83b).

Clusium is the only city in Etruria for which we can, to some extent, follow the various stages of expansion and their direction. The Valle della Chiana to the north and the region up to the Tiber to the east, beyond the Trasimeno lake, became part of Clusine territory in a later phase.

The river Chiana, a tributary of the Arno, now runs from one end to the other of the long wide valley which lies between Chiusi and the Arno (see the map of the region on p. 175). In antiquity the river Chiana was a tributary of the Paglia, which was in turn a tributary of the Tiber. In the Middle Ages the valley was swampy and malaria-ridden but this does not seem to have been the case in Etruscan or Roman times for there were frequent settlements on the lowest slopes of the adjacent hills. And this means that the region was both fertile and healthy. Development of the valley of the Chiana began early in the 6th century B.C. and made rapid progress. The agricultural character of this expansion is evident in the types of settlement—farms, clusters of houses, villages, all with their tombs, either isolated or in groups, and the small cemeteries at the edge of the valley on the lowest slopes of the hills. There were no large cities or trade centres.

The settlers came from Clusium because settlements dating from the 6th to the 4th century B.C. are only in the southern part of the valley. The northern limit of this early expansion is given on the west by Bettolle and Foiano della Chiana (two small settlements rich enough to have black- and red-figure Attic vases), by the votive deposit of Brolio and by Marciano, where an archaic torso and inscriptions were found. On the east, the limit is given by the three rich monumental tombs below Cortona, at the Sordo and at Camucia. They have false vaults, are covered by tumuli, are far apart and isolated and were evidently the family tombs of rich landowners. All these small centres in the Val di Chiana depended on Clusium: the bronzes from Brolio and the torso from Marciano were probably made at Clusium. These settlements increased in number in the 4th and 3rd centuries B.C. Only then did new centres appear in northern Val di Chiana. Late Etruscan coins with the legend Peithesa have been found in the Val di Chiana, but we do not know to which centre they belong.

Clusium communicated with the Arno valley and the region beyond, with Bologna and the plain of the Po via the Val di Chiana, the ford at Florence, the valleys of the Ombrone and the Reno (see Volterra).

The problems presented by the two cities in the valley of the Chiana— Cortona and Arezzo—are anything but simple.

Etruscan Arezzo apparently occupied only a small part of the modern city. The hill on which it was probably built controlled the northern end of the Val di Chiana. It is lower, however, and more insignificant than is usual for Etruscan centres. It seems rather to be the site of a small agricultural centre such as those in the valley of the Chiana.

According to Vitruvius (II, 8) it had brick walls. Part of these walls may have been found north—east of the city, but they are Roman rather than Etruscan. Remains of walls in limestone blocks, thought to be Etruscan, are only part of the medieval wall. The earliest Etruscan finds are some fine terracotta plaques from the late first half of the 5th century, which decorated the raking cornice of a pediment. The battle scenes they depict are in a relief so high that it is almost in the round. Many fragments of later architectural terracottas, also from temples, have been found in other parts of the modern city. Arezzo evidently had a good school of terracotta artists: the terracotta fragments found in a heap not far from the brick wall are striking. The head of a youth with

delicate, almost feminine features, framed by curls and wearing a Phrygian cap, and the helmeted head of a woman, perhaps Athena, are outstanding for the swift touch and fine modelling.

Bronzes of various periods have been found at Arezzo and near it. A number of them came to light outside the Etruscan and Roman city, along the road to Florence, when the Medici fortifications were built in 1552. Among these was the famous Chimaera (Florence, Museo Archeologico), said to have been restored by Benvenuto Cellini, though that is doubtful. Some years prior to this the large bronze Minerva (also now in the Museo Archeologico at Florence) was found in the opposite part of the town. It is impossible to say whether these and other bronzes were locally made. In the 3rd century B.C. Arezzo was an industrial metallurgic centre. In 205 B.C. it was the only Etruscan city which supplied Scipio with arms—and a great number too—for the fight against the Carthaginians: 3,000 shields; 3,000 helmets; 50,000 swords, poles, axes, hoes, scythes and other objects. But this industrial production is not necessarily related to an artistic production.

The Etruscan necropolis was to the west of Arezzo, on Poggio del Sole. The earliest tombs, with bucchero vases, or painted pottery vessels, were at the top of the hill and the latest ones at the foot. The few archaic tombs are probably not prior to the first half of the 6th century B.C. In the 4th and 3rd centuries B.C. the tombs increased in number. Arezzo began as a modest settlement, like the villages in the Val di Chiana, and became important later between the 5th and the 4th centuries B.C. The very fact that Arezzo had only one cemetery until the 3rd-2nd century B.C. shows that it was not a large settlement. Compared with Clusium, or even Perugia, the cemetery of Arezzo strikes one as extremely modest.

In the 6th century B.C. the city was still too unimportant to have its own government. It probably depended on Clusium, for Etruscan material is found only along the route that led from Arezzo to Clusium.

Dionysius of Halicarnassus states that Arezzo, together with other cities of north Etruria, helped the Latins against Tarquinius Priscus. But, judging from the finds, Arezzo, if it existed, was quite insignificant at the time. The fragmentary elogium found in Tarquinia, which among other undertakings mentions a war waged against Arezzo by Tarquinia, may be one of those scholarly tales meant to sing the praises of a city or a family. If however the Tarquinian inscription were to be taken as a late proof of some real event, the war could not have taken place until the close of the 4th or the beginning of the 3rd century B.C. Only then, when flourishing economic conditions in the Val di Chiana had brought about an increase in the population, could Arezzo have been independent of Clusium, with a government of its own. Etruscan inscriptions do not mention magistratures, but this does not mean that there were none.

According to its foundation legend Cortona, the Etruscan name of which may have been 'Curtun' (a name given in a votive inscription), is a very ancient town. But an examination of the finds and its cemetery make this extremely doubtful. The city itself has only Roman remains. The walls, which have never been thoroughly studied, do not seem to be as old as they are said to be. The isolated monumental tombs previously mentioned on the plain, at Sodo and Camucia, date to the beginning of the 6th century B.C. They are isolated tombs, not cemeteries, and are too far away from Cortona (over 2 km.) to belong to the city. The later tombs (4th and 3rd centuries B.C.) are nearer the city, and this would be absurd. True, various museums have bronzes 'from Cortona', but are they really from the city? We know that some of them were found in various places in the valley; a few impasto vases which have just recently come to light are too isolated to prove the existence of a Villanovan centre.

In 310—or in 295—B.C. Cortona was mentioned as an important Etruscan centre. On the basis of what we know, I would not dare to date the beginning of the city prior to the 5th century B.C.

Excavations at Murlo (Siena), in the locality of Poggio Civitate, on the hills which separate the Val di Chiana and Chiusi from coastal Etruria, have brought to light a place of worship which probably belonged to the territory of Clusium. It is a quadrangular area, enclosed by walls and porches and with a small building on the west side. The finds seem to indicate that it was built in the second and third quarters of the 6th century B.C. A great many architectural terracottas of interest have been found: antefixes, acroteria, revetment plaques, etc. The decorative motifs are generally like those used in other parts of Etruria, especially in the south. But these terracottas have a distinctive style of their own and the decorative motifs, some of which are not found elsewhere, have been dealt with independently. These include the lateral sima with rosettes alternating with heads of women and felines. Some of the revetment plaques repeat the characteristic motifs of the Clusine 'a cilindretto' buccheros.

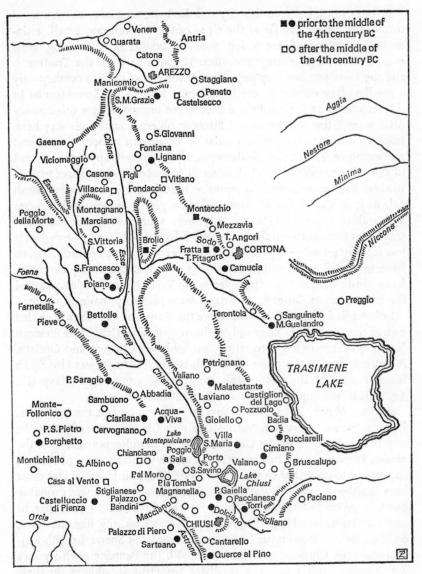

Chiusi and the Val di Chiana

CHIUSI; AREZZO; CORTONA; PERUGIA

East of Chiusi, between this city and the Trasimene lake, an occasional tomb may go back as far as the close of the 6th century. Small settlements consisting of just a few families, typical of a farming area, existed in the 5th century and after. The area between the Trasimeno and the Tiber was not very populous. At the end of the 6th century only a small village existed where Perugia was later to be. Some tombs in the cemeteries of Sperandio and Monteluce prove that late 6th-century Attic vases, a few buccheros and Etruscan objects found their way here. Impasto vases and fragments similar to Villanovan pottery were found at Monteluce. The earliest settlements, all very small, appear at the end of the 6th century: at San Valentino di Marsciano, where three tripods in sheet bronze decorated in repoussé were found in a chamber tomb (Pl. 86); at Castel San Mariano, where a group of beautiful bronzes cast and in repoussé (Pls. 87, 88) were found. They are the most important finds between the Trasimeno lake and the Tiber. The region is too scarsely populated, devoid of artistic experiences and traditions, to have produced such technically fine pieces. Nor were they imported from Clusium. Both the tripods from San Valentino and at least part of the bronzes from Castel San Mariano were probably made in Caere.

Isolated finds like this do not prove the Etruscans had already settled east of the Trasimene. They only indicate that both Greek and Etruscan luxury goods were imported there, probably via Clusium and Orvieto. A century later, at the close of the 5th century, Perugia was already an Etruscan city. At the end of the 4th century, according to Livy (IX, 37, 13), it was one of the most important Etruscan towns.

Servius (Ad Aen., X, 201) states that an Umbrian people, the Sarsinates, lived in Perusia (Perugia), but he also says (Ad Aen., X, 198) that the city had been founded by the Etruscans. It is quite possible that the nearest Etruscan city, Clusium, with a culture similar to that of Perusia, spread out to the Tiber in the 5th century. The land is fertile and must have attracted an agricultural people. Etruscan occupation was probably due to a group of farmers searching for new fertile land rather than to any warlike undertaking. It must have been something like the scene on the Clusine sarcophagus from the necropolis of Sperandio (Pl. 80).

In any case, Clusium was in contact with the Perusine territory and with Orvieto, and acted as a mediator for Etruscan objects on their way to the upper Tiber valley. Objects like the Sperandio sarcophagus are the earliest evidence of the presence of the Etruscans, who, judging from the imports, seem to have come from Clusium. Perugia is on a

naturally fortified site like other Etruscan cities, but its walls are more recent. The large sarcophagus in pietra fetida previously mentioned (pp. 169–70) came from one of the earliest tombs. The finest pieces in the tombs were imported: bucchero vases from Clusium, Attic vases from the Tyrrhenian coast, a few Campanian vases from south Italy, 4th-century Etruscan red-figure vases from Volterra. Local industry produced ceramics and objects for everyday use, perhaps also the bronzes found in the tombs of the 4th to 2nd centuries B.C., and certainly the small ash urns.

The many cemeteries around the city prove that Perugia was flourishing and populous from the 4th to the 2nd century B.C. The large villages which crowded around it, as is always the case with prosperous cities and which can be identified by their cemeteries, are also proof of its importance. A populous centre was north-east of the city, at the Palazzone, where one of the richest and most beautiful tombs of Perugia, that of the Velimna family, better known as the hypogeum of the Volumni, was found in 1842. Recent excavations have shown that the cemetery at the Palazzone is more extensive and important than had been thought.

The small ash urns, generally in travertine, are a characteristic Perusine production. They are later than those made in Clusium and in Volterra. Perugia drew inspiration from both towns, sometimes using the low relief of Clusium, sometimes the very high relief figures, almost detached from the background, of Volterra. Figures move on a high plinth, very similar to a platform, which projects sharply from the wall of the urn. Here, too, as at Volterra, the figures move towards the spectator, but the effect is less pleasing: the relief looks as if it were about to part from the background, since there is no frame at the top or at the sides. Often the relief on the front continues without interruptions on both sides. As far as the subjects are concerned, scenes from the afterlife and the journey to the Underworld are rare. Mythological scenes are less frequent than at Clusium or Volterra: some supposed mythological scenes may simply be battle scenes. The urns are small, almost square, the lid is often gabled, generally forming a pediment above the front panel. In some cases the dead man at a banquet is depicted on the lid, but the scene differs from similar ones found elsewhere. Some late urns are shaped like a wooden chest with a wide flat frame and large nail heads. The work is often crude, due in part to the irregular surface of the travertine and to the fact that the sculptor applied the colour and gilding directly on the stone without preliminary stuccoing. Urns which were first stuccoed, such as those from the tomb of the Volumni, are extremely rare. On the whole, the quality is poor and only rarely up to that of Clusium or Volterra. Really fine urns, like that of Arnth Velimna in the tomb of the Volumni and a few others, are unusual.

In the preceding chapters we have been able to reconstruct, at least partially, the character of each city thanks to the excavations and finds in the various regions of Etruria. The safest historical source for Etruria is the objects found in tombs, as long as they are studied impartially without preconceived theories and without neglecting artistically uninteresting objects in favour of the finer, more striking examples. They are the only truly Etruscan source and the only one unaltered by personal ideas, or by interpretations and prejudices of the ancient writers whose works we use as historical sources. Archaeological finds are the archive documents of antiquity, documents that have to be studied patiently in museums and in excavation diaries. They are safer and more credible than the scant information handed down by ancient Greek and Latin historians, for, as far as Etruria is concerned, the Greek or Latin author was never contemporary with or even close to the events he describes. On the contrary, centuries often separated the two, and he almost always turned to sources which were not Etruscan and which he reworked to suit himself. At best he adapted information from an Etruscan source to Greek or Roman tradition. And the source he chose was often the one which harmonized best with his personal opinions on the subject, or which interested him and his readers most. But, given the absence of Etruscan historical works, these unreliable sources are all we have in the way of literature.

Although it has been possible to reconstruct partially the history of the Etruscan cities—their beginnings, their economics, what they produced in the way of crafts and art, what their relations were with each other, their commerce, their rise and fall, the differences between one city and the next, in other words the local life—the picture we have drawn is anything but definitive. A single new discovery could change the picture, just as the discovery of new documents in an archive can change medieval or modern history. This is no excuse for basing any reconstruction that we attempt on purely hypothetical or non-existent grounds.

Our picture of the world of the Etruscans is not complete however without some reference to the public and private antiquities of Etruria. The field is difficult and haphazardous, for archaeological, epigraphical

and historical sources are not only extremely scarce but are difficult to interpret.

Many of the ancient texts make more or less casual references to some aspects of Etruscan religion. The Romans were particularly interested in one specific aspect, the discipling etrusca, or the practical norms by which good relations with the gods could be maintained. According to ancient sources there were Etruscan books in which extremely ancient precepts were collected: the teachings of the wise Tages, who suddenly came forth from the earth while a peasant was ploughing his field near Tarquinii; those of a nymph, 'Begoe' or 'Vegoia', who taught men how to interpret lightning and, according to the Agrimensori, how to survey land and set the boundaries. Tages was the son of Genius and a grandson of Jupiter according to a late tradition; he belongs to Tarquinian legend. Vegoia has been related to Clusium, but without sufficient proof.

Various names are given to these Etruscan books by ancient authors: the Libri Fulgurales dealt with lightning and its interpretation; the Libri Rituales gave the rules for founding cities and temples, for surveying fields, etc.; the Libri Fatales were concerned with destiny; the Libri Acheruntici; the Libri Haruspicini, the Libri Tagetici, etc. They may not always be different books and the Libri Tagetici, for example, may have included some of the books mentioned above. These Etruscan books were written at a late date (2nd or 1st century B.C.), when the Etruscans were already quite Romanized. Roman antiquarians of the 1st century B.C. (Caecina and others) based their compilations on these late Etruscan books. And although their works have not reached us, they are quoted from the 1st century B.C. on. The first Roman writer to mention them was Cicero in the 1st century B.C., but the most comprehensive excerpts are much later-from the 1st to the 4th centuries A.D. Just how much of what our sources attribute to the discipling etrusca represents ancient teaching, and how much was added through the centuries as a result of foreign contacts, to conform Etruscan doctrine to Babylonian astrology or to lend authority to recent doctrines, has not yet been determined. A systematic attempt in this sense was made by Professor Weinstock for the lightning doctrine. He succeeded in demonstrating that the exceedingly elementary original doctrines were transformed under the influence of Hellenism and Chaldean doctrines. Franz Cumont has suggested a case of late additions. It is likely that contaminations existed—it would be strange if they did not.

The extremely fragmentary picture of Etruscan religion provided by Greek and Roman writers gives us a religion composed primarily of a series of norms and practical information, of formulae for preserving what the Romans called the pax deorum, that is peace and harmony in the relations between men and the gods. We have no way of knowing just how accurate this picture is. Roman antiquarians, who have told us what little we know about Etruscan religion, handed down primarily what they themselves and their public were interested in. It is therefore quite possible that what we have mirrors Roman attitudes and mentality more than it does Etruscan ones. The Romans were very interested in the doctrine of the haruspices, that is of the priests charged with examining the liver of the sacrificial victims, with interpreting natural phenomena and the will of the gods. But they were not interested in the Etruscan gods, their character or their worship. For the Romans they were foreign gods. In the first century B.C. when information on the Etruscan religion began to be collected in Rome, Etruscan gods may already have been just as vague for Etruria as the ancient divinities of primitive Rome were for the Romans. When the Romans say that the Etruscans were a very religious people, 'religious' may have been interpreted in the Roman sense. That is the Etruscans were 'religious' because they had laws and formulae which taught them how to act so as not to arouse the wrath of the gods, either deliberately or involuntarily. And these formulae were the only part of Etruscan religion which interested Roman scholars and their readers.

That is why we know so little about the Etruscan gods. For the most part we have only names which mean nothing to us. And our information concerning the nature and attributions of these gods, or their worship, is nil. The names written in the sections on the so-called 'liver of Piacenza' are presumably those of divinities. This bronze model of a liver was found in 1878 near Piacenza, in the valley of the Po. The alphabet used in the inscriptions shows that its date is not prior to the 3rd century B.C., but it may be later. At that date the Etruscans had abandoned northern Italy for more than a century and the inhabitants of the Po valley were Roman. The Piacenza liver was not therefore used by Etruscan priests and seers, but by Roman haruspices. This fact is never properly taken into consideration. It does however seem to be of Etruscan make, for the alphabet used is Etruscan. Moreover one of the letters, the m, has a form used in inscriptions after 150 B.C. in an exceedingly limited territory of north Etruria (Cortona, Lucignano,

Montepulciano, Pienza, the Siena area). The importance of the liver is limited by the fact that it belongs to a period when the scrutiny of the liver may have been adapted to Roman ideas and beliefs, or transformed by foreign or even Eastern influences.

The surface of the liver is divided into sections, in each of which the name of one, or perhaps more, divinities is inscribed. We know very little about these gods, absolutely nothing about some. The transliteration of the names is also sometimes doubtful. It has been suggested that the names in some of the compartments were abbreviated or that two or three names were fused into one. In some cases it is extremely difficult to make the names on the liver correspond to those we know from other Etruscan, or Roman, monuments.

The key to the interpretation of the Piacenza liver has been sought in an obscure pamphlet by a late Latin author, Martianus Capella (5th century A.D.), entitled 'The Wedding of Mercury and Philology'. While it has no literary value, it is greatly valued by scholars of Etruscan religion. But the five or six centuries which separate the Etruscan liver and the Roman author counsel us to proceed with great caution—500 years is a long time. Moreover those were the years when Rome came in contact with all the religions of the known world. Eastern religions became particularly fashionable and were assimilated into Roman beliefs. Differences between the liver and Martianus Capella have been noted—and it would be strange indeed if these differences were limited to what we are able to verify and not to other points for which we are unable to do it.

The principal Etruscan god seems to have been Tinia, mentioned four times on the liver and known to us from votive inscriptions. There are no certain representations of Tinia prior to the 6th century B.C., when Greek motifs and patterns were adopted in Etruria and the divinities were represented in Greek guise. Some bronze figurines the earliest are 5th century B.C.—represent a bearded god armed with a thunderbolt, similar to the Greek Zeus. But there is nothing to prove that this Greek type was the Etruscan Tinia. A young beardless man is also often represented with a thunderbolt (a bronze figurine in the Museum of Cortona, another in Rome in the Museo di Villa Giulia, 4th century B.C.?) and he resembles neither a Greek Zeus nor a Roman Jupiter. Tinia is one of the figures that appears most frequently on bronze mirrors, where he is obviously identified with the Greek Zeus. Even so, unlike Zeus he is often shown young and beardless. Which of

the two is the real Tinia? If there were no thunderbolt and above all if he were not identified by the inscription TINIA, it would often be possible to interpret him as Apollo, or some other youthful god. We easily forget—in reference to Tinia as well as the other divinities that in the 6th and 5th century B.C. Etruria imitated foreign Greek models for the iconography of its gods, and from the second half of the 4th century on, those of south Italy, particularly Taranto. How much of what we judge to be Etruscan is an adaptation of Greek ideas and patterns? Not that I want to discredit all hypotheses a priori. I only want to advise caution in drawing conclusions from statues and figurines.

Two other names inscribed on the liver are also known to us from literary sources and votive inscriptions: Uni, identified with the Greek Hera and the Roman Juno, and Selvans, if that is the proper interpretation of the 'Selva' on the liver. Uni was the principal goddess of Veii, and is mentioned in votive inscriptions at Cortona, Pyrgi and perhaps in Perugia and Caere. None of the representations we have is completely free of Greek influence. A sanctuary at Caere has votive inscriptions to Hera and she may have been worshipped by the Greeks who lived there. Volsinii has votive inscriptions dedicated to Selvans and a precinct. Other names inscribed on the liver appear in Etruscan texts and sometimes on mirrors, such as Tecum, Letham and perhaps 'Catha'. The names of a woman, on a frieze which decorated a temple in Bolsena, may be Cilens, but we only have a name. We do not know the character and attributes of the goddess. Other names on the Piacenza liver appear on late monuments (late 4th to 2nd century B.C.), on mirrors on which the character of the god is sometimes rather questionable.

Many scholars have identified the name 'Maris', found on various Etruscan mirrors and in the inscription of Magliano, with the 'Mar', 'Marisl' and 'Mari' on the Piacenza liver. These names sound very near to that of the Roman god Mars: an identification has been suggested. But this hypothesis cannot be accepted, since the Maris on the mirrors is neither an agricultural divinity (as Mars seems to have been in Rome in the archaic period) nor a war god like the later Mars, for he is generally unarmed and only rarely has a spear or sword. On Etruscan mirrors he is a secondary figure without any identifying characteristics. It is not even sure that he is a god and he could just as well have been anyone else. It has also been stated that Maris replaced the real Etruscan

war god, Laran, who appears on Etruscan mirrors armed with a helmet, cuirass, greaves and a drawn sword. But there is no proof for this. Laran appears only on a mirror found at Populonia. He pursues an unknown fleeing figure, Cersclan, who only wears a cuirass. It is the usual fight between two warriors. A great deal of imagination is needed to identify the winner as a war god, who is not mentioned in our sources. But some scholars even give the Etruscans a third war god, Letham. And three war gods for a people who seem more dedicated to commerce and agriculture than to war seems just too many.

We might, if we wanted, list the names of hypothetical divinities identified by scholars in Etruscan inscriptions and monuments. But there is no point in giving a long list of names simply to add after each one that it is purely hypothetical.

The excavations made in Pyrgi since 1957 by the Istituto di Etruscologia e Antichità Italiche of Rome have brought to light a sacred complex of a type previously known in Greece and the Greek colonies but not in Etruria (p. 78). Two temples were found, which may have belonged to the same cult. The earliest, Temple B, is a peripteral temple and Greek in plan. The other, Temple A, has an Italic plan with three cellae and a porch, and is a little later, about 480–470 B.C. We knew that there was a temple at Pyrgi, for in 384 B.C. Dionysius, tyrant of Syracuse, sacked it. For the Greeks the temple was that of Leucothea. Inscriptions on sheets of gold foil found in a ditch between the two temples refer to Uni-Astarte, and other votive inscriptions on clay have a dedication to Uni.

The importance of this religious complex is shown by the existence of a road which connected Caere to the sanctuary and which has since disappeared.

Thanks to votive inscriptions we know the names of Etruscan gods, worshipped by the Etruscans, such as Culsans, Menerva (the Italic Minerva), Ceres, Fufluns; they do not appear on the Piacenza liver. The identification of Menerva with Tecum, written on one of the sections, is arbitrary. This silence may be due to the fact that in some cases the gods were local. Culsans, for example, has so far been mentioned only in two inscriptions from Cortona. A late bronze statuette (2nd century B.C.?) shows him double-faced, but quite unlike the Roman Janus. If the cult of Menerva had been found only at Veii—where she was already worshipped around 500 B.C. in the sanctuary of Portonaccio—there might be a possibility of her cult

being Italic, and of having been introduced in Veii because of the city's close contacts with Italic territory, while it was unknown or not accepted until later in the rest of Etruria. But Minerva appears as a major divinity, replacing Zeus in the gigantomachy which decorated the ridgepole revetment of the temple of Uni at Pyrgi; that she was worshipped in a temple at Santa Marinella as well as the fact that she makes her appearance in the highly Italic zone of Veii and on a frieze of the temple of Poggio Castetta at Bolsena is proof of the existence of a cult of Minerva in Etruria (at least in south Etruria) under the Etruscan name of Menerva, or 'Menrva', 'Merva' or 'Mera'. Ceres, whose name does not appear in the Veientine sanctuary of Campetti until the 3rd century B.C. (on a vase dedicated by the Faliscan Tolonios), was not necessarily a goddess adopted by the Etruscans.

The gods said to be Etruscan in Roman written tradition have either no or very dubious archaeological proof to sustain them. Vortumnus, who according to Varro (De Lingua Latina, V, 8, 46) was the principal god in Etruria, may also have been the god of Volsinii if, as some scholars have recently maintained, he is to be identified with the Vertumnus mentioned by Propertius. Vortumnus does not appear in Etruscan worship, nor on Etruscan reliefs or small bronzes (see Volsinii above). Voltumna, whose sanctuary is mentioned by Livy, is an unknown god, thought to be male by some scholars, female by others.

Nor is the goddess Nortia mentioned on the Piacenza liver, or in any place of worship. She had a temple near Volsinii and according to Tertullian she was the principal goddess of the city. We also know that the passing of the years was indicated by nails driven into the wall of her temple. The cult enclosure, found at Pozzarello, within the city walls of Volsinii, had been thought to be her sanctuary, but an inscribed cippus recently found there seems to indicate that the enclosure belonged to the god Selvans, here called 'Sanchuneta' (god of the boundaries?) But a Minerva Nortina, mentioned in a Latin inscription from Bisenzio and the family name 'Nurtines', that existed in Bolsena in Roman times (Nortinus: CIL, XI, 2690) confirm her worship in the region.

We know that Tinia used three kinds of lightning, but other gods might also use it. Of these three kinds of lightning, Tinia could use the first any time he wished. He needed the consent of the 12 gods for the second, and for the third that of mysterious and superior gods, whose names we are not told. In this Tinia differs from the Greek Zeus and the Latin Jupiter. As already said, no archaic representation of Tinia exists.

Nor do we have any cult statues of the god. A terracotta statue which may be that of a bearded Zeus (or Jupiter) was found in the temple of Conca, the ancient Satricum. But Conca is in southern Latium, outside Etruscan territory where Campanian, i.e. Greek, influence was strong. Greek influence is evident in the antefixes (of Capuan type) and in the plan of the temple which was of a peripteral Greek type, that is, it had columns all around the cella like the temples of Paestum. There is therefore no reason to suppose that the Zeus of Conca was the Etruscan Tinia. Moreover the terracotta figure was probably part of a decorative group and not really a cult statue. The goddess of the temple at Conca was an Italic goddess, the Mater Matuta.

It is debatable up to what point the Greek gods were really identified with Etruscan ones. We must distinguish between the cult and the decorative motifs and patterns. Simply using a subject which belongs to a foreign religion or belief does not necessarily mean that that religion is accepted. Scholars such as Altheim who take the decorative group of Apollo and Hercules at Veii as a sign that the Etruscans had accepted the Greek god and his cult are mistaken. As far as we know Apollo appears in Etruria only in mythological scenes of Greek inspiration. Recently his name has been read on a stone altar found in Volsinii, but the reading is uncertain and should probably be discarded.

The adoption of a motif belonging to a foreign god in order to represent a native divinity does not mean that the god and his cult are also accepted. From the beginning Christianity used decorative schemes and motifs taken from Greek and Roman art. The Good Shepherd is the ancient Chriophoros (lamb-bearer); God the Father repeats the theme of Zeus; the iconography of the Madonna and Child goes back to types prevalent throughout antiquity in Greece, Rome and Etruria. Yet this does not mean that the Christians accepted the pagan beliefs when they used these motifs. All, or almost all, the Greek and Roman motifs were used in the Italian Renaissance, but only as decoration, not as beliefs. The fact that Apollo and the Muses appear in the 'Stanze' of Raphael, in the Vatican, does not mean that Raphael in painting them, nor Pope Julius II for whom they were painted, believed in the god and worshipped him. When Benvenuto Cellini executed the bronze statue of Perseus holding up Medusa's head, and Pollaiolo painted Heracles fighting Antaeus, they were doing, from a religious point of view, just what the Etruscans had done. They used subjects and patterns which were to them nothing but a source of artistic inspiration. In our houses we

have Chinese or Japanese furniture, vases, objects, or statues of Indian gods, or the fetiches of primitive peoples, but for us they are only a pleasing, fashionable decoration. Only a temple, or a sanctuary, or a votive inscription or an open-air place of worship proves the existence of a cult. A Greek divinity seems to have been worshipped in a sanctuary at Caere, excavated by Mengarelli, where offerings of the 3rd century B.C. had votive inscriptions to Hera. Since the inscriptions are in Greek, this presumably means there were Greeks at Caere, unless one is willing to admit that the Etruscans of Caere spoke Greek. A Greek temple was found at Graviscae, but there were Greeks living there at the time.

The Etruscans did not accept Greek religion and Greek gods, although they copied Greek mythological scenes. We only have to see how Greek myth was modified and deformed in Etruria. When Greek, and especially Attic, vases began to arrive en masse in the 6th century B.C. the motifs painted on them were imitated, particularly in south Etruria. Artists and artisans often misinterpreted and deformed them, mixing one with the other. A well-known myth in Greece is that of Perseus who cuts off the head of Medusa, one of the three Gorgons. Two sons were born of her blood, the winged horse Pegasus, and the young Chrysaor. In Etruria the story was modified: on a painted plaque found at Caere her two sons are two small Gorgons. On an Etruscan black-figure vase Medusa is dead and two winged horses, two Pegasuses, sprout from her neck (Pl. 92). On another Etruscan vase (Reading Museum, England) and on a bronze rod tripod Medusa still has her head but holds in her hands the haltères, the weights used for jumping in the palaestra.

Another myth frequently found in Greek art, especially in Athens, is that of Theseus killing the Minotaur. On Greek vases the Athenian hero is shown with drawn sword about to kill the Minotaur, the Cretan monster with a human body and the head of a bull to whom the Athenians had to send an annual tribute of six youths and six maidens. On an Etruscan vase, now in the Louvre, it is Hercules, not Theseus, who is about to kill the Minotaur with his club. Many such examples could be listed. They were frequent above all in south Etruria, while in the north mythological subjects were infrequently used in local ware until the 4th century B.C., an indication that Greek myth was relatively unimportant.

The recent statement by R. Hampe and E. Simon that the Etruscans had completely accepted Greek myths, even the most unusual ones, and reproduced them on pottery and bronzes, cannot therefore be accepted.

First of all this hypothesis is based on the interpretation of generical scenes, which are never accompanied by the names of the figures, so as to leave no doubt as to their identity. Secondly the various examples cited above and the many other deformations of Greek myth in Etruria contradict their statement.

We have no statues which we know definitely to have been cult statues, and which could therefore show us how the Etruscans represented their gods. An inscription at Pyrgi seems to refer to a statue which may or may not have been that of a divinity, but the statue has not been found. Part of a terracotta statue of Mercury comes from a temple in Falerii. It has been interpreted as a cult figure and as a result the temple is conventionally called the temple of Mercury. But the piece may belong to the pediment decoration. The only statue found in Etruria, which is probably a cult statue, is the marble female figure (end of the 6th century B.C.) from a sanctuary in the cemetery of Cannicella in Orvieto (see p. 123). Although the figure is that of a woman, the hair falls halfway down her back as is usual for male figures. Furthermore she is nude. This is quite unusual, for nude female figures are extremely rare in archaic Etruria. Originally the goddess had a sacred precinct, perhaps later an aedicula was added; a base found in the excavation may have been an altar. The votive gifts give no clue to her name or to her cult. She does not seem to have had anything specific to do with the necropolis and nothing indicates that she was a funerary divinity.

There was also a cult in the necropolis at Sovana (see p. 102). We do not know the name of the divinity, but the votive gifts—parts of the human body—point to a health-giving goddess or god. I know of no other cults in a cemetery area.

Handbooks and studies often give a cult of three divinities as the basis of Etruscan religion. This Etruscan triad, consisting of Tinia, Uni and Menerva, later became the Capitoline triad in Rome, Jupiter, Juno and Minerva. The fact that Greek and Roman writers made no mention of this Etruscan triad, proves little, but the lack of religious or votive inscriptions referring to the Etruscan triad bears more weight. The three gods are mentioned separately, but never together. The triple cella temples (such as the Capitoline temple in Rome, where the central cella was for Jupiter and the lateral ones for Juno and Minerva) often seem to be meant for only one divinity in Etruria.

Another Etruscan triad proposed by P. Ducati, the infernal triad,

corresponding to the Roman triad of Liber (Bacchus), Ceres and Libera (Proserpina), is non-existent.

Servius (Ad Aen., X, 198) mentions an infernal god, Mantus, and some scholars have coupled him with a female divinity (Mantua or Mania) but the existence of such a couple is extremely doubtful. In Etruscan painted tombs the rulers of the Underworld are the Greek gods Hades and Persephone. But this Underworld and its gods were inspired by south Italian vase-paintings.

Divergences from Greek usage are frequent. Whereas in Greece the bothros for libations was reserved for the infernal cults, a bothros was found in Uni's precinct at Pyrgi. Its use in Etruria for the upper gods is also confirmed by similar altars at Veii, Volsinii, Bagnoregio, Orvieto and Santa Marinella.

Nothing has reached us about the cult of any of these gods or the places of worship—temples, sacred precincts, etc. We have no idea of Etruscan private spiritual devotion, of the individual attitude towards the god, of man's intimate feelings for his divinity, in other words of what we consider 'religion'. The many temples in each city must have been well attended to judge from the great number of votive gifts, but we know nothing of the spirit with which these gifts were made.

Open-air cults and sanctuaries must have had their priests and priestesses but there is practically no trace of them. Livy (V, I, 5) mentions a priest who was elected for a festival (sollemnia ludorum), but, according to some scholars, the Romans translated the word 'king' as 'priest'. A priest is mentioned for the temple of Uni at Pyrgi. Funerary inscriptions—as far as we can tell—refer to priests and give us their names.

A number of votive gifts were thrown into a lake near the source of the Arno. These coins and bronzes of various date and make are now dispersed in various museums (Pl. 74): we know nothing of the cult they indicate.

Etruria was believed to have had only one kind of temple—the temple with three cellae preceded by a portico—described by Vitruvius (IV, 7) as a 'Tuscan' temple. We now know that the three-cellae temple is characteristic of all central Italy and not only of Etruria: the earliest example is the Capitoline temple in Rome. Other types also existed in Etruria (see pp. 31 ff.)—with a single cella, with one cella and two alae or with an external colonnade like the Greek peripteral

temples. There were also open-air places of worship in precincts. It is impossible to say whether specific gods had special kinds of temples.

We know somewhat more about the Etruscan Underworld thanks to interpretations of reliefs and paintings. The Etruscan concept of the Underworld is extremely interesting. There may have been something about it in the Libri Acherontici, which Servius (Ad Aen., VIII, 398) gives as the work of Tages, but the only two passages still extant, thanks to two late 4th-century A.D. authors, Arnobius (Advers. Nat. II, 62) and Servius (Ad Aen., III, 168; VIII, 398), have no connections with the Underworld we know. They only provide information which must have been well accepted by the Roman mentality: the Etruscans believed that by sacrificing certain animals to certain gods (we know neither which gods nor which animals) these animals became divine and were transformed into 'animal gods' ('animal', means that it derives from anima—soul). There were also some rites which could delay destiny for ten years.

But what these authors wrote does not explain the funeral reliefs and paintings. From these we can deduce that the Etruscans believed in a life after death similar to the one on earth. The amount of funeral equipment, the care taken by the family, in particular from the 8th century on, to provide the dead not only with the objects and vases needed for everyday life but with luxury goods as well, shows that they believed in a life after death. Recently traces of ancestor-worship have been deduced from Etruscan inscriptions.

Tombs like those in Tarquinia and Chiusi and reliefs like some of the Clusine ones, show that life continued. The dead man hunted hares, birds, boars; he fished, watched athletic games and dances. A sarcophagus from Tarquinia (Florence, Museo Archeologico) shows the dead man playing the kottabos.

Some of the later tomb-paintings tell us how the Etruscans imagined life in the afterworld. The second chamber in the Tomb of Orcus in Tarquinia (early 3rd century B.C.) shows us an Underworld that is very Greek but which also has some specifically Etruscan details. Hades with his hair covered by a wolf's head is not Greek, nor are the demons in the tomb, Charu and Tuchulcha. The afterworld of the more provincial inland towns, such as Orvieto, is not nearly as Greek. The Golini I tomb (second half of the 7th century B.C.) carries us to a dark Underworld, lighted by candelabra, where the life of an Etruscan house continues (see Orvieto). It could be a family scene were not the

banquet presided over by Hades and Persephone, the two rulers of the Underworld.

The painted tombs of Orvieto are among the earliest examples in Etruscan painting of a subject that was to be extremely popular in the centuries to come—the journey of the deceased to the Underworld. There is proof for this belief throughout Etruria. The first example is in a badly ruined Tarquinian tomb, the Querciola I. It was painted about the middle of the 7th century B.C. The standard 5th-century themes are still shown: the banquet, dancers (see the tombs of the Triclinium and of the Leopards) and a boar hunt, but above the entrance door the dead man is shown arriving on a chariot drawn by two horses.

It has been suggested that the same subject is represented on a painted plaque (last quarter of the 3th century B.C.) found at Caere: a winged male being holds a woman in his arms, but the composition differs from that normally encountered. It is doubtful whether a panel in the Campana tomb at Veii (Pl. 20b) represents this journey to the beyond. The motif of the dead man on a horse-drawn chariot, often with a large umbrella and accompanied by a servant or an infernal demon, may be recognized on a Bolognese stele of the late 3th century B.C., on a stele from the territory north of the Arno, and on Clusine cippi from the 5th century B.C. Late sarcophagi, urns and paintings (3rd, 2nd and 1st centuries B.C.) show the procession, with friends, servants and musicians, which accompanies the dead man to the entrance of the Underworld. A large door has been interpreted by some scholars as reminiscent of the Chaldean Underworld, which was surrounded by seven walls, even though there is no trace here of these seven walls. Sometimes a demon is shown guarding the door. The journey may also be on horseback (the earliest example is on a Fiesole stele) or on foot.

The marine monsters painted in tombs or carved on urns and sarcophagi have sometimes been interpreted as allusive to a journey to the Underworld via sea. There is no proof that the Etruscans imagined an afterworld beyond the sea as the Greeks did.

From the 4th century on, male and female infernal demons, with or without wings, are often present in the journey to the Underworld shown on vases, mirrors, sarcophagi, urns and painted tombs. The female demons are commonly called by the general but inexact name of Vanth or Lasa, the male demons, Charun. Actually we know various names of demons. The Etruscan Charun derives his name from Greece, where he is often represented on Attic white-ground lekythoi. He is

the demon and boatman of the Underworld, a dignified bearded middleaged man who ferries the dead in his boat. But this resemblance is limited to the name. In Etruria the male demons are old and ugly, with pointed ears and shaggy hair; they hold a hammer or snakes. Less frequently and in later monuments, such as the Tomb of the Cardinal in Tarquinia, the male demons are young and hold a torch. Often no name is given. The numerous female demons (Pl. 91) are often winged, with serpents in their hands and around their heads or waists; they rarely have a torch or hammer but sometimes have a scroll. They are always beautiful, with all the beauty and dignity of the Greek winged victory figures (Nikai) often painted on Attic vases of the second half of the 5th century B.C. Only the head of the female demon on a Clusine sarcophagus urn in pietra fetida (Perugia, Museum) is ugly, but the head is a 19th-century restoration.

R. Herbig thinks that the various Etruscan demons may have each had special functions, but there are no grounds for this assertion. It has also been suggested that the different names of the demons are due to local cults and that they were originally different divinities, but there is no proof for this either.

It has often been said that torture and punishment were inflicted on the souls in the afterworld. We realize now that this statement is wrong. Male and female demons are harbingers of death, and are present as such in battle scenes, but they do not punish. The male demons raise their hammers, but strike neither the living nor the dead, as has sometimes been said. The torches held by the demons in the Tomb of the Cardinal give light to the dark way, but they do not menace. There are no infernal punishments except the mythological ones of classical Greek literature and painting.

The demons accompany and guide the dead. They guard the entrance to the tomb so as to turn back any who would pass, for he who is in the kingdom of the dead may not leave, nor may the living penetrate the Netherworld.

The language spoken by the Etruscans is an obscure and often misunderstood subject. Two equally harmful extremes must be avoided: scholars who refer to the 'mystery' of the Etruscan language and assure us that we know nothing nor will ever be able to know anything about it are just as wrong as those deluded amateurs who think they have discovered the key and provide us with fantastic and ridiculous translations.

We can read Etruscan inscriptions because we know the forms of the various letters and their meaning. The origin of the Etruscan alphabet is debatable. Some say the Etruscans adopted the Chalcidian alphabet of Cumae in Campania, others that it derives from a hypothetical Oriental Greek forerunner of the known Greek alphabets. The hypothesis of a Cumaean derivation might be supported by the results of recent excavations by the British School at Veii, which have revealed the existence of contacts between Veii and the Chalcidian colonies of Cumae and Pithekousai from the second half of the 8th century on. The two Greek centres could quite easily have sent their alphabet as well as their pottery to southern Etruria.

But Etruria has given us something that none of the other regions of the ancient world have given us—model alphabets of various dates, generally found in tombs, often incised on vases. They are reminders for anyone not used to writing much. The earliest (second half of the 7th century B.C.) are those from Caere, Formello (Veii) and Marsiliana. The alphabet on the bucchero cock from Viterbo (Pl. 93) is later. The most recent alphabets date down to Roman times.

The best known primer is the one incised on the frame of a tiny ivory tablet (Pl. 94b) found at Marsiliana (see pp. 116 ff.). A recent wild hypothesis has it sent to Etruria by a merchant of Tyre or Byblos to promote commerce through writing. Frankly it is hard to understand why, if this Syrian or Phoenician merchant intended to teach the Etruscans how to write, he did not send an ivory tablet of the kind normally used where he lived. The one from Marsiliana is not eastern, neither in size nor in its small handle. But the man who made it knew eastern writing-tablets.

In recent years some new alphabets have been added to those already known: an alphabet from Vetulonia (3rd century B.C.), one from Bolsena (2nd century B.C.), two archaic ones (6th century B.C.) from Graviscae and Vulci. Only one Etruscan alphabet was found outside Etruria at Spina in the Po valley. Only gradually have we learned the phonetic value of the letters. From the end of the 15th century, when Annio da Viterbo copied Etruscan inscriptions, to 1936 when Eva Fiesel proved that the sign \times (or +) represented a form of S, to 1965 when J. Heurgon made new contributions on a special form of M, to 1967 when Massimo Pallottino studied the vertical sigma with four strokes, more than four centuries have passed.

Only now are we beginning to realize what form the letters took in various periods and to recognize local differences.

The translation of Etruscan texts is much less advanced. This may seem strange in view of the fact that so many other languages and alphabets which are at least as difficult if not more so have been interpreted; for example, the recent decipherment of the Mycenaean tablets found in Greece and Knossos, on Crete, and written in the second half of the 2nd millennium B.C. But the method used in deciphering the Mycenaean language apparently cannot be used for the Etruscan. A known language (Greek in this case) was found that was close to Mycenaean, and could thus be used as a key. This method, the 'etymological' method, has been used for Etruscan ever since the Renaissance, but without results. Etruscan has been unsuccessfully compared and translated with all, or almost all, the ancient and modern languages. Recently it has been translated using Celtic, Russian, ancient Greek, Hungarian, the Semitic tongues-one of the latest attempts was even with Chinese. The key is still missing. An inscription on a stele found at Caminia on the Island of Lemnos is in a language close to Etruscan, but it too is incomprehensible and is of no help.

Besides those already mentioned, the difficulties encountered in deciphering Etruscan texts are as follows:

1. In many Etruscan inscriptions the words are separated by punctuation marks, generally dots, from one to four. But there are inscriptions in which the letters follow each other without any interruptions, as for example on the cup found in the Tomba del Duce in Vetulonia (Pl. 10C). In other inscriptions these dots are so frequent (as in the tile from Capua) that they probably do not

indicate separate words. In these cases scholars propose word divisions, on the basis of comparisons with other inscriptions. And since the text is not understood, these may be wrong. For example the English word manslaughter, could also be read 'man's laughter'; and 'all's well' could be read 'all swell'. The meaning changes but since we know the main sense of the text we can fit in the right words even though they lack all punctuation and the letters are run together. In Etruscan inscriptions we have no guides of this sort.

2. In all languages there are words which are written alike or almost alike but which have different meanings. 'Bow', for instance, can either be a weapon, the forward part of a vessel, or an inclination of the head or body as a sign of respect. In Latin, for example, the word 'manubia' means 'lightning'; the word which would seem to be its plural, 'manubiae', means war booty. When we study Etruscan texts we perhaps try too hard to find in them words whose meaning we know. Purth, or purthne, for instance, indicate as far as we know a magistrate, but it may be arbitrary to relate purtsvana, purtvavcti, eprthieva, eprthnev to the same word. This tendency to give the same meaning to words that look more or less alike is frequent and probably often wrong. The fact that in Etruria there are not only differences in the alphabet from one city to another, but also in the language, should put us on our guard.

3. The real difficulty is that although we have many Etruscan inscriptions—about 9,000—they are very short and are almost exclusively funeral inscriptions, which limits the number of words used. Most Etruscan inscriptions give only the name and family name of the deceased. A large number also have the names of the father and mother, sometimes even those of the grandparents, and, especially in south Etruria and at Volterra, the age at which he died. An inscription on a sarcophagus in Tarquinia, found in the tomb of the Partunu family, gives us a typical example of an Etruscan funeral inscription of average length: Velthur larisal clan cuclnial thanchvilus lupu avils XXV, that is 'Velthur, son of Laris and of Thanchvil Cuclni, died at 25 years of age'.

The words are few and always the same. Inscriptions of any length are an exception. The mummy wrappings in Zagreb, our longest text, have about 1,200 words. They are strips of linen which were wound

around the mummy of a woman and were found in Egypt—an Etruscan mirror was also found in Egypt. The mummy was brought to Zagreb in Yugoslavia, but only much later people noticed that a roll of cloth, upon which an Etruscan religious text was written, had been used for the wrappings. The text was published in 1892. The inscription on a tile, found in Capua in 1899 and now in Berlin, also seems to be a religious text. It is the second in length of the Etruscan inscriptions. The lines are read alternately from left to right and from right to left; only 29 of the original 61 lines were legible when it was found. It was badly damaged during the war and very little can still be read.

Other texts are shorter. The lead tablet found at Magliano near Marsiliana d'Albegna, now in Florence, is inscribed on both sides; the inscriptions form a spiral that begins in the centre. The cippus of Perugia, which may be a sepulchral inscription or a definition of boundaries, the inscription in the tomb of S. Manno, near Perugia, the inscriptions on a lead sheet from Campiglia, and other inscriptions from Volterra and Chiusi comprise the best-known ones.

Some inscriptions are of particular interest despite their shortness. One recently found in the necropolis of Villa Tarantola at Tarquinia mentions an Etruscan, Larth Felsna, who fought in Hannibal's army and had been in Capua.

Important discoveries have recently been made in the sanctuaries of Pyrgi and Santa Marinella (the ancient Punicum), both in the territory of Caere (see pp. 51 ff.). Three inscribed thin leaves of gold were found in Pyrgi: two were written in Etruscan, the third in Punic (Pls. 94a, 95, 96). It looked at first as if a bilingual inscription had finally been found, but the Punic inscription is not a translation of the Etruscan ones. Still, this in no way diminishes the importance of these inscriptions, nor of the two fragments of an inscribed bronze sheet, also found in the sanctuary and perhaps earlier than the others. A sheet of lead, inscribed on both sides, was in the sanctuary of Minerva, at Punta della Vipera in Santa Marinella.

These new inscriptions are of extreme importance. They are long archaic texts. They increase our knowledge of Etruscan epigraphy and also raise unexpected epigraphic, historical, and religious problems. They all come from sacred precincts and may also help us to a better understanding of Etruscan religion.

The method generally used at present for studying the Etruscan language is slow but sure. It is called the 'combinatory' method.

The interpretation of the words is based on the comparison of the inscriptions with each other. Sometimes a comparison with similar inscriptions in another language may also be useful: this is the bilingual method based on the well-known fact that religious formulae and indications related to magistrates are often expressed in like manner in different languages. But recent attempts to use the bilingual method have reached anything but satisfying results.

What is needed for a more rapid solution of the problem is the discovery of a really bilingual inscription of sufficient length, such as an Etruscan text with its Greek or Latin translation. The famous Rosetta Stone which gave us the key to Egyptian hieroglyphics was such a bilingual text. There are a few bilingual inscriptions in Etruria but they are all very short, simple sepulchral inscriptions. The discovery of a real bilingual text is not easy. Important inscriptions were probably inscribed on bronze tablets, and were destroyed in antiquity. Bronze was a useful metal so the tablets were melted down and re-used. Moreover real bilingual texts, where one language is the exact translation of the other, are not known in antiquity.

The combinatory method has led to results which should not be undervalued. We know the meaning of about 100 words, such as those indicating relationship (clan-son, sech or sec-daughter, puia-wife, etc.). Various dedication formulae are also certain, such as mini muluvanice (he dedicated me) followed by the name of the votary. We are able to recognize the names of magistrates and priesthoods, although unable to specify their functions; we recognize the names of most divinities although we are ignorant of the character of the god himself. Ancient grammarians and glossarians have preserved a few Etruscan words. The transcription of foreign words, generally Greek (names of gods, or of vessels), has revealed various characteristically Etruscan tendencies. We are also able to recognize that the formulae used in inscriptions differ from one city to the next. In Perugia, for example, the age of the deceased is not given; Volterra adds the word ril (aged) after the number of years; south Etruria uses avils (years). New information, particularly with regard to Caeretan epigraphy, has been given by the recent inscriptions of Pyrgi and Santa Marinella.

We know something about Etruscan grammar and can distinguish male from female gender, the singular from the plural (clan—son; clenar—sons); we also know some prepositions, conjunctions and adverbial forms, the conjugation of verbs, etc. Much is still uncertain.

But even if we cannot translate all, it is possible to get a general idea of the text. The discovery of new inscriptions, the systematic and careful publication of those already known, will gradually confirm the hypotheses advanced or open the way to new, more precise interpretations.

Etruscan numbers are still a point of debate, especially those from one to six written on the six sides of two dice found in Tuscania, now in the National Library of Paris: thu, huth, ci, sa, mach, zal. But we still don't know exactly which numbers they correspond to.

Progress is slow. The Etruscologist would do well to adopt the old proverb: slow but sure. Some Etruscan words have gone through long series of mistaken or only partially exact interpretations, until they now seem to have reached a definite meaning. Thus lautni, interpreted as slave, servant, friend, client, is now believed to mean 'freedman'. For etera, a word characteristic of Perugian inscriptions, the translation has also changed: formerly son, adopted son, freedman—we now believe it to mean 'servant'.

8 THE HISTORY AND GOVERNMENT OF ETRUSCAN CITIES—THE PROBLEM OF THE ORIGINS

The History and Government of Etruscan Cities

Progress in interpreting the language and comparisons with the formulae on Latin inscriptions have permitted us to identify the names of many Etruscan magistrates.

Ancient historians say little about the governments of the cities: in archaic times it was in the hands of kings, called lucumoni (Servius, Ad Aen., II, 178; VIII, 65 and 475). The monarchy was then abolished, but it existed in Veii in the second half of the 5th century B.C., in 437 (Livy, IV, 17–19) and in 404 (Livy, V, 1, 3), although it may have been of an intermittent nature. For the Republican period, Roman historians used the generic word principes, that is the principal, the most important, citizens. For this period inscriptions are useful.

Etruscan inscriptions, like Roman ones, sometimes add the offices held by the deceased after the onomastic and genealogic formulae. In Rome this list is called the cursus honorum (the sequence of offices held): offices are listed according to their importance, either beginning or ending with the most important. It has been said that a regular cursus honorum also existed in Etruria, but the statement is not altogether convincing. In any case the specific formulae used in Rome do not seem to have existed in Etruria. Many problems would be solved if an example of a real cursus honorum were found in Etruria. Doubt still surrounds the interpretations of some names of magistrates: camthi, cepen, tamera, cechase, etc. But we all accept the three most important magistrates: the zilath, the maru, the purthne.

Zilath, a name which appears under various forms (zilat, zilach, zilac, etc.), is the name most frequently mentioned. The word is sometimes followed by a term which, we think, defines or limits the functions of

the magistrate, such as ziloth eterov, ziloth parchis, etc. The meaning of these specifying adjectives is unknown or uncertain. Some believe the ziloth to be the main magistrate of the city, others think he was less important than the purthne.

Some scholars have connected the maru (also marunuch, marunchva, marniu) to an Umbrian magistrate, the maro. We do not exactly know what his duties were. In Tuscania, Tarquinia and perhaps in Orvieto, the word maru is followed by the name of a divinity. Some scholars believe him to be a priest, but others think he was an administrator. As the earliest mention of a maru in Etruria is in the 4th century B.C., in Orvieto (other mentions are later and are limited almost exclusively to Tarquinia and the neighbouring territory), we may have here an Umbrian infiltration into Etruscan territory, via Orvieto, a town which is on the border between Etruria and Umbria and whose artistic production was influenced both by Umbria and Tarquinia.

The supposition that in Etruria the zildth was an eponymous magistrate, that is an annual magistrate who gave his name to the year, has been suggested by comparison with Rome where events were dated by the names of the consul in office. But the inscription in the Tomb of the Shields in Tarquinia, zilci velusi hulchuniesi, interpreted by some scholars as 'when Vel Hulchnie was zilath', is too isolated to support this interpretation.

Inscriptions mentioning magistrates are limited almost exclusively to the territory of Tarquinia, Vulci, Orvieto, Caere (Caere, Tarquinia, Vulci, Norchia, Tuscania, Musarna, Bomarzo, Orvieto). The maru is found only there (it is unlikely that the word mar in an inscription at Chiusi indicates a maru). The zilath also exists at Chiusi (two inscriptions), Vetulonia (one inscription) and Volterra (one inscription). The purthne also appears in three inscriptions at Chiusi. Tarquinia and the centres supposed to depend on it (Norchia, Tuscania and Musarna) have more inscriptions that mention magistrates than all other Etruscan cities together. They have 28 inscriptions (16 in Tarquinia, 6 in Musarna, 4 in Tuscania, and 2, but 1 is uncertain, at Norchia) while there are only 17 inscriptions in the rest of Etruria. Although important cities have no inscriptions mentioning magistrates, scholars generally believe that the three main magistrates have existed throughout Etruria.

This statement is anything but satisfactory. As we have seen, the cities differed from one another economically and artistically. Some

were trade centres. others agricultural. Can the hypothesis that they all had a similar government and similar magistrates (and hypothesis it is, for ancient sources do not mention this) be accepted? We need but think of medieval Europe. The absurdity of attributing a republican government, such as existed in Genoa or Florence around 1300, to Piedmont and the Milanese area is obvious. Just as it would be absurd to think that in 14th-century Germany Bohemia, Saxony, and Lübeck had the same form of government as Trier, Mainz or Cologne which were governed by the bishop. Moreover, Livy states that in 437 B.C. Veii was under a king, while other cities seem to have been under the leadership of republican magistrates.

Cities for which we have no indications of magistrates are Veii, Populonia, Perugia, Arezzo, Cortona-the centres north of the Arno. The absence of Etruscan magistrates at Veii is not surprising since the town was under Roman rule as early as the beginning of the 4th century B.C. This would seem to contradict the hypothesis advanced by some scholars (Santangelo, Hubaix) that Veii continued to be an important city even after the Roman conquest. But it does seem odd to find only a single reference to magistrates at Caere which, according to tradition, did not fight against Rome. The episode of 354 B.C. (see p. 50) had no harmful effects on the city. In the 4th and 3rd centuries B.C. Caere traded with Greece and was the place where good Roman families sent their sons to study. Not until 274 or 273 B.C. (Cassius Dio, fr. 30) did Caere lose half her territory. The colonies deduced there by Rome between 264 and 246 B.C. (Castrum Novum, Alsium, Fregenae) show that the coast-and therefore also maritime tradehad been taken from Caere. The deduction of a colony at Pyrgi, Caere's port, must have taken place about the same time, or not much later, if in 191 B.C. Rome had Pyrgi help her against Antiochus of Syria (Livy, XXXVI, 3). Despite this, Caere's condition was no worse than that of the other south Etruscan cities, especially Tarquinia.

Not only the number of inscriptions mentioning magistrates sets Tarquinia apart. Elsewhere, these inscriptions were only found in the main town. In the territory round Tarquinia, the lesser centres also had magistrates. We find the three principal magistrates at Musarna; Tuscania has the maru and the zilath; Norchia only the purthne. These magistrates might easily have performed their duties in Tarquinia, but an inscription at Musarna shows this to be doubtful as it specifies that Arnth Alethna, son of Laris, had been zilath in Tarquinia, that is in a

town other than his own city. The inscriptions of the other members of the Alethna family, in the same tomb, do not mention the city in which they held office, and there is no reason to suppose that it was not in Musarna.

The explanation proposed by Heurgon is that Tarquinii enjoyed special privileges after the Roman conquest, privileges that allowed her an active civic life. This hypothesis is attractive but neither tradition nor archaeological finds support it. Excavations have not proved Tarquinii to be more prosperous than other cities of southern Etruria. On the contrary, ancient sources state that the city was harshly dealt with. After the fall of Veii, Tarquinii was Rome's bitterest enemy, the city which either alone or in alliance with other towns attempted to arrest Roman advance. The first reference to these fights goes back to 509 B.C., but the real struggle against Rome did not begun until 396 B.C., the year about which Livy says that Tarquinii was 'the new enemy' of Rome (V, 16, 2; 17, 2ff.). Other wars are mentioned for 388 (VI. 4, 8ff.), and perhaps also in the preceding year; for 357 B.C. (VII, 15, 9ff.). The wars between 356 and 351 B.C. (Livy, VII, 17, 2ff.; 18, 2; 19, 2 ff.; 22, 4f.) show anything but generosity on the part of Rome. On the contrary, Livy wrote that the Romans dealt very severely with her (VII, 19, 2) they executed all the Tarquinian prisoners, and 354 nobles, sent to Rome, were killed in the Forum. Livy's account may be exaggerated (the Fasti Triumphalesdonot mentionatriumph over Tarquinii), but it does show that there was little sympathy for Tarquinii and that Rome cruelly avenged the execution of the Roman prisoners in 357 B.C.

The devastation of her territory forced Tarquinii to ask for a 40 years' truce in 351 B.C. (Livy, VII, 22, 5). Livy again mentions Tarquinii in 308 B.C. (IX, 41, 5). The consul Decius is said to have frightened the Tarquinians into furnishing grain for the Roman army. A new 40 years' truce was concluded: as there had been no war we do not know why it was concluded, but this does not show much good will on Rome's part. It is clear that Tarquinii was by now in the Roman orbit. The city is not mentioned thereafter. It is doubtful whether the Roman triumph over the Etruscan league in 281 B.C. included Tarquinii. The victory of 280 B.C.—over Vulci and Volsinii—shows that Rome had already passed Tarquinii in her fight against the Etruscan cities and had probably already annexed the Tarquinian coast. When Rome deduced the colony of Graviscae, in 181 B.C., the words used by Livy (XL, 29, 1) show that the coast had already been in Roman possession for a long

time. We cannot therefore accept Heurgon's explanation for the numerous magistrate-inscriptions of Tarquinii, above all for those of her territory. It is much more likely that the Tarquinian hinterland was already divided up into small centres and municipia as early as the 2nd century B.C.—as, according to Pliny's description, it was in the second half of the 1st century B.C. These centres and municipia, since they were independent from Tarquinii, may have used the names of Etruscan magistrates for their own magistrates in the 2nd century B.C. The fact that so many small centres appeared in Tarquinii's hinterland, or grew more important after the middle of the 3rd century B.C. may confirm this hypothesis. Rome could have given them their independence, so as to provide a counterweight for Tarquinii. This seems particularly likely for Musarna.

Magistrates are an unsolved problem in north Etruria. Excavations show that north Etruria flourished and prospered from the end of the 4th century B.C. on, in contrast to the gradual decadence of south Etruria. It is strange to find such scanty information about magistrates. The poverty of the urns used for the zilath at Clusium is also odd. A recent hypothesis which ascribes this poverty to the decadence of Clusium in the 3rd and 2nd centuries B.C. is unfounded, for Clusium had always been a rich city and continued to be so, according to what we see in her cemeteries, from the 3rd to the 1st centuries B.C. There is no trace of decadence in the artistic production: the sarcophagi and ash urns of Clusium are the finest in north Etruria.

We know the names of the magistrates but not their functions. Scholars, who have tried to define them as well as to give a meaning to the word 'principes' used by ancient historians, have given us fascinating but often arbitrary reconstructions. Such are, for example, Der Staat der alten Italiker by A. Rosenberg and in particular F. Leifer's Studien zum antiken Amterwesen, I. Zur Vorgeschichte des römischen Führeramts. There may be some grounds for saying that the Etruscan zilath corresponds to the Roman praetor, but it is uncertain whether he really had all the functions of the praetor. Many scholars do not accept this interpretation. Some interpret zilath as 'supreme magistrate', others, more generically, as 'magistrate'. According to Roman historians the power must have been in the hands of a few important families, popular uprisings were frequent and the magistratures were actively contested (Livy, V, 1, 3).

It is unfortunate that we have no Etruscan indications at all on Caere's

magistrates after her submission to Rome. In the 2nd century B.C. Caere was governed by a dictator and two aediles, which may reflect an earlier Etruscan administration (S. Mazzarino and others) or may have been imposed by Rome (the opinion of G. De Sanctis). But even in the latter case, these magistratures go back to the republican period and it would be interesting to know what the corresponding Etruscan words were. It is extremely doubtful whether the ailf in an inscription in Orvieto can be identified with aedile.

Inscriptions with references to magistratures are recent. The earliest date to the second half of the 4th century B.C. (Tomb of Orcus at Tarquinia; Golini I tomb at Orvieto), but most of them are from the close of the 3rd to the 1st century B.C. and fall within the period of Roman domination. Some scholars maintain that they continue the magistratures of the preceding free period but we have no proof of this. The many changes which took place in the republican magistratures in Rome should be enough to make anyone sceptical about the immobility of the Etruscan magistratures.

There are some reliefs which may represent the magistrates of the earliest period. One is the frieze on a terracotta plaque (end of the 6th or early 5th century B.C.) which decorated a temple at Velletri in Latium (Pl. 3e); the other is a Clusine funeral cippus (Pl. 79b) from the early 5th century, in the Palermo museum. The plaque from Velletri has three seated figures: a man with a sceptre or a lance (the zilath), one with a lituum (interpreted as the maru) and one with no attribute (the camthi). The same group is repeated behind these three figures. There is no proof that we have three magistrates. Most scholars identify them as divinities. The figures on the Clusine cippus are supposed to be the magistrates of Clusium: a zilath (with lance or sceptre), two maru (with a lituum), various camthi (without attributes). But one important fact has been overlooked: the cippus is broken on the right. Since the composition on these cippi is always symmetrical, we must add on the right two seated magistrates, with or without attributes, and a group of standing figures. The number of magistrates would amount to eight-which is too many. But are they really magistrates? And are they the magistrates of Chiusi? If we compare this fragmentary cippus with other contemporary Clusine sculptures this interpretation is doubtful.

This cippus is not an isolated monument. There are other contemporary sculptures from Chiusi (three cippi and a small urn) very

similar both in motif and in composition, that is with men seated and standing. Only two men are seated and they hold staffs of varying height, slightly curved at the top. The same scene appears on other Clusine funeral cippi, but the two seated figures and the ones standing behind them are women. A cippus in Munich has both scenes, with men and with women, on two adjoining sides. These cippi cannot be ignored in interpreting the cippus on which magistrates are supposed to be represented. An explanation of the one cippus has to explain the others, including the groups with women. The old interpretation of the scenes—men and women, probably relatives, gathered together for the funeral—is still the best. Motifs on cippi are almost exclusively funerary. Moreover in Chiusi similar groups with people seated on high-backed thrones or folding chairs, holding a sceptre or a lance, are also the favourite decoration on a series of cylinder-decorated bucchero vases. I do not think one could consider these magistrates.

As for the terracotta plaque from Velletri with 'magistrates', the same motif appears at Veii and at Tarquinii. In fact the plaque was probably made from a Veientine mould and reflects the situation in Veii more than in Velletri. But Veii still had a king in 437 B.C. (Livy, IV, 17–19); buildings or temples would hardly have been decorated with republican magistrates.

Still another factor makes the matter dubious. The men with curved staffs have been identified by modern scholars as maru. But there is evidence to the contrary in the Tomb of the Augurs in Tarquinii. On the right wall, to the left of the wrestlers, are two bearded men and two servants. The first bearded man holds a curved stick, a lituum; the inscription gives his office as tevarath. The word has been interpreted in various ways: gymnasiarch (the official who superintended the young men exercising in the palaestra), priest and overseer. The most likely interpretation is 'judge of the competition' or 'arbiter', for the bronze vases behind the wrestlers are the prizes to be given to the one who wins. There is only one judge (the other man has no lituum) and a servant is bringing him the folding chair (the sella curulis of the Roman magistrates). In Tarquinii then, in the last quarter of the 6th century B.C., the lituum was the symbol of the officer who judged the games. In Caere a model of a lituum was found in a chamber tomb, the Tomba del Lituo, dated to the early 6th century B.C. It does not seem to throw any light on the magistrate, or magistratures, of which it was the symbol.

One of the basic points of reference accepted by modern scholars when studying the political structure of Etruria is the existence of an Etruscan confederation of 12 cities. Ancient authors who mention this league do not say when or how long it existed, nor what cities belonged to it. The lists proposed by modern scholars often forget to take into account the archaeology of the region. It is not always possible to find 12 important cities between the 6th and the 1st centuries B.C. Vetulonia, for example, disappeared in the first half of the 6th century B.C. and must be excluded from all political activity from the first half of the 6th to the end of the 4th century B.C. Marsiliana vanished from the scene shortly before Vetulonia and never again appeared in Etruscan history. The cities of northern Etruria, except for Rusellae, Clusium, and probably Volaterrae, do not seem to have had an independent development until the 4th century B.C. The beginnings of Arezzo go back to the early 5th century B.C., of Fiesole to the 3rd century B.C. The 5th and 4th centuries are the most difficult periods despite the fact that this is just when the league is supposed to have existed. Unless new finds provide further evidence, the 12 cities are not to be found.

There is a tendency to consider Etruria as a political structure which continued through the centuries unchanged. The 'Etruscan league' has become a heavy chain attached to the Etruscans throughout their history. But it is unlikely that such a league was able to unite the Etruscans for any length of time-even superficially. The cities were much too individualistic, jealous and constantly bickering with each other to support the same political or religious structure for very long, especially if they had to submit to the command of an individual from some other city. The history of Veii provides a good example. According to Livy (V, I, 4ff.) in 403 B.C. the king of Veii asked that he be elected presiding priest of the festivals in which other Etruscan cities also participated. We do not know where these festivals took place. He was not elected, and out of spite withdrew the actors, who were his slaves, and spoiled the festival. As a result the other cities refused to help Veii against Rome. A comparison with Greek history shows what short lives most leagues and confederations generally had. In less than 150 years, between 498 and 338 B.C., four different leagues came and went in Greece. Each league, of course, represented the hegemony of a different city: the Delio-Attic league, constituted in 478-477 B.C. which ended with the Peloponnesian war, was dominated by Athens: the Peloponnesian league, which arose after the battle of

Egospotami (404 B.C.), was dominated by Sparta; then came the Boetian league, with the predominance of Thebes, and lastly the Greek federation, promoted by Philip of Macedonia after the victory of Chaeronea (338 B.C.) and dominated by Macedonia. Actually a glance at modern times is sufficient to show how short-lived leagues between nations are. Are we then expected to believe that the Etruscans were the sole exception, the only example of constancy?

There are various references to this league in Livy—although he never calls it a league, but a concilium (gathering, meeting) or a foedus (alliance), both of which have a much more transitory meaning. The '12 peoples' or cities of Etruria are mentioned only for 434 B.C. (Livy, IV, 23, 5). The number of cities which took part in later meetings is never given. Livy limits himself to generic phrases such as 'all the cities of Etruria' (in 405 and 397 B.C.). Strictly speaking these gatherings might have had the character of a federation until the early 4th century B.C.although Livy says nothing of the sort-that is, as long as they took place at the sanctuary of Voltumna. The last one was in 389 B.C. Thereafter there were alliances and meetings involving the threatened cities off and on as the Roman menace approached. There could hardly have been a league of 12 peoples for the wars of the 3rd century B.C. since the most important cities were actually, if not nominally, already in Roman hands. Veii had gone into the Roman orbit in 396 B.C., Tarquinii in 351 or at best in 308 B.C., Vulci in 280 B.C., Volsinii in 265 B.C., Caere certainly in 274-73 B.C. Rome could not possibly have allowed these cities to take part in meetings which discussed war against her. This is only a hypothesis, but it is more likely than the hypothesis of a confederation which lasted several centuries.

Scholars thought that some inscriptions, which refer to a zilath mechl rasmal, interpreted as 'zilath of the Etruscan people' may be an echo of this union.

The league is supposed to have had its centre in a sanctuary of Voltumna ('fanum Voltumnae') repeatedly mentioned by Livy between 434 and 389 B.C. during the wars against Veii and immediately afterwards. The sanctuary was probably in southern Etruria. Some scholars say it was at Volsinii, a hypothesis based on the identity, which is open to question, of the gods Vertumnus and Voltumna mentioned above in the section on Etruscan religion (see p. 185). Nothing more is said about this sanctuary after the beginning of the wars against Tarquinia. In 296 B.C., and perhaps in 298 B.C., some Etruscan cities

ETRUSCAN ORIGINS

united to fight Rome, but there is no mention of preparatory meetings at the sanctuary, nor does Livy, or anyone else, ever again say anything about a meeting of the 12 cities.

Etruscan Origins

We shall refer briefly here, without going into details, to a problem on which more has been written and said than on any other Etruscan problem—the origin of the Etruscans and how their presence in the region where they are known to have lived in historical times can be explained. It is a problem of minor importance: the political and religious history of the Etruscans, their art and language can be studied without reference to their origins. In this field we still find echoes of the philosophical theories of the 19th century, which considered that the nature of the region where a writer or artist was born determined the character of his work.

Besides, we rarely know anything about the prehistorical origins and migrations of ancient peoples. Egyptians, Phoenicians, Assyrians, Babylonians, Minoans, Mycenaeans, etc. are all peoples whose remote origins are a mystery but whose culture we study in all its various aspects.

Greeks and Romans often referred to the origins of the Etruscans, but they did so only fleetingly. Their hypotheses—and as such they must be considered for the events they refer to admittedly took place 700–800 years prior to the time in which they were recorded—are two. One refers to a migration from Lydia in Asia Minor, the other to an autocthonous origin.

The first hypothesis was originally sustained in the 5th century B.C. by the Greek historian Herodotus. His account (I, 94) is as follows. There was a great famine in Lydia. The Lydians, under king Atys, tried various ways of distracting their minds from the famine and invented new games, playing and eating on alternate days. Eighteen years passed and since the famine showed no signs of abating, the king divided his people into two parts: one stayed in Lydia and the other, led by his son Tyrsenos, emigrated. They went to Smyrna, built ships, loaded them with what was needed, and left in search of new lands. After having visited many peoples they settled among the Umbrians, founding the cities they still live in. They called themselves

'Tyrsenoi' after their leader. According to Herodotus this took place after the Trojan war, around 1250 or 1200 B.C., that is, almost 700 years before his time. As has been noted by some scholars, the story follows a literary pattern used for other migrations of ancient peoples to Italy, such as the Peucetians and the Enotrians to southern Italy, or the Idomeneus migration to Calabria. In the latter we also find the 'Etruscan' theme of 12 peoples who divided up the region (Prob., Ad Verg. Ecl., VI, 31; Fest., 329). Greek and Roman historians and antiquarians liked to dwell on the theme of a voyage from Asia to Italy, the same one developed with such fervour and imagination by Greek and Roman poets for the heroes of the Trojan war.

The Greek historian, Dionysius of Halicarnassus (second half of the 1st century B.C.) proposed another theory (I, 28, 2ff.), the autocthonous origin of the Etruscans. Etruscans and Lydians, he says, differ in religion, language, laws, customs. The Etruscans, who called themselves 'Rasenna', were the aboriginal, that is the earliest, inhabitants of Etruria, for they are ancient and do not resemble other races.

Modern scholars have modified Herodotus' theory of a Lydian origin so radically that nothing of his story is left. Not even the Lydian origin, for under the influence of possible relationships and comparisons, the Etruscans have been related to far distant zones of Asia Minor, Armenia and Mesopotamia. Even America has recently been proposed, on an extremely flimsy basis, a basis that is erroneous or non-existent. Some say the Etruscans arrived as a single group (as Herodotus said); others, that they arrived in small groups over a period of centuries, landing on the Adriatic or Tyrrhenian coast. The date given for this migration oscillates between the 14th and 13th centuries B.C. (Schachermeyr, 1955) to the 7th century B.C. (beginning of the Orientalizing period). Broadly speaking that is how things stand now. The differences in details are infinite.

Modern followers of Dionysius of Halicarnassus consider the Etruscans to be either the survivors of the inhabitants of Neolithic Italy driven into Etruria by the arrival of the Indo-European peoples, or the remnants of a people which once inhabited the entire Mediterranean basin.

There is also a third theory, first formulated by Freret in 1741, that the Etruscans came to Italy from the north, across the Alpine passes.

The supporters of the Nordic theory are fewer in number and their

ETRUSCAN ORIGINS

hypotheses do not therefore diverge as widely, except for details. This theory is based on the undeniable relationship between the culture in Villanovan Etruria and the Danubian culture, and on Livy's statement (V, 33, 11) that the Alpine peoples were of Etruscan origin. They presumably arrived in the Po valley either at the beginning of the Iron Age, that is at the beginning of the Villanovan civilization, or during the Bronze Age, in which case the Etruscans would have been the inhabitants of the Bronze Age terramare of Emilia, who developed into the Villanovans of the Iron Age. From Emilia the Villanovan culture came to Etruria. There is some uncertainty among scholars about the route taken by the Etruscans between the Danube and the Alps. A scission of the Danubian peoples before they came to Italy has also been postulated, with one group going down into the Balkan peninsula, another into Italy.

A double migration, via sea from the eastern Mediterranean, and by land, has also been considered.

In calculating the date the Etruscans arrived in Italy (or when they became aware of themselves as a state) some turn to a passage by Varro, preserved by Censorinus (17, 5ff.). According to Varro, the Etruscan nation existed for ten 'centuries'. Modern scholars base their calculation of the 'centuries' (which did not always last the standard 100 years) on what Censorinus says, but these interpretations differ by as much as 150 years.

Each of these theories has its enticing and convincing aspects. They all try to explain the archaeological and linguistic documentation and tradition, but no theory explains them all. Each has some dark spots and is unable to provide satisfying answers to certain questions. It would take a book to list the various objections.

Here are a few examples. The followers of Herodotus offer no explanation for the fact that the Lydian people, although they came from a highly developed country where art and literature flourished and writing was used, should have brought nothing of their own culture and civilization and should have adapted themselves to a primitive way of life (for many years, according to some), and should then have taken their alphabet from the Greeks. The Nordic theory does not succeed in explaining why the earliest Villanovan centres of Etruria are in south Etruria and not in north Etruria, where they should logically be if the Etruscans came from Emilia. Those who consider the Etruscans survivors of the Neolithic inhabitants of Italy offer no explanation for

the fact that in historical times they lived in one of the richest and most fertile regions of ancient Italy, rich in minerals. It is a well-known fact that survivors of ancient peoples are always to be found in poor, generally mountainous, areas, where they were pushed by the invaders who took the best land for themselves. This is the case of the Ligurians in Italy and of the Basques in France.

There is not one of these theories that cannot be easily dismantled. The weak spots are evident to anyone who takes the pains to study them with an unprejudiced eye. It is a pity that so much time and energy are spent on a problem which for the time being is insoluble.

In 1854 a great historian, Th. Mommsen, in his History of Rome very wisely said that we do not know, nor is it worth while knowing, where the Etruscans came from. What matters is their history. His attitude was criticized; it was rather contemptuous, but wise. The research field is much wider and includes art, religion, society, relationships between cities and other peoples. Recently another scholar, M. Pallottino, has accepted a hypothesis very near to Mommsen's. The Etruscans, he writes, must be studied there where their culture can best be grasped—in Etruria. The real problems are no longer those of their origins or of the 'mystery' of their language, but those relative to their civilization.

and deduced in the Friday have a start of the have related the short

The Ente per la Diffusione e l'Educazione Storica and the author of this book wish to thank the directors of the following museums and art galleries, as well as the photographic art agencies for their generous cooperation in providing the photographs, often made to order, to be used in the plates: Istituto Archeologico Germanico, Rome; Walters Art Gallery, Baltimore; Staatliche Museen, Berlin; Museum of Fine Arts, Boston; Metropolitan Museum, New York; British Museum, London; Vatican Museums, Vatican City; Museo Nazionale, Palermo; Gabinetto Fotografico Nazionale, Rome; Brogi (Soc. I.D.E.A.), Florence; Anderson, Rome; Alinari, Florence; Giraudon, Paris.

I am particularly grateful to Professor G. Caputo, Soprintendente alle Antichità in Florence, and to Dr G. Maetzke, his successor, for their generosity in putting the photographic material of the Soprintendenza at my disposal as well as to Mr P. Paoli, the Soprintendenza photographer, for his patience and skill.

I

François Tomb, warriors fighting, Vulci. (Rome, Museo Torlonia). Missing at the left of the photograph is Caelius Vibenna (Caile Vipinas), painted on the back wall, next to the door. He undoubtedly was part of the composition. Some scholars consider the right-hand group on the adjacent wall, Marce Camitlnas and Cneve Tarchunies Rumach, as not belonging to the battle scene, but others see it as an integral part of the central picture. 3rd cent. B.C. Photo Gab. Fot. Naz. E 8192.

2

Tomb of the Deposito de' Dei, Chiusi. Known also as the Tomb of Poggio al Moro and as Grotta delle Monache. It was discovered in 1826 and was already in poor condition.

We know it only through drawings, of doubtful accuracy. As usual in Chiusi the decorations, of which only a part is reproduced here, are painted high up on the wall of the central chamber. Gymnastic contests are depicted in the frieze, banquet scenes in the pediments. The chariot race is particularly interesting because of the motif of the unfortunate

charioteer thrown from his chariot and coming down head first. The tomb seems to have been used up to the 1st century B.C., for many cinerary urns were found there, one of them with a bilingual Etruscan and Latin inscription.

Second quarter of the 5th cent. B.C. From G. Micali, Monumenti per servire alla storia dei popoli italiani, Florence, 1832, pl. LXX.

2b

Oinochoe with a trefoil mouth, from Veii. (New York, Metropolitan Museum of Art, inv. n. 25.78.160). It is entirely covered with a brown glaze. The animals are incised and have touches of creamy white and reddish purple. The shape imitates Corinthian vases of the last quarter of the 7th century B.C.; the frieze of animals on the body (winged griffin; lion?; deer; wild goat; horse; fawn) is influenced by Corinthian vases of 630-620 B.C. Characteristic of Etruria is the division of the bodies of the animals into zones of contrasting colours. This same system also occurs in Greece, i.e. the animals on Rhodian vases after 500 B.C., but in Etruria this decorative division of the animal body is much more daring and decisive. The pitcher is not earlier than 600-575 B.C., but may be as late as 550 B.C. Photo Met. Mus. of Art 65700 (Courtesy of the Metropolitan Museum of Art, Fletcher Fund, 1925).

2C

Hemispherical bronze bowl with three feet, from the Barberini tomb at Praeneste. (Rome, Museo di Villa Giulia, inv. n. 13131). The basin is decorated in high relief and incision; six sirens with 'layer-wigs' are seen frontally; their legs end in claws that rest on the head of a bull. Rectangular ornaments with four volutes fill the space between these heads. The wings of the sirens are so stylized that they almost appear to be arms. The decorative motifs are emphasized by dots. Bronze basins similar in style and technique are found at Praeneste and in the Faliscan area. Their style is characteristic of the baroque taste prevalent in South Etruria. The inspiration is eastern, but so far nothing similar has been found in Egypt, Asia Minor or Mesopotamia. Fragments of a similar bowl, but with sirens with spread wings, have been found in a tomb in the Kerameikos cemetery at Athens: although the Kerameikos bowl is Greek in style and pattern, it is so close to another Etruscan bowl, found in the Bernardini tomb in Praeneste, as to suggest that both were

influenced by the same model. Late 7th cent. B.C. Photo Gab. Fot. Naz. E 2737.

3a, b

Janiform askos with caricature heads (Vatican, Museo Gregoriano Etrusco). The liquid was poured into the wide open mouth of the head and came out of the small round spout on the cranium both have in common. 4th cent. B.C. Photo Anderson 42091.

3C

Reconstruction of the Portonaccio Temple, Veii. From Notizie di Scavi di Antich., 1953, p. 111, fig. 77.

3d

Axonometric view of the temple at Faesulae (Fiesole). 3rd cent. B.C. From Studi Etruschi, XXIV, 1955-6, fig. 10.

3e

Terracotta revetment plaque of a temple, from Velletri. (Naples, Museo Nazionale). Length 0.71m.; ht. 0.21m. Found, together with other plaques with different decoration, in 1784. Two figures, the first holding a bow and arrows, move from the left towards five persons seated on folding chairs. The plaque was probably restored arbitrarily on the far right. The seated figures were six, instead of five. The first and the fourth are bearded and hold sceptres, the second and the fifth have litui and turn to speak to the third and sixth figures. We are therefore dealing with two groups of three people each, repeated in the same order. The plaque has been variously interpreted : a meeting of a god and two worshippers ; a meeting of magistrates with standing citizens. Attempts have been made to identify them with the college of magistrates at Velletri, but similar clay plaques were found at Veii; the same motif, but with only two people, appears at Tarquinia. This weakens any hypothesis that they represent the magistrates of a given city. It was a purely ornamental motif used in different terracotta or sculpture workshops. Late 6th or early 5th cent. B.C. Photo Soprint. Antich., Florence 6690.

4a

Ficoroni cist, from Praeneste. (Rome, Museo di Villa Giulia, inv. n. 24787). Engraved bronze with cast bronze ornaments. The cist (box)

was already known prior to 1738. The scene on the box itself illustrates an episode from the legend of the Argonauts: the punishment of Amycus, king of the Bebrycians, who refused to let the Greeks draw water at a spring. The side reproduced here shows the ship Argo with two seated Argonauts and a sleeping one. A youth is leaving the ship with a cist and a vessel for water. Second half 4th cent. B.C. Photo Anderson 4925.

4b

Foot of the Ficoroni cist.

4C

Bronze cist from Vulci. (Rome, Museo di Villa Giulia). The handle on the lid is in the shape of an animal, perhaps a panther. 3rd-2nd cent. B.C. Photo Gab. Fot. Naz. E 26359.

4d

Detail of a bronze cist, from Praeneste. (Rome, Museo di Villa Giulia, inv. 13199). Abduction scene. 4th–3rd cent. B.C. Photo Alinari 20230.

5a

Tumulus I and Tumulus II, along the main road of the Banditaccia cemetery at Caere. The Banditaccia, north-west of Caere, between the Fosso del Manganello and the Fosso del Marmo, is the best known, the most imposing and perhaps the most extensive of the cemeteries at Caere. The tombs are laid out along roads and piazzas, almost as if they were houses in the city of the dead. A cylindrical drum cut into the rock and with a moulded cornice forms a base for the mound which covers one or more chamber tombs. Tumulus I (the first on the right) has a diameter of 31m. and is 13m. high. It encloses two chamber tombs. The upper part of the rectangular construction between the tumulus and the Main Road has been destroyed. We do not know what it was meant to be. Traces of a flight of stairs suggest that it may have been used to get to the top of the tumulus. This might be the most logical explanation but it could also have been an altar or anything else. Tumulus II, the second largest in the necropolis, is 40m. in diameter and 15m. high. The moulding on the high drum at its base is very complex. It encloses four chamber tombs, in one of which, the

Tomb of Greek Vases (Tomba dei Vasi Greci), were found many very good black- and red-figure Attic vases. There are three lesser roads between these two tumuli, with later chamber tombs all along them. Photo Alinari 35846.

5b

Tomb of the Seats and Shields (Tomba degli Scudi e delle Sedie) in the Banditaccia Necropolis, at Caere. This chamber tomb, covered by a tumulus, was discovered on 9 February 1834. The entrance corridor opens onto a vestibule which has a chamber on each side, and leads to a large rectangular room with a flat roof and beams in relief. Six beds, cut into the rock, with pilaster-shaped legs and half-moon pillows in relief, served for male depositions. The women were placed in sarcophagi. Three doors lead to three small chambers and two narrow rectangular windows open in the back wall. Fourteen shields are carved on the walls and two chairs with semicircular backs and foot-stools are between the doors. The chairs and shields have given the tomb its name. Chairs like this or with a rectangular back are frequent in the tombs of Caere. They do not seem to have had any special functionin only one tomb were there statuettes seated on them (Pl. 8d) and this was an exception-but represent the furniture of the house. There were also traces of painted decoration in the tomb. First half 6th cent. B.C. Photo Brogi 18427.

6a

Interior of the Regolini-Galassi Tomb, Caere. It is the most famous, the richest and also one of the earliest chamber tombs of Caere. One of the rare tombs that was not plundered, it is to the south in the Sorbo cemetery, which is the closest to the city and therefore the earliest. It has tombs of varying periods, but primarily Villanovan fossa and pozzetto graves. The tomb is named after General Vincenzo Galassi and Alessandro Regolini, the priest of Cerveteri, who discovered it. It was once covered by a tumulus of considerable size (diam. 48m.), which farming had almost levelled off when the tomb was discovered in 1836. The tomb consists of a long narrow fossa (the cella 7.30×1.30 m.) preceded by a corridor (the antechamber, $9m \times 1.28 - 1.58$ m.), with two opposing niches. The cella and antechamber are half sunk, that is cut into the tufa to a depth of 1.10 - 1.70m. The upper part was built up with horizontal courses of dressed blocks, each row over-

lapping the other. It is closed by a row of single slabs along the top which give the tomb the aspect of a long corridor covered by a false arch. There were two inhumation burials and one cremation burial in the tomb. The latter (a man, for he was buried with his chariot) was in the right hand niche. The body in the cella has been said by some scholars to have been that of a man, and by others, that of a woman. Tomb furniture—bronzes and jewellery—was extremely rich. The bronze bowl (Pl. 9a) and the shield (Pl. 28c) seem to have belonged to the man buried in the antechamber. The tomb was built around the middle of the 7th cent. B.C. Photo Alinari, 35868.

6b

Detail of a painted plaque from Caere (Paris, Louvre). This is one of the so-called 'Campana plaques', named after the man who first owned them. They were found in 1856. The colours and technique are those of vase painting. There are three figures on this plaque, two of which are reproduced: a winged demon holds a woman in his arms; he moves to the left preceded by a bearded man with a bow and arrow in his hand. The interpretation of this and of the other plaques is uncertain. This may be the first representation of a subject which was to become frequent in the 4th century B.C.: the journey to the Underworld. It has been greatly restored. C. 530 B.C. From 'Tyrrhenica', Saggi di Studi Etruschi, Istituto Lombardo, Accademia di Scienze e Lettere, Milan, 1957, pl. VIII, 1.

6c

Interior of the Tomb of the Sarcophagi, at Caere, in the Banditaccia cemetery. It has one large chamber, characteristic of late tombs. Benches, cut into the tufa, run all along the walls. They are simpler than those in tombs of the 6th century B.C. and are covered by a layer of stucco. In the 19th century painted hippocamps, dolphins and fighting animals, could still be seen. The walls of the tomb also had traces of ornamental painting. It is one of the rare tombs in Caere in which sarcophagi were found. Generally the dead were placed on the benches without any coffin, or in a wooden coffin. Three sarcophagi are still in place: two have a male figure reclining on the lid, the third is an unornamented chest with a gabled lid. The finest sarcophagus was taken to the Museo Gregoriano in the Vatican (Pl. 17b). The holes which are visible in the sarcophagi were made by tomb robbers. It is strange, and incomprehensible, that the figures on the sarcophagi face

the wall, but there seems to be no doubt that this is the way they were put into the tomb. The tomb itself was built at the end of the 5th or early 4th century B.C., which is the date of the sarcophagus in the Vatican. The decoration of the benches is later and must have been due to remodelling. Photo Brogi 18426.

7a

Sarcophagus in terracotta found in an unidentified tomb at Caere. (Rome, Museo di Villa Giulia, inv. 6646). Although there is no doubt as to its provenance, we have no information on the find. We do however know the tomb from which came a similar sarcophagus, made in the same workshop, now at the Louvre, and ash urns similar to the one in Pl. 8c. The Villa Giulia sarcophagus was fired in four sections. On the cover husband and wife are lying together on the banquet couch (kline). As usual, they lean on a pillow with their left arms. The man affectionately encircles his wife's shoulders with his right arm. His torso is nude. The woman wears a long chiton, with a cloak which covers her legs. Her shoes have a curved point (calcei repandi) and on her head she wears the so-called tutulus. The large mattress and the cover fall heavily on either side of the kline, in a typically Etruscan fashion, found neither in Greece nor in the East. The motif, a banquet with figures reclining on the kline, is Greek, but the Greeks never showed husband and wife sitting together. The Greek wife never appeared in public, let alone sat at a banquet together with her husband. In Etruria we often find husband and wife together, both in sculpture, and in the banquets in the painted tombs (Pl. 30b). The Greeks were scandalized by this equality, which was incomprehensible to them, and considered it depravity. The high quality of the sarcophagus is not shown to advantage in the museum, for the sculptor made it for the semi-obscurity of the tomb. In the museum the bright light flattens the relief, as it does for the small ash urn from Chiusi, Pl. 81b. The sarcophagus must be dated to around 510-500 B.C. Photo Anderson 6292.

7b

Detail of the preceding sarcophagus. Photo Anderson 6293.

8a

Ornamental plaque of hammered bronze, from the Regolini-Galassi

tomb, at Caere. (Vatican, Museo Gregoriano Etrusco, inv. 562). The nailholes show that it once decorated a piece of wooden furniture. There is no proof that it was facing for a high-backed throne, as has been suggested. A winged sphinx is crowned by a lily ornament which recalls, in simplified form, the flowers with drooping petals and a central sphere frequently used as handles (Pl. 63b). The hair curls up, Hittite style. Both in style and drawing the sphinx is very close to the reliefs on the bucchero cups of Caere, such as those on the inside of the cup from the Tomba del Duce in Vetulonia, and cannot be far off in date. It is therefore doubtful if it belonged to the equipment of the chamber itself. The piece is exceedingly ornamental and the metal-worker made full use of the curved line without becoming manneristic. Last quarter of the 7th cent. B.C. (?). Photo Musei Vaticani XX-22-34.

8b

Detail of the sarcophagus reproduced in Pl. 7: profile of the dead woman. From 'Tyrrhenica', Saggi di Studi Etruschi, Istituto Lombardo, Accademia di Scienze e Lettere, Milan, 1957, pl. VII, 1.

8c

Cover of a small clay ash urn, from Caere. (London, British Museum, Tc. B 629). The funeral couch is similar to that of the sarcophagus in Pl. 7a, with the large mattress which falls down at the sides. There are two cushions on the mattress. Only the feet can be seen extending from under the blanket. The woman wears large disc earrings, and her hair falls over her breast in three locks. This is the exposition of the dead, not a banquet scene. Three similar urns, at the Louvre, come from the same tomb in which the large sarcophagus, which is also at the Louvre and which was mentioned in Pl. 7a, was found. On these are figures of a bearded man, of a young man, of a woman. The last is almost identical to the woman on our little urn but her eyelids are shut in death. There is little doubt that all four come from the same workshop, which also made the antefixes of Caere in the first half of the 9th century B.C., not only because the style is the same, but because some of the heads were made with the moulds used for the antefixes. 480-460 B.C. Photo Brit. Mus., LIX C 45.

8d

Head of a terracotta statuette of a woman, from Caere (London, British

Museum, Tc D 220). Found in 1863 in a tomb that had many chambers. It was seated on a chair cut out of the living tufa, like those in the Tomb of the Seats and Shields (Pl. 5b). Several other similar statuettes were with it, but only the three most complete were preserved, a male figure (Rome, Palazzo dei Conservatori), and two female figures (London, British Museum). The hair of the two female figures is modelled only in front. At the back of the head incisions stop at the nape, as is also the case in the Clusine canopic jars. Probably little attention was paid to the hair since it was hidden by the back of the chair. In the frontal view the large hoop earrings completely hide the lack of hair. The modelling is lively and expressive, with soft passages. The cloak closed at the shoulder with a brooch is Greek and not Etruscan and can be compared only with the Greek chlamys. It shows the beginning of Greek influence in Caeretan sculpture and may be dated between 600 and 570 B.C. Photo Brit. Mus. XXXVII B 6.

9a

Hammered bronze cauldron from the Regolini-Galassi Tomb in Caere (Vatican, Museo Gregoriano Etrusco, inv. 496). Diam. 0.47m. Round the rim are five lion protomes in hammered bronze, each set into a ring of cast bronze. It is an imitation of the imported cauldrons found at Praeneste and Vetulonia. The protomes of this cauldron differ both in style and technique from the imported ones. Their decorative stylization is characteristic of Etruria and both cauldron and protomes were surely made there. The hard angles of the folds at the muzzle, of the nostrils, of the eyebrows and ears are an Etruscan modification of the style of the imported protomes. This and another similar cauldron seem to have belonged to the funeral equipment of the antechamber. Second half of the 7th cent. B.C. Photo Anderson 42140.

9b

Bucchero pyxis with a low foot, without a cover. From Caere (Vatican, Museo Gregoriano Etrusco, inv. 457). Height 0.175m. The pyxis (a receptacle of varying form and size which served as a coffer) is footed and very elaborate. The bottom has knobs on the outside. The protome of a goat is fitted onto a projection above each of the four handles.

9C

Pyxis like the preceding (Vatican, Museo Gregoriano Etrusco, inv.

459). Diam. 0.22m. All around the base are projections which terminate in small spheres. On the outside three animals are modelled in low relief: a goat, a panther, a lion, from the mouth of which issues a human leg, and two animals in graffito, smaller and unrecognizable. The bodies of the animals have a punched ornamentation. It is strange to find just the part of the vase which cannot be seen decorated, but I do not think this was a cover. For the animals which have a human leg or arm in their jaws see Pl. 64a. The two vases come from a chamber tomb in the Sorbo necropolis, excavated in 1836, but it is not certain that they were in the Calabresi Tomb, as Pareti states. Late 7th or early 6th cent. B.C. Photo Anderson 42122.

IOa

Vase in bucchero sottile, from a tomb in the Sorbo cemetery at Caere (Vatican, Museo Gregoriano Etrusco, inv. 461). Height 0.285m. It was found in 1836 in excavations carried out by Alessandro Regolini near the Regolini-Galassi tomb to which Pareti has assigned it (La tomba Regolini-Galassi, p. 364). Documents give only the year in which it was found. It is one of the finest Etruscan buccheros known. The extremely complex form has nothing of the 'baroque' taste which so often characterizes the production of south Etruria. The contours are smooth, harmonious, uninterrupted. Shape and technique clearly indicate that it was an imitation of a bronze vase. This is particularly evident in the two lilies, or lotus flowers, with drooping petals, which are the stoppers for the openings in the heads of the horses, and which are so often found as handles in bronze objects (see pl. 57). Here the material has forced the artist to join the petals to the calyx of the flower; the handle with its interlace motif was used for other buccheros from the same workshop (for ex. Pl. 10c). Late 7th cent. B.C. Photo Anderson 42120.

ıob

Pitcher in bucchero sottile, with trefoil mouth, from a tomb in the Sorbo cemetery, Caere (Vatican, Museo Gregoriano Etrusco, inv. 460). Height 0.30m. It was found in 1836 in the same excavation as the preceding vase. It is doubtful whether it belongs, as has been proposed, to the Calabresi tomb. The body and the foot are finely ribbed; the handle and the neck have zones in extremely delicate graffito, framed by

lines of punctured dots. It belongs to the same workshop as the preceding vase. End of the 7th cent. B.C. Photo Musei Vaticani XXXII-34-14.

IOC

Cup in bucchero sottile, found in the fourth trench of the Tomba del Duce, Vetulonia (Florence, Museo Archeologico, inv. 7082). Height, 0.24m. The hemispherical bowl of this extremely lustrous cup is separated from the foot by a large torus moulding. The outside is decorated in incised lines. On the inside, the cup is decorated with three winged animals in low flat relief which imitates repoussé bronze, around a protuberance. The fine wide ribbon-like handle is decorated with lines, interlacing, and impression, and recalls that of the vase in Plate 10a. A long inscription was cut into the foot after firing. A similar cup, identical in size and shape, also with an inscription incised on the foot, comes from a tomb near Monteriggioni, in north Etruria. A third cup, from Chiusi, is at the Museum of Berlin. Many fragments, similar in technique and reliefs, found in excavations at Caere, are in the Museo Gregoriano Etrusco in the Vatican. The workshop which produced this cup and the preceding vases was active in south Etruria, perhaps in Caere. Late 7th cent. B.C. Photo Soprint. Antich., Florence 87.

па

Bucchero cup from the Tomb of the Painted Lions, at Caere (Rome, Museo di Villa Giulia). The decoration is on the outside only. Immediately below the rim is a band of tongues and under this a series of twelve small heads in high relief. These heads have almond eyes, prominent noses, arched mouths, decided chin. Shape and decoration are clearly derived from models in metal. The heads, especially the shape of the mouth, betray an Ionian influence. First half of the 6th cent. B.C. Photo Soprint. Antich., Rome II.

11b

Globular impasto cauldron, with a tall conical support (Leningrad, Hermitage). The cauldron, decorated with four lion protomes, imitates the great bronze cauldrons with lion or griffin protomes which were imported to Etruria from the East or, according to a rather unconvincing hypothesis, from Greece. These imported cauldrons were imitated in

Etruria in bronze (Pl. 9a), in terracotta, or in impasto. The support, which has the usual form of those in bronze or impasto in Latian Etruria, is important for the plastic decoration and the openwork, which is emphasized by white paint. The closest comparisons are at Caere. Late 7th cent. B.C. Photo Istit. Arch. Germ., Rome 50.61.

1 2a

Dolio and plate, in red impasto, perhaps from Caere (Vatican, Museo Gregoriano Etrusco, Pareti nos 647; 654). Height of the dolio, 0.45m. diameter of the plate, 0.49m. The bottom part of the dolio is ornamented with a vertical fluting interrupted at the height of the handles by an impressed horizontal band. The upper half is divided into bands of impressed ornament, either continuous (rosettes, garlands, and half circles) or in panels (horses). The plate has a frieze of animals impressed by rolling a cylindrical stamp along the surface of the vase while the clay was still wet (griffin, ram, deer, boar). Vases in red impasto are frequent in the tombs of Caere, but were also made in other places in south Etruria, such as Veii and Vulci. The finest examples of red impasto, which has many impurities and is red both outside and inside, have a polished surface. Sometimes a thin layer of purified clay with impressed decoration was first applied so as to make the impression more precise. Vases in red impasto may have begun in the second half of the 7th century and definitely continued throughout the 6th century B.C. Photo Anderson 42150.

12b

Large gold plaque with animals in the round, from the Bernardini Tomb of Praeneste (Rome, Museo di Villa Giulia). It measures $0.17 \times$ 0.067m. At either short end of the plaque is a gold tube, decorated in granulation. They are joined by a central tube. The plaque is covered by 131 creatures consisting of lions, sirens and chimeras with a human head sprouting from the middle of their backs. Each animal is made of two gold sheets, each worked in repoussé so as to give them the required shape, and soldered together. The details are in the granulation technique. This use of granulation for the details of such tiny figures in the round is specifically Etruscan. The plaque may have been a belt clasp, used to keep the folds of the dress together. A similar piece was found in the Barberini Tomb of Praeneste. The object is remarkable

more for its ornamentation and intricacy than for its good taste. Second half of the 7th cent. B.C.

13

Gold necklace from the cella of the Regolini-Galassi Tomb at Caere (Vatican, Museo Gregoriano Etrusco, inv. 691). A chain of gold meshes strung with three amber medallions (diameter 0.05–0.06m.), mounted in gold, decorated in granulation. Each medallion has a pendant terminating in four lion heads in the round, in repoussé gold plate. Amber was imported and used in Etruria from Villanovan times. Mid-7th cent. B.C. Photo Anderson 42200.

14a, b

Gold bracelet worked in repoussé and granulation, from the cella of the Regolini-Galassi Tomb, at Caere (Vatican, Museo Gregoriano Etrusco, inv. 668). An identical pair of bracelets is at the British Museum in London. Our example is made of a single wide gold band. The decoration is in rectangular panels, separated by a meander design in granulation. Each panel has three women holding four flabelli, worked in repoussé, with the outlines and details picked out in granulation. In the end panels is a female figure between two rampant lions each of which she holds by a paw (the so-called 'mistress of the animals'). Behind each lion stands a man in the act of plunging a dagger into the back of the beast. At the end of the bracelet is a fastening tongue and slender chains which go from one side to the other. It has been supposed that this bracelet and its mate were used as earrings (see Pl. 28b). In technique it is very close to Greek goldwork, but in Etruria granulation is used where the Greeks would have used incision. Photo Anderson 42196. Pl. 14b is a detail of the same bracelet.

14C

Gold ring with oval bezel, from Caere (Rome, Museo di Villa Giulia, inv. 40877). It is divided into three panels. Represented in intaglio are, from top to bottom, a seated lion, a winged horse and a running dog, a running boar. The decorative motifs in the first two panels are standard for Etruria in the second half of the 6th century B.C. This date is confirmed by the boar in the lowest panel, whose bristles do not make a continuous line along his back but are interrupted halfway down. This is characteristic of boars in Ionian painting and sculpture, but only

from the middle of the 6th century B.C. on. The ring must then date to the second half of the 6th cent. B.C. Photo Gab. Fot. Naz. R127.

14d

Gold cylinder earring (Rome, Museo di Villa Giulia). In its form (a baule) the earring is similar to the one shown in 14e. The decoration on the gold foil was generally divided into two panels—exceptionally into three. The one in front, which was most visible, is the most ornate. On this earring the ornament is an eight-petalled rosette. 6th cent. B.C. Photo Gab. Fot. Naz. R 137.

14e

Gold a baule earring (so-called because it resembles a small bag), from Caere (Rome, Museo di Villa Giulia). These earrings are made of a sheet of gold foil bent into a semi-cylinder. The ends are joined by a wire which went through the earlobe. The visible panel has a rosette in the centre and four small spheres at the corners worked in granulation. There are four spheres along the upper border, two in granulation and two smooth. A comparison between this granulation and that of the 7th century B.C. (Pls. 14a-b, 28b), reveals at first glance how much this technique has declined. The spheres are too large, and the execution is not as delicate or fine. In some pieces the effect of granulation was obtained by repoussé dots. 6th cent. B.C. Photo Gab. Fot. Naz. R 124.

1 5a

Ivory pyxis found in the Sorbo Cemetery at Cerveteri (Caere). (Baltimore, Walters Art Gallery, inv. no. 71.489). It cannot have come from the Regolini-Galassi Tomb. It has the shape of a truncated cone. As a handle the lid has a winged sphinx with a Phoenician palmette on her head. Her hair, parted in the middle, falls to her shoulders in a spiral curl. Like the pyxides found in three chamber tombs at Chiusi (Pls. 75c-d) this pyxis is a strange mixture of retarded orientalizing motifs and others found on Etruscan vases of the second half of the 6th century B.C. For example, in some details the animals in the upper zone resemble those on Etruscan black-figure vases of the second half of the 6th century B.C. The sphinx on the lid is the three-dimensional version of the one carved on an ivory pyxis, also from the Sorbo cemetery, which is now in the Vatican Museum. They were probably

both made in the same workshop. Second half of the 6th cent. B.C. Photo Walters Art Gallery, Baltimore.

15b

Terracotta head of a woman (Vatican, Museo Gregoriano Etrusco, inv. n. 13749). It is carefully modelled and retouched with a modelling tool. The slightly melancholy idealized face reminds one of the Praxitilean canons, the hair-style is Hellenistic.

16

Votive head of a woman, in terracotta, from Caere (Vatican, Museo Gregoriano Etrusco, inv. 14207). The unaffected liveliness of this piece gives it a place among the best production of the 1st century B.C. Heads like this were made from matrixes and pieces made with the same mould were found in different sanctuaries. One mould might also be used for different types, a few quick strokes of the modelling tool transforming, say, the head of a young boy into that of a bearded man. The same matrix was used for heads completely in the round and half heads, meant to be seen only in profile since the other part was flat. Evidently the latter were meant for whoever could not afford a higher price. The transformation of pieces from the same mould are evident when dealing with a large number of votive heads, from the same sanctuary. It should make one very sceptical about the possibility that the heads, even when they seem to reproduce individual features, are really portraits. 1st cent. B.C. Photo Anderson 42222.

17a

Terracotta plaque for temple decoration, from Caere (Vatican, Museo Gregoriano Etrusco). Height, 0.55m.; length of each plaque, 0.51m. It is in very high relief, with flowers, cupids, male and female heads. 1st cent. B.C. Photo Anderson 42227.

17b

Limestone sarcophagus from the Tomb of the Sarcophagi, Caere (Vatican, Museo Gregoriano Etrusco, inv. 59). Length, 1.88m. (For the tomb and the other sarcophagi found there, see Pl. 6c). The man reclines full length on the lid and holds a patera. He wears a wreath and a necklace with bullae round his neck, and a bracelet with bullae on his arm (Pl. 48a-b). The head and the lid are both of excellent

quality. The relief on the sarcophagus shows a funeral procession: a horn player, a man with a lituus (or a trumpet? but the shape is that of a lituus), a man with a herald's intertwined baton, a lituus player, and a flute player are followed by a woman and a man. Behind them is a boy with a folding chair, and lastly a chariot. Late 5th or early 4th cent. B.C. Photo Alinari 35606.

18

Terracotta group from Temple A at Pyrgi. (Rome, Museo di Villa Giulia). Despite its fragmentary state, a gigantomachy is recognizable. The first figure on the left (of the beholder) is easily identified by her armour as Athena. The group covered the head of the columen (ridge-beam). Around 475 B.C. Photo Soprint. Antich., Rome II.

19

Ponte Sodo, Veii. It is one of the most imposing and picturesque sights of Veii. The Fosso di Formello, which separates the Etruscan city from the necropolis of Monte Michele to the north, runs through a long tunnel. At this point the rock consists of two strata. The upper one, of peperino, is hard and forms an excellent natural bridge. The lower one, a soft tufa, was cut to permit the water to run through. The tunnel may be partly natural, but it was certainly enlarged by man. Photo Alinari 28740.

20a

Campana Tomb, necropolis of Monte Michele, Veii. It was discovered in 1842 or 1843. Two small lateral chambers open off a corridor which leads to a chamber at the back, behind which is a second chamber. Here there were three ash urns, each with a semi-cylindrical lid with a small head jutting from the centre (Pl. 21) and vases similar to those in the first chamber. On the floor was a three-footed 'brazier' in bronze. In the first and most important chamber there was an inhumation burial on the bench on the right. This funerary equipment, including a so-called 'candelabrum' (Pl. 64b) was lying near the dead man. He also had his cuirass and his helmet with a spear hole in it. The drawing by Canina also shows an inhumation burial on the bench at the left. The material, once left in the tomb for the benefit of the visitors, is now partly in the Museo di Villa Giulia, Rome, partly lost. The prime importance of the Campana Tomb lies in the interesting painting on

the back wall of the first chamber, on either side of the door, which has been variously interpreted. The multicoloured bodies of the animals, the contrasting colours which cancel form and volume, the lavish use of space fillers, give it a unique character. It was painted directly on the tufa, thus differing from Tarquinia where the paintings generally have a preparatory layer of clay and lime. As noted in our discussion of Veii, the dating of the tomb is controversial and no parallels with other paintings (see a painted vase with similar colour contrasts on Pl. 2b) exist. Reports published in the first half of the 19th century describe other tombs, now lost, which seem to have been akin to the Campana tomb, such as one in Magliano and one in Chiusi which are, to judge from the description, quite late. One in Cosa, found in 1870, is said to have had extremely ancient paintings 'similar to those in the Campana tomb'. Some of the tombs at Caere (Tomb of the Painted Lions-'dei Leoni Dipinti'; Tomb of the Painted Animals) bear comparison. Last quarter of the 6th cent. B.C. From L. Canina, Descrizione dell' antica città di Vejo, 1847.

20b

Campana Tomb, the two panels to the right of the door. Much has been written regarding the subject matter and possible parallels for the upperpanel, which is the most complex in the tomb. The subject is uncertain: conjectures include the return of Hephaestus to Olympus; a hunting scene; the journey to the Underworld. From L. Canina, Descrizione dell'antica città di Vejo, 1847.

20C

Terracotta antefix from Veii (Rome, Museo di Villa Giulia). This antefix with the head of a woman (maenad?) decorated an archaic temple with a rectangular plan in the so-called Piazza d'Armi. It was made from a mould and was not retouched with a modelling tool. The wide flat face, the large eyes, the triangular nose with its wide bridge, the two deep folds which run obliquely from the nose to the wide mouth with its thin tightly closed lips, recall the statue of a woman from the Grotta di Iside, at Vulci (Pl. 43a). 'Daedalic' features are evident here too, but the sculptor has softened the passages and has modelled the hair as a compact unit. The details were painted, but the colour has now disappeared. About 550 B.C. Photo Gab. Fot. Naz. E 16329.

21a

Ash urn in terracotta (Vatican, Museo Gregoriano Etrusco, inv. 14145). It is a rectangular box with the head of a man projecting from the semicylindrical lid. The raised border of the lid is decorated with a row of semicircles and dots impressed with a punch. The same motif also appears in the centre of the lid below the head and on the box. Three similar ash urns were in the second chamber of the Campana tomb, at Veii (see pl. 20a). We do not know where the Vatican urn came from for it is not one of those from the Campana tomb, even though the type is so characteristic that it too must have come from Veii. Third quarter of the 6th cent. B.C. (?). Photo Alinari 35610.

21b, c

Details of the head of a man on the same urn. Photo Mus. Vatic. XXXII-75-20.

22a

Terracotta statue of Apollo, from Veii (Rome, Museo di Villa Giulia). Found at Veii in the excavation of the sanctuary of Minerva, in the Portonaccio area. It formed part of a group representing the struggle between Apollo and Heracles for the Ceryneian hind and seems to have decorated the roof-tree of the temple. It is perhaps the most famous of the Etruscan statues. Most photographs show Apollo without his right arm, which was not found until after the Second World War. The addition of the arm has given this magnificent figure an unsuspected balance and has attenuated the violence of his movement. C. 490 B.C. Photo Gab. Fot. Naz. E 26232.

22b, c

Head of the preceding statue. Photo Anderson 27813; 27834.

23a

Terracotta antefix with the head of a woman, from Veii. (Rome, Museo di Villa Giulia). Found in the excavation of the temple of Minerva, at Portonaccio. Notwithstanding its fragmentary state, the head is one of the loveliest and most vivacious of the temple. Most of the wide shell of tongues framing the head is now missing. Although the piece is still under Ionian influence, the strong modelling and the feeling for bone structure contrast with the softness of modelling and the search for

chiaroscuro effects characteristic of eastern Greece. It belongs to the artistic current of the Apollo of Veii, although it is not by the master himself. First quarter of the 5th cent. B.C. Photo Gab. Fot. Naz. E 26277.

23b

Terracotta antefix from Veii (Rome, Museo di Villa Giulia). The antefix with the head of a woman (maenad) was found in the excavation of the temple of Minerva, at Portonaccio. This fine piece is akin to the head of the so-called 'peplos kore', a statue of a girl (kore) which was dedicated on the Acropolis of Athens to the protecting goddess of the city (Athens, Museum). But Attic style has been translated into Etruscan. The oval face is not as pure, the features are heavier and the soft wavy locks which frame the face of the Greek girl have become large twisted ropes. The feeling for bone structure which gives the Greek kore its unmistakable character has almost completely disappeared. The two heads are chasms apart and the comparison serves to show only how profoundly different Attica and Etruria were. Yet both are beautiful, each in its own way. The Greek statue dates to 530-520 B.C.; the Etruscan antefix is not prior to 510-500 B.C. but may be later. Photo Gab. Fot. Naz. E 26273.

23C

Terracotta head of a woman from Veii (Rome, Museo di Villa Giulia). From the sanctuary of Minerva at Portonaccio. The fine head is influenced by the Polykleitan current of the middle of the 5th century B.C. It could be dated to the second half of the 5th cent. B.C. Photo Gab. Fot. Naz. E 26250.

23d

Terracotta statuette of a youth, from Veii (Rome, Museo di Villa Giulia). Found in the excavation of the sanctuary at Portonaccio. A Polycleitan influence is also evident here, although not to the same extent as in the head in Pl. 23c. Late 5th or early 4th cent. B.C. (?). Photo Gab. Fot. Naz. E 26234.

24a

Impasto ash urn, from Falerii (Florence, Museo Archeologico, inv. 74318). It is covered with a creamy white slip, the decoration is reddish-brown. Because of the white slip some scholars have con-

nected it with the Geometric pottery of the Greek islands, although both the technique and decorative motifs are simple enough to have had an independent origin. Photo Soprint. Antich., Florence 5614.

24b

Footed globular crater (Vatican, Museo Gregoriano Etrusco, Sala delle terrecotte, Vetrina C). It is of impasto with a shiny surface and with impressed decoration and intaglio. The latter was filled with a red clay of which there are still traces. In the main area between the two handles is shown a man between two horses which bend a leg before him: the so-called 'Lord of the Animals'. The young god between two horses is a frequent motif in Picenum and in Faliscan territory, particularly Narce. In Greece it was frequent in the Geometric period, but from the 7th century on it was generally replaced by the 'Mistress of the Animals', the goddess between two animals (in general two lions), a motif taken from the East. Etruria, too, seems to have preferred the Mistress of the Animals. The exact provenance of the crater is unknown, but Faliscan territory is likely. Late 7th cent. B.C. Photo Musei Vaticani XXXII-25-10.

24C

Painted terracotta slab, from the temple of Celle at Falerii (Rome, Museo di Villa Giulia, inv. 3790). Head of a youth. Late 4th cent. B.C. Photo Gab. Fot. Naz. E 26343.

25a

Faliscan red-figure crater, from Falerii (Rome, Museo di Villa Giulia, inv. 1197). By a painter conventionally called the Painter of Nazzano. Scenes of the destruction of Troy are shown: the old Priam, on the ground, is threatened by a warrior; above him Neoptolemus kills Astyanax; to the left, an ugly fat Aphrodite defends a half naked Helen from the wrath of Menelaus. 4th cent. B.C. Photo Gab. Fot. Naz. C 9189.

25b

Red-figure stamnos, from Castel Campanile (Baltimore, Walters Art Gallery, inv. 48.62). In Greece, red-figure vases (with the background covered by black glaze, the figures reserved in the natural red of the clay) began about 530 B.C. In Etruria they began about 450 B.C. and

became frequent early in the 4th century. This stamnos belongs to a group of Etruscan vases influenced by south Italy and therefore called the Campanizing Group. First half of the 4th cent. B.C. Photo: Museum.

26a

Terracotta antefix from the Scasato temple, Falerii (Rome, Museo di Villa Giulia, inv. 2678). Height 0.235m. Possibly Diana. The figure was probably leaning against some object. Late 3rd or 2nd cent. B.C. Photo Anderson 6304.

26b

Male bust in terracotta from the pediment of the Scasato temple, Falerii (Rome, Museo di Villa Giulia, inv. 2670). Height 0.56m. In the round. The figure, generally identified as Apollo, was fired in two parts. It is a magnificent piece, influenced by Lysippus, but much more recent than generally admitted. The decoration of the Scasato temple reveals the eclectic taste of the Hellenistic period. Late 3rd or 2nd cent. B.C. Photo Alinari 27261.

27a

Hut-urn, from Poggio di Selciatello, Tarquinia (Florence, Museo Archeologico). It measures $0.26 \times 0.29 \times 0.26$ m. From a trench tomb lined with tufa slabs. The quadrangular plan of this urn is unusual; hut-urns are generally circular or oval in plan. It reproduces the form of the primitive hut. Three beams on each side cross above the central beam and there is a round smoke hole. In front the door has a projecting boss as a handle: at the corners are four holes which correspond to those at the corners of the opening. A window, indicated by an impressed rectangular line, is on the side not shown in the photograph. The decoration is graffito and impressed. Photo Soprint. Antich., Florence, 9682.

27b

Biconical Villanovan ash urn, from Poggio di Selciatello, Tarquinia. (Florence, Museo Archeologico). It has the characteristic Villanovan shape with a flaring rim and a single horizontal handle at the widest point. The bowl with one handle used as a cover is often upside down but it could also have been right side up. The material is impasto, a dark coarse clay, poorly fired, grey, brownish or black in colour. It is

handmade with incised and impressed decoration around the mouth of the vase, above the handle and at the widest point. Ht., 0.38m. The associated funerary equipment included a bronze disc-shaped fibula and a semi-lunar razor. Photo Soprint. Antich., Florence, 2323.

27C

Animal-shaped impasto vases (askoi) from the cemetery of Monterozzi, Tarquinia (Tarquinia, Museo Nazionale). Both end with the head of a bull. One has a circular body, and feet which accentuate the resemblance to an animal. The other has two rudimentary human figurines on its back, one at each side of the handle. The characteristic hatched decoration is called a cordicella (with a rope design), since it seems to have been done by impressing a cord onto the soft clay of the vase before firing. The askoi have two openings: the liquid was poured into the large one and out of the smaller hole, which corresponded to the mouth of the animal. Photo Moscioni 10035.

28a

Bronze perfume stand (?) in the shape of a bird's body, from a pozzetto tomb in the necropolis of Monterozzi at Tarquinia (Tarquinia, Museo Nazionale). The receptacle has four wheels and two curving necks ending with the stylized heads of a fawn, or more likely, a bull. It is one of the most suggestive and decorative pieces from the early Iron Age in Etruria. It reveals the technical skill and decorative sense of Tarquinii, the most important centre for the working of bronze in the 8th century B.C. Photo Anderson tages 8th century B.C. Photo Anderson 40990.

28b

Two bracelets in gold foil, decorated in repoussé and granulation, from Tarquinia (London, British Museum, 1358, 1359). Each bracelet is made of two sheets soldered together. The inside sheet has repoussé decoration (sphinxes, palmettes, guilloche and meander bands). The external one is decorated in a very fine granulation. There are bands of warriors and horsemen, divided by meanders and zigzag patterns. At one end is a rosette between two seated human figures in the round, made from two repoussé sheets and then soldered. The granulation technique (minute beads of gold fastened to the design on the sheet with a soldering material) was used throughout the ancient world, generally together with repoussé. The jewellery made in Rhodes in the

7th century B.C. was unmatched in taste and beauty but Etruscan goldwork attained a high level of technical perfection. These two bracelets come close to those made by Vetulonian goldsmiths (Pl. 65). The figurines in the round worked in repoussé, with the details picked out in granulation, are however characteristic of south Etruria. The two bracelets stand alone in Etruscan production. They have been considered large earrings instead of bracelets, but the hypothesis is not very convincing due to the practical difficulty of fixing the long earring to the ear. Furthermore if the deposition in the cella of the Regolini-Galassi tomb in Caere where similar bracelets were found was that of a man, as is presently believed, the hypothesis that they are earrings must be excluded. Second half of the 7th cent. B.C. Photo Br. Mus. LXXXIV C 50.

28c

Round shield in bronze from the Regolini-Galassi tomb, Caere (Vatican, Museo Gregoriano Etrusco, inv. 345). The bronze plate is quite thin and the shield was either purely decorative, or for funerary purposes only. Similar shields are particularly frequent in Tarquinia. Some of the eight shields found in the Regolini-Galassi tomb seem to have decorated the walls of the antechamber, but where the others were found is unknown. In the 7th and 6th century B.C., shields, either painted or in relief, were not infrequently used as wall decoration in the chamber tombs (see Pl. 5b), but in Tarquinii they are still to be found painted on the walls of the Tomb of the Shields (3rd cent. B.C.) and in the Giglioli tomb (2nd cent. B.C.). In later tombs the vases destined for the use of the dead were hung on the walls with nails. The shield illustrated has a central knob and is decorated in concentric zones with geometric motifs executed on the reverse with a punch. Five shields with geometric decoration and fragments of three of a more evolved type were found in the Regolini-Galassi tomb, and this would seem to indicate that they belong to two different depositions. The decoration on this shield shows a fine feeling for pattern in the way in which the undecorated areas alternate with the decorated ones. The bronze-smith succeeded in obtaining surprising effects with extremely simple elements and motifs. 7th cent. B.C. Photo Anderson 42176.

29a

Tomb of the Bulls (Tomba dei Tori), Tarquinia. This is one of the

earliest painted tombs found in the necropolis of Monterozzi and is the only archaic tomb with a mythological subject. It has three chambers and an entrance corridor. The principal painting is on the back wall of the first chamber, between the two doors which lead to the smaller chambers. The tomb takes its name from the bulls painted in the pediments and above the doors (Pl. 29b-c). The back wall pictures the ambush laid by the Greek hero Achilles for the son of Priam, Troilus, during the Trojan war. It was a frequent subject in Greece, especially on the painted vases of the second half of the 6th century B.C. Achilles had hidden behind a fountain where Troilus was in the habit of watering his horses. When Troilus arrived, Achilles came out of hiding, followed and killed him. The Etruscan painter only slightly modified the composition given on imported Greek vases, but he introduced landscape elements which the Greek models did not have, such as the stylized palm in the middle of the scene, the flowers which can be seen behind the frame of the painting, the bushes around the fountain. This stress on nature is a new element brought by the Etruscan painter. Contemporary Greek painters excluded nature from their compositions because they did not want to deviate attention from the human drama. C. 530-520 B.C. Photo Brogi 17876.

29b

Detail of the Tomb of the Bulls: the bull above a door. The painter has shown himself to be an excellent decorator. Here, and in all the animals in the secondary frieze, he translated the natural forms into a precise pattern of curves and clean-cut angles. From Studi Etruschi, XXIV, 1955-6, pl. IVb.

29C

Detail of the Tomb of the Bulls: Achelous, above a door. From Studi Etruschi, 1955-6, pl. IVc.

30a

Tomb of Hunting and Fishing (Tomba della Caccia e della Pesca), Tarquinia. Detail: a bird on the back wall.

30b

Tomb of Hunting and Fishing, Tarquinia: the back wall of the second chamber. The tomb was discovered in 1873 and was then called the

Grotta dei Cacciatori. There are two chambers, one behind the other, access to which is through a corridor. The paintings in the first chamber show dancers, separated by trees; those in the second room gave the name to the tomb. All four walls of the second chamber have scenes of hunting and fishing: rocky islands with small trees and bushes, boats with fishermen, hunters, a youth diving, innumerable birds flying singly or in flocks, fish. The subject is not new. It was known in Egypt, in the East, in Greece, but this tomb gives it a fullness, an importance, it does not have in the ancient world. The birds are drawn rapidly, without corrections or hesitation (pl. 30a). With their simplified stylized form and abstract colours—red, white, blue—they are anything but naturalistic studies. Yet the way in which the painter has placed them, in irregular varied groups, produces an unforgettable effect of being very close to nature. 510-500 B.C. Photo Anderson 41038.

31a

Tomb of the Augurs (Tomba degli Auguri), Tarquinia. The name is the result of an erroneous interpretation of a figure on the right wall (see below). The tomb, one of the best of the last quarter of the 6th century B.C., was discovered in 1878. It has a single chamber, decorated on all four walls. The ceiling is gabled, with the central beam painted in red. In the pediment a lion and a panther have captured a wild goat. The first thing seen upon entering is the door painted in the centre of the back wall. On either side stands a man, motionless in the typical Etruscan gesture of the mourner. It is clear that the deceased was imagined as being behind the closed door. This scene of mourning and sorrow on the back wall is clearly set off from the rest of the composition not only through the stiff vertical branches at the corners which stress the immobility of the scene, but also by the different character of the paintings on the side walls in which the games in honour of the deceased are painted with a wealth of movement and life. C. 520-510 B.C. Photo Anderson 41027.

31b

Tomb of the Augurs, Tarquinia. Right wall. There are three separate but interrelated groups: to the left are the two judges and their servants; to the right the Phersu and his group; in the centre, the powerful group of wrestlers in a fine triangular composition. At first sight the central

group seems motionless. The two figures seem to be equally straining masses, their efforts balancing and cancelling each other. But a second glance reveals that the group moves slightly towards the right and in fact the arms of the wrestler on the right have begun to bend back. This initial movement passes, increasing in intensity, to the figure that follows. His name is given in the inscription as 'Phersu'. He wears a short mottled jacket, a pointed brimmed hat and a mask. Much has been said about this figure. The most widespread opinion is that Phersu means 'masked man'. The bearded man to the left of the wrestlers has a curved baton in his hand, generally identified with the augur's lituum. When the tomb was discovered, in the 19th century, this curved baton and the birds flying towards him led people to believe he was an augur, giving the tomb its name. It is more likely that the man is a judge of the contests. Photo Anderson 41030.

32a

Etruscan black-figure amphora, from Vulci (London, British Museum, Vas. B 64). This is an early work of a painter known conventionally as the Micali Painter. He worked with ease and rapidity: his vases are found throughout Etruria, even in north Etruria. 520–500 B.C. Photo Brit. Mus. XII D 41.

32b

Tomb of the Augurs, Tarquinia. Right wall: a judge and two servants.

33a

Tomb of the Triclinium, Tarquinia. Detail of the right wall: two dancers (Tarquinia, Museo Archeologico). The tomb, discovered in 1830, is sometimes referred to as the Marzi Tomb, from the name of the owner of the land. It is one of the best tombs painted in the first half of the 5th century B.C., but unfortunately it is in extremely poor condition. The paintings, quite ruined, were detached from the walls and are now in the Museum in Tarquinia. There are three klinai with banqueters on the back wall; on each side wall is a group of dancers or musicians, separated by trees, with birds resting on the branches or fluttering about. The banquet scene is similar to the one in the following illustration: it is a banquet as the Etruscan painters saw it on Attic vases, and no longer a family banquet as it was in 6th-century paintings (see pl. 30b). The painter of the Tomb of the Bighe (c. 490

B.C.) may have made this innovation in Etruria. A second innovation is the foreshortened view of the last kline to the right, which is seen from behind. In Greece foreshortening had already appeared by 500 B.C. In Etruria it seems to have been introduced by the painter of the tomb of the Triclinium. The delicacy, the grace and rhythm of his dancers reveal an original artist, a fine draughtsman and composer. 480-470 B.C. Photo Anderson 41075.

33b

Tomb of the Triclinium, Tarquinia. Detail: a dancer. Photo Anderson 41075.

34a

Tomb of the Leopards (Tomba dei Leopardi), Tarquinia. Back wall. This is one of the best preserved tombs in Tarquinia. It is rather monotonous—figures look heavier than those in the tomb of the Triclinium. Perhaps this is why it is generally considered as being earlier, although it is actually only a matter of quality. Here too the banquet is in the 'Greek style': three men and three women are reclining on the klinae. The two animals in the pediment, after which the tomb was named, have no relationship with the banqueters. They are simply a pediment decoration. 470–460 B.C. Photo Anderson 41047.

34b

Tomb of the Leopards, Tarquinia. Detail: double flute player on the right wall.

35a

Tomb of the Jugglers (Tomba dei Giocolieri), Tarquinia. Back wall. This tomb has been discovered recently and the paintings are fairly well preserved. The back wall, shown here, shows a game of skill taking place before a man, probably the dead man, seated on a folding chair and holding a long cane in one hand. A flute player keeps time for a dancer who balances a tall candelabrum on her head at which a youth tosses rings. The same scene, but without the boy, is painted on the entrance wall of the Tomb of the Monkey (Tomba della Scimmia) at Chiusi. Late 6th or early 5th cent. B.C. Photo Soprint. Antich., Rome, II.

35b

Tomb of the Jugglers, Tarquinia. Right wall. A sirynx player has two dancers on his right and two on his left: it is a scene of music and dance in honour of the dead man. There is a small tree between each figure and the next, a scheme which began at the end of the 6th century and continued down to the middle of the 4th. The profile and the shape of the head of some of the figures closely resemble those of some of the figures in the tomb of the Augurs-for example the first dancer to the right-but other figures look later. Photo Soprint. Antich., Rome, II.

36

Tomb of Orcus (Tomba dell'Orco), Tarquinia. First chamber. Head of a woman of the Velcha family. Second half of the 4th cent. B.C. Photo Anderson 41052.

37a

Tomb of Orcus, Tarquinia. Second chamber. The Lords of the Underworld: Hades is seated on a throne, Persephone is standing next to him. In front of them is three-headed Geryon (Cerum) who seems to be receiving orders. 3rd cent. B.C. Photo Moscioni 24100.

37b

Tomb of Orcus, Tarquinia. Second chamber: Hades.

37C

Tomb of Orcus, Tarquinia. Second chamber: Persephone. Photo Moscioni 24101.

38a Tomb of the Shields (Tomba degli Scudi), Tarquinia. The name of the tomb derives from the shields painted on one of the walls. 3rd cent. B.C. Photo Anderson 41064.

38b

Nenfro slab from Tarquinia (Florence, Museo Archeologico). The slab has square panels divided by a guilloche pattern and slanting lines. Below a band in relief goes the whole length of the slab. Each set of vertical panels is separated from the next by a step-like element. The arrangement of the decoration in each section is the same and

only the motifs change-palmettes, or animals, or human figures either singly or in groups. Some slabs have mythological scenes (death of Ajax; Heracles and Pholos; etc.). The craftsmanship is never of high quality and the flat relief recalls wood carving. The arrangement of the panels is similar to that found on the Corinthian bronze lamina used for shields and decorated in repoussé and engraving, although the resemblance is limited to the arrangement in panels, framed by guilloche, and may therefore be pure chance. These slabs were found in the cemeteries of Tarquinia, especially in the Monterozzi cemetery, and a few come from Poggio Quarto degli Archi. A sporadic fragment came to light in the cemetery of Chiusi. A fragmentary cippus shaped like a pillar, found at Vulci (Pl. 43b), is similar in technique and decoration (panels separated by bands). None of these slabs has ever been found in situ and their exact use is not known. Various hypotheses have been suggested, all rather unlikely. The dating too is open to question: the crudeness of the work has often been taken as an indication of antiquity. 6th cent. B.C. Photo Soprint. Antich., Etruria, 2624.

39a

Sarcophagus of the Amazons, from Tarquinia (Florence, Museo Archeologico). Length 1.94 m. Greek marble. The trough is painted on all four sides, proof of its importance, with scenes of battles between Amazons and Greeks. The inscription, which gives us the name of the dead woman, is repeated on the cover and on the box, with no regard for the painting. The quality is extremely fine. One of the long sides is particularly beautiful: two four-horse chariots, each with two Amazons, move towards the centre, where two groups, each an Amazon and a Greek, are fighting. Late 4th or early 3rd cent. B.C. Photo Alinari 17067.

39b

Detail of the Sarcophagus of the Amazons: two Greeks and a wounded Amazon. Photo Alinari 46198.

39C

Detail of the sarcophagus of the Amazons: a chariot. Photo Alinari 46199.

40a

Winged horses in terracotta, from Tarquinia (Tarquinia, Museo Archeologico). They were part of a pediment decoration. 4th-3rd cent. B.C. Photo Anderson 41089.

40b

Lid of a sarcophagus, in limestone. Said to have been found in the tomb of the Triclinium, Tarquinia (London, British Museum, Sc. D 22). Found in 1830. The trough has disappeared. The figure wears a Gallic torque and a necklace with five bullae. The long thyrsos, the kantharos and the fawn show that the dead woman was a follower of Dionysius. There are traces of colour on her face and on the fawn. Circa middle of the 3rd cent. B.C. Photo Brit. Mus. IC 25.

41a

Disc of gold foil, from Vulci (Vatican, Museo Gregoriano Etrusco, inv. 1345). Decorated in low relief with the head of a youth in profile set against a wreath. The profile recalls Greek profiles of 460-450 B.C. In Etruria we may date it to the second half of the 5th cent. B.C. Similar circular gold discs come from Tarquinia and Vetulonia. The examples from Vulci had a second undecorated gold disc underneath. We do not know what they were used for. The examples from Tarquinii belong to a bulla. Photo Alinari 35558.

41b

Gold fibula with serpentine bow and long sheath (London, British Museum, Jew. 1376). The sheath (into which the pin fitted) and the triple bow with balls and horses heads on either side are decorated with geometric motifs in granulation. Sphinxes and lions in the round cover the bow; lions looking back over their shoulders stand on the sheath. Each figurine is made from two sheets in repoussé soldered together, the details are picked out in granulation. The fibula was found in a tomb at Ponto Sodo, in Vulci. A similar fibula (Pl. 58a–b) was in a tomb that may be dated to around 600 B.C.; the two fibulae cannot be earlier than the last quarter of the 7th cent. B.C. Photo British Museum LXVIII C 49.

4IC

Gold bulla from Vulci (Vatican, Museo Gregoriano Etrusco, inv.

13410). It is decorated in repoussé: Zeus, holding a thunderbolt, drives a quadriga of winged horses. The figure next to him could be Athena. 4th cent. B.C. Photo Anderson 42197.

41d

Gold bulla, from Vulci (Vatican, Museo Gregoriano Etrusco, inv. 13411). Decorated in repoussé. A woman, seated between two men, rests her arms on their shoulders. 4th cent. B.C. Photo Anderson 42197.

41e

Etruscan mirror in bronze, from Vulci (Vatican, Museo Gregoriano Etrusco, inv. 12241). Diameter 0.17m. It is decorated in relief. Ivy leaves frame an intarsio of silver on bronze of a winged female figure with a rayed nimbus around her head. She moves towards the left and holds a young man in her arms. This is an abduction scene (see Pl. 49a), interpreted as Aurora carrying off the young Kephalos. The group is beautifully fitted into the tondo of the mirror. In Greece the motif first appears on vases of the second quarter of the 5th cent. B.C. The mirror probably dates to c. 450 B.C. Photo Anderson 42178.

42a

Gold wreath of oak leaves, from Vulci. (Vatican, Museo Gregoriano Etrusco, inv. 13472). The leaves are in thin gold, with stamped veins. 3rd cent. B.C. Photo Anderson 42203.

42b

Gold earring. (London, British Museum, Jew. 2256). It belonged to the Campanari collection and might therefore be from Vulci. The shape is common in the early 4th century and throughout the 3rd century B.C. The date Andrén gives to the earliest examples—the last two decades of the 5th century B.C.—is too early. The size and richness of the decoration make this an outstanding example. It is in thin gold worked in repoussé with convex discs, cut-out rosettes and globules. The effect of granulation has been achieved through repoussé dots. For heads wearing earrings like this see Pls. 36, 37a, 78b. Photo Brit. Mus. XCII B 46.

42C

Gold earring, from Todi (Rome, Museo di Villa Giulia, inv. 2731).

Decorated in repoussé, with pendants: the central one is in the shape of a woman's head. 3rd cent. B.C. Photo Gab. Fot. Naz. R60.

43a

Alabaster statue of a woman, from the Grotta of Isis, Vulci. (London, British Museum, Sculpt. D 1). Height: 0.85m. She wears a long dress, held at the waist by a girdle with a gilded clasp and a cloak which covers her back and arms and falls down in front in two long parallel folds. This type of cloak is found in Greece, in Attica, only between 570 and 550 B.C., and in Etruria, at Chiusi, after 550 B.C. The statuette cannot therefore be prior to the end of the second quarter of the 6th century B.C. Seen from the front her hair falls in two cigar-shaped curls at either side: a concession to Greek fashion. But behind her, hair is a compact mass of many flat braids which fall down to below the waist where they are tied in the Etruscan style with 11 turns of ribbon (Pl. 75c). Long braids are still frequent in the first half of the 6th century B.C. All we know about the tomb in which the figurine was found in 1839 is that it was a chamber tomb in the Polledrara cemetery—also called the Polledrara tomb. Photo Brit. Mus. XXIV C 21.

43b

Nenfro cippus, from Vulci (Florence, Museo Archeologico, inv. 75840). This free-standing funerary pillar had panels carved on at least three sides, and perhaps on all four. It is split lengthwise and all three panels are intact on one side only. In style, technique and motifs, it recalls the stepped reliefs from Tarquinia (Pl. 38b). Second half of the 6th cent. B.C. Photo Soprint. Antich., Florence, 5615.

43C

Centaur in nenfro, from Vulci (Rome, Museo di Villa Giulia). Height in its present state: 0.77 m. It was found inside a tomb, but did not seem to belong to it. It was probably a guardian for a burial and is the usual type of Greek centaur: a human body which turns into a horse's body halfway down the back. Seen from the front the figure resembles a Greek kouros (a standing nude youth, his arms along his sides) of the type found in Greece from the end of the 7th century to 500 B.C. The resemblance to the Greek kouros type (compare with the statue of Cleobis at Delphi) is evident, but the interpretation is Etruscan. It is more massive, the forms are heavier. The figure was conceived in distinct

blocks which were summarily modelled with abrupt passages from one plane to the other, almost as if they were hewn out with an adze. The huge bulging eyes set deep into the sockets and the wide-bridged nose, the fat puffy face, the hands, not clenched like those of the Greek kouros, but open, are all Etruscan qualities. Close of the first quarter of the 6th cent. B.C. Photo Gab. Fot. Naz. E 8403.

43d

Lion in nenfro from the cemeteries of Vulci. (Vatican, Museo Gregoriano Etrusco). Height: 0.58 m. length 0.80 m. The stylization is characteristic of lions in Vulci and Tarquinii in the second half of the 6th century B.C. There is no indication of muscle or modelling and the body and mane are drawn rather than sculptured. But the haunches and the beginning of the collarlike mane which forms a frame around the face in front of the ears are powerful. Ears behind the mane, as this lion has, are unusual in Greece, but Oriental and Italic lions have them. 550–500 B.C. Photo Istituto di Etruscologia e Antichità Italiche, University of Florence.

44a

Three bronzes of the so-called 'Vulci' group (Paris, Louvre). Photo Giraudon n. 9739. Left: base of a candelabrum (Louvre, Br. 1477); a dancer in a long close-fitting chiton with sleeves which widen at the elbow-the Etruscan style fashionable in the late 6th and first half of the 5th century B.C. (for ex. Pls. 7, 44c). She wears a wide girdle, characteristic of the same period, especially in the production of Vulci and Tarquinii, which forms a pouch of semicircular folds over her stomach in a decorative, but unnatural, stylization, and with a loose end at the side over one hip. The characteristic dancing position of the arms is also found in bronzes and paintings of Tarquinii. The hand, with its long thin fingers bent back, is typical of Etruscan dancers: an archaeologist called it 'the hand of the Etruscan dancer'. As far as I know only a few Etruscan works have the semi-circular stylization of the girdle. It appears on a fine mirror in London, and on a statuette in bronze in Bologna. In the latter, however, it is the cloak which is thus stylized. The girdle with its loose end at the side or with two flaps floating down as in Pl. 44c is frequently found on Greek vases of the end of the 6th and of the early 5th century B.C. The small moulded base, on which the dancer stands is typically Etruscan in its shape.

500-470 B.C. Centre: candelabrum consisting of a base with feet ending in lions' paws. On the base stands a dancer with castanets from whose head rises a shaft ornamented with discs which terminates in a whose head rises a shart ornamented with discs which terminates in a flower (500-480 B.C.). Right: 'trolley' censer (Louvre, B. 3143). The wheels permitted the censer to be moved, increasing the rate of combustion. The youth wears the characteristic Etruscan bullae (Pls. 41c-d) around his neck and heavy bracelets on his upper arms. The modelling is soft, almost feminine. First quarter of the 4th cent. B.C.

44b Base of a bronze candelabrum, or censer, from Vulci. (Vatican, Museo Gregoriano Etrusco, Collez. Guglielmi, Br. 1). A nude youth holds an egg in his right hand, and in his left the foot of a cup of which the egg in his right hand, and in his left the foot of a cup of which the bowl is missing. Around his neck is a bulla shaped like an animal's head (see Pl. 44c). On his feet are calcei repandi: in Etruria nude figures often wear shoes (e.g. Pl. 29a). It appears only exceptionally in Greece. The modelling of the body is not as soft as that in the bronzes of the 'Vulci' group (compare with Pl. 44a and with Pl. 45b) and the features are more clearly cut. The profile of the youth is similar to that of some in Tarquinian paintings—the young servant-boy with the folding chair of the Tomb of the Augurs (Pl. 32b); the young flute player in the Tomb of the Baron, both of whom have the same long nose, sharp chin, and clearly drawn features. C. 500-480 B.C. Photo Anderson 42141.

44C

44C Base of a candelabrum, in bronze (London, British Museum, Br. 598). This is one of the most beautiful pieces of the 'Vulci' group. A dancer stands on a double base, the upper one with serpents, the lower one with three lions (note the linear quality of the mane as in Pl. 43d). She wears a long chiton which falls in folds between her legs. Her sleeves flare out at the elbow and her cloak forms a swelling girdle round her waist, terminating in two swallow-tail flaps. She wears heavy bracelets at her wrists and round her neck a heavy bulla, with the head of an animal, similar to that of the youth in Pl. 44b. Her shoes with their up-curving points (calcei repandi) are of Oriental origin, but were occasionally used in Greece. Long feet are characteristic of 6th and 5th century art in Etruria. Etruscan craftsmen and artists of of 6th and 5th century art in Etruria. Etruscan craftsmen and artists of

this period never bothered to model them and they are always long and often rather shapeless (e.g. Pl. 45b). There is an upward movement to the whole figure, which the garments and the beautiful line of her arms accentuate. The 'hand of the Etruscan dancer' (see Pl. 44a) is strikingly decorative. The features might suggest a date towards the close of the 6th century, but the sharply stylized folds recall the Apollo of Veii (Pl. 22) and are to be dated in the first quarter of the 5th cent. B.C. Photo Brit. Mus. CXVIII C 42.

45a

Bronze handle of a vase, with a drinking satyr (Vatican, Museo Gregoriano Etrusco). This bronze has been attributed to the 'Vulci' group. Late 6th or early 5th cent. B.C. Photo Anderson 42129.

45b

Detail of a bronze tripod similar to the one in Pl. 46b (Leningrad, Hermitage). Each arch of the vertical supports and of the lateral supports is surmounted by a group of two figures. The group visible in the photograph shows the struggle between Hercules and Achelous. Photo Ist. Arch. Germ., Rome 53.450.

46a

Handle of a bronze crater, of the 'Vulci' group (Paris, Louvre, inv. 434). The two horsemen at the point of juncture with the vase may be the Dioscuri. Stylized palmettes like those we see here may be found on bronzes of the same group and on painted vases. Photo Alinari 23956.

46b

Cast bronze tripod, from Vulci (London, British Museum, Br. 588). It was used to hold a cauldron. Three arched rods alternate with a straight rod. At the bottom they end in three lion paws, at the top they are decorated with spirals, palmettes, acorn pendants. Above, the curved rods are decorated with two horse protomes back to back, and the straight rods with one or two figurines in bronze. The one shown here is a figure wearing a bonnet, something like the tutulus. He wears a short tunic and winged shoes and holds a sword in his left hand. This figure has been identified, on insufficient grounds, as Hermes. On the other sides are Heracles and a winged man carrying off a woman. This

tripod and others like it, mostly found in Vulci, have been attributed to a bronze workshop active in Vulci in the first half of the 5th cent. B.C. Photo Brit. Mus. XVII D 11.

47a

Detail of a 'Pontic' amphora by the Paris Painter (New York, Metropolitan Museum of Art, inv. 55.7). Panel on the shoulder of the vase. This was a companion piece to the amphora in Pl. 47b (q.v.). Four women, wrapped in cloaks and lying two by two on high couches, have taken off their slippers and hung them on a nail on the wall. The scene remains enigmatic: are they resting? Is it a banquet scene? If it were, it would be one of the earliest Etruscan banquets in which the guests are reclining on a kline. Prior to the middle of the 6th century B.C. the Etruscans ate seated at a table (Pl. 72a). But there are no cups or food, and the meaning of the covers draped over the long benches and behind their shoulders is not clear. The interpretation suggested by E. Simon and R. Hampe is unacceptable. 540-440 B.C. Photo Metrop. Mus. of Art 158697 (Courtesy of the Metropolitan Museum of Art, Gift of N. Koutoulakis, 1955).

47b

^{47D} 'Pontic' amphora by the Paris Painter (New York, Metropolitan Museum of Art, inv. 55.11.1). The painter of this amphora is the best and most gifted of the painters of the so-called 'Pontic' vases. We do not know his name, for he has not signed any of the vases he painted. Conventionally he is called the 'Paris Painter' from an amphora, found in Vulci and now in Munich, with the judgement of Paris. Three stately centaurs move to the left, carrying a branch (here a small tree) on their shoulders, the attribute of centaurs ever since their first appearance in Greek art in the 8th cent. B.C. All three are close to the Greek classical models: it is clear that the painter leaned on Greek models. He has skilfully alternated the colours and characterized the types: one centaur is old, with a white beard; another is middle-aged; the one on the right is a slender adolescent, with the first signs of down on his cheeks. The procession of centaurs must have been particularly popular with the Etruscans for it appears in almost identical form on two other amphorae by the same painter, one from Vulci (now in Würzburg) and one from Caere (Rome, Museo di Villa Giulia). The lions in the lower frieze are characteristic and are found on other vases painted by this painter.

The amphora belongs to his earlier production as shown by the abundant use of white: 540–530 B.C. Photo Metrop. Mus. Art 158670 (Courtesy of the Metropolitan Museum of Art, Rogers Fund, 1955).

47C

Frieze of animals on a black-figure amphora from the workshop of the Paris Painter (Berlin, Antikensammlungen, F. 1885). The shape of the wide ribbon handles (not visible in the illustration) show that this amphora imitates metal vases. It was a shape dear to the Etruscans who used it in impasto vases, and from the first half of the 6th century on, for bucchero vases, which imitated bronze ware better than terracotta. Athenian ceramists, especially Nikosthenes, produced amphorae of this shape exclusively for importation to Etruria between 530 and 500 B.C. There are three groups of fighting animals in the panel: lions have brought down respectively a bull, a boar, a deer. The lions look more like large dogs than lions. Coloured stripes on the neck of the bull often appear on vases by the Paris Painter. 530-520 B.C. Photo Berlin Museum 5635.

48a

Etruscan red-figure crater (Florence, Museo Archeologico inv. 4026). The subject is uncertain. It has been supposed that it represents the Argonauts (see the scene on the Attic crater of the Argonauts at the Louvre), but the painter has added details which are obviously Etruscan, such as the bracelets with bullae worn by the man with the spear. First quarter of the 4th cent. B.C. Photo Soprint. Antich., Florence, 9147.

48b

Detail of the preceding crater.

48c

Etruscan cup, from Vulci (Hannover, Kestner-Museum, inv. 773). Height: 0.167 m. It is painted in 'superposed colour': the vase was completely covered with black glaze and on this the figures were painted in red and the internal details were incised. Vases made in this way are rare in Greece, where the red-figure technique was in use from the last quarter of the 6th century B.C. on, due to the greater precision of detail, modelling and gradation of colours possible. In Etruria vases

using this technique were not made until the second half of the 5th century B.C. Vases in superposed colour had all those limitations which had made the Greeks abandon the black-figure technique. Even so, they were popular in Etruria in the first half of the 5th century and continued to be made in the second half of that century. First half of the 5th cent. B.C. Photo, Kestner-Museum.

49a

Red-figure cup, from Vulci (Vatican, Museo Gregoriano Etrusco). A god (Zeus, or Hades) has abducted a woman. Both composition and drawing are done with great care. The painter has used the 'relief-line' of Attic painters. The bullae bracelet, the diadems, the earrings (see Pls. 42b, 42c) are in gold. The cup has been attributed to a workshop in Vulci. First half of the 4th century B.C. Photo Alinari 35833.

49b

49b François Tomb: Achilles kills the Trojan prisoners, Vulci (Rome, Museo Torlonia). Length of the wall, 3.25 m. The figures are identified by the inscriptions. From left to right we have achmenrun (Agamemnon), hinthial patrucles (shade of Patrocles), vanth (the name of the female demon), achle (Achilles), truials (Trojan), charu (the male demon), aivas tlamunus (Ajax Telamones), truials (Trojan), aivas vilatas (Ajax Oileo). One Trojan prisoner is painted on the next wall: see Pl. 50a for a detail. The bandages which Patrocles has around his breast refer to his wounds, ard cent B.C. Photo Cab. Fot Naz E 8186 wounds. 3rd cent. B.C. Photo Gab. Fot. Naz. E 8186.

50a

François Tomb, Vulci (Rome, Museo Torlonia). Head of a Trojan prisoner. Above is the caption truials (Trojan). Photo Ist. Arch. Germ. Rome, 29.376.

50b

François Tomb, Vulci (Rome, Museo Torlonia). Head of Vanth. This is one of the few undamaged heads in the tomb. Photo Ist. Arch. Germ. Rome 29.376.

51

François Tomb, Vulci (Rome, Museo Torlonia). Detail of Pl. 49b: head of Charu. Photo Ist. Arch. Germ. Rome 29.380.

52

End wall of the sarcophagus in Pl. 53 (Boston, Museum of Fine Arts). It measures 0.75×0.56 m. The journey to the Underworld becomes frequent at the end of the 4th century B.C. But the skilful composition in this example is not original, for while the sculptor avoided overlapping the figures on the front of the sarcophagus as much as possible, he was quite unconcerned about it here. The sarcophagus presents a problem in that the lid refers to a double deposition—of a husband and wife—while the inscription refers only to the wife. The figures seated together on the chariot under the large umbrella, travelling towards the kingdom of the shades, are two women. Museum photo.

53

Sarcophagus in peperino, from Vulci (Boston, Museum of Fine Arts). Length: 2.08m. The tomb in which it was found in 1865 can no longer be identified. The trough has relief decoration on three sides. On the lid a man and a woman sleep the sleep of death. The two figures seem to indicate that the sarcophagus contained a double burial. This custom of burying husband and wife together is confirmed by urns in Chiusi and in Volterra which show the couple on the lid and give two names in the inscription. But in this case the inscription provides only the name of a woman, Ramtha Visnai, wife of Arnth Tetnie. Some scholars have said that her husband was also buried in the sarcophagus and that his name was missing because the wife's position in Etruscan society was so high that her name would be enough to identify her husband as well, but the hypothesis is not very convincing. The sarcophagus is the work of a fine sculptor. One of the ends is shown in Pl. 52. First half of the 3rd cent. B.C. Museum photo.

54a

Terracotta revetment slab, from a temple (Copenhagen, Ny Carlsberg Glyptothek, H. 177). Found at Poggio Buco, near Vulci. Length 0.52m.; height: 0.215m. Nothing is known of the temple except the place where it once stood. The size of the slab shows that the temple was very small, for the frieze, in which a griffin alternates with a stag, is only 0.135m. high. Despite the fact that the animals belong to the Orientalizing repertory, the slab was not made prior to the last quarter of the 6th cent. B.C. Photo Soprint. Antich., Florence, 2687.

54b

Terracotta revetment slab from Poggio Buco (Copenhagen, Ny Carlsberg Glyptothek, H. 176). It covered the pediment beams, perhaps the verge, considering the movement of the figures (see caption for Pl. 54a). Length of the slab; 0.565m. total height: 0.265m. The dimensions confirm the fact that the temple must have been small and low. Otherwise it would have been impossible to see the figured frieze, only 0.155m. high as it was. A moulding of vertical convex fluting projects at the top of the frieze and a guilloche motif runs along the bottom. The scene in between shows a two-horse chariot with a warrior behind it on the left and three ahead on the right. The charioteer wears the long garments which became frequent in the 5th century B.C. and one of the warriors is armed with a shield and spear. Details were added in colour which has now disappeared. The movements of the figures are free and easy: the two horses are drawn according to a pattern which began in Greece in the second quarter of the 6th century B.C.: the outer horse had its head lowered, and the one in the back held its head high. The Etruscan town of Poggio Buco, a small provincial centre in inland Etruria. received these patterns from the coastal cities, and they probably did not arrive until the second half of the 6th century B.C. This date is confirmed by the profiles of the warriors which are decidedly slanting, Ionian in type. Like all the terracotta decoration, the slabs were made with moulds. The date is not prior to the last quarter of the 6th century B.C. Photo Soprint. Antich., Florence, 2689.

55a

Niche tomb for cremation burials in the western cemetery of Blera. Photo Ist. Arch. Germ., Rome, 6023.

55b 'Dado' tomb (hewn in the shape of a cube) in the necropolis of Blera. The shape of the door and its typical raised moulding are similar to those of the chamber tombs. The cornice, at the top of the cube, has the same kind of moulding as that found on the drums of some Caeretan tumuli, which is characteristic of Etruscan architecture. Photo Ist. Arch. Germ., Rome, 6076.

56

Terracotta sarcophagus, from Tuscania (Florence, Museo Archeologico). It was made in four pieces which were fired separately. The workmanship was swift and sure and was done with the aid of a modelling tool. Late 3rd cent. B.C. Photo Soprint. Antich., Florence, 2192.

57

Bronze censer of 'Vetulonian' type, found in the Circle of the Fibula at Marsiliana (Florence, Museo Archeologico). Height of the censer 0.30m.; of the chain: 0.28m. The cylinder which flares out bell-like at the top and bottom is decorated with two rows of triangles cut into the thin bronze plate. The lotus flower on the lid, with its drooping petals and the central sphere, the chain with its little spheres and cylinders, are cast. The chain is articulated and is really a jointed handle: by swinging the censer the fragrant resin would burn better. Censers of this type have so far been found only in Etruria, especially at Vetulonia, and in places influenced by Etruria. They were used in the second half of the 7th century B.C. Photo Soprint. Antich., Florence, 157.

58a

Detail of the 'Corsini' fibula (Pl. 58b). Photo Soprint. Antich., Florence, 7747.

58b

The 'Corsini' fibula, in gold, from the Circle of the Fibula, at Marsiliana d'Albegna (Florence, Museo Archeologico). It was found in the excavations carried out by Prince Tommaso Corsini. It has a serpentine bow and a long catch-plate of gold sheet, with decorations similar to those on the fibula shown in Pl. 41b. The figures in the round—ducks and lions—are made of hammered sheets soldered together. It is simpler and more beautiful. C. last quarter of the 7th cent. B.C. Photo Soprint. Antich., Florence, 7747.

58c

Terminal part of an ivory handle, from the Circle of the Ivories in Marsiliana d'Albegna (Florence, Museo Archeologico). It was found together with the writing tablet (Pl. 94b). The handle is cylindrical (length: 0.14 m.) with a hole at the top so that something which no longer exists could be inserted. It cannot be the handle of a mirror

since no 7th-century mirrors are known to exist, but it could be the handle of a flabellum (fan.) At its lower end it terminates in an almost circular disc which is decorated in very high relief (diameter 0.07 m.). An animal with long pointed ears, a long wavy mane and curling tail, is stretched out along the centre. It looks more like a dog than anything else, but it is probably supposed to be a lion. In fact, on either side lie two nude youths, contorted and with their legs converging. The craftsman intended them to be upright on either side of the wild beast into which they have each sunk the blade of a dagger, but he found it difficult to compose the group within a circle. The handle must have been held with the disc at the bottom for this is the only way in which the two figures appear to be standing and victorious. The composition is naïve but effective. The ingenuity also testifies to an Etruscan and not an Eastern origin for the handle. There are no real parallels availablethe closest is an ivory from the Barberini tomb in Praeneste, where the hair of a young man is treated much like the mane of our lion. But the Praenestine piece was carved by a much more skilful craftsman. The Marsiliana handle may be dated to the last quarter of the 7th cent. B.C. Photo Soprint. Antich., Florence, 156.

59a

Terracotta head of a bearded man wearing a diadem, from Orvieto (Orvieto, Nuovo Museo Faina). Height: 0.175 m. From the decoration of a temple in Via San Leonardo. 1st cent. B.C. Photo Soprint. Antich., Florence, 2942.

59b

Vase in bucchero sottile, with a single handle, from Orvieto (Florence, Museo Archeologico, inv. 71212). The body is decorated with incision. The cover, with a handle in the shape of a small horse, has an impressed 'cylinder' decoration, with a motif of four animals in a row repeated, on its wide rim. The decorative style is akin to that of south Etruria, where the 'cylinder' decoration differs considerably both in style and motifs from that of Chiusi. Compare the Clusine vases done with this technique (Pl. 83a). Late 7th cent. B.C. Photo Soprint. Antich., Florence, 2926.

59C

Terracotta head of a silenus, from Orvieto (Florence, Museo Archeo-

logico, inv. 41210). Height: 0.11m. From the decoration of a temple near S. Giovanni Evangelista. Early 4th cent. B.C. (?) Photo Soprint. Antich., Florence, 2694.

59d

Terracotta head of a Gorgon, from Orvieto (Orvieto, Nuovo Museo Faina). Height: 0.28 m. Central acroterium of the Belvedere temple. A similar gorgon-head antefix comes from the sanctuary of Cannicella, Orvieto. 4th-3rd cent. B.C. Photo Soprint. Antich., Florence, 6462.

60a

Terracotta head of an old man, from Orvieto (Orvieto, Nuovo Museo Faina). From the decoration of the Belvedere temple. 4th cent. B.C. Photo Soprint. Antich., Florence 7782.

6ob

Head of a warrior, in nenfro, from Orvieto (Florence, Museo Archeologico). Height: 0.43m. It was found in the necropolis of Crocifisso del Tufo and may have belonged to a funerary cippus. The piece impresses one as being particularly compact and spherical because the crest of the helmet has been broken off. The curves which give this head its peculiar character are also found in other sculptures from Orvieto and in bronzes from the territory of Chiusi, all of them sculptures influenced by Ionian art. The fluid outline, the summary modelling, the drawing of the mouth are Ionian although no precise parallels are to be found in Greece. The closest ones are a few Etruscan small bronzes and the Orvieto sculpture. Beginning of the last quarter of the 6th cent. B.C. Photo Soprint. Antich., Florence, 6100.

6oc

Peperino sarcophagus from Torre San Severo (Orvieto, Nuovo Museo Faina). The form is that of a wooden chest with a wide base at either end. The importance of the piece is shown by the fact that it is decorated on all four sides. A winged female demon with serpents in her hands and hair stands on either side of the principal scene. From left to right: woman with serpents in her hair (Persephone?); dead Trojan; behind him Hades with a wolf's head hood and a sceptre; Achilles; the shade of Patrocles with bandages to indicate his wounds, as in the François tomb (Pl. 49b); a Trojan being killed by Achilles; behind him a

funeral monument similar to a cube tomb (Pl. 55b) and the cippi of Vulci; a Greek; a Trojan, like the one in a similar position in the François tomb; a Greek; a Trojan; in the upper corner, head of a demon. The composition and the drawing, best on this side, are derived from the painted model. The harsh grating colours are quite unlike those on the sarcophagus of the Amazons. 3rd cent. B.C. Photo Alinari 25997.

61a

Sarcophagus from Torre S. Severo (Orvieto, Nuovo Museo Faina). Right half of one of the sides: the sacrifice of Polyxene. Note the monotony of this group when compared with the other side (Pl. 60c). On the right is a demon with serpents and a torch, of the type generally known as Charun. Photo Soprint. Antich., Florence, 1175.

61b

Golini I Tomb, Orvieto (the paintings, detached from the walls of the tomb, are now in Florence, Museo Archeologico). The kitchen and a banquet in the Underworld. Last quarter of the 4th cent. B.C. From a drawing by G. Gatti. Photo Soprint. Antich., Florence, 2531.

61C

Golini I Tomb, Orvieto (Florence, Museo Archeologico). The larder of the Underworld. From a drawing by G. Gatti. Last quarter of the 4th cent. B.C. Photo Alinari 46159.

62a

Golini I Tomb, Orvieto (Florence, Museo Archeologico). Detail: the cup bearer. Last quarter of the 4th cent. B.C. Photo Ist. Arch. Germ., Rome, 951.160.

62b

Golini II Tomb, Orvieto (the paintings, detached from the walls of the tomb, are now in Florence, Museo Archeologico). Detail: the dove on the footstool of a kline. 3rd cent. B.C. Photo Ist. Arch. Germ. Rome, 51.161.

62C

Golini II Tomb, Orvieto (Florence, Museo Archeologico). Detail:

head of a banqueter. 3rd cent. B.C. Photo Ist. Arch. Germ., Rome, 51.159.

63a

Tripod in bronze plate, with a hemispherical bowl, from the Tomb of Bes, Vetulonia (Florence, Museo Archeologico). Near the rim are groups of ornamental studs. The bowl is supported by three arched cast legs which are flattened at the top and fastened to the bowl with rivets. At the bottom they end in crude human feet and are decorated with a helmeted horseman, without legs or arms, below whom, in a separate compartment, is a goose. Similar tripods have been found at Vetulonia and elsewhere. 7th cent. B.C. Photo Soprint. Antich., Florence, 8016.

63b

Footed pyxis, in impasto, from Vetulonia (Florence, Museo Archeologico). Height of the cover, 0.23m.; the cup, without the foot which has been restored, measures 0.11m. In its form and decoration it recalls those found at Caere (Pls. 9b, 9c), but it is simpler. The base of the bowl and the cover have a fluting in relief; the broad rim of the cover has an incised decoration. The handle, with drooping petals and a central knob, imitates examples in bucchero and in bronze (Pls. 10a, 57). It was found in a fossa tomb next to the tumulus of the Pietrera. Photo Soprint. Antich., Florence, 2400.

63C

Circolo della Costiaccia Bambagini, in Vetulonia. 'Circle' tombs are characteristic of the cemeteries of Vetulonia and Marsiliana di Albegna. Photo Soprint. Antich., Florence, 46.

64a

Handle of a vase, from Fabbrecce, near Città di Castello (Umbria). Bronze. (Florence, Museo Archeologico). It was a chance find. The bust of a man rests on the point at which the bodies of four animals, probably lions, meet. A human leg, or arm, issues from the jaws of each animal. With his huge hands the man supports the curved handle above him, which terminates in a bull's head. The entire right half of the handle has been lost. What is left shows a dog tightly grasping the handle as he moves towards a lion from whose jaws issue a human arm. On his head the man has a seven-petalled headdress, almost a

daisy, similar to the one on furniture finials from the Bernardini tomb in Praeneste. The motif of the arm, or leg, coming out of the jaws of a feline, is typical of Etruria. Elsewhere, both in the East and in Greece, the feline devours his prey in a more realistic manner. Here both motif and animals have been treated as decorative elements and the effect is striking. The remains of a similar handle were found in Marsiliana; two others in Vetulonia. Second half of the 7th cent. B.C. Photo Soprint. Antich., Florence, 5458.

64b

Finial of a so-called 'candelabrum', from the Second Circle of Le Pelliccie, in Vetulonia (Florence, Museo Archeologico, inv. 6083). Height of the candelabrum: 0.74m.; of the figurine; 0.12m. The upright pole in bronze has four feet. Wiry arms, bent upwards, branch off the pole. A nude woman, wearing large armlets, and holding an amphora on her head, terminates the pole. The word 'candelabrum' is incorrect, although commonly used. The arms could not have held candles. Those on the lower branches would have melted the candles above them. The hypothesis, confirmed by a tomb in Vetulonia, is that vases were hung on these arms, as can be seen in a tomb in Caere, the Tomb of the Triclinium (1st cent. B.C.). The 'candelabra' are frequent in Vetulonia in the tombs of the 7th cent. B.C. Photo Soprint. Antich., Florence, 8505.

64C

Gold filigree bracelets of 'Vetulonian' type, from the Circle of the Bracelets (Circolo dei Monili) in Vetulonia (Florence, Museo Archeologico). Length: 0.305m. Narrow bands with edges in relief are joined together by a line of filigree in a wave pattern. The shape of the bracelet is characteristic of Vetulonian bracelets, composed of three units, the central one of which is longer and forms a sort of catch. In this piece all three elements terminate with a semilunar gold plate; in other bracelets they may be female heads. Filigree, one of the favourite techniques in Vetulonia, was known and used throughout the ancient world, but nowhere did it achieve such perfection as in Etruria. Last quarter of the 7th century B.C. Photo Soprint. Antich., Florence, 9792.

65a

Gold leech fibula (fibula a mignatta: the arched bow is thickened so as

to resemble a leech) with a long catch-plate decorated in the 'pulviscolo' technique, found in the Tomb of the Lictor, at Vetulonia (Florence, Museo Archeologico, inv. 77261). Length: 0.156m. The bow of the fibula is decorated with stylized animals around a central motif. On the catch-plate are plant motifs and winged quadrupeds. The first and the last have a volute issuing from their jaws, perhaps a stylization of the human leg which often issues from the jaws of felines (as Pl. 64a). This extremely decorative fibula with its superb workmanship is one of the finest examples of Vetulonian goldwork. Only a few pieces using the 'pulviscolo' technique are known, probably the products of a single workshop. Those in the Tomb of the Lictor all seem to have been made by the same goldsmith. 'Pulviscolo' jewellery is attributed to Vetulonia because a large number of pieces were found there. Last quarter of the 7th cent. B.C. Photo Soprint. Antich., Florence, 9477.

65b

Detail of the gold fibula in Pl. 65a. Photo Soprint. Antich., Florence, 10258.

65C

Mignatta fibula with a long catch-plate, from the Tomb of the Lictor in Vetulonia (Florence, Museo Archeologico inv. 77259). Length of the body: 0.068m.; of the catch-plate: 0.154m. It is of gold plate reinforced internally with silver and completely decorated in repoussé without any retouching. On each side of the mignatta body are two heraldic sphinxes in front of a volute motif, the so-called 'sacred tree', with two lions below them, back to back. The long catch-plate has a row of winged sphinxes; the first on the right is cut in half. Although the individual decorative elements are also found in the rest of Etruria, and eventually can be traced to the East, the way in which they are used and grouped and the general impression of the piece are characteristic of Vetulonian jewellery. Last quarter of the 7th cent. B.C. Photo Soprint. Antich., Florence, 10277.

65d

Detail of the gold fibula in Pl. 65c. Photo Soprint. Antich., Florence, 10256.

66a

Urn sheathed in silver, from the Tomba del Duce, in Vetulonia (Florence, Museo Archeologico, inv. 7095). It is a bronze chest with a gabled top, sheathed in a sheet of silver decorated in repoussé highlighted by engraving. It is rather poorly preserved. The sides are divided horizontally into zones—two on the front and back, and three on the ends. The panels are framed and divided by interlacing arches crowned by palmettes. The various zones contain rows of animals of a characteristically Orientalizing style. Sometimes two are placed heraldically. The motif of the 'lord of animals' is repeated several times on the one preserved leg. The form, the technique of construction, and the decorative repertory make the urn unique at Vetulonia but close parallels exist with the products of south Etruria, especially Caere. It is quite surely an import to Vetulonia from Caere. Last quarter of the 7th cent. B.C. Photo Soprint. Antich., Florence.

66b

Detail of the silver-sheathed urn, from the Tomba del Duce in Vetulonia. Photo Soprint. Antich., Florence.

67a

Aedicule tomb (tomba a edicola: i.e., shaped like a small house) on the Podere di S. Cerbone, at Populonia. The tomb was found under the ancient slag heaps in October 1957. It is the only tomb of this type which still had its original gabled roof. Generally all the tombs found under the slag, whether chambers with a false dome, or aediculas, were crushed by the weight of the slag above them. It measures 3.85×8.20 m.; height: 2.85m.; the door (1.75×0.60 m.) was closed by slabs; a fragment of these is leaning against the tomb to the right of the door. The tomb, which was built in the second half of the 6th cent. B.C., served for several burials. Around the tomb are sarcophagi; seven or eight people were buried in the one on the left. Photo Soprint. Antich., Florence, 11579.

67b

Gold ring with an elliptical bezel, from the Tomb of the Bronze Flabelli in Populonia (Florence, Museo Archeologico). In relief on the bezel is a bearded man in a short tunic; he is fighting a monster whose three human bodies end in a single fishtail. The first body of the monster

holds a dolphin in his hands. The most evident interpretation is Heracles fighting the three-bodied monster, a subject taken from Greek mythology. Rings of this type are generally worked in intaglio (see the ring in Pl. 14c); only a small group of beautiful examples in relief are known. Late 6th cent. B.C. Photo Soprint. Antich., Florence, 6469.

68a

Ajax killing himself, bronze figurine from Populonia. (Florence, Museo Archeologico). It comes from a tomb that was destroyed by the iron slag, in the Podere of San Cerbone. It crowned, or decorated, some unknown object and is perhaps the best of the small bronze statuettes found in Populonia. Photo Soprint. Antich., Florence, 355.

68b

Bronze mirror, from Populonia (Florence, Museo Archeologico, inv. 79283). Laran killing Cersclan. The episode is unknown. 4th cent. B.C. Photo Soprint. Antich., Florence, 3126.

69a

Porta all'Arco, Volterra. 2nd cent. B.C. Photo Soprint Antich., Florence, 465.

69b

Stele of Avile Tite, from Volterra (Volterra, Museo Guarnacci). Height: 1.695m. It is a rectangular slab, rounded at the top, with a raised listel framing it on all sides, except on the right. In the field is a warrior armed with a spear and bow (in other stelae he has a knife), wearing a short-sleeved close-fitting tunic. His hair recalls the layer-wigs of the Daedalic statues, but the way it billows up over his forehead and the round skull prove that the stele is later. The profile of the figure shows Attic influence, and therefore the generally accepted date is too early. The layer-wig is only the sign of a provincial craftsman who is behind the times. Notwithstanding some features which would seem to indicate the 6th century (vigorous body, full chest), it must be set at the beginning of the 5th cent. B.C. Evidence of the sculpture being later than it looks is the fact that the torso is shown in almost three-quarter view.

70a

Interior of a chamber tomb in Volterra. The tomb is known as the Inghirami tomb after its excavators, the Inghirami brothers. It was discovered in 1861 in the necropolis of S. Girolamo, north of Volterra, and has been rebuilt in the garden of the Museo Archeologico in Florence. The tomb, which consists of a circular chamber and an entrance corridor, was cut into the tufa, including the central pilaster. It is characteristic of Volterran tombs of the 4th-1st cent. B.C. The urns on the benches and round the central pillar are arranged as they were found. They are all in alabaster, and in type suggest a date not earlier than the late 3rd cent. B.C. for the first burials. Photo Alinari 31146.

70b

Red-figure crater, from Volterra (Volterra, Museo Guarnacci). It is of Volterran make. A winged female figure is seated on a dolphin. The stylized palmettes and the triangular motifs are typical of this workshop. The painter is known as the Hesione Painter, from one of his best vases, found in Perugia. Last decades of the 4th cent. B.C. Photo Alinari 34714.

70C

Red-figure crater (Florence, Museo Archeologico, inv. 4035). The piece, of Volterran make, shows the battle between a pygmy and a crane. On the neck is a human head between two horses tied to a column. Last decades of the 4th cent. B.C. Photo Soprint. Antich., Florence, 5874.

71a

The interior of the tomb of Casalmarittimo (Volterra). It was discovered in 1898 and rebuilt in the garden of the Museo Archeologico in Florence. It is circular in plan (diameter: 3.30m) with an entrance corridor and a small square ante-chamber ($1.60 \times 1.62m$.). It is built of almost regular courses of limestone slabs. The false dome, which consists of blocks laid in concentric circles which gradually narrow towards the centre, forming steps, until they can be closed at the top with a single slab, begins at a height of 1.52m. At the centre is a square pier (height: 2.40m.). The tomb was covered by a tumulus. It was plundered in antiquity but the few fragments found in the excavation seem to show that it was built at the beginning of the 6th century B.C. There were inhumation and cremation burials. The most recent burial was in a sandstone ash urn, similar to Volterran urns of the 4th century B.C., with four feet and a gabled lid. Traces of painted decoration remain on the chest.

Another circular false dome tomb was found at Casaglia. near Montecatini in Val di Cecina (Volterra), and two others at Quinto Fiorentino (near Florence). One of the latter, discovered recently, also has two small rectangular chambers, with false pointed vaults, which open off the corridor. All these tombs belong to the early 6th century. Circular false dome tombs have so far been found only in territory dependent on, or influenced by, Volterra. Photo Alinari 31150.

71b

Ash urn in alabaster, from Volterra (Volterra, Museo Guarnacci, inv. 226). Paris recognized as the son of Priam. Both the material (alabaster) and the style are characteristic of Volterran urns of the 2nd century B.C.: figures have long slender bodies and long legs; they completely hide the background and move towards the spectator. Paris has taken refuge on the altar, the crowd approaches, two soldiers run up with drawn swords. A winged figure (Aphrodite?) glides over the ground, almost as if she had descended from Olympus to defend young Paris. Photo Brogi 13674.

72a

Cover of an ash urn in reddish impasto, from Montescudaio, in the valley of the Cecina river near Volterra (Florence, Museo Archeologico). On the cover is a group in the round: a bearded man is seated before a table laden with food. Next to him are an attendant and a large crater. There may have been another crater on the other side. This type of banquet scene is prior to the type in which people are shown reclining on the couch. According to a study by S. De Marinis the latter was introduced into Etruria via the Greeks about the middle of the 6th century B.C. The decoration on the body of the urn is in relief and differs from the incised or impressed decoration of the Villanovan ash urns; relief decoration is also found elsewhere in Volterran territory. Total height: 0.64m. Late 7th or early 6th cent. B.C. Photo Soprint. Antich., Florence, 2952.

72b

Interior of the cella of a tomb in the tumulus of Montecalvario, Castellina in Chianti. The large tumulus (diameter: c. 40m.) covered four rectangular chamber tombs: they are similar but not identical in plan. Each has a corridor and small rectangular chambers which open off the corridor. They are built of squared blocks. The roof is in the form of a false vault. All the tombs had been plundered. The few remnants of the tomb furniture date them to the beginning of the 6th cent. B.C. Photo Moscioni 22158.

73

Stele from Travignoli, near Pontassieve (Fiesole, Museo). Height: 1.30m. It belongs to a group of monuments known as 'Fiesole' stelae because they were carved in the pietra serena of the quarries near Fiesole and because they are spread throughout the territory around Fiesole. There are about 20, all homogeneous in material, decorative motifs and shape. The three panels from top to bottom show: a banquet; two dancing youths and a flute-player; two felines attacking a deer. The banquet scene is particularly interesting. The banqueters are men; on the left, the cup-bearer, standing behind the mensula, or three-legged table with wine jars, is ready to pour wine. To the right, a woman is seated on a high-backed chair. Under the couch is a rooster, a domestic animal which could therefore wander around the house. Artistically these stelae are not particularly fine; some are even decidedly poor in quality. They are modest provincial works, behind the times but pleasing. In the area north of the Arno the decorative motifs and stylistic currents came from Volterra and Chiusi. The Ionian profile of the figure is a retardatory motif, a sign of the distance which separated the region from more developed cities, for the stele must be dated to the second quarter of the 5th century B.C. Photo Alinari 45780.

74

Head of a bearded man, from Falterona (Casentino). (London, British Museum, Br. 614.) This is one of the many small bronzes found in 1838 at Ciliegeta, a little lake on Monte Falterona, not far from the source of the Arno. The site, which even now is far from towns, lay outside Etruscan territory. The upper valley of the Arno and the Casentino do not seem to have been inhabited by Etruscans before the 3rd century B.C., when northern Etruria prospered both economically

and demographically. There seems to have been no sanctuary or building, not even a small aedicula, near the lake. The votive gifts were thrown into the water. The objects found—more than 650bronzes, as well as weapons, fibulae, rings, etc.—came from various parts of Etruria. Some of the bronzes belong to the 'Vulci' group. The one shown here recalls the heads of the sarcophagi figures and cippi from south Etruria. First half of the 4th cent. B.C. Photo Brit. Mus. XCVII B 2.

75a

Head of a canopic jar, from Chiusi (Florence, Museo Archeologico). In the 7th century in Chiusi the covers of ash urns were transformed into covers in the shape of a human head. This type of vase is called 'canopic' for its rather vague resemblance with some jars of this name in Egyptian tombs which also have a human or an animal head. First used by archaeologists in the first half of the 19th century, the word has continued in use. Some consider the Clusine ash urns in impasto, to which a mask in impasto or bronze was tied with a string or wire, as archaic forms of the canopic jar. Attempts have been made to trace an evolution in the form from the most primitive with barely indicated features, to the more evolved ones with individualized facial features. But it is not certain that those canopic jars which seem to be the crudest and most primitive are always the oldest. Our canopic jar, for example, is so stylized and the features of the face are so clear and surely indicated that they seem to indicate a conscious stylization. The rings hanging from the protruding ears, which are stylized in question mark form, indicate the head to be that of a woman. There are holes around the face, the eyes and the mouth: we do not know why they were made. They may be reminiscent or in imitation of the holes in the old detached masks; the clear distinction between the front and back of the head, indicated by the incision which frames the face, is also a hangover from the earlier masks. The dating of the canopic jars is extraordinarily uncertain, for there is hardly ever any tomb furniture. And when there is, it consists either of atypical vases, or of types of vases which were used over a long period (such as impasto vases, or Italo-Protocorinthian ones, or Italo-Corinthian), which therefore do not help in solving this problem. 7th cent. B.C. Photo Soprint. Antich., Florence, 4497.

75b

Canopic jar from Chiusi (Florence, Museo Archeologico). In dark impasto. The ash urn has two bent arms, the hands are resting on the body. The head, with its large amorphous neck which is normal for canopic jars since its purpose was to cover the mouth of the urn, has more individual characteristics than the preceding specimen. The bobbed hair is held by a ribbon below the ears and ends at the neck in curls. Those on the forehead have fallen off, but traces are still visible. The ash urn is on an impasto seat, with a semi-circular back, modelled on bronze thrones. The large relief studs copy the nails which kept the bronze sheets together. For similar thrones see Pl. 5b. 6th cent. B.C. Photo Soprint. Antich., Florence, 5560.

75C

Detail of an ivory box (Florence, Museo Archeologico, inv. 73846). The box was found in a chamber tomb in Chiusi. A nude warrior, wearing a large Corinthian helmet, seems to be dancing, perhaps the armed dance of the gymnastic games painted in tombs and on vases (Pl. 32a). To the left is a group of women with the long braids characteristic of Etruscan women up to the middle of the 6th century B.C. Sometimes there are six or seven braids falling down their backs, gathered together at the bottom and tied with several turns of ribbon. Like our grandmothers Etruscan women were proud of their long thick braids. The gesture of the arms is interesting: it is typical of the scenes of mourning. First half of the 6th cent. B.C. Photo Soprint. Antich., Florence, 6542.

75d

Details of an ivory box, from a chamber tomb in Chiusi (Florence, Museo Archeologico, inv. 73846). The shape of the box is similar to that in Pl. 15a. A detail is shown in Pl. 75c. The scene is the flight of Ulysses from Polyphemus' cave, the Greek ship with its sails folded and the steersman holding the rudder. On either side of the mast are an amphora and a jug for the water needed on the trip. Rams, each of which has one of Ulysses' companions under its belly, arrive from the right. The subject was inspired by Homer's Odyssey. In Greece the earliest appearance of this myth is on a Proto-Attic jug from 650 B.C., but this subject only became frequent shortly before the middle of the 6th century B.C. The Greeks never show the ships of Ulysses in this

scene. The characteristic retardatory motifs, such as the branches among the animals, are also present. First half of the 6th cent. B.C. Photo Soprint. Antich., Florence, 6541.

76a

Seated bearded man in pietra fetida from Chiusi (Palermo, Museo Archeologico). Height: 1.35m. The statue is an ash urn in the shape of a human figure, the oldest of this type. There are similarities with the canopic jars (Pls. 75a-75b): the large neck and the chair with its semi-circular back are standard types for Etruria. The pattern is that of the seated statues in the East, which was then taken up in Greece and Etruria, in which the figure rests both hands on his knees, one open, the other clenched. The statue is hollow inside so as to contain the ashes. 540-520 B.C. Photo Mercurio, Milan.

76b

Standing male figure, in pietra fetida, from Chianciano, near Chiusi (London, British Museum, Sc. D 8). The man is wrapped in a cloak which crosses his chest obliquely. There is a hollow inside to contain the ashes. It is the only standing ash-urn statue known. All others, both male and female, are seated. The bobbed hair and the large eyes do not indicate an archaic date. The urn is from the first half of the 5th century B.C. The pupil is indicated by an incised circle and a small central hole, perhaps to mark the area to be painted. Hair, beard and eyebrows were black, the flesh red. Photo Brit. Mus. XXIX C 1.

76c

Cippus in the shape of the bust of a woman, from Chiusi (Chiusi, Museum). Height: 0.30m. Like all the Clusine statuettes of this group, only the upper part has a human form. The lower part is made of one or more generally almost circular drums. The craftsman was interested only in the front view. Although these statuettes are characteristic of the necropolis of Chiusi, their exact provenance and use is not known. The hypotheses proposed—a goddess or the deceased—have no valid basis. The hair tied around the head with a ribbon is typical of the Clusine statues and bronzes of the 6th century B.C. It forms a smooth cap on the skull, frames the forehead with stylized curls and falls on either side in a large braid. The arms are folded on the breast with the elbows forming sharp angles, and the fingers of the right hand lie on

top of those of the left. In other statuettes it is the left hand which rests on the right. We have been unable to interpret this gesture, for it has no relationship with that usual for women in mourning scenes (arms held tight to the breast, hands clenched, but with extended thumbs: see Pl. 75c), nor with the gesture of the Eastern statuettes—nude women who press their breasts. First half of the 6th cent. B.C. Photo Alinari 37507.

77a

Ash urn in pietra fetida, from Chianciano (Florence, Museo Archeologico). Height: 0.80m. The dead man is reclining on a kline. A winged female is seated at the foot. Archaeologists call her lasa, a word to which they wrongly attribute the generic meaning of winged female demon. She holds an open scroll. According to the current interpretation, which is purely hypothetical, the scroll contains a list of the good or bad deeds of the deceased. The diadems encircling their heads are of a type characteristic of Chiusi and Orvieto. In style the group is close to the statue shown in Pl. 77b. The Greek models which inspired both date to the decade 460-450 B.C. but a date of the 5th century B.C. seems to be excluded by the demon seated at the foot of the bed. In the tomb paintings of Tarquinii the motif of a woman seated at the foot of a kline is first found in a tomb dated to the 3rd cent. B.C. (Pl. 38a). Photo Brogi 20620.

77b

Ash urn in pietra fetida, from Chianciano, near Chiusi (Florence, Museo Archeologico). Height: 0.90m. It represents a woman holding a child in her arms. It was probably not a divinity (Bona Dea, Persephone) but the dead woman, as a comparison with similar male statues suggests. Various parts have been restored. The date has been the object of much debate and oscillates between the middle of the 5th and the 4th centuries. A similar statue, but harder and colder looking and without the child, was found at Città della Pieve and is at the Ny Carlsberg Glyptothek, Copenhagen. Photo Soprint. Antich., Florence, 8019.

77C

Detail of the ash urn in Pl. 77a: the head of the man. Photo Soprint. Antich., Florence, 11250.

78a

Clay antefix, from Chiusi? (Chiusi, Museo Archeologico, Coll. Paolozzi, inv. 825). Height: 0.22m. The oval face is framed by wavy hair pulled tight around the head by a high diadem which held the veil. The elongated, slightly irregular eyes give the face individuality. One ear has a disc earring in it. The wide nimbus frame—a standard motif for antefixes of this period—was broken off in Etruscan times. The hair, which falls on the breast in archaic curls, and the severe dignity date the models for the antefix to 470–460 B.C., but the piece itself is certainly later. It is hard to say just how much later, for the style differs from that of other antefixes in Chiusi. Museum photo.

78b

Fragmentary antefix in terracotta (Siena, Museo Archeologico, coll. Chigi-Zondadori). The diadem and the stylization of the hair recall the group on Pl. 77a. The carefully executed large fine earrings, of which we have numerous examples in gold (Pl. 42b), indicate a date not prior to the beginning of the 4th century B.C. The archaic appearance is not surprising in an antefix which may have been made in Chiusi, despite the fact that its provenance is given as Caere. Photo Soprint. Antich., Florence, 7759.

78c

Tomb of the Monkey (Tomba della Scimmia), in the necropolis of Poggio Renzo, Chiusi (from a drawing by G. Gatti). The chambertomb, discovered in 1846, has a large ante-chamber and three small chambers. Most of the painted decoration is on the walls of the antechamber. The narrow friezes in this tomb, painted high up on the walls, are characteristic of the tombs of Chiusi. The painting was done directly on the tufa, as in the Campana tomb in Veii. The quality is inferior to the Tarquinian paintings; it is old fashioned, more provincial. The figures have been placed next to each other with no attempt at interrelation. But they have freshness and a pleasing vivacity. Some figures and motifs in this tomb recall those of the Tarquinian paintings, but the closest parallels are with a black-figure amphora, painted at the end of the 6th century in south Etruria—perhaps in Vulci where it was found (Pl. 32a). To the right of the door a woman is seated under an umbrella; the sports painted in the tomb may be in her honour. A girl dances in front of her; she is balancing some unrecognizable

object on her head, a motif also found at Tarquinii (Pl. 35a). The illustration shows the painted wall between the back door and the door on the right: a youth carries a vase with unguents (like the one on the vase in Pl. 32a), a man with a spear, two wrestlers, a dancing warrior and two flute-players, one of whom is a ridiculous little dwarf. On the back wall, to the left of the door, the monkey after which the tomb was named is sitting on a shrub to which it is tied. Second quarter of the 5th cent. B.C. Photo Soprint. Antich., Florence, 2837.

79a

Front of an ash urn in pietra fetida, from Chiusi (London, British Museum, Sc. D 13). A hunting scene: two dogs have caught a hare. Hunters, one of whom is armed with a spear and a club, the other with two sticks, come running. The curved pole of the hunter on the left was used for hunting hares: the Greeks called it lagobolos (lagos=hare, bolos=something thrown). There was a tree in the background behind the hare. It stressed the centre of the scene, which was composed with the symmetry characteristic of this group of Clusine monuments. It is carved in a flat low relief that imitates wood and ivory carving. This group of monuments dates from circa 550 to the end of the 5th century B.C. They are interesting because they seem to reflect local customs to which the Greek schemes have been adapted. It is noteworthy that subjects taken from Greek mythology seem to have been avoided. The battle scene on this urn has been interpreted as a battle between Greeks and Amazons, but the pattern is so different from the Greek one as to make this interpretation dubious. Second quarter of the 6th cent. B.C. Photo Brit. Mus. XXVIII B 36.

79b

Quadrangular cippus, fragmentary, from Chiusi (Palermo, Museo Archeologico, inv. 152). Height: 0.38m.; length: 0.49m. A piece has been sawn off and part of the scene is missing on the right. Since the composition of such pieces is symmetrical, we may calculate that two seated personages and two standing ones (the outstretched arm of one can be seen) are missing. The scene is complex: to the left are four men seated on stools with curved crossed legs. One has a long pole, or sceptre; two have a curved stick which may be the lituum of the Augurs, but which also resembles a hunter's lagobolos (see 79a). Two figures stand behind them. A third standing figure emphasizes the

centre of the scene. To the right only two seated figures can still be seen. Movements are lively, but the legs are stiff and parallel. All the figures wear short tunics and cloaks which cross the breast obliquely, in the Greek fashion. The scene has been interpreted as a family reunion and recently as a meeting of the magistrates of Clusium. But this scene also exists on reliefs found in other towns, although with fewer figures : we generally have only two men, seated on folding chairs. Scenes like this, with women instead of men, appear on other cippi. Any interpretation of the Palermo cippus should take into account all the cippi and reliefs having the same scene. None of these cippi were found in their original positions. We do not know how they were used. We only know that they were used for tombs. First quarter of the 5th cent. B.C. Photo Soprint. Antich., Palermo.

80a, b

Sarcophagus in pietra fetida, from a tomb in the Sperandio necropolis, Perugia (Perugia, Museo Archeologico). Although it was found in Perugia, it was undoubtedly made in Chiusi. The decoration runs on three sides. Both short sides have a banquet scene: on the front is a complex scene which does not belong to the standard repertory of the Clusine artists. From right to left we find a group of four prisoners tied with a rope; men with heavily laden animals (see the detail below: Pl. 8ob); other men with spears and the picturesque group of two goats and two oxen. This scene has had many interpretations, most likely would seem to be the return from a raid. Second quarter of the 5th cent. B.C. Photo Alinari, 47587.

81a

Urn, from Chiusi (Florence, Museo Archeologico, inv. 5713). The death of Eteocles and Polyneices, who are supported by attendants; in the centre a demon with a sword. The cover does not belong. This is one of the best Clusine urns. Middle of the 2nd cent. B.C. Photo Alinari 31128.

81b

Portrait on the urn of Larth Sentinate, son of Cae, from the Tomb of the Pellegrina, Chiusi (Chiusi, Museo Archeologico). The white veined alabaster is from a Clusine quarry. The left arm of the man rests on cushions. His wavy locks do not cover his high forehead or

his bald pate, in strange contrast to the fine oval of the face, the parted lips which lend an almost boyish expression to the face, and the vitality of the head as a whole and the man himself. It may be just this contrast which gives the figure its special character. Scholars talked of the passion of Scopas when referring to the head, but this is carrying things too far. The passion and pathos of Scopas and the sentimentality and histrionics of his imitators is missing. As long as the figure was in the half light of the chamber tomb for which it was made, it was extraordinarily effective. But in the impersonal setting of a museum, where it could be better preserved, much of its beauty was lost. The dating varies and some scholars consider it last quarter of the 3rd century while others prefer the second half of the 2nd cent. B.C. The later date is preferable. Photo Soprint. Antich., Florence, 3580.

82a

Sarcophagus of Seianti Thanunia Tlesnasa, from Chiusi (London, British Museum, Tc. D 786). In terracotta. It was found in a chamber tomb at Poggio Cantarello. The chest is surprisingly decorative and the Doric triglyph-and-metope frieze has been transformed, acquiring new life. The four-leafed rosettes are quite sculptural. At the corners the triglyphs have become engaged pilasters. The dead woman, whose name is incised on the moulding at the base of the chest, holds a mirror in her left hand and raises her right hand to adjust her cloak. The sarcophagus is very close to that of Larthia Seianti, at the Museo Archeologico in Florence, but is of better quality. The funeral equipment—situla, mirror, pyxis, unguentary—were hung on the walls of the tomb. Shortly after the middle of the 2nd cent. B.C. Photo Brit. Mus. VIII D 19.

82b

Detail of the bust of Seianti Thanunia Tlesnasa (London, British Museum Tc. D. 786). Photo Brit. Mus. XLVII C 48.

83a

Decoration of an amphora in bucchero pesante (Florence, Museo Archeologico). The decoration was impressed with a cylinder which had five figures. The shape of the vase and its decoration are typical of Clusine territory. Cylinder decoration also existed in south Etruria, where the decorative motifs generally consist of rows of animals

(Pl. 59b). The relief on the amphora is not very accurate or sharp. There are two male figures in the centre, holding sticks or sceptres, seated before a table with three curved legs on which gaming pieces are arranged. Above the table is a two-handled cup, the kantharos. To the right of the players are two warriors, to the left a woman. The two types of seats shown in this relief—the rectangular one and the folding stool—are frequently found together in Etruria. In Rome the folding stool was only used by magistrates. In Etruria generally, but not always, it was used for divinities, heroes of Greek mythology and sometimes for figures it would be difficult to define as magistrates. It was not used for women. Late 6th, or early 5th cent. B.C. Photo Soprint. Antich., Florence, 11027.

83b

Red-figure cup, from Montepulciano (Florence, Museo Archeologico). Dionysus, supported by a satyr, prepares to play a game of kottabos which a maenad is preparing. The workshop which produced this vase and others like it has been attributed both to Chiusi and to Volterra. Mid 4th cent. B.C. Photo 1st. Arch. Germ., Rome, 6306.

84

Terracotta revetment slab of a temple, from Arezzo (Arezzo, Museo Archeologico). Height: 0.52m.; width: 0.585m. It decorated a pediment. First half of the 5th cent. B.C.

85a

Terracotta head of a young man wearing a Phrygian cap, from Arezzo (Florence, Museo Archeologico). From the decoration of a pediment. 2nd cent. B.C. Photo Soprint. Antich., Florence, 6523.

85b

Chimera, from Arezzo. Bronze. (Florence, Museo Archeologico, inv. 1.) It is one of the most famous bronzes found in Etruria. Some scholars attribute it to a Greek artist from Sicione, but nothing justifies this completely arbitrary attribution. The way in which the mane joins the head around the muzzle, forming a collar, the way in which the ears sprout from behind this point of juncture—unlike Greece where they are on the mane itself—are features which we have already discussed as being characteristically Etruscan with reference to the funerary lion

shown on Pl. 43d. Nor is the stylization of the locks on the neck of the goat Greek. In his Vita Benvenuto Cellini tells us how it was found in 1554 together with other bronze statues. Cellini was charged with the restoration, but only added the front and the back left legs, because the snake, one of the horns of the goat and the beard are missing in contemporary drawings of the chimera, as well as in those of slightly later date. The restoration of the snake biting one of the horns of the goat is probably wrong.

The chimera may have belonged to a group of the Chimera and Bellerophon, since it looks upwards towards an enemy which it cannot reach. The group may have been similar to that incised on a mirror from Praeneste (Rome, Villa Giulia, inv. 42221). The chimera has already been wounded and the goat is dying. One leg bears the inscription tinscul (gift, votive offering). The date is uncertain, since there are no parallels, either in Etruria or in Greece. Late 5th cent. B.C.? Photo Soprint. Antich., Florence, 8661.

86a

Cauldron (lebete) in hammered bronze, from S. Valentino di Marsciano, south-east of Perugia (Munich, Antikensammlungen, S. L. 66). It was found in a tomb together with the 'Loeb' tripods (Pl. 86b). Lions and sphinxes along the rim are in repoussé bronze, their tails in bronze wire. The cast bronze warrior, who at present forms the handle of the cover, may not be part of the original. The cauldron belongs to the production of Caere. Compare the head of the sphinx with that of the dead woman on the sarcophagus on Pl. 7. The sphinx has a more serious expression, but the relationship is clear. The four large animals crouching along the rim of the cauldron are too large and too voluminous for the object they decorate. They display that same heavy, showy, over-laden, 'baroque' taste noted in the goldwork (Pls. 12b, 41b) and in some of the bronzes (Pl. 2c) of the second half of the 7th century B.C. found in south Etruria and Praeneste and, perhaps, made in Caere. Predecessors of these are the lions and sphinxes in jewellery of the 7th century, in repoussé gold sheet, but in the round. End of the 6th cent. B.C. From 'Tyrrhenica', Saggi di Studi Etruschi, Istituto Lombardo, Academia di Scienze e Lettere, Milan 1957, Pl. VII, 3.

86b

Panel of a tripod in thin bronze plate, from S. Valentino di Marsciano,

south-east of Perugia (Munich, Antikensammlungen, S. L. 67). It was found together with two tripods of the same shape, known as the 'Loeb tripods' because they form part of the Loeb collection. In this panel Peleus is pursuing Thetis, who tries to defend herself by becoming an animal. The serpent who rises up menacingly behind her alludes to this transformation. The relief is high, but flat. The three profiles are quite close to those of the figures on the sarcophagus from Caere (Pl. 7). They have the same high forehead, the same oblique cut of the mouth which stresses the round pronounced chin. The tripod was influenced by the sarcophagus and was made by a Caeretan workshop. It can be dated to 510-500 B.C. From 'Tyrrhenica', Saggi di Studi Etruschi, Istituto Lombardo, Accademia di Scienze e Lettere, Milan, 1957, Pl. VI, 1.

87a

Bronze panel in repoussé, from Castel S. Mariano, Perugia (Perugia, Museo inv. 1428). Height: 0.355m. A simple moulding frames the panel. The scene on it is a gigantomachy with Zeus, holding his thunderbolt in his right hand, about to kill a giant whom he has caught by the hair. The same metalworker also made a similar panel (now in Perugia) showing Zeus and Heracles, which was found in the same place. Physically and stylistically the figure recalls one of the 'Loeb' tripods (Pl. 86b) and a sarcophagus from Caere (Pl. 7). Zeus has the same profile, the same soft modelling, the same robust body as the figures on the tripod. The panel fits into the Caeretan picture, perhaps even came from the same workshop which made the Loeb tripod, but the figures are stiffer and have less personality. The craftsman was extremely skilful in repoussé and the use of the engraver's tool, but lacked the inventiveness of an artist. Around 510 B.C. From 'Tyrrhenica,' Saggi di Studi Etruschi, Istituto Lombardo, Accademia di Scienze e Lettere, Milan, 1957, Pl. VII, 2.

87b

Detail of a panel in repoussé bronze, from Castel San Mariano, near Perugia (Munich, Antikensammlungen, 720 r.). It was found together with numerous other bronzes, both repoussé and cast, of varying periods. This specimen is one of the earliest. C. 550 B.C. Photo Istituto di Etruscologia e Antichità Italiche, University of Florence.

88a

Marine being (merman) with a human body ending in a fish tail, bronze, from Castel San Mariano, near Perugia. Length: 0.196m. Three similar pieces exist—one in Perugia (Museo Archeologico, inv. 1422) and two in Munich (Antikensammlungen). Because of its sinuous body and extremely soft modelling the figurine, which may have decorated a piece of furniture, has been interpreted as a girl, but the breast is so rudimentary that it must be a youth. All the more so in that ancient art did not know the 'girl-fish' type of the 'womanfish', which we now call a mermaid. They knew only the merman, the Triton (young or old). They knew the girl-bird (they called it 'siren') and the girl-lion (the sphinx). The soft modelling of this small bronze leads us to surmise that these three figures, like the other bronzes from Castel San Mariano, were made at Caere. Late 6th cent. B.C. Photo Istituto di Etruscologia e Antichità Italiche, University of Florence.

88b

Bronze mirror, from Perugia (London, British Museum, Br. 620). Pherse (Perseus), seated on the left, holds the sickle with which he has cut off the head of the Gorgon, which Menerva (Minerva), at the centre, is holding high. Turms (Hermes) is seated on the right. They are all looking at the reflection of the head in a pool of water, for looking directly at it would have changed them to stone. 4th-3rd cent. B.C. Photo Brit. Mus. XV D 8.

89

Clay urn, from Perugia (Perugia, Museo). The subject has been variously interpreted. A man, his head covered by a wolf's head, rises from a circular receptacle (a well?) to the marvel and fear of those present; behind him a man pours liquid on his head. It has been suggested that this illustrates a passage in Pliny which mentions a monster, Olta or Volta, which devastated the countryside around Volsinii. The protruding base of the urn is characteristic of Perugian cinerary urns. 2nd cent. B.C. Photo Alinari 47593.

90

Funeral urn of Larth Velimna, from the tomb of the Volumni, at the Palazzone near Perugia (Perugia, Ipogeo dei Volumni). Found in 1840. The chest is typical of other Perugian urns: on the front a frame

in relief and large discs (paterae?) frame the head of a female demon with snakes, sculptured in high relief. Some interpret her as a Gorgon (the head of Medusa), but in Hellenistic Etruria these heads with serpents may mirror Etruscan beliefs in the Underworld. The urns of the Volumni differ from the usual type of urn: the funerary chest and the kline on which the dead man is resting are two separate elements. The dead man reclines on a high draped kline with carved legs. The ashchest is only a pedestal for the kline. Like all the urns from this tomb, this one is in local travertine, but it has been coated with a fine stucco. It is one of the rare examples of stuccoed urns. The quality both of the portrait of Larth Velimna as well as of the decoration of the chest are way above the general level of Perugian urns. The head of the female demon is similar to the one on the urns of Aule and Vel Velimnathe father and the brother of Larth—in the same tomb; the three urns were probably made at the same time and in the same shop. The head is also very close to those of the two female demons on the beautiful well-known urn of Arnth Velimna, the founder of the tomb of the Volumni. The tomb was dated to between 75 and 40 B.C. by Prof. Gerkan; to the middle of the 2nd cent. B.C. by Prof. Thimme, whose date seems more acceptable. The urn of Larth Velimna, shown here, would then date to 150-125 B.C. Photo Alinari 21312.

91

Female demon, on an urn from Volterra (Vatican, Museo Gregoriano Etrusco, inv. 13387). In alabaster. On the short end a beautiful demon holds a torch (only the flame is left next to her foot). She has serpents and small wings on her head, that is, the attributes of the Hellenistic Gorgon. 2nd cent. B.C. Photo Musei Vaticani XXXII—56—23.

92

Etruscan black-figure oinochoe (Florence, Museo Archeologico, inv. 3780). Painted on the body is an episode inspired by Greek myth of the birth of Pegasus. The hero Perseus killed Medusa by cutting off her head with the sickle given him by Hermes. From her blood sprang forth the young Chrysaor and the winged horse Pegasus. Only rarely did the Greeks represent the moment in which Pegasus rises from the neck of the Medusa. Generally she is shown with her head still in place and with both her children next to her. Here the painter has embroidered on the legend, drawing two opposed winged horses which

rise from the neck of Medusa. The incised details were drawn quickly and with no other purpose than decoration, but the composition is pleasing and effective. The painter was influenced by the Micali Painter, although he is inferior to him. The wings of the two winged horses with their feathers stylized in parallel listels, such as the feathers of the birds in the Tomb of the Augurs in Tarquinia (Pl. 31), are extremely decorative. Late 6th cent. B.C. Photo Soprint. Antich., Florence, 5454.

93a, b, c

Vase in bucchero sottile in the shape of a rooster, from Viterbo (New York, Metropolitan Museum of Art, 24.97.21 ab.). The upper part of the head is the cover of the vase. Wings and feathers are incised. The quality of the bucchero seems to indicate that it was produced in a south Etrurian workshop. Plastic vases in bucchero, in the shape of animals, are not infrequent. Here the stylization and simplification of the natural forms is particularly pleasing. The real importance of the vase consists in the fact that after firing it was inscribed from left to right, on the body, with the Etruscan alphabet in its most archaic form, with the 22 letters of the Phoenician alphabet—including those which practically fell into disuse when the alphabet was adopted by the Greeks-and the four letters which the Greeks added later. Of these 26 letters, three, and perhaps even four (B, D, O, perhaps the samek), were never used in Etruscan inscriptions. Others are found only in archaic inscriptions. The late Etruscan alphabet had only 20 letters. a. The alphabet on the rooster (the letters from A to M are visible), usually known as the Viterbo alphabet, is one of the oldest found in Etruria. Other archaic alphabets include the one from Marsiliana (Pl. 94b), the one from Formello, and the one on the small bucchero vase from the Regolini-Galassi tomb. It has been suggested that the rooster contained a liquid for writing; it would then be an Etruscan inkpot. Late 7th, or early 6th cent. B.C. Photo Metrop. Mus. of Art, 112648 A (courtesy of the Metropolitan Museum of Art, Fletcher Fund, 1924).

b. The same bucchero vase with the letters from K to T. Photo Metrop. Mus. of Art 112647 A (courtesy of the Metropolitan Museum of Art, Fletcher Fund, 1924).

c. The same bucchero vase with the letters from coppa to chi. In place of the x (that is, two slanting lines which cross each other) the s made

with three strokes has been repeated by mistake. Photo Metrop. Mus. of Art 112649 A (courtesy of the Metropolitan Museum of Art, Fletcher Fund, 1924).

94a

Phoenician inscription on a sheet of gold foil from the sanctuary of Pyrgi (Rome, Museo di Villa Giulia). It is the dedication of a 'sacred place' to Astarte by Tbry' Wlns, the Thefarie Velianas of the Etruscan inscriptions found in the same sanctuary. The sheet was found together with the Etruscan ones in a basin, between temple A and temple B, filled with architectural terracottas. Opinions as to the linguistic classification of the text vary—some (the majority) are inclined to consider it a Phoenician–Punic language, others believe it to be a Phoenician–Cypriot one. First half of the 5th cent. B.C. Photo Soprint. Antich., Rome, II.

94b

Model of a writing tablet in ivory, from the Circle of the Ivories, Marsiliana d'Albegna (Florence, Museo Archeologico). Length: 0.088m. It has a raised border all round the edge (width: 0.005m.). The handle, in the shape of a double-lion protome, is on one of the short sides. It is not a real writing tablet, for it is too small. The scratches on the surface were not produced by the sharp point of a stylus writing in a wax coating. It is in the archaic Etruscan alphabet incised on one of the long sides, from left to right (Marsiliana alphabet), that the tablet's importance lies.

Similar ivory tablets, although much larger, have been found in the East. It is logical to suppose that there were also wooden ones in southern Italy and in Greece. They were used to write on. The Marsiliana tablet differs from all these others in that it was meant to suggest to the writer the shape of the letters and was probably worn on a string around his neck, since there is a hole in the handle. There is no problem in our reading the alphabet incised on the tablet—just as we have no difficulty in reading an Etruscan inscription. It is a Greek alphabet, of the type known as western, and the letters are read exactly like those in the Greek alphabet. They both go back to the Phoenician alphabet, but, according to some scholars, the Etruscan alphabet, which was probably transmitted via the Chalcidian Greek alphabet, which was probably transmitted via the Chalcidian colony of Cumae, in Campania, founded around 750 B.C. Other scholars, though, think that the presence

in the Etruscan alphabet of signs which are not present in Archaic Greek inscriptions shows that the Etruscans got their alphabet from the peoples living on the coast of Asia Minor. Objections can be found to either hypothesis, but both are possible. Unfortunately there are no model alphabets for the Greek cities, and for all we know these cities may, as in Etruria, have had model alphabets containing more letters than those we know through inscriptions. Even in Etruria not all the letters of the model alphabet are found in the inscriptions.

A frequent error concerns the dating of the tablet. When it was discovered it was dated in the 8th century B.C., a date still repeated by some scholars. In itself the tablet offers no stylistic characteristics which would tend to suggest one date rather than another. It can be dated only through the material from the tomb in which it was found. The Circle of the Ivories had three burials, and therefore, in all likelihood three groups of tomb goods of various dates. But the material forms a rather homogeneous unit which does not allow much leeway in dating. The ivories, which may have been imported from another Etruscan city, are more or less contemporary and can be dated in the last quarter of the 7th cent. B.C. The tablet must be dated within the second half of the 7th century B.C. Photo Soprint. Antich., Florence, 167.

95a, b

Sheets of gold foil with Etruscan inscriptions, from the sanctuary of Pyrgi (Rome, Museo di Villa Giulia). They are two dedications of a temple or of something sacred to Uni (actually only the longer text specifies anything) by Thefarie Velianas. The two sheets were found together with the Phoenician one (Pl. 94a) and another fragmentary bronze sheet with an Etruscan inscription. The texts on the gold sheets in Etruscan and in Phoenician are similar in content, but are not translations of each other. Interesting deductions of linguistic and historical character have resulted from their analysis. The most generally accepted date is within the first quarter of the 5th cent. B.C. Photo Soprint. Antich., Rome, II.

96a, b

Sheets of gold foil with Etruscan inscriptions, from the sanctuary of Pyrgi. The sheets (discussed in the preceding caption) are shown still rolled up, before they were restored by the Istituto Centrale del Restauro di Roma. Photo Soprint. Antich., Rome, II.

I have no intention of giving a complete bibliography on the Etruscans and Etruria here. Nor would it be possible to do so: a bibliography on Etruria alone would require more than a thousand pages. In the list presented here I have tried to indicate works that would be useful and comprehensible to the non-specialist as well, providing a guide-line for those interested in following up the subjects dealt with in this book. Often the opinions expressed by the various authors will differ from mine, but the works mentioned were all written by serious scholars.

I have excluded those books and articles which are out of date and those of a too strictly scientific nature, too difficult and dry for anyone unused to the technical language of each field. Nor have I included works by authors whose enthusiasm seems to run away with them so that their excess imagination and lack of judgement lead them to facile but unacceptable solutions of problems that are actually much more difficult and complicated. They are all the more dangerous for anyone lacking the specialization which would permit him to separate fact from fantasy. The limits of space also oblige me not to list books and pamphlets of a purely popular nature or collections of illustrations which have only a brief introductory comment. I have however mentioned only two of these (in the third section: Etruscan art in general), those by Giglioli and by Tarchi, since they provide a full range of the development of Etruscan art.

EXCAVATIONS AND DISCOVERIES In the 18th and 19th centuries:

Annali, Bullettino e Monumenti dell'Instituto di Corrispondenza Archeologica (from 1829).
G. MICALI: Monumenti per servire alla storia degli antichi popoli italiani, 1832.
—: Monumenti inediti a illustrazione d. storia d. antichi popoli italiani, 1844.
F. INGHIRAMI: Monumenti etruschi, 1821.
—: Etrusco Museo Chiusino, 1833.

After 1870:

Notizie degli Scavi di Antichità; Monumenti ant. dell'Accademia dei Lincei; Bollettino d'Arte; Studi Etruschi.

GENERAL

For a general idea on the various problems concerning Etruria:

B. NOGARA: Gli Etruschi e la loro civiltà, 1937.
 M. PALLOTTINO: Etruscologia, 6th edition, 1966.

J. HEURGON: La vie quotidienne chez les Etrusques, 1961, (English translation: Daily Life of the Etruscans, 1964).

In the following list the first two works, even though written in the 19th century, are still extremely useful and interesting:

G. DENNIS: The Cities and Cemeteries of Eturia, 3rd edition, 1878; indispensable and at the same time a pleasure to read, (reprinted 1968). MÜLLER-DEECKE: Die Etrusker, 1877 (reprinted in 1965 and the bibliography

In addition:

G. PINZA: Materiali per l'etnologia antica toscano-laziale, 1914.

D. RANDALL MACIVER: Villanovans and early Etruscans, 1924.

E. FIESEL: Etruskisch. Grundriss der indogerm. Sprach- und Altertums-kunde, 1931.

Scritti in onore di B. Nogara, 1937.

Tyrrhenica. Saggi di Studi Etruschi, 1957.

brought up to date by A. J. PFIFFIG).

Historia. Zeitschrift f. alte Geschichte, vol. VI, 1957, pp. 1-132 has a useful review of the achievements in the various fields. It is not always acceptable.

Études étrusco-italiques (from 1963).

Studi in onore di Luisa Banti, 1965.

A. J. PFIFFIG: Die Ausbreitung des Röm. Städtewesens in Etruria, 1966.

H. H. SCULLARD: The Etruscan Cities and Rome, 1967.

Studi Etruschi: specialized periodical, published from 1927 on by the Istituto di Studi Etruschi e Italici. Essential for anyone intending to study the Etruscan problem. This bibliography cites only a few of the most important works.

ETRUSCAN ART

O. MONTELIUS: La Civilisation primitive en Italie, I-II, 1895-1910.

F. V. DUHN-F. MESSERSCHMIDT: Italische Gräberkunde, 1923–1939.

P. DUCATI: Storia dell'Arte etrusca, 1927.

G. Q. GIGLIOLI: L'Arte etrusca, 1935; useful for its large collection of reproductions.

A. BLAKEWAY: BSA, XXXIII, 1932-3, pp. 170 ff.

A. BLAKEWAY: JRS, XXV, 1935, pp. 129 ff.

R. BIANCHI BANDINELLI: in Enciclopedia dell'Arte antica classica e orientale, see "Etrusca arte" (with a full bibliography).

N. TARCHI: L'arte etrusco-romana nell'Umbria e nella Sabina, 1936; a good collection of photographs.

P. J. RIIS: An Introduction to Etruscan Art, 1953.

T. DOHRN: Grundzüge etrusk. Kunst, 1958.

Etruscan decorative motifs:

W. L. BROWN: The Etruscan Lion, 1960. G. CAMPOREALE: in Röm. Mitt.,

LXXII, 1965, pp. 1 ff. (Etruscan lion). S. DE MARINIS: La tipologia del banchetto nell'Arte etrusca arcaica, 1961. R. BRONSON: in Studi Banti, pp. 98 ff. (races in Etruscan art). For the theme of the charioteer thrown from his chariot see E. PFUHL: Malerei und Zeichnung der Griechen, III, 1923, fig. 206. R. BRONSON: in Arch. Class., XVIII, 1966, pls. 6–8. M. MORETTI, R. BARTOCCINI: La tomba delle Olimpiadi, 1959. — G. CAMPOREALE: in Arch. Class., XVII, 1965, pp. 36 ff. (the "lord of the animals"). O. TERROSI ZANCO, in St. Etr., XXXII, 1964, pp. 29 ff. (chimera).

Museum Guides and Exhibition Catalogues:

L. A. MILANI: Il Museo Archeologico di Firenze, I–II, 1912. A. DELLA SETA: Il Museo di Villa Giulia, 1918 (excellent study of the art and culture of southern Etruria). M. MORETTI: Museo di Villa Giulia, 1964. HELBIG-SPIERE-DOHRN: Führer durch die öffentlichen Samml. kl. Altertümer Rom, II (Vatican, Gregorian Museum).

Mostra dell'Arte e della Civiltà etrusca, 2nd edition, 1955. Arte e civiltà degli Etruschi, Turin, June–July 1967.

Villanovan civilization: in addition to the works mentioned above see the following:

AO. AOBERG: Bronzezeitliche und Früheisenzeitliche Chron., I, 1930. M. PALLOT-TINO: in St. Etr., XIII, 1939, pp. 85 ff. J. SUNDWALL: Die älteren ital. Fibeln, 1943. M. PALLOTTINO: in Rend. Pont. Accad. Archeol., XXII, 1946–7, pp. 31 ff. C. F. C. HAWKES: in Atti I Congr. Intern. di Preist. e Protost. Mediterr., 1952, 256 ff. L. PARETI: in St. Etr., XXV, 1957, pp. 537 ff. H. MÜLLER-KARPE: Beitr. zur Chronologie der Urnenfelderzeit nördlich und südlich der Alpen, 1959. M. PALLOTTINO: in St. Etr., XXVIII, 1960, 11 ff. G. CAMPOREALE: in St. Etr., XXXII, 1964, 3 ff. J. CLOSE-BROOKS: in St. Etr., XXXV, 1967, pp. 332 ff.

ARCHITECTURE

City Planning:

F. CASTAGNOLI: Ippodamo da Mileto, 1956; —: in Arch. Class., XV, 1963, pp. 181 ff. G. A. MANSUELLI: in Parola del Passato, XX, 1965, 314 ff.

Temples:

A. KIRSOPP-LAKE: in Mem. Amer. Acad. Rome, XII, 1935, pp. 39 ff. A. ANDREN: Archit. Terracottas from Etrusco-Italic Temples, 1940. L. POLACCO: Tuscanicae dispositiones, 1952. A. ANDREN: in Rend. Pont. Acc. Arch., XXXII, 1959–60, pp. 21 ff. E. G. COLONNA: in Arch. Cl., XVIII, 1966, pp. 268 ff.

Architectural mouldings:

L. SHOE: in Mem. Amer. Acad. Rome, XXVIII, 1965.

Houses:

G. PATRONI: in Rend Lincei, 1902, pp. 467 ff. A. GARGANA: in Historia, 1934, pp. 204 ff. A. BOETHIUS: in Palladio, 1965, pp. 3 ff. G. A. MANSUELLI: in Röm. Mitt., 1963, pp. 44 ff.

Tombs:

AO. AOKERSTROEM: Studien über d. etrusk. Gräber, 1934. A. MINTO: in Palladio, III, 1939, pp. 1 ff. M. DEMUS-QUATEMBER: Etruskische Grabarchitektur, 1958.

SCULPTURE

BRUNN-KOERTE: I rilievi delle urne etrusche, 1870–1916: indispensable despite the fact that it is no longer complete.

A. RUMPF: Katalog d. etrusk. Skulpturen d. Berliner Museums, 1928.

G. KASCHNITZ-WEINBERG: in St. Etr., VII, 1933, pp. 135 ff.

G. HANFMANN: Altetruskische Plastik, 1936.

P. J. RIIS: Tyrrhenika, 1941: this is the first attempt to identify local schools. F. MAGI: in BEAZLEY-MAGI: La Raccolta B. Guglielmi nel Museo Gregoriano, vol. I, 1939.

G. HANFMANN: in JHS, LXV, 1945, pp. 47 ff.

R. HERBIG : Die jüngeretruskischen Steinsarkophage, 1952.

A. HUS: Recherches sur la sculpture en pierre étrusque archaique, 1961.

See also the sections on Etruscan sculpture in Antike Plastik (S. HAYNES, A. ANDRÉN), numbers IV and VII.

PAINTING

BYRES: Hypogaei or Sepulchral Caverns of Etruria.

STACKELBERG, KESTNER, THÜRMER : Unedierte Gräber von Corneto.

F. WEEGE: Etrusk. Malerei, 1921; important for the photographs and for the fact that many of the drawings done by Stackelberg, which were formerly in Strasburg and no longer exist, are reproduced here.

F. POULSEN: Etruscan Tomb-Paintings, 1922.

F. MESSERSCHMIDT : Beiträge zur Chronologie d. etruskischen Wandmalerei, 1928.

-: in Jahrb., XLV, 1930, pp. 62 ff.

G. BOVINI: in Ampurias, XI, 1949, pp. 63 ff.

P. DUCATI: St. Etr., XIII, 1939, pp. 203 ff.

M. PALLOTTINO: La Peinture étrusque, 1952.

H. MOEBIUS : in Röm. Mitt., 1966–7, pp. 13 ff.; unpublished drawings by Byres. G. A. MANSUELLI : in Rev. Archéologique, 1967, pp. 41 ff.

L. BANTI: in St. Etr., XXXV, 1967, pp. 575 ff.; drawings by H. Labrouste.

Various painted tombs have been published in Monumenti della Pittura antica scoperti in Italia (DUCATI, BIANCHI BANDINELLI, ROMANELLI, BECATTI, MAGI). See also under the individual cities.

CERAMICS

P. DUCATI: Pontische Vasen, 1932.

T. DOHRN: Die schwarzfigurigen etrusk. Vasen aus der zweiten Hälfte d. sechsten Jahrhunderts, 1937.

AO. AOKERSTROEM: Der geometrische Stil Italiens, 1943; the dating given here for the Italo-geometric vases is not acceptable. See the reviews in Rend. Pont. Acc. Arch., XXII, 1946–7, pp. 31 ff.; Eranos, XLII, 1948; JRS, XXXIX, 1949, pp. 137 ff.

J. D. BEAZLEY, F. MAGI: La raccolta Guglielmi, I-II, 1941.

J. D. BEAZLEY: Etruscan Vase-Painting, 1947; an excellent general work, the first of its kind, on Etruscan pottery.

St. Etr., XX, 1948-9, pp. 241 ff.; XXIX, 1961, pp. 89 ff.

Impasto and bucchero:

P. MINGAZZINI: in I vasi della Collezione Castellani, I. F. MAGI in BEAZLEY-MAGI: La raccolta Guglielmi, II, 1941. G. CAMPOREALE: in Arte Antica e Moderna, V, 1962, pp. 130 ff.; G. BATIGNANI: in St. Etr., XXXIV, 1966, pp. 295 ff. I. PECCHIAI: in St. Etr., XXXV, 1967, pp. 487 ff. L. DONATI: in St. Etr., XXXV, 1967, pp. 619 ff. T. DOHRN: in Studi Banti, pp. 143 ff. (impasto amphoras); L. BANTI: in St. Etr., XXXIV, 1966, pp. 371 ff. (red bucchero). See also "Commerce and contacts between Greece and Europe".

Etrusco-Corinthian vases:

H. PAYNE: Necrocorinthia, pp. 206 ff. J. G. SZILÁGYI: in St. Etr., XXVI, 1958, 273 ff. G. COLONNA: in St. Etr., XXIX, 1961, pp. 47 ff. D. A. AMYX: in Studi Banti, 1965, pp. 1 ff. (with an earlier bibliography). —: in St. Etr., XXXV, 1967, 87 ff. J, G. SZILÁGYI: in Wissenschaftliche Zeitschrift d. Univ. Rostok, XVI, 1967, 543 ff.

4th-3rd cent. vases of southern Etruria:

M. DEL CHIARO: The Genucilia Group, 1956; —: in St. Etr., XXVIII, 1960. —: in St. Etr., XXX, 1962, pp. 203 ff.; —: in Mem. Amer. Acad. Rome, XXVII, 1962, pp. 203 ff. —: in AJA, 1960, pp. 56 ff. —: in Röm. Mitt., LXVII, 1960, pp. 29 ff. —: in Studi Banti, 1965, pp. 135 ff. I. DE CHIARA: in St. Etr., XXXIV, 1966, pp. 385 ff.

Vases from Chiusi and Volterra:

J. D. BEAZLEY: Etruscan Vase-Painting, pp. 133 ff. E. FIUMI: in St. Etr., XXVI, 1958, pp. 243 ff.; P. BOCCI: in St. Etr., XXXII, 1964, pp. 89 ff.

DECORATIVE ARTS

Mirrors:

GERHARD-KÖRTE-KLUGMANN: Etruskische Spiegel, 1840-97; J. D. BEAZLEY:

in Journ. Hell. St., LXIV, 1949, pp. 1 ff. I. MEYER-PROKOP: Die gravierten etruskischen Griffspiegel arch. Stils, 1967.

Various articles deal with the mirrors by groups:

St. Etr., VIII, 1934, pp. 129 ff.; X, 1936, pp. 463 ff.; XV, 1941, pp. 99 ff. and 307 ff.; XIX, 1946–7, pp. 9 ff.; XX, 1952, pp. 59 ff.; XVI, 1942, pp. 531 ff.; XVII, 1943, pp. 487 ff.; XXIV, 1955–6, pp. 183 ff. For the relationship between mirrors and the painted pottery of southern Italy: K. SCHAUENBURG: Perseus in der Kunst.

Jewellery:

The studies by G. KARO on the jewellery of Vetulonia and Narce are still basic: in Studi e Materiali di Archeologia e Numismatica, I, 1901, pp. 235 ff.; II, 1902, pp. 97 ff.; III, 1905, pp. 143 ff.; St. Etr., VIII, 1934, pp. 49 ff. For a general orientation see G. BECATTI: Oreficerie antiche, 1955, with its bibliography. A group of rings: J. BOARDMAN: in Papers Brit. School Rome, XXXIV, 1966, pp. 1 ff.

Ivories:

Y. HULS: Ivoires d'Étrurie, 1957: useful as a collection of material but the dating and classification is not particularly good. R. REBUFFAT: in Mélanges d'Arch. et d'Hist., 1962, pp. 369 ff.; the pyxis does not belong to the Regolini-Galassi tomb of Caere.

Gemstones:

FURTWÄNGLER: Die antiken Gemmen, I-III, 1900.

Situla:

M. V. GIULIANI-POMES: in St. Etr., XXIII, 1954–5, pp. 149 ff.; XXV, 1957, pp. 39 ff.

Belts:

G. COLONNA: in Arch. Class., X, 1958, pp. 69 ff.; J. CLOSE-BROOKS: Univers. of London, Institute of Class. Studies, XIV, 1967, pp. 22 ff.; D. REBUFFAT EMMANUEL: in Mél. d'Arch. et d'Hist., 1962, pp. 335 ff.

Bronze lebeti:

M. G. MARUNTI: in St. Etr., XXVIII, 1960, pp. 65 ff.

Candelabra:

F. MESSERSCHMIDT: in St. Etr., V, 1931, pp. 71 ff.; what he says about the tomb of the Triclinium at Caere had already been noted by DENNIS, op. cit. T. DOHRN: in Röm. Mitt., LXVI, 1959, pp. 45 ff.

Funnels (Infundibula):

M. ZUFFA: in St. Etr., XXVIII, 1960, pp. 165 ff.

Vetulonian censers:

E. VINATTIERI: in St. Etr., XX, 1952, pp. 199 ff.

Ritual spades:

M. ZUFFA : in Atti e Mem. Deput. St. Patria Bologna, 1960, pp. 67 ff.

COMMERCE AND CONTACTS WITH GREECE AND EUROPE

M. GUARDUCCI: in Arch. Class., IV, 1952, pp. 241 ff. L. H. JEFFERY: in BSA, L, 1955, pp. 69 ff. M. PALLOTTINO: in Accademia Naz. Lincei, quaderno 87, 1966, pp. 11 ff.

Bucchero:

F. VILLARD: in Hommages Grenier, III (Latomus, LVIII), 1962, pp. 1625 ff. O. FREY: in Mostra dell'Etruria Padana e della città di Spina, II, pp. 147 ff. B. SHEFTON: in Perachora, II, pp. 385 ff.

Bronzes:

R. KUNZE: in Studies Robinson, I, 1951, pp. 736 ff.; J. CLOSE-BROOKS: Univ. of London, Inst. of Class. St., XIV, 1967, pp. 22 ff.

Greek ceramics:

Cycladic geometric ware in St. Etr., XXXV, 1967, pp. 307 ff. Protocorinthian in BSA, XXXIII, 1932–3, pp. 170 ff.

ETRUSCAN EXPANSION NORTHWARDS

Contacts with Pisa and the territory north of the Arno river:

L. BANTI: Luni, 1937; —: in Memorie Pont. Accad. Archeol., 1943, pp. 97 ff. (Pisa). See also 'Fiesole – Firenze'.

Etruria Padana: Atti del I Convegno di Studi Etruschi: Spina e l'Etruria Padana, supplement to St. Etr., XXV, 1957. Civiltà del Ferro, 1959. Mostra dell'Etruria Padana, 1961, with bibliography. G. A. MANSUELLI, E. SCARANI: L'Emilia prima dei Romani, 1961; Latornus, 1962, pp. 99 ff.; Preistoria dell'Emilia e della Romagna, 1963.

Bologna in the Etruscan period:

The works of A. GRENIER: Bologne Villan. et étrusque, 1912, and P. DUCATI: Storia di Bologna, I, 1928, are outdated. Besides the works mentioned above see:

Sculpture: Monum. Ant. Lincei, XX, 1911; XXXIX, 1943. St. Etr., XIV, 1940, pp. 33 ff.; XXI, 1952, pp. 59 ff. 107 ff., 305 ff.; XXII, 1953, pp. 233 ff.; XXXV, 1967, pp. 655 ff. Riv. Ist. Arch. St. d'Arte, 1956–7, pp. 5 ff.; Studi Banti, pp. 51 ff. Arch. Class., XIII, 1961, pp. 26 ff. Mem. Pont. Accad. Arch., VI, 1943, pp. 143 ff.

Marzabotto:

Still useful is E. BRIZIO: in Monum. ant. Lincei, I, 1899, pp. 249 ff. In addition: P. E. ARIAS: in Atti e Memorie Deput. St. Patria Romagna, III, 1953, pp. 225 ff. and Riv. Istitut. Archeol. St. Arte, 1952, pp. 422 ff.; G. A. MANSUELLI: in Parola del Passato, 1965, pp. 314 ff. and in Studi Banti, pp. 241 ff. An exhaustive study of unpublished material is in St. Etr., XXXV, 1967, pp. 381 ff.

Spina:

S. AURIGEMMA: La necropoli di Spina, 1960–5; P. E. ARIAS, N. ALFIERI: Il Museo Archeologico di Ferrara, 1955; N. ALFIERI, P. E. HIRMER; Spina, 1958.

"Alto-adriatic" ceramics:

B. FELLETTI MAJ: in St. Etr., XIV, 1940, pp. 43 ff.

Adria:

G. RICCIONI: in Riv. Istitut. Arch. St. Arte, 1956-7, pp. 29 ff.; G. B. PELLEGRINI, G. FOGOLARI: in St. Etr., XXVI, 1958, pp. 103 ff.; G. B. PELLEGRINI: in St. Banti, pp. 263 ff.

Contacts between Etruria and Este:

P. BOCCI: in Studi Banti, pp. 69 ff.

EXPANSION INTO LATIUM AND CAMPANIA

Latium:

S. I. RYBERG : An archaelogical Survey of Rome from the seventh to the second cent. B.C., 1940. Etruscan inscriptions in Rome: M. PALLOTTINO: in Bull. Arch. Com. Roma, LXIX, 1941, pp. 101 ff.; St. Etr., XXII, 1952–3, pp. 309 ff.; St. Etr., XXXIII, 1965, pp. 505 ff.

Campanian painting:

FR. WEEGE: in Jahrb. Inst. XXIV, 1909, pp. 105 ff. C. P. SESTIERI: in Riv. Istit. Arch. St. Arte, 1956–7, pp. 65 ff.

Capua:

V. H. KOCH: Dachterrakotten aus Campanien, 1912. J. HEURGON: Recherches sur l'histoire, relig., civil. de Capoue préromaine, 1942. A. ADRIANI: Sculture in tufo, 1943.

M. PALLOTTINO: in Parola del Passato, XI, 1956, pp. 81 ff. M. BONGHI 10VINO: Terracotte votive, I, 1965. Other volumes on Capuan terracottas are about to be published.

Pompeii and the Campanian cities:

A. BOETHIUS: in Symbolae Philol. Danielsson dicatae, 1932. A. SOGLIANO: Pompei nel suo sviluppo storico. I. Pompei preromana, 1937. A. MAIURI: Saggi di varia antichità, 1954, pp. 241 ff., 11 ff.; G. PUGLIESE CARRATELLI: in Parola del Passato, X, 1955, pp. 417 ff. See also St. Etr., XXXIII, 1965, pp. 661 ff. A helmet found at Delphi, with a dedicatory inscription by Dionysus of Syracuse after the battle of Cumae, has been known for quite some time. A second Etruscan helmet, also with a dedicatory inscription, was found at Delphi in 1959: Bull. Corr. Hell., 1960, pp. 721 ff.

Pontecagnano:

C. P. SESTRIERI: in St. Etr., XXIX, 1960, pp. 73 ff.

CAERE

R. VIGHI, G. RICCI, M. MORETTI: in Mon. Lincei, XLII, 1955: this is the publication of a part of Mengarelli's excavations. See also the brief report by MENGARELLI himself in St. Etr., I, 1927, pp. 145 ff.; IX, 1935, pp. 83 ff.; X, 1936, pp. 67 ff.; XI, 1937, pp. 77 ff. Also Boll. Arte, 1965, pp. 107, 167. L. PARETI: La tomba Regolini-Galassi, 1947.

L. BANTI: in Tyrrhenica. Saggi di Studi Etruschi, 1957, pp. 77 ff.; study of the Loeb tripods.

Painting:

PLINY: N. H., XXXV, p. 17, mentions the painting of Caere; M. MORETTI: in Arch. Class., IX, 1957, pp. 18 ff.; F. RONCALLI: Le lastre dipinte da Cerfetri, 1965. Serious doubts exist as to the authenticity of the painted plaques in the Museum of Fine Arts in Boston. A rather unconvincing interpretation of the plaques in the British Museum was given by MESSERSCHMIDT: in Archiv. f. Religionswissenschaft, XVIII, 1941, pp. 364 ff. For the painted plaques: L. RICCI PORTOGHESI: in Arch. Class., XVIII, 1966, pp. 16 ff. (Lastra del Guerriero – Plaque of the Warrior). For the painted tombs of Caere see R. MENGARELLI: in St. Etr., I, 1927, pls. 49, 50. L. CANINA: Cere antica. M. MORETTI: in Mon. Lincei, XLII, 1955, pls. 2, 4.

Votive terracottas:

Q. F. MAULE, H. R. W. SMITH: Votive Religion at Caere. Prolegomena, 1949.

Tombs:

A. STENICO: in St. Etr., XXIII, 1954, pp. 208 ff. (Tomb of the Reliefs). M.

CRISTOFANI: La tomba delle Iscrizioni a Cerveteri, 1965. M. MORETTI: La tomba Martini-Marescotti, 1966.

Sculpture:

G. HANFMANN: Altetr. Plastik, 1936, pp. 15 ff.; —: in Crit. Arte, II, 1937, pp. 162 ff. C. Albizzati: in Dissert. Pont. Accad. Arch., 1920, pp. 2 ff. G. Q. GIGLIOLI: in St. Etr., XX, 1948–9, pp. 277 ff.; XXII, 1951, pp. 319 ff.

Sarcophagi:

Bull. Inst., 1869, pp. 258 ff. H. SAUER: Die archaischen etr. Terracottasarcophage aus Caere, 1930. P. J. RIIS: Tyrrhenika, cit., pp. 14 ff. M. MORETTI: Mus. di Villa Giulia.

History:

M. SORDI: I rapporti romano-ceriti e l'origine della civitas sine suffragio, 1960. S. MAZZARINO: Il pensiero storico classico, I, 1966.

Pyrgi:

CASTAGNOLI-COZZA: in Papers Br. School Rome, 1957, pp. 16 ff. GIULIANI-QUILICI: 'La via Caere-Pyrgi', Quaderni Istit. Topogr. Ant. Univ. Roma, I, 1964. Complete bibliography is to be found in Arch. Class., XVIII, 1966, pp. 275 ff. See also: Arch. Class., XVIII, 1966, pp. 251 ff., 268 ff.; XIX, 1967, pp. 332 ff., 336 ff., 342 ff. St. Etr., XXXV, 1967, pp. 331 ff. The fourth inscribed tablet: M. PALLOTTINO: in St. Etr., XXXIV, 1966, pp. 175 ff. J. HEURGON: in JRS, 1966.

Castrum Novum:

St. Etr., X, 1937, pp. 447 ff.; XI, 1937, pp. 451 ff.; XII, 1938, pp. 385 ff.; XV, 1941, pp. 283 ff. Arch. Class., XVIII, 1966, pp. 175 ff.

Santa Marinella (Punta della Vipera):

Boll. Arte, 1965, pp. 125 ff. St. Etr., XXXIII, 1965, pp. 505 ff.; XXXIV, 1966, pp. 330 ff.; XXXV, 1967, pp. 331 ff. Arch. Class., XVIII, 1966, pp. 91 ff.; 285 ff. Die Sprache, XIV, 1968, pp. 149 ff.

Monterano:

L. GASPERINI: in Études étrusco-Italiques, 1963, pp. 19 ff.

Monti della Tolfa:

S. BASTIANELLI: in St. Etr., XVI, 1942, pp. 229 ff.; —: Centumcellae, Castrum Novum, 1954. O. TOTI: I Monti Ceriti nell'età del Ferro, 1959; —: Allumiere e il suo territorio, 1967. G. COLASANTI: Le Miniere della Tolfa e le origini dell'imperialismo

romano. M. DEL CHIARO: in Rend. Lincei, 1961, pp. 108 ff.; —: in AJA, 1962, pp. 49 ff.

Montetosto:

St. Etr., XXXI, 1963, pp. 135 ff.; Boll. Arte, 1965, p. 107.

VEII

J. B. WARD PERKINS: 'Veii', in Papers Br. Sch. Rome, XXX, 1962; an excellent study. Another fine article, by the same author, is 'Veio', in the Enciclopedia Arte Antica e Orientale. Studies on Veii and its territory: Papers Br. Sch. Rome, XXIII, 1955, pp. 44 ff.; XXVII, 1959, pp. 38 ff.; XXVIII, 1960, pp. 55 ff.; XXXI, 1963, pp. 33 ff.

The excavations of the sanctuary of Portonaccio have not yet been published. See the various reports by E. STEFANI, in Not. Scavi and in Monum. Lincei; by M. SANTANGELO, specially in Boll. Arte, 1952, pp. 147 ff.; Rend. Lincei, 1948, pp. 454 ff. For religious practices: L. BANTI: in St. Etr., XVII, 1943, pp. 187 ff.

Excavations in the Campetti area:

Le Arti, I, 1938–9, pp. 402 ff.

For Juno Regina:

S. FERRI: in St. Etr., XXIV, pp. 107 ff.

Cemeteries:

to be added to the bibliography provided by WARD PERKINS: Not. Scavi, 1963, pp. 77 ff.; 1965, pp. 49 ff.; 1967, pp. 87 ff. Arch. Class., XVIII, 1966, pp. 300 ff. (Quattro Fontanili); St. Etr., XXXV, 1967, pp. 295 ff.

Sculpture:

C. Q. GIGLIOLI: in Ant. Denkmäler, III, 1918–26. M. PALLOTTINO: La scuola di Vulca, 1945; —: in Arch. Class., II, 1950, pp. 122 ff.

Painting:

A. RUMPF: Die Wandmalereien in Veii, 1915. E. STEFANI: in Archeol. Classica, 1951, pp. 128 ff. M. CHRISTOFANI, F. ZEVI: in Arch. Class., XVII, 1965, pp. 1 ff. (Campana tomb). A. DE AGOSTINO: in Arch. Class., 1963, pp. 219 ff. (Tomb of the Ducks).

Terracottas:

L. VAGNETTI: in Arch. Class., XVIII, 1966, pp. 110 ff.

Cunicoli:

JUDSON, KAHANE: in Papers Br. Sch. Rome, XXXI, 1963, pp. 74 ff.; J. B. WARD PERKINS: in Hommages Grenier, III (Latomus, LVIII), 1962, pp. 1636 ff.

History:

J. GAGÉ: in Mél. d'Arch. et d'Hist., 1954, pp. 39 ff. G. BAFFIONI: in St. Etr., XXVI, 1959, pp. 303 ff. G. D. B. JONES: in Latomus, XX, 1963, pp. 773 ff.

Veii after the Roman conquest:

M. SANTANGELO: in Latomus, VIII, 1949, pp. 37 ff. The hypothesis that Veii was important in the 4th and 3rd centuries has been reproposed, among others, by J. HUBAIX: Rome et Véies, 1958, but to date archaeological finds do not seem to confirm the hypothesis. On L. Tolonios: ST. WEINSTOCK: in Glotta, XXXIII, 1954, pp. 306 ff.

FALERII - CAPENA

W. DEECKE: Die Falisker, 1888. L. A. HOLLAND: The Faliscans in Prehistoric Times, 1925. A. DELLA SETA: Il Museo di Villa Giulia. E. H. DOHAN: Italic Tomb-Groups, 1942. G. GIACOMELLI: La lingua falisca, 1966. I. DE CHIARA: in St. Etr., XXXIV, 1966, pp. 385 ff.

Capena:

Mon. Lincei, XVI, pp. 277 ff. G. COLONNA: in Arch. Class., X, 1958, pp. 69 ff. G. D. B. JONES: in Papers Br. Sch. Rome, XXX, 1962, pp. 116.

Temples:

A. ANDRÉN OP. cit. E. STEFANI: in Not. Scavi, 1947, pp. 69 (temple of Juno Curite).

Lucus Feroniae:

P. AEBISCHER: in Rev. belge Philol. Hist., XIII, 1934, pp. 8 ff. Not. Scavi, 1953, pp. 13 ff. R. BARTOCCINI: in Atti VII congr. Intern. Arch. Classica, II, 1960, pp. 249 ff. G. D. B. JONES: in Pap. Br. Sch. Rome, XXX, 1962, pp. 101 ff.; XXXI, 1963, pp. 189 ff.; —: in Latomus, 1963, pp. 773 ff.

PRAENESTE

For Praeneste, its tombs, its production see DELLA SETA: Museo di Villa Giulia. In addition C. DENSMORE CURTIS: in Mem. Amer. Acad. Rome, III, 1919

(Bernardini tomb); V, 1925 (Barberini tomb). For the inscription Vetusia: Arch. Class., II, 1950, p. 85; Dialoghi d'Arch., I, 1967, pp. 1, 38 ff.; Die Sprache, XIV, 1968, pp. 36 ff.; St. Etr., XXXV, 1968, pp. 569 ff.

TARQUINIA

M. PALLOTTINO: in Mon. Lincei, XXXVI, 1937 (a good monograph on the city and the region, with bibliography).

The small guidebook to Tarquinia (Itinerari dei Musei e Monumenti d'Italia) by P. ROMANELLI is excellent for a general picture of the cemeteries.

City:

P. ROMANELLI: in St. Etr., XII, 1938, pp. 331 ff.; Le Arti, I, pp. 438 ff. (terracotta sculpture with winged horses); Boll. Arte, XXXIII, 1948, pp. 54 ff.; Not. Scavi, 1948, pp. 133 ff.

Cemeteries:

Not. Scavi, 1959, pp. 112 ff., as well as the old publications mentioned in Pallottino's monograph. In addition there are more recent studies, H. HENCKEN: Tarquinia, Villanovans and early Etruscans, I–II, 1968; —: Tarquinia and Etruscan Origins, 1968.

Painted Tombs:

Not. Scavi, 1881, pp. 56 ff.; 88 ff.; 1948, 212 (fragment of a painted pinax); 1955, pp. 185 ff. (painted tomb in the Tarantola grounds). St. Etr., XXIII, 1954, pp. 185 ff. F. W. WEEGE: in Jahrb. Inst., XXXI, 1916, pp. 195 ff. P. DUELL: in Mem. Amer. Acad. Rome, VII, 1927, pp. 47 ff. C. C. VAN ESSEN and F. MESSERSCHMIDT: in St. Etr., II, 1928, pp. 83 ff.; F. MESSERSCHMIDT: in St. Etr., IV, 1930, pp. 425 ff.; L. BANTI: in St. Etr., XXIV, 1955-6, pp. 179 ff. M. CAGIANO DE AZEVEDO: in Arch. Class., II, 1950, pp. 59 ff.; —: in St. Etr., XXVII, 1959, pp. 79 ff. BARTOCCINI, LERICI, MORETTI: La Tomba delle Olimpiadi, 1959. M. MORETTI: Nuovi Monumenti della pittura etrusca, 1966. F. MESSERSCHMIDT: in Scritti Nogara, 1937, pp. 289 ff.

Various painted tombs have been studied in Monumenti della Pittura antica scoperti in Italia. See also the bibliography for 'Painting'.

Other tombs and materials:

M. CRISTOFANI: in Dialoghi di Archeologia, I, 1967, pp. 288 ff. F. VILLARD: in Mon. Piot, 48, 2, 1956, pp. 42 ff. G. CULTRERA: in Ausonia, X, 1921, pp. 37 ff. (carved slabs, perhaps from a tomb).

Tomb of the Warrior (Tomba del Guerrioro) (in Berlin):

Bull. Inst., 1869, pp. 258 ff. Ann. Inst., 1874, pp. 249 ff. Monum. Inst., X, pls

10-10d. MACIVER: Villanovans and early Etruscans (with bibliography). On the material from the tomb: Å. ÅKERSTRÖM: Der Geometr. Stil in Italien, 1943, pp. 69 ff.

Tomb of the reclining Warrior (Tomba del Guerriero giacente), or Avvolta tomb:

Ann. Inst., 1829, pp. 95 ff. L. CANINA : L'antica Etruria Marittima, 1846, II, Pl. 88, 1–4.

Nuragic bronzes (?):

Not. Scavi, 1881, p. 357; 1882, p. 177.

Elogia Tarquiniensia:

P. ROMANELLI: in Not. Scavi, 1948, pp. 260 ff. St. Etr., XXI, 1950, pp. 147 ff.; XXIV, 1955-6, pp. 73 ff. J. HEURGON: in Mél. d'Arch. et d'Hist., 1951, pp. 119 ff. U. KAHRSTEDT: in Symbolae Osloenses, 1953, pp. 3 ff.

Bisenzio:

U. GALLI: in Mon. Lincei, XXI, 1913, pp. 409 ff.; Not. Scavi, 1928, pp. 434 ff. U. PANNUCCI: Bisenzio e le antiche civiltà intorno al L. di Bolsena, 1964. G. COLONNA: in St. Etr., XXXV, 1967, pp. 3 ff.

Tuscania:

E. S. TUERR: in Röm. Mitt., 70, 1963, pp. 68 ff. (terracotta sarcophagi). L. MARCHESI: Il museo di Tuscania, 1964.

VULCI

ST. GSELL : Fouilles dans la nécropole de Vulci, 1891.

F. MESSERSCHMIDT, U. V. GERKAN : Die Nekropolen von Vulci, 1930.

U. V. GERKAN: in Röm. Mitt., 57, 1943, pp. 206 ff. gives a much later date for the François tomb (c. 150-130 B.C.) than the one originally suggested. See the recent article by M. CRISTOFANI, in Dialoghi di Archeologia, I, 1967, pp. 186 ff.

J. D. BEAZLEY, F. MAGI: La raccolta B. Guglielmi nel Museo Gregoriano, 1941; the objects were found in the Vulci area.

M. T. FALCONI AMORELLI: La Collezione Massimo, 1968.

Excavations:

St. Etr., I, 1927, pp. 129 ff.; III, 1929, pp. 103 ff.; X, 1936, pp. 15 ff., 55 ff.; XI, 1937, pp. 107 ff. R. BARTOCCINI: in Études Étr. Ital., 1963, pp. 9 ff. Atti VII Congr. Intern. Arch. Classica, 1961, pp. 257 ff., 274 ff. S. PAGLIERI: in Riv. Ist. Arch. St. Arte, 1960, pp. 74 ff. AMORELLI, PALLOTTINO: in St. Etr., XXXI, 1963, pp. 183 ff. Vulci. Zona dell'Osteria. Scavi dell'Hercle.

Sculpture:

A. HUS : in Mél. d'Arch. et d'Hist., 1955, pp. 71 ff. L. BANTI : in St. Etr., XXVIII, 1960, pp. 277 ff. (Polledrara statue).

Bronzes:

St. Etr., X, pp. 15 ff.; XI, pp. 107 ff.; XVIII, pp. 9 ff. K. A. NEUGEBAUER : in Jahrb. Instituts, 58, 1943, pp. 206 ff.

Tomb with the sarcophagi in Boston:

Bull. Inst., 1846, pp. 86 ff.

Nuragic bronzes:

M. T. FALCONI AMORELLI: in Arch. Class., XVIII, 1966, pp. 1 ff.

Ceramic kilns:

S. CAMPANARI: in Atti Pont. Acc. Arch., VII, 1836, pp. 58 f.

Castro and surrounding territory:

St. Etr., XV, 1941, pp. 299 ff.; XX, 1948–9, pp. 267 ff. Riv. Sc. Preistoriche, IV, 1951, pp. 151 ff. St. Etr. XXIX, 1961, pp. 297 ff.; XXXV, 1967, pp. 285 ff. F. DE RUYT: in Rend. Pont. Acc. Arch., XXXVII, 1964–5, pp. 63 ff.; XXXIX, 1966–7, pp. 1 ff.

Cosa:

Mem. Amer. Acad. Rome., XX, 1951, pp. 5 ff.; XXV, 1957, pp. 65 ff.; XXVI, 1960.

Coastal zone:

M. SANTANGELO: L'antiquarium di Orbetello. A. MAZZOLAI: Mostra Archeologica del Museo Civico di Grosseto, 1958.

MARSILIANA

A. MINTO: Marsiliana d'Albegna, 1921 —: in St. Etr., IX, 1935, pp. 11 ff. (Heba).

SATURNIA

A. MINTO: in Mon. Lincei, XXX, 1925.

POGGIO BUCO – PITIGLIANO – STATONIA

J. BOEHLAU: in Jahrb. Inst., XV, 1900. E. BALDINI: Pitigliano nella Storia e nell'Arte, 1937. G. MATTEUCCI: Poggio Buco. The Necropolis of Statonia, 1951. A. MAZZOLAI: Appunti per la cronologia di Poggio Buco, 1960.

SOVANA – RUPESTRAL CEMETERIES

G. FOTI: Museo civico di Viterbo, 1957. G. ROSI: in Journ. Rom. St., XV, 1925, pp. 1 ff.; XVII, 1927, pp. 59 ff. G. COLONNA: in St. Etr., XXXV, 1967, pp. 3 ff. with an extensive bibliography.

Sovana:

R. BIANCHI BANDINELLI: Sovana, 1929.

Bieda and Norchia:

H. KOCH, E. V. MERCKLIN, C. WEICKERT: in Röm. Mitt., XXX, 1915, pp. 161 ff.

S. Giuliano:

A. GARGANA: in Mon. Lincei, XXXIII, 1931.

Casteldasso:

E. and G. COLONNA: Casteldasso e dintorni, 1969-70.

S. Giovenale:

Etruscan Culture, Land and People, 1962. Not. Scavi, 1960, pp. 1 ff.

Luni:

Not. Scavi, 1961, pp. 103 ff. AJA, 1964, pp. 373 ff. C. E. OESTENBERG : Luni sul Mignone e problemi della preistoria d'Italia, 1967.

Bomarzo:

Not. Scavi, 1955, pp. 189 ff. (painted tomb).

BOLSENA AND THE SHORES OF THE LAKE

See the reports of the French excavations in Mél. Arch. Hist. Éc. Fr. Rome, from 1947 on. In addition: R. BLOCH: in Civiltà del Ferro, 1959, pp. 253 ff. R. ENKING: in PAULY-WISSOWA, see 'Volsinii'; U. PANNUCCI: Bisenzio e le antiche civiltà intorno al lago di Bolsena, 1964.

Sanctuary of the goddess Nortia:

E. GABRICI: in Mon. Lincei, XVI, 1906, pp. 170 ff.

Cippo with a dedication to Silvano:

St. Etr., XXXII, 1964, pp. 161 ff.; XXXIV, 1966, pp. 165 ff. Die Sprache, XIV, 1968, pp. 147 ff.

Volsinian vases:

I. DE CHIARA : in St. Etr., XXVIII, 1960, pp. 127 ff.

ORVIETO

P. PERALI: Orvieto etrusca, 1928. S. PUGLISI: Studi e ricerche su Orvieto etrusca, 1934. F. MESSERSCHMIDT: in St. Etr., III, 1929, pp. 525 ff. M. PALLOTTINO: in St. Etr., XXI, 1950–51, pp. 229 ff.; XXII, 1952–3, pp. 179 ff.

Painting:

G. C. CONESTABILE: Pitture murali a fresco scoperte in una necropoli presso Orvieto, 1865. D. CARDELLA: Le pitture della tomba etrusca degli Hescanas, 1893. M. MAR-ELLA VIANELLO: in Antichità, I, 1947, pp. 1 ff.

Recent excavations:

M. BIZZARRI: in St. Etr., XXX, 1962, pp. 1 ff.; XXXIV, 1966, pp. 3 ff.

Sanctuary of Cannicella:

A. ANDRÉN : in St. Etr., XXXV, 1967, pp. 41 ff.

Belvedere Temple:

Dedalo, VI, pp. 158 ff.

Sappinum and Orvieto:

G. BAFFIONI: in St. Etr., XXXV, 1967, pp. 127 ff.

ROSELLE

R. BIANCHI BANDINELLI: in Atene e Roma, VI, 1925, pp. 35 ff. R. NAUMANN: in Neue Ausgrabungen im Mittelmeergebiet und im vorderen Orient, 1959.

For the recent excavations see the reports in St. Etr., beginning with vol. XXVII, 1959.

A. MAZZOLAI: Roselle e il suo territorio, 1960.

VETULONIA

I. FALCHI: Vetulonia e la sua necropoli antichissima, 1891.

St. Etr., V, 1931, is dedicated to Vetulonia; in vol. VI, 1832, pp. 117 ff. R. Cardarelli has attempted to reconstruct the ancient boundaries of the territory.

D. LEVI: in Mon. Lincei, XXXV, 1933, pp. 5 ff.; excavation of the necropolis of the Accesa, near Massa Marittima. The excavation shows the untenability of Milani's hypothesis according to which the population of Vetulonia moved to the lake of the Accesa in the 6th cent. B.C., despite the fact that it was supported by Schachermeyer and recently by Radke, in PAULY-WISSOWA, see "Vetulonia".

G. CAMPOREALE: in St. Etr., XXXV, 1967, pp. 595 ff. (sculpture from the Pietrera).

A. TALOCCHINI: in St. Etr., XVI, 1942, pp. 47 ff. (weapons).

Tomb of the Lictor (Tomba del Littore):

C. BENEDETTI: in St. Etr., XXVII, 1959, pp. 229 ff.; XXVIII, 1960, pp. 449 ff.

Tomba della Pietrera:

R. PINCELLI: in St. Etr., XVII, 1943, pp. 47 ff.

G. CAMPOREALE: La Tomba del Duce, 1967. See also his I commerci di Vetulonia, 1970.

POPULONIA

A. MINTO: Populonia. La necropoli arcaica, 1922.

-: Populonia, 1943.

-: in St. Etr., XXIII, 1954, pp. 255 ff. (on the mining industry).

A. DE AGOSTINO : in St. Etr., XXIV, 1955, pp. 255 ff.

F. NICOSIA : in St. Etr., XXXV, 1967, pp. 248 ff.

Iron sent from Austria:

R. EGGER: in Oester. Akad. d. Wiss., Denkschriften phil.-hist. Klasse, 89, 1961, 8, n.30, pl. II, 30.

VOLTERRA

L. CONSORTINI: Volterra nell'antichità, 1940 (to be used with caution).

A. MINTO: in Scritti Nogara, 1937, pp. 305 ff. (archaic stelae of Volterra). A new stele from Montaione in St. Etr., XXXV, 1967, pp. 516 ff.
R. ENKING: in PAULY-WISSOWA, see 'Volaterrae' (very accurate).
E. FIUMI: in St. Etr., XXIX, 1961, pp. 417 ff. By the same author, in Archivio Stor. Italiano, 1968, pp. 23 ff., an article on possible boundaries.

Cemeteries:

L. CONSORTINI: La necropoli etrusca di Volterra, 1933. Reports on the excavations of G. GHIR ARDINI, in Mon. Lincei, VIII, 1898, pp. 101 ff.; St. Etr., IV, 1930, pp. 9 ff. Interesting archive documents concerning excavations in the 19th century have been published by E. FIUMI, in St. Etr., XIX, pp. 349 ff.; XXV, pp. 367 ff., pp. 463 ff.

Monumental tombs:

L. PERNIER : in Not. Scavi, 1916, pp. 263 ff. (Castellina in Chianti); A. MINTO : in St. Etr., IV, 1930, pp. 54 ff.; P. MINGAZZINI : in St. Etr., VIII, 1934, pp. 59 ff.; R. BIANCHI BANDINELLI : in St. Etr., II, 1929, pp. 132 ff. For the inhabited centre of Castellina in Chianti, St. Etr., XXXV, 1967, pp. 280 ff.

Val d'Elsa:

R. BIANCHI BANDINELLI: in La Balzana, II, 1928. The tomb of the Calini Sepus is discussed in St. Etr., II, 1929, pp. 132 ff. The painted vases from this tomb were studied by T. DOHRN: A stele from Colle Val d'Elsa in St. Etr., XXXV, 1967, p. 518.

Castiglioncello:

St. Etr., XVI, 1942, pp. 489 ff.; XVII, 1943, pp. 463 ff.

Fibule:

in St. Etr., XXIII, 1954, pp. 417 ff.

FIESOLE – FIRENZE

F. MAGI: in Atene e Roma, XI, 1930, pp. 83 ff.

Fiesole stelae:

St. Etr., VI, 1932, pp. 11 ff.; VII, 1933, pp. 59 ff.; VIII, 1934, pp. 401 ff., pp. 407 ff. Arch. Class., X, 1958, pp. 201 ff. Boll. Art., 1963, pp. 207 ff. St. Etr., XXXIV, 1966, pp. 149 f.

Fiesole, temple:

G. MAETZKE : in St. Etr., XXIV, 1955-6, pp. 227 ff. G. CAPUTO, G. MAETZKE :

in St. Etr., XXVII, 1959, pp. 41 ff.: important for its dating and topography of Fiesole.

False vault tombs:

A tomb at Quinto Fiorentino has been known ever since the Renaissance: PETERSEN, in Röm. Mitt., 1904, pp. 204 ff. Another tomb was discovered in 1959: G. CAPUTO: in St. Etr., XXVII, 1959, pp. 269 ff. Arte Antica e moderna, XVII, 1962, pp. 58 ff. Boll. Arte, 1962, pp. 115 ff. Études Étrusco-Italiques, 1963, pp. 13 ff. Antichità viva, 1964. St. Etr., XXXIII, 1965, pp. 521 ff. A brief reference to the new finds in St. Etr., XXXIV, 1966, pp. 277 ff. and XXXV, 1967, 267 ff.

CHIUSI

R. BIANCHI BANDINELLI: in Mon. Lincei, XXX, 1925; excellent monograph on Chiusi.

D. LEVI: in Riv. Istituto Arch. St. Arte, IV, 1932–3, pp. 7 ff., pp. 101 ff. (tomba della Pellegrina).

E. PARIBENI: in St. Etr., XII, 1938, pp. 57 ff.; XIII, 1939, pp. 179 ff.; archaic Clusian cippi.

D. THIMME: in St. Etr., XXIII, 1954-5, pp. 25 ff.; XX, 1957, pp. 87 ff.; basic in its study and dating of the late urns from Chiusi and all of northern Etruria.

Casuccini Collection in Palermo:

St. Etr., II, pp. 55 ff.; IX, 1935, pp. 61 ff.

Val di Chiana:

R. BIANCHI BANDINELLI, R. BIASUTTI: La Val d'Ambra e la Val di Chiana, 1927. M. FAZZI: in St. Etr., VII, 1933, pp. 421 ff.

Arezzo:

St. Etr., I, 1927, pp. 99 ff. (votive deposit); 103 ff. (Castelsecco). G. DEVOTO: in Atti Accad. Petrarca, XXXIV, 1947–8, pp. 60 ff. G. MAETZKE: in St. Etr., XXIII, 1955, pp. 35 ff. —: in Enciclopedia dell'Arte antica classica e orientale, see 'Arezzo'. M. PALLOTTINO: in Atti Accad. Petrarca, XXXVIII, 1965–7, pp. 70 ff.

Excavations at Murlo:

Not. Scavi, 1966, pp. 5 ff. Amer. Journ. Arch., 71, 1967, pp. 133 ff.; 72, 1968, pp. 121 ff.

CORTONA

A. NEPPI MODONA: Cortona etrusca e romana, 1925.

Monumental tombs:

L. PERNIER : in Monum. Lincei, XXX, 1925, pp. 89 ff. (first Melone del Sodo). A. MINTO : in Not. Scavi, 1929, pp. 158 ff. (second Melone del Sodo). Palladio, I, 1951, pp. 60 ff. (Tanella Angori). St. Etr., XXIII, 1954, pp. 17 ff. (Camucia).

PERUGIA

L. BANTI: in St. Etr., X, 1936, pp. 97 ff. (the territory, with bibliography up to 1936).

City and cemeteries:

A. PAOLETTI: Studi su Perugia etrusca, 1923. L. BANTI: in PAULY-WISSOWA, see 'Perusia'. U. CALZONI: in St. Etr., XIX, 1951, pp. 313 ff.; XXI, 1950-51, pp. 275 ff.

Bronzes:

Röm. Mitt., 1894, pp. 253 ff. BRUNN-BRUCKM., Pl. 588 f. Ant. Denkm., II, pp. 14 f. Amer. Journ. Arch., 1908, pp. 278 ff. St. Etr., IX, pp. 410 ff. Tyrrhenica. Saggi di st. etruschi, 1957, pp. 77 ff.

Cover of a bronze ash urn:

A. J. VOSTCHININA : in St. Etr., XXXIII, 1965, pp. 317 ff.

Hypogeum of the Volumni:

A. V. GERKAN, F. MESSERSCHMIDT : in Röm. Mitt., 57, 1942, pp. 122 ff.

RELIGION

C. CLEMEN: Fontes historiae religionum primitivarum, 1936, pp. 27 ff.: collects what the ancient sources have to say about Etruscan religion. There are many lacunae and occasionally passages essential to an understanding of the text have been omitted.

-: Die Religion der Etrusker, 1936: this is only a review of published works.

L. ROSS TAYLOR : Local Cults in Etruria, 1923.

G. Q. GIGLIOLI: 'La religione degli Etruschi', in Storia delle Religioni edited by Tacchi Venturi (brought up to date by G. CAMPOREALE).

A. GRENIER : Les religions étrusque et romaine, 1948.

M. PALLOTTINO: La religione degli Etruschi, 1950.

R. HERBIG : Götter und Dämonen der Etrusker, 1948 : short popularized summary of various aspects of Etruscan religion (reprinted and revised in 1965 by E. SIMON).

Gods:

F. MESSERSCHMIDT: in Archiv f. Religionswissenschaft, XXIX, 1931 (gods writing). —: in Archiv. f. Religionsw., XXXVII, 1941, pp. 364 ff. (gods with snakes). G. DEVOTO: in St. Etr., VI, 1932, pp. 243 ff. (Fuffuns); VII, 1933, pp. 259 ff. (Culsans); XXXII, 1964, pp. 131 ff. (Aisera). P. AEBISCHER: in St. Etr., VI, 1932, pp. 123 ff. (water cults). E. BENVENISTE: in St. Etr., III, 1929, pp. 249 ff. (Acaviser). R. PETTAZZONI: in St. Etr., XIV, 1940, pp. 163 ff. (Carna). G. CAMPOREALE: in St. Etr., XXVIII, 1960, pp. 233 ff. (Thalna). L. BANTI: in St. Etr., XVII, 1943, pp. 187 ff. (the triads in Etruria). Good articles by E. FIESEL: in ROSCHER, Lexikon d. Mythologie, under the individual headings. For the goddess Nortia see 'Bolsena'.

Demons:

F. DE RUYT: Charun, démon étrusque de la mort, 1934; large collection of archaeological documents: the general part is less acceptable. S. WEINSTOCK: in Studi Banti, 1965, pp. 345 ff. On female demons: R. ENKING: in Röm. Mitt., LVII, 1942, pp. 1 ff.; LVIII, 1943, pp. 48 ff.

Divination, haruspicy, etc.:

C. THULIN: Die etruskische Disciplin, I-III, Göteborge Högsk. Arsskrift, XI-XIV, 1905-7; this is still the best study on the subject. R. PETTAZZONI: in St. Etr., I, 1927, pp. 195 ff.

Marciano Capella:

ST. WEINSTOCK: in Journ. Rom. St., XXXVI, 1946, pp. 101 ff.

Etruscan books:

ST. WEINSTOCK: in Pap. Br. Sch. Rome, XVIII, 1950, pp. 44 ff.; XIX, 1951, pp. 122 ff. R. BLOCH: in Studi Banti, 1956, pp. 63 ff.

Relationships with Greece and Rome (myth and religion):

E. FIESEL: Namen des griech. Mythos im Etruskischen, 1928. J. HEURGON: in Rev. Ét. Latines, XXXV, 1957, pp. 106 ff. G. CAMPOREALE: in Studi Banti, pp. 111 ff. For the Greek myth see various articles by G. CAMPOREALE in the more recent numbers of St. Etr.

Exhibition of the deceased:

G. CAMPOREALE: in Röm. Mitt., 1959, pp. 31 ff.

HISTORY AND GOVERNMENT

J. HEURGON: in Historia, VI, 1957, pp. 63 ff. R. LAMBRECHTS: Essai sur les magistratures étrusques, 1959; includes archaeo-

logical documents (paintings and reliefs) without arriving at new conclusions. The first studies based on monuments are by S. MAZZARINO: Dalla monarchia allo stato republicano, 1945.

E. VETTER : in Jahresh. Oesterr. Instituts, XXVII, 1948, pp. 57 ff.

M. PALLOTTINO: in St. Etr., XXI, 1950-51, pp. 147 ff.; XXIV, 1955-6, pp. 45 ff.

M. CRISTOFANI: in St. Etr., XXXV, 1967, pp. 609 ff.

A. J. PFIFFIG : in Historia, XVII, 1968, pp. 307 ff.

Political disunion:

L. PARETI: in Rend. Pont. Acc. Arch., VII, 1929–31, pp. 89 ff. For an evaluation of references to Fanum Voltumnae: G. CAMPOREALE: in Parola del Passato, XIII, 1958, pp. 5 ff.

INSCRIPTIONS AND LANGUAGE

G. BUONAMICI: Epigrafia Etrusca, 1932; the imposing size of the book belies the usefulness it might have had with proper indexes and indications of the sites.

M. PALLOTTINO: Elementi di lingua etrusca, 1936. The book by STOLTENBERG on the same subject is not recommended because of the inacceptable statements and interpretations it contains.

The Etruscan inscriptions have been published in the Corpus Inscriptionum Etruscarum (C.I.E.), which was begun in 1898 and is still in progress, and in the Corpus Inscriptionum Italicarum (C.I.I.). Additions in M. BUFFA: Nuova raccolta di iscrizioni etrusche, 1935. Studi Etruschi, in which the "Rivista di Epigrafia Etrusca" annually publishes numerous new inscriptions and corrects old errors of reading.

A. J. PFIFFIG : in Die Sprache, XIV, 1968, pp. 135 ff.

M. PALLOTTINO: Testimonia Linguae Etruscae, 1954; this is an extremely useful collection of the most important inscriptions.

A. I. CHARSEKIN: Zur Deutung etruskischer Sprachdenkmäler, 1963 (only pages 70 ff. are to be used, where the Etruscan inscriptions in Russian museums have been collected).

Acknowledged new Etruscan letters:

E. FIESEL: in Amer. Journ. Philol., LVII, 1936, pp. 260 ff. J. HEURGON: in Studi Banti, 1965, pp. 177 ff. M. PALLOTTINO: in St. Etr., XXXV, 1957 (the 'S' in four strokes).

Recent studies on the tablets of Marsiliana:

L. H. JEFFERY: Local scripts of archaic Greece, 1961, pp. 236 ff. D. DIRINGER: in Studi Banti, pp. 139 ff. M. GUARDUCCI: Epigrafia greca, 1967.

Inscriptions which mention Hannibal:

A. J. PFIFFIG: in St. Etr., XXXV, 1967, pp. 659 ff.

New alphabet charts:

St. Etr., XXXI, 1963, pp. 398 ff.; XXXIV, 1966, pp. 239 ff.; XXXV, 1967, pp. 522 ff. Arch. Class., XVII, 1965, pp. 126 ff.

ETRUSCAN ORIGINS

The works listed here sum up the principal trends:

L. PARETI: Le origini etrusche, 1926. —: La tomba Regolini-Galassi. St. Etr., XXV, 1957, pp. 537 ff. F. SCHACHERMEYER: Etruskische Frühgeschichte, 1929. M. PALLOTTINO: La origine degli Etruschi, 1947. F. ALTHEIM: Der Ursprung d. Etrusker, 1950. G. DEVOTO: Gli antichi Italici, 3rd ed., 1967.

NUMISMATICS

A. SAMBON : Les monnaies antiques de l'Italie, I, 1925, pp. 8 ff. S. L. CESANO : Tipi monetali etruschi, 1926. — : in Atti e Mem. Ist. Numismatica, VIII, 1934, pp. 71 ff.

A BAULE: term applied to a barrel- or cylinder-shaped earring

A CHINDRETTO: decoration in which a carved cylinder is pressed and rolled over the surface of a freshly moulded vase creating a band of raised motifs

ACROTERIA: ornaments, generally of terracotta, placed above the angles of a pediment or along the gable of the roof

ALA: a wing on either side of the central cella of a temple

ALABASTRON: an elongated ovoid flask for perfumed oil, of Egyptian origin ALBERESE: a kind of limestone

ANTA, ANTAE: rectangular pilasters which terminate the side walls of the porch of a temple

ANTEFIX: an ornamental tile placed upright along the cornice of the roof

- ARYBALLOS: small round-bellied perfume flask with a narrow mouth and flat surrounding lip
- ASKOS: flask that is wider than it is high with a narrow opening at one side of the top and a handle crossing to the other side. Often in the shape of an animal or head
- BLACK-FIGURE: process evolved at the end of the 7th cent. B.C. in Athens in which the figures were painted on the pots in a black glaze or varnish with details picked out in white or dark red and through the use of fine incised lines

BOTHROS: a sacred pit or well hole

BUCCHERO: wheel-made pottery which is black (or grey) throughout after firing and generally has a compact shiny surface

BUCCHERO PESANTE: bucchero with thick walls

BUCCHERO SOTTILE: bucchero with thin walls

BULLA: a hollow pendant, unusually lenticular in shape

CALCEI REPANDI: soft shoes with turned-up toes, of Asiatic origin, used by the Etruscans

CANOPIC JAR: ovoid ash urn with a cover in the shape of a human head, characteristic of Chiusi

CARDO: the principal north-south street or axis in town planning

CHITON: characteristic Greek tunic

CIPPUL: tomb marker in stone

CIRCOLI CONTINUI: "continuous circle" tombs in which one or more fossa tombs are surrounded by a ring of white stones set upright next to each other

CIRCOLI INTEROTTI: groups of pozzetto, rarely fossa, tombs, grouped within a ring of upright stones, spaced a metre or more apart

CIST: box, probably for jewellery, generally cylindrical

CRATER: large deep bowl for mixing wine

DAEDALIC: term applied to sculpture of about the middle of the 7th cent. B.C., at which time the earliest large statues in stone or marble appeared in Greece. The concept is still entirely frontal

- DECUMANUS: the main east-west street established by orientation in town planning
- DISCIPLINA ETRUSCA: the norms through which good relations with the gods could be maintained

DOLIO: a large earthenware jar

DROMOS: passageway leading into a tomb

FASCES: a double axe with eight rods of iron, symbol of the Roman lictor FOSSA: see tomba a fossa

GIGANTOMACHY: struggle of the Gods and Giants

GORGONEION: representation of the head of Medusa, one of the Gorgons, generally believed to have amuletic power

HARUSPEX: priest who examined the liver of sacrificial animals and interpreted natural phenomena

HUT-URN: an ash-urn typical of Latium which reproduces the primitive hut. Also found in Etruria

HYDRIA: a three-handled pitcher for carrying water

IMPASTO: an unpurified roughly mixed clay, generally blackish, brown, red, or yellowish when fired

KLINE: type of Greek bed or couch

- KORE: "maiden": name applied to a specific type of statue of the draped female figure, which first appeared in Greece in the 7th cent. B.C.
- KOTTABOS: an Etruscan game in which the contestants sought to hit a saucer balanced on top of a tall shaft with wine from their cups, thus causing it to fall and strike a second disc fastened halfway down the shaft
- KOUROS: "youth": statue of a nude male figure in a standing pose. First appeared in Greece 7th cent. B.C.

KYLIX: a shallow broad wine cup with two horizontal handles

LEBETE: a cauldron

LIBRI RITUALES : book of Etruscan lore giving rules for founding cities, surveying, etc.

- LIBRI FULGURALES: book of Etruscan lore dealing with the interpretation of lightning
- LITUUS: stick with a curved end, somewhat like a shepherd's crook, the mark of priestly office or of a judge or magistrate

MARU: the name of an Etruscan magistrate or magistrature

MIGNATTA: leech: term applied to bronze or gold fibulae or brooches whose body has a swollen leech-like shape

MUNICIPIUM: Roman term originally for a town in which the inhabitants only possessed part of the rights of Roman citizenship. In 90 B.C. the Lex Julia made all towns of Italy municipia with full civic rights

NENFRO: a hard grey tufa

OINOCHOE: trefoil wine jug

OLPE: a type of tall jug

ORIENTALIZING PERIOD: the period of Eastern influences (in Etruria) following the Villanovan period and beginning around the middle of the 8th cent. B.C.

PATERA: a broad flat dish with an umbone used by the Etruscans for proffering libations

POZZETTO: See TOMBA A POZZETTO

PULVISCOLO: term applied to jewellery decoration executed in an extremely minute granulation

- PYXIS: generally a simple round handleless box for cosmetics or trinkets
- RED-FIGURE: technique in pottery painting in which the figures are reversed against a black ground and the details are picked out in fine lines drawn with a brush. Introduced in Athens c. 535 B.C.

REPOUSSÉ: metal-working technique in which the design is raised by hammering on the reverse side

RIPOSTIGLI STRANIERI: "foreign deposits": a special type of pozzetto tomb found at Vetulonia, erroneously considered to have held only imported material and to have been without an ash-urn

SELLA CURULIS: the curule chair, symbol of office, prerogative of men of magisterial rank

SITULA: bucket

SKYPHOS: a deep drinking cup

SPHYRELATON: statue in thin bronze plates, hammered into shape and nailed together

STAMNOS: neck-amphora with the handles set horizontally

STELE: an upright slab or pillar used as a burial stone

THOLOS: a circular building or tomb with a false dome

THYRSOS: a staff with a pine cone at the top, carried by Dionysios and his votaries

TINIA: principal Etruscan god

TOMBA A BUCA: a simple "hole" grave

TOMBA A CADITOIA: tomb in which a sort of chimney rises to the surface from the roof of the entrance passage

TOMBA A CAMERA: chamber tomb in the form of a room or house dug into the rock or built partially above ground, sometimes covered by a tumulus

TOMBA A CASSONE: a trench tomb lined with stone slabs

- TOMBA A CORRIDOIO: corridor tomb, a transitional form from the trench tomb to the chamber tomb, hewn out of the tufa, rectangular in plan with a barrel vault or with inward slanting walls closed by slabs of tufa
- TOMBA A DADO: a cube-shaped tomb cut from the rock; also known as die tombs
- TOMBA AD AREA SCOPERTA: a trench tomb or an open roofless chamber tomb entered by stairs, with niches in the walls for the funerary urn
- TOMBA A DOLIO: burial in which the tomb material and the urn are placed inside a dolio (q.v.)
- TOMBA A EDICULA: aedicule tomb, in the form of a small chapel or house TOMBA A FOSSA: a trench tomb
- TOMBA A POZZETTO, or POZZO: tomb in the form of a cylindrical pit or well dug in the earth or rock
- TOMBA A ZIRO: burial in which the tomb material was put into a ziro (large jar) TRIGLYPH: architecturally a thick block divided into 3 smooth vertical bands
- by 2 full and 2 half grooves. Also applied to an equivalent decorative motif TUFA: a building stone of volcanic detritus, easy to work when freshly cut but

hardening on contact with air

TUTULUS: a pointed cap of Ionic origin, worn by women

UNI: Etruscan goddess, identifiable with the Greek Hera

VILLANOVAN CULTURE: a pre-Etruscan Iron Age culture, so-called from Villanova, a village near Bologna where it was first identified. Characterized by cremation of the dead and hut-urns or biconical urns covered by a shallow bowl or helmet

ZILATH: title of a chief magistrate in Etruscan cities ZIRO: a large unglazed terracotta jar, characteristic of Chiusi

INDEX OF AUTHORS

Ainsley, 101 Alberti, Leandro, 37 Altheim, F, 141, 186 Andrén, A., 124, 242 Annio da Viterbo, 194 Aristodemus of Cumae, 13 Aristonothos, 41 Aristotoles, 51 Arnobius, 190 Baffioni, G, 121 Bittel, K, 115 Bocci, Giuliano, 35 Brizio, E, 8, 9 Bronson, R, 12, 76 Byres, J, 80, 81 Caecina (Roman antiquarian), 180 Cagiano De Azevedo, M, 77, 79 Camporeale, G, 127, 136 Canina, Luigi, 37, 227 Cardarelli, R, 18 Cassius Dio, 201 Cato, 2, 4 Censorinus, 210 Cicero, 104, 157, 180 Columella, 105, 118 Cumont, Franz, 180 De Marinis, S, 262 Dempster, Th, 164 Dennis, G, 39, 86, 88, 97 De Sanctis, G, 204 Diodorus, 4, 61 Dionysius of Halicarnassus, 2, 10, 58, 63, 67, 111, 128, 140, 147, 163, 173, 209 Ducati, P, 8, 188 Falchi, Isidoro, 129 Festus, 13 Fiesel, Eva, 194 Fréret, N, 209 Frontinus, 105 Gabrici, E, 119, 121 Gerkan, A. von, 276

Gozzadini, G, 8 Grenier, A, 8 Gsell, S, 86 Guarducci, M, 117 Hempe, R, 187, 247 Hallanicus, 10 Herbig, R, 192 Herodotus, 4, 50, 208, 209, 210 Heurgon, J, 194, 202, 203 Hubaix, J, 201 Jeffery, L, H, 117 Labrouste, H, 81 Leifer, F, 203 Levi, D, 137 Livy, 5, 6, 13, 50, 53, 61, 62, 67, 68, 97, 102, 110, 120, 121, 147, 158, 162, 163, 176, 185, 189, 199, 202, 203, 205, 206, 207, 210 Mansuelli, G. A, 9 Mazzarino, S, 204 Mengarelli, R, 37, 39, 51, 187 Minto, A, 113 Mommsen, T, 211 Oltzcsha, K, 117 Orioli, F, 104 Ovid, 69 Pallottino, M, 122, 194, 211 Pareti, L, 135 Pliny, 11, 52, 63, 70, 85, 97, 98, 99, 102, 105, 110, 118, 144, 203 Plutarch, 58, 63 Probo, 209 Propertius, 61, 62, 185 Pseudo-Scylax, 10 Ptolemy, 102, 128 Riis, P. J. 44 Romanelli, P, 71 Roncalli, F, 76 Rosenberg, A, 203 Rumpf, A, 56 Schachermeyr, F, 72, 209

INDEX OF AUTHORS

Scipio, 97, 121, 155, 173 Seneca, 99 Servius, 5, 17, 37, 62, 74, 140, 147, 152, 176, 189, 190, 199 Simon, E, 187, 247 Strabo, 15, 16, 51, 67, 97, 105, 128, 146, 152, 157, 158, 163 Tacitus, 13 Tertullian, 185 Thucydides, 1 Tolonios, L, 60, 185 Varro, 13, 121, 185, 210 Verrius Flaccus, 5 Virgil, 5, 85, 140 Vitruvius, 31, 105, 172, 189 Ward-Perkins, J. B, 57 Weege, F, 77 Weinstock, F, 60, 180 Zilagy, 81 Zonara, 64, 120

GENERAL INDEX

(References in italics are to plates)

- Acerra (Campania), 11, 13
- Achelous, 235, 246
- Achilles, 36, 75, 95, 235, 249, 254
- Acquapendente (Viterbo), 85
- Acquarossa, 103
- Adria, 6, 11, 88; Greeks at, 6
- Agylla, see Caere
- Ajax, 81, 143, 240, 260
- alabaster, in Corinth, 117
- Alalia, battle of, 4
- Albegna (Roman Albinia), river and valley, 19, 110, 111, 112, 113
- Alethna, family, 105, 201-2
- Allumiere, ore-producing area, 28, 37, 74
- alphabet, Chalcidian, 193
- alphabet, Etruscan, 117, 193-4, 278-9; Bolsena, 194; Caere, 117, 193; Formello, 56, 117, 193; Graviscae, 194; Marsiliana tablet, 116-17, 193; Spina, 194; Vetulonia, 194; Viterbo, 108, 117, 193, *93a*, *b*, *c*, 277-8; Vulci, 194
- 'Alto Adriatico' pottery, 11
- Alsium (mod. Palo): 39, 50, 201
- Amazons, 83, 97, 39a, b, c, 240
- Amiata, Mount, 113; mines, 84, 113
- Antella, stele, 159
- Apenninic civilisation, 22
- Apollo: Bolsena, inscription, 119; Delphi, sanctuary of, 41; Falerii, Scasato temple, 69, 26b, 232; of Piombino, 143; Sorano, 67; representations in Etruria, 186; Veii, 25,

32, 59, 22a, b, c, 229; Veii, temple of, 31, 59

- Ardea, 14
- Arezzo, 172-4, 206; and Rome, 128, 147; bronzes, 173, 85b, 272-3; cemetery, Poggio del Sole, 173; magistrates, 201; routes, 156; terracottas, temple, 84, 272, 85a
- Argonaut group (ceramics), 94
- Argonauts, 215, 248
- Argos, 63
- Aricia, 14; battle of, 13
- Armine, river, 85
- Arno, river, valley, 1, 4, 5, 146, 154, 156
- Arno, territory north of, 156-61, 172
- Arnth Alethna, sarcophagus, 105
- Arrone, river, 37, 38, 84
- Artimino (Florence), 156–7, 158, 160, 161
- Asia Minor, 20, 28, 32, 35, 41, 44, 208
- Astarte, 51, 184, 278
- Athena, 18, 227, 242; see also Minerva Athenaeus, 126
- Attic pottery, 10, 29, 30, 40, 58, 64, 68, 87, 88, 97, 99, 107, 127, 130, 131, 142, 166, 177
- Attic style, 59, 230
- Atys, king of Lydia, 208
- Augustus, 18
- Aulestes, 5
- Aulus Vibenna, see Vibenna
- Aurinia (inc. Saturnia), 110, see also Saturnia

Avile Vipiiennas, 60

- Bagnoregio, altar at, 189
- Banditaccia, see Caere, cemeteries
- Barberini tomb, see Praeneste, tombs
- Begoe, nymph, see Vegoia
- Bernardini tomb, see Praeneste, tombs
- Bettolle, 172
- Bibbona, 152 Biscorea (La) reach tombs
- Biccocca (La), rock tombs, 101
- Bisenzio (Roman Visentium), 100, 108, 105–6, 118; canopic jar, 164; cemeteries, 106; Villanovan culture, 26, 70, 100, 106
- Blera, 17, 37, 101; tombs, dado, 55b, 251; niche, 55a, 251
- Boken-ranf (see Tarquinii, Bocchoris Tomb), 73
- Bologna (Felsina), 5, 6, 7, 8, 10, 88, 136, 148, 154, 155, 159; cemeteries (Giardino Margherita), 8; stelae, 155, 161
- Bolsena, city: cemeteries: Barano, 119; Poggio Pesce, 119; Poggio Sala, 119; Viètena, 119; temples: La Civita, 31, 32, 118; Poggio Casetta, 119, 185; Pozzarello, 119, 121; sarcophagi, 104, 105; Villanovan culture, 26, 118
- Bolsena, lake and region, 19, 70, 85, 99, 102, 105, 110, 118-20, 122
- Bomarzo (near Viterbo), 18, 105, 108, 109; sarcophagi, 104, 125
- books, Etruscan, 180; see also Libri
- bothros, 189
- Bracciano, lake, 37, 62, 63, 70
- Brolio, votive deposit, 172
- bronzes, 12, 21, 34, 40, (see also individual cities)

and iron, 143

Arezzo, Chimera, 85b, 272-3; Caere: 46, 47, 28c, 234; Castel San Mariano, 87a, b, 274, 88a, 275; Fabbrecce, 64a, 256-7; Falterona, 74, 263-4; Marsiliana, 57, 252; Populonia, 142, 143, 68a, b, 260; Praeneste, 4a, b, d, 214-15; San Valentino di Marciano, 86a, 273, 86b, 273-4; Tarquinii, 73, 28a, 233; Vetulonia, 132, 133, 135, 137, 63a, 256, 64b, 257; Visentium, 105, 106, Vulci, 4c, 215, 41c, 242, 44a, b, c, 245-6, 45a, b, 246, 46a, b, 246-7

- cauldrons, 46; from Caere, ga, 220; from Marsciano, 48; from Praeneste, 48
- plaque, from Regolini-Galassi tomb, 8a, 218-19
- tripods, 46
- bucchero, 30, 44, 46, 47, 74, 127
 - Caere, 138, 9b, 220, 9c, 221, 10a, b, 221-2, 11a, 222
 - Orvieto, 59b, 253; Veii, 57; Vetulonia, 130, 132, 10c, 222
- bucchero pesante, 170, 171, 834, 271-2
- bucchero, 'red', 47, 52, 57
- bucchero sottile, 46
- Viterbo, 93a, b, c, 277-8
- bulla, 83, 41c, d, 241-2
- Busca, 5, 155
- Caecina, 5
- Caecina family, 8
- Caelian Hill, 15
- Caelius Vibenna, 13; see also Vibenna
- Caere (Agylla, Cisra, Cerveteri), 12, 14, 16, 19, 20, 29, 37–52, 59, 74, 88, 89, 108, 122, 123, 132, 136, 138, 139, 154, 157, 164, 201, 205, 273, 274
 - and Greece, 3–4, 28, 187; and Sovana, 102–3; and Rome, 20 I, 203–4, 207; and Tarquinii, 70; and Veii, 62, 63
 - alphabet, 133-4, 258
 - antefixes, in Sienna, 32
 - bronze, 73, 176, 8a, 218–19, 9a, 220, 86a, b, 273–4, 87a, b, 88a, 275
 - boundaries, 17
 - bucchero, 113, 133-4, 142, 9b, c, 220-21, 10a, b, 221-2, 11a
 - cemeteries: Banditaccia, 42-3, 5*a*, 215-16, 217; Monte Abatone, 42; Pisciarelli, 37, 52; Sorbo, 39-40, 42, 46, 47, 57, 164, 216, 221, 225
 - dolio, 12a, 223
 - ivory, 48, 115-16, 164, 15a, 225-6
 - jewellery, 13, 224, 14a, b, c, d, e,
 - 224-5 magistrates, 200, 204
 - painting: plaques, 187, 191, 6b, 217; tomb: 57, 75
 - pottery, red-figure, 49
 - sarcophagi, 44, 45, 7a, b, 218, 8b, 219,

Caere, sarcophagi-cont.

17b, 226-7; of the Lions, 44, 48

- sculpture, 30, 44, 8d, 219-20, 16, 226, 17a
- temples: decoration, 49; to Hera, 187; Manganello, heads from, 51
- tombs, 25, 41, 42, 66; Argilla, 43; Greek Vases, 216; of the Hut, 25; del Lituo, 205; of the Painted Animals, 43, 228; of the Painted Lions, 43, 228; Regolini-Galassi, 2, 42, 46, 47-8, 6a, 216-17, 8a, 277, 289, 9a, 290, 13, 14a, b, 293-4, 28c, 302; of the Reliefs, 43; of the Sarcophagus, 43, 49, 6c, 217-18; of the Shields and Seats, 43, 5b, 216; Tomb II of the Ship, 47; of the Ship, 43; of the Triclinium, 43, 257
- urn, 8c, 219
- Villanovan culture, 26
- Caeretan hydriae, 41, 94
- Cagli (near Pesaro Urbino), 18
- Cales, 13
- Caletra, 112
- Calini Sepus family, tomb of, Monteriggioni, 18
- Camillus, 52, 53
- Camars, 214
- Campagnano (Faliscan territory), 66
- Campana dinoi, 41
- Campana plaques, 6b, 217
- Campania, 11, 12, 32
- Campanian influence, 186
- Campanizing Group (ceramics), 232
- Campiglia, inscriptions, 196; mines 143
- Camthi, 204
- Camucla, tomb, 172
- Cancelli, 164
- Candelori brothers, 86
- Canino, 98; Prince of, 86
- canopic jars, Clusium, 45, 163-4, 75a, b, 264-5
- Capena (Civitucola), 60, 62, 63, 66, 67, 68, 100, 121
- Capenati, I
- Capitoline Jupiter, 52
- Capitoline Triad, 31, 188
- Capriola (Bolsena), 118
- Capua, 11, 12, 13, 15, 92; tile from, 194, 196

- cardo, 8
- Carinthia, 146
- Caroggio (near Pistoia), 158
- Carthage, Carthaginians, 4, 48, 50, 82
- Casaglia (territory of Volterra), 152, 262
- Casale, 159
- Casalmarittimo (territory of Volterra), 152, 261
- Casalecchio (near Bologna), 154
- Càsole (near Siena), 154
- Castel Campanile (Faliscan territory), pottery, 25b, 231-2
- Castel d'Asso, 101, 103
- Castellina in Chianti, 136, 154, 155
- Castelluccio di Pienza, 136, 162, 166; jewellery, 164
- Castel San Mariano (Perugia), 21, 46, 176; bronze, 87a, b, 274, 88a, 275
- Castiglioncello, 152
- Castro (Viterbo), 89, 98, 99
- Castrum Novum (Caere), 50, 52, 201
- Catha (god), 183
- cauldrons (lebeti), bronze, 9a, 220; Caere, 40; San Valentino, 86a, 273
- cauldron, impasto, 11b, 222-3
- Cava della Scaglia, 37
- Cecina, river and valley, 128, 146, 152, 156
- Cellini, Benvenuto, 273
- Celts, 5
 - Ceres, 184, 185; Falerii, cult, 69; Veii, temple, 53, 61
 - Ceri, 37, 44
 - Cerracchio, rupestral tombs, 101
 - Cerreta near Montecatini, 151
 - Cersclan, 184, 260
 - Cerveteri, see Caere
 - Cetamura, 154
 - Cetona, 85, 165
 - Chalcidia, 53, 58
 - Chalcidian influence, 180, 193
 - Chalcidian vases, 41
 - Chalden industry 41
 - Chaldean influence, 191
 - chamber tombs, see tombs, and individual cities
 - Charu, 96, 190, 191, 51, 249
 - Chiana, valley, river, 85, 156, 160, 162, 163, 170, 171-2, 174
 - Chianciano, sculpture from, 167, 168, 77a, b, c, 267

Chigi olpe, 56

- chimera, 28; from Arezzo, 34, 173, 85b,
- 272-3
- Cilens, 119, 183
- Ciminian hills, 62, 128
- cippi, 8, 158, 159; Caere, 42, 166; Volaterrae, 150; Vulci, 43b, 243; see also individual cities
- Cisra, see Caere
- Civita Castellana (= Falerii Veteres), 63, 82, 123
- Civitavecchia, 19, 37, 52
- Civitella San Paolo, 67
- Civitucola, see Capena
- Clanis (Chiana), valley and river, 162; see also Chiana
- Claudius, Emperor, 13, 139
- Clazomenian ware, 41, 93
- Clevsin, see Clusium 162
- Clitias, 166
- Clusium (mod. Chiusi), 6, 16, 30, 47, 59, 81, 132, 155, 159, 161, 162–72, 206, 222, 225, 243
 - and Bolsena, 106; and Caere, 45; and Poggio Buco, 98–9; and Rome, 128, 147; and Saturnia, 111; and Volaterrae, 150; and Vulci, 85
 - bronze, 136-7, 254
 - bucchero, 170-71, 83a, 271
 - canopic jars, 163-4, 75a, b, 264-5
 - cemeteries, 163; Fonte all'Aia, 162; Fonterotella, 164, 166; Fornace, 162; Poggio Cantarello, 271; Poggio Renzo, 162, 268
 - cippi, 169, 79b, 269-70
 - ivory, 48, 164, 75c, d, 265-6
 - jewellery from, 48
 - painted tombs, 76, 169, 228
 - Porsenna, king, 4, 13
 - sarcophagi, 44, 169, 170; of Seianti Thanunia Tlesnasa, 82a, b, 271
 - sculpture, 166, 167
 - temple decoration, 168–9, 78a, b, 268
 - tombs, 125; Casuccini (or Colle), 77; Deposito de' Dei, 23, 24, 77, 2, 212–13; del Granduca, 170; of the Jugglers, 169; La Pania, 164; of the Monkey, 77, 170, 238, 78c, 268; Pellegrina, 270
 - urns, 35, 170, 250, 76a, b, 266, 267, 79a, 269–70, 81a, 270; of Larth

Sentinate, 81b, 270-71; Seianti, 170 Villanovan cemetery, Poggio Renzo, 162, 268 Villanovan culture, 26 zilath, 203 ziro tombs, 163, 164, 165 Colle (near Siena), 154 Colle di Mezzo, 52 Colonna di Buriano, see Vetulonia, 129 Conca, temple, 186, see Satricum Contenebra, 102 Corchiano (Faliscan territory), 66 Corfu, temple of Artemis, 136 Corinth, 6, 28, 40, 74, 213 Corinthian ware, 47, 58, 74, 87, 99, 107, 127, 130, 131, 138 Corneto, see Tarquinii Corsica, 4, 140, 141 Corsini fibula, 48, 114, 58a, b, 252 Cortona, 2, 4, 172, 174, 181, 183, 201; tomb, 172 Cortuosa, 102 Cosa, 4, 84, 85, 86, 228 Culsans, 184 Cumae, 13, 15, 28, 30, 33, 41, 50, 64, 193, 278 cuniculi, Veii, 53 cursus honorum, 199 Curunas family, Tuscania, 108 Cyprus, 41, 48 Cypselus, 74 Daedalic style, 30, 45, 90, 91, 136, 167, 228, 260 Dardans, 2 decorative motifs, 27, 72, 93; Master of the Horses, 68; winged horse, 68 decumanus, 8 Delphi, 4; sanctuary of Apollo at, 41 Demaratus, 74, 75 dice, 108, 198 Diocletian, 18

- Dionysius, cult, 241
- Dionysus of Syracuse, 51
- Dioscuri, 93
- disciplina Etrusca, 180
 - Dolciano (Chiusi), 164
- dolio, 26, 12a, 223

Eileithya, 51

Elba, 143, 144

Elsa, river, see Valdelsa

- Emilia, 26
- Era, Val d' (Arno), 146, 148
- Ergotimus, 166
- Etruscan league, 202, 206-8
- Etrusco-Corinthian ware, 30, 47, 81, 99, 107, 130, 138, 166
- Euboea, 30, 58
- Exekias, 171
- Fabbrecce, 114, 133; bronze, 64a, 256-7
- Fabii, battle of against Veii, 53
- Faesulae, see Fiesole
- Falerii Novi, 63, 64, 68; Porta Bove, 64; Porta di Giove, 64; tombs, 42
- Falerii Veteres (=Civita Castellana), 60, 61, 62, 63, 66, 100, 123, 154, 188 acropolis, hill of Vignale, 63
 - cemeteries, 64; Colle, 63; Colonnette, 63; Monterano Penna, 63; Valsiarosa, 63
 - ceramics, 25a, 231
 - painted plaque, from temple of Celle, 24c, 231
 - terracotta sculpture, Scasato temple, 26a, b, 232
 - temples, Celle, 68, 69; Fosso dei Cappuccini, 68; of Juno Curitis, 63; 'of Mercury', 188; Sassi Caduti, 68, 69; Scasato, 68, 69; Vignale, 68, 69
 - tombs, 66
- Faliscan-Capenate territory, 28, 31, 49, 55, 56, 59, 62–9, 102, 103, 108, 147, 231
- Faliscans, 1, 60
- Faliscan ware, 68
- false vault, 27, 41, 42, 71a, 261-2
- Falterona, bronze, 74, 263-4
- fanum Voltumnae, 121, 207
- Fasti Capitolini, 86
- Fasti Triumphales, 120, 147, 202
- Felsina, see Bologna
- Feluska, A, stele of, 135
- Ferentum, 103, 109
- Fescennium, 66
- Ficoroni cist, 34, 4a, b, 214-15
- Fidenae, 61, 64
- Fiesole (Faesulae), 16, 31, 161, 206; stelae, 155, 159, 73, 263; temple, 31,

161, *3d*, 214

- 'Fiesole' stelae, Antella, 159; Artimo, 161; Castello, 159; Larth Ninie, 159, 160; Settimello, 161
- Fiora, river, valley, 17, 19, 84, 85, 89, 98, 99, 100, 110, 122, 166
- Foce, pass, 136, 166
- Foiano della Chiana, 172
- Fontanile di Vacchereccia (Faliscan territory), 67
- Fonterutuli (Siena), 145
- Formello alphabet, 56, 117, 193
- fossa tombs, 8, 27; Falerii, 64; Tarquinii, 72, 73; see also individual cities
- Fosso di Formello, 53, 54
- Fosso dei due Fossi, 53
- Fosso di Valchetta, 53
- Fossombrone, 18
- François Tomb, Vulci, 13, 34, 35, 36, 60, 94, 95, 96, 120, 1, 212, 49b, 50a, b, 51, 249
- François vase, 166
- Fratte (province Salerno), 12
- Fregenae, 38, 50, 201
- French School, excavations Bolsena, 118
- Fufluns, 119, 140, 184

Gauls, 5, 7, 10, 50, 61, 145

- Geometric ware, 30, 40, 58
- Genucilia group (vases, Caere), 49
- Germinaia (Pistoia), 158
- Geryon, 80
- Giardino Margherita, see Bologna
- Giogo pass, 5
- Gods, Etruscan, 184; Cersclan, 184; Cilens, 183; Culsans, 184; Laran, 184; Letham, 184; Mantus, 189; Maris, 183; Menerva, 184; Nortia, 185; Sanchuneta, 185; Selvans, 183, 185; Tinia, 182, 185; triads, 188-9; Uni, 183; Vortumnus, 185
- Golasecca civilization, 148
- gold, see jewellery
- Gorgon, 12, 124, 187, 276; Orvieto, 59d, 254
- Graviscae, 83, 87; temple, 187, 202; alphabet, 194
- Greece, 2, 16, 20, 23, 24, 25, 26, 27, 28, 29, 33, 64, 136, 183, 186, 187, 191, 220; see also individual cities Asia Minor

Greeks, 6, 7, 12, 41, 47, 51, 84 Greek artists, 59 Greek ware, 74, 142, 153, 166; see also Attic pottery, Corinthian, Proto-Corinthian, Orientalizing Grotta Colonna (Faliscan area), 67 Hades, 80, 95, 125, 189, 190, 37a, b, 239 'hand of the Etruscan dancer', 244, 246 Hannibal, 50, 67, 147, 196 haruspices, 181 Heba, 118, 125 Hekina, Laris, stele, 155 Hera, 84, 183; temple to at Caere, 39, 41 Heracles, see Hercules Herculaneum, 11, 15 Hercules, 52, 81, 103, 187, 240, 246, 67b, 260 Hesione Painter, 70b, 261 Hieron of Syracuse, 15 houses, 103, Veii, 54 hut-urns, 25, 72, 87; Tarquinii, 27a, 232 Hyria, II

Inghirami, F., 164

- inscriptions, 5, 6, 8, 13, 98, 194-8; A. cerra, 13; 'm', 181; Magliano, 117; Orvieto, 122, 123, Phoenician, from Pyrgi, 94a, 278; Pyrgi, 95a, b, 96a, b, 279-80; Tuscania, 108; Veii, 60
- Ionia, 30, 32, 44, 45, 46, 59, 92, 167, 168, 222
- Ionian ware, 41, 138, 142
- Iron Age, 22, 25
- iron mines, 9, 28, 37, 103, 137, 143, 145, 146
- Ischia (anc. Pithekousai), 15, 28, 30, 58, 64, 193
- Isola Farnese (Rome), 52
- Italic lion, 92
- Italo-Corinthian ware, 26, 30, 57, 87, 106, 107
- Italo-Geometric pottery, 26, 30, 87, 106, 107
- ivory, 9, 41, 75, 142; Caere, 48, 164, 15a, 225-6; Clusium, 75c, d, 265-6; Marsiliana, 114-16, 58c, 252-3, 94b,

278–9; tablet, 193; see also individual cities

Janus, 184

jewellery: Bernardini tomb, 12b, 223-4; Caere, 13, 224, 14a, b, c, d, e, 224-5; granulation, 48; Marsiliana, 114, 58a, b, 252; Populonia, 67b, 259-60; pulviscolo, 258; Regolini-Galassi tomb, 47, 48, 13, 224, 14a, b, 224; repoussé, 48; Tarquinii, 28b, 233-4; Todii, 42c, 242-3; Vetulonia, 64c, 65a, b, c, d, 257-8; Vulci, 41a, b, c, d, 24I-2; see also individual cities

Juno, 183; see also Capitoline Triad

- Juno Curitis, 63, 69
- Jupiter Capitolinus, temple of, 52; see also Zeus

Kerameikos cemetery, Athens, 40 Kaikna, Vel, funerary stele, 155 Klagenfurt, 146 kline, 43, 78 kouros, 10, 90

Laconian ware, 41 Laiatico, stele from, 160 Laran (god), 184, 260 Lari (Pisa), 156 Lars Tolumnius, 60 Lasa, 191 Latins, 13, 67, 147 Latium, 32, 53, 56, 58, 59, 67, 73, 186 La Tolfa, see Tolfa Letham, 184 Leucothea, 51 Leucothea, temple of, Pyrgi, 184 Libri Acherontici, 180, 190; Fatales, 180; Fulgurales; 180; Haruspicini, 180; Rituales, 180; Tagetici, 180 Ligurians, 7, 9, 156, 157, 158, 160 'Ligurian' tombs, 158 lituum, 205 liver (bronze), 6, 181-2 Loeb tripods, 21, 86b, 273-4 Lord of the Animals, 24b, 231 Lucca, 18 lucumoni, 199 Lucus Feroniae, (Scorano), 67 Luni (anc. Luna), 4, 17, 103

Luni sul Mignone, 101 Lustignano (Volterra), 152 Lydia, Lydians, 208, 209, 210 Lysippus, 69, 232 magistrates, 50, 51, 70, 122, 199-205, 214 Magliano, 19, 110, 117, 228; lead of: 117, 183, 196 Magra, river, 1, 4, 159 Manganello, stream, 39, 42, 215 Mantua, 5, 6, 70 Mantus, 6 Marce Camitlnas, 14 Marche, 26 Marcianise (Caserta), 13 Marciano (Arezzo), 46, 172 Marcina, 12 Marica, temple of at Garigliano, 92 Maris (Mar, Mari, Marisl), 183 Marius, 145 Marliana (Pistoia), 158 Marmo, stream, 42, 215 Marsciano, see San Valentino di Marsciano Marsiliana, 19, 48, 88, 110-17, 130, 133, 136, 137, 206 alphabet, 116-17, 193 bronze, 57, 252 cemeteries: Banditella, 112 ivories, 48, 49, 114-16, 58c, 252-3, 946, 278-9 jewellery, 114, 58a, b, 252 tombs: circles (fosse 'con circolo'), 112; Circle of the Fibula, 112, 114, 115, 252; Circle of the Ivories, 112, 117, 252, 278-9; Perazzeta Circle, 112, 114 writing tablet, 116-17, 193, 94b, 278-9 Marta, river, 83, 105, 106 Marta, island, 118 Martianus Capella, 182 maru (magistrate), 199, 204, 205 Marzabotto, 6, 8, 9, 154, 155; cippus, 161; stele from, 160; temples, 31 Massa Marittima, 137 Mastarna, 13, 95 Master of Olympia, 59 Mater Matuta, 186

Medusa, 187, 276-7

Meidias Painter, 142

Melpis, river, 14

Melpum, 6, 14

Memnon, 80

Menerva, see Minerva

Mercury, 69, 188

Mezzano, Lake (Lacus Statoniensis?), 99 Mezzavia, 165

Micali Painter, 12, 77, 94, 127, 32a, 237

Mignone (Minio), river and valley, 17, 37, 74, 103, 104

Minerva, 54, 59, 61, 69, 119, 184–5, 188, 275; bronze, Arezzo, 173; Nortina, 185; sanctuary of Punta della Vipera, 51, 196; sanctuary at Veii, 59, 61, 230

mines, 113, 118, 137, 151, 156; see also iron

Minotaur, 187

Misano (=Marzabotto), 10

Modena, 6

Montaione, 155, 160

Montale Agliana, 158

Montalto di Castro, 89, 98

Monte Abatone, see Caere, cemeteries

Monte a Colle, near Montecatini, 158

Monte Amiata, 84

Monte Argentario, 84

Montecalvario, tumulus, 72b, 263

Montepulciano, 170, 182; pottery 83b, 272

Monteriggioni, 7, 17, 136, 155, 222

Montescudaio, 152, urn from, 72a, 262

Montetosto, tumulus, 51

Mozzetta di Viètena (Bolsena), 118

Mugello, 5, 161

mummy wrappings, see Zagreb

Murlo (Siena), temple, 174

Musarna (territory of Tarquinia), 104, 105, 108, 201, 202, 203

Mycenae, 157

Mycenaean pottery, 103

Mycenaean tablets, 194

Naples, 13

Narce, 66, 231; inscriptions, 66 Nazzano (Faliscan territory), 67 Nazzano Painter, 25a, 231 Nepi (Nepet), 53, 62, 63, 66 Netos Painter, 40, 88 Nicaea (Corsica), 4

GENERAL INDEX

Nikosthenes, 77, 248 Ninie, Larth, stele of, 159 Niobe, 107 Noa, II Nocera, II Nola (Naples), 13 Nomadelfia (Grosseto), 138 Norchia, 101, 108, 200; magistrates (purthne), 201; sarcophagi, 104; tombs, 104 Nortia (goddess), 119, 121, 185; cult of, 119, 121 Nortinus, Etruscan Nurtines, 185 numbers, 198 nuragic objects, 84, 87, 137, 142 Ocnus, 5 Olpeta, river, 99 Ombrone, river, 1, 5, 9, 129, 136 Orbetello, 85 Orientalizing period, 26, 27, 28, 29, 49, 137; motifs, Veii, 56, 57 Orvieto, 12, 16, 19, 66, 70, 85, 94, 108, 110, 120, 121-7, 149, 159, 166, 176, 189, 267 and Clusium, 166 bucchero, 127, 59b, 253 cemeteries: Cannicella, 122, 123, 188; Crocefisso del Tufo, 122, 123 inscriptions, 204 ivories from, 75 maru, 200 pottery: Greek, 126, 127, Vanth Group, 94 sarcophagi, 104, 125; from Torre San Severo, 60c, 254-5, 61a, 255 sculpture, stone: head of warrior, 60b, 254; Venus of Cannicella, 123 sculpture, terracotta: from Belvedere temple, 59d, 254, 60a, 254; from San Giovanni Evangelista, 123, 59c, 253-4; from Via San Leonardo, 124, 590, 253 temple, Belvedere, 3, 124 tombs: Golini I (Veii), 125, 126, 190, 61b, c, 62a, 255, Golini II (Chariots), 125, 126, 62b, c, 255-6; Poggio Rubello (Hescana), 126; Settecamini, 125

Via della Cava, 122

Villanovan culture, 122

Paestum, 95 Paglia, river, 19, 85, 122 Painter of Nazzano, 231 painting, 60; tomb, 12, 33, 34, 35, 43, 56, 75-81, 190, 228; Bomarro, 105; Caere, 43; Orvieto, 125-6; Veii, 56, 57; Vulci, 95, see also individual cities, tombs Panzano, 154, 155 Paris (mythology), 262 Paris Painter, 47a, 47b, c, 247-8 Parma, 6 Parthenon sculpture, 123 Partunu, Laris, 82 Partunu, Velthur, 82, 195 Pegasus, 187, 92, 276-7 Peithesa, 172 Pelasgians, 7, 10, 111 Peloponnese influence, 59, 157 peplos kore (Athens), 59, 230 Persephone, 80, 94, 125, 189, 374, c, 239 Perseus, 187, 88b, 275, 92, 276 Perugia, 4, 5, 173, 176-8; 183, 197, 201 cemeteries: Monteluce, 176; Palazzone, 177, 275; Sperandio, 176, 270 sarcophagi, 177; from Chiusi, 80a, b, 270 tombs: San Manno, 196; hypogeum of the Volumni, 177, 275 urns, 35, 177-78, 89, 275; Arnth Velimna, 178 Pescia Romana, 89, 98 Pheidias, 33, 69 Phersu, 76, 77, 236-7, 31b Phocaeans, 50 Phoenicia, 41, 48 Phoenician alphabet, 278-9 Piacenza, 6; liver, 181-2 Pian di Voce, 84 Pian Sultano, 52 Picene region, 66 Picentine district, II Piedmont, 5, 155 Pienza, 182 Piombino, Apollo of, 143 Pisa, 1, 4, 5, 70, 156, 157, 158 Pisciarelli, see Caere, cemeteries Piteglio, 158 Pithekousai, see Ischia Pitigliano (Grosseto), 98, 99

316

- Pitinum Mergens, 18
- Po Valley, 5, 6, 7, 9, 10, 159, 161, 172, 210
- Poggio Buco, 98, 99, 250, 251
- Poggio di Castiglione, 138
- Poggio di Colle (Vicchio), tombs, 161
- Poggio Civitate, 143
- Poggio Montano (rock tombs), 100, 101
- Polledrara statue, 58
- Polykleitos, 33, 60, 230
- Polyxene, sacrifice of, 61a, 255
- Pomarance, 152; stele from, 160
- Pompeii, 11, 12, 13, 15
- 'Pontic' vases, 81, 93, 127, 47a, b, 247-8
- Populonia (Fufluna, Pufluna, Pupluna), 16, 19, 28, 85, 87, 136, 140-46, 148, 152, 153, 162, 184, 201; and Attica, 144
 - bronze, 142, 143, 68a, b, 260
 - cemeteries: Costone della Fredda, 141; Piano and Poggio delle Granate, 141; Porcareccia, 141; San Cerbone, 141
 - ivory, 142
 - jewellery from, 48
 - tombs: aedicule, 67a, 259; of the Flabelli, 143, 259; Grande Tumulo dei Carri, 142, 143
 - Villanovan culture, 26, 141
- Porsenna, 4, 13, 162
- Porto Baratti, 144, 145
- Porto Clementino, 83
- Portonaccio temple, see Veii, temples
- pozzetti, tombs, Tarquinii, 72, 73; see also tombs

pozzi tombs, Falerii, 64; see also tombs

- Praeneste (Palestrina), 14, 16, 20, 28, 29,
 - 88, 95, 96, 114, 130, 143, 213, 220 bronze, 40, 46, 48, *2c*, 213–14, 273
 - cistae from, 34, 2c, 213-14, 4a, b, d, 214-15
 - ivories, 49, 115, 253
 - jewellery from, 48, 12b, 223-4
 - tombs: Barberini, 29, 48, 49, 115, 2c, 213-14, 223, 253; Bernardini, 29, 48, 116, 213, 12b, 223, 257
- Praxiteles, 69
- Prile, lake, 132, 138
- principes, 199
- Procoio di Cerii, 44
- Proto-Corinthian ware, 47, 56, 64, 74,

87, 88, 99, 130, 133

- Punic inscription, 196
- Punta della Vipera, inscription, 196; sanctuary at, 51
- purthne (magistrate), 199
- Pyrgi (Santa Severa), 2, 39, 41, 50, 51, 184
 - inscriptions, 38, 188, 196, 95a, b, 96a, b, 279-80; Phoenician, 94a, 278
 - temples, 184; Temple A, 31, 32, 18, 227; Temple B, 31, 32; of Uni, 185
- Querceta, 157
- Quercianella, 153
- Quinto Fiorentino, 128, 262; tombs, Montagnola, 155, 157; Mula, 155, 157
- Rasenna, 2, 209
- Reggio Calabria, 93
- Regolini-Galassi tomb (Caere), 42, 43, 46, 47, 49, 88, 117, 6a, 216–17, 28c,
- 234; bronze, 9a, 220
- Reno, river, 5, 8, 9, 136 Rhodes, jewellery, 233, 234
- Rhodian ware, 41
- Rio Maggiore, 63, 69
- Rio Vicano, 63
- rock tombs, 101-4, 55b, 251
- Rome, 2, 4, 13–15, 33, 37, 38, 51, 66, 97, 106, 108–9, 118, 120
 - and Caere, 50, 201, 203-4, 207; Capitoline temple, 31, 32, 189; Capitoline Triad, 188; and Cosa, 84, 85; and Etruscan religion, 179, 180, 181, 182, 185; and Falerii, 61, 64, 68; magistrate, 203, 272; and Populonia, 145; and Saturnia, 111; and Tarquinii, 201-3, 207; and Veii, 52, 53, 54, 61, 64, 201, 206, 207; and Vetulonia, 128, 139; and Volaterrae, 147; and Volsinii, 86, 121, 207; and Vulci, 86, 97, 207
- Romulus, 13, 52
- Rusellae (Roselle), 19, 28, 47, 60, 84, 85, 112, 113, 117, 128, 137-40, 147, 148,
- 206; stele, 138, 149; Villanovan, 138 Rutilius Namatianius, 144, 145, 146, 152

Sabine region, 66 Sabines, 13, 67 Salerno, 26

Saline di Volterra, 146

Salpinum, 121

salt route, 7, 8

Samnites, 15, 147

Samos, 30, 46; temple of Hera, 92

Sanchuneta, 185

- San Giovenale, 17, 37, 103; Villanovan period, 103
- San Giuliano, 17, 37, 89, 100, 101, 103; altar, Grotta Porcina, 104
 - cemeteries: Caiolo, 103; Chiusa di Cima, 103
 - sarcophagi, 104
 - sculpture, rock, 104
 - temples: Noce, 103; Poggio Castello, 103
 - tombs: Tomba Cima, 103; Coccumella di Caiolo, 103
- S. Rocchino (Massarosa), 157

Sansepolcro, stele of, 161

- Santa Marinella, inscriptions, 196; temple, 31, 185; see also Punta della Vipera
- Santa Severa (Pyrgi), see Pyrgi
- San Valentino di Marsciano, 176, 86a, b, 273-4
- San Vincenzo di Campiglia (Livorno), 152

sarcophagi, 36, 104, 105, 125

- Caere, 44, 45, 49, 7a, b, 217-18, 8b, 219, 17b, 226-7; Chiusi, 82a, b, 271; Tarquinia, 82, 83, 40b, 241; Tarquinia, of the Amazons, 39a, b, c, 240; Torre San Severo (Orvieto), 60c, 254-5, 61a, Tuscania, 107, 108, 56, 252; Volaterrae, 150; Vulci, 52, 53, 250
- Sardinia, 84, 87, 133, 137, 141, 142
- Sarsinates, 176
- Sarteano, 85, 162, 164, 166; cemeteries, Sferracavalli, 162; Solaia, 162

- Satricum, see Conca
- Satricum, inscription, 14
- Saturnia, 19, 110–11, 112, 136, 164; cemeteries, Villanovan, 111; tombs: chamber, 111; trench, 111
- Scopas, 69
- Scorano (Lucus Feroniae), 67
- sculpture: bronze, Arezzo, 85b, 272-3

- stone: Caere, 17b, 226–7; Chianciano, 77a, b, c, 267; Chiusi, 76b, c, 266–7, 79a, 269, 81a, b, 270–71; Perugia, 80a, b, 270, 90, 275, 60b, 254; Tarquinia, 38, 238–40, 40b, 241; Volterra, 71b, 262, 91, 276; Vulci, 92, 43a, 43c, 43d, 243–4, 53, 250
- terracotta: Caere, 7a, b, 218; 8b, 219, 8d, 219–20, 15b, 16, 226, Chiusi, 78a, 268, 82a, b, 271; Falerii Veteres, 69, 26a, b, 232; Orvieto, 59a, 59c, d, 253–4, 60a, b; Poggio Buco, 54a, b, 250– 51; Pyrgi, 18, 227; Tarquinia, 40a, 241; Tuscania, 56, 252; Veii, 20c, 228; 22a, b, c, 23a, b, c, d, 229–30; Volterra, 72a, 262 Arezzo, 84, 272, 85a

see also individual cities, bronze, ivory Selinunte, 92

sella curulis, 128

- Selvans (god), 83, 119, 183, 185
- 'Seperna', 67
- Serrazzano (territory of Volterra), 152
- Servius Tullius (Mastarna), 13
- Sestinum, 18
- Settimello, cippus, 161
- Siena, 165, 182
- Sieve, river, 158
- Silarus (Sele), river, 12
- Silius Italicus, 128
- Silvanus, 119
- Sisyphus, 80

Sorbo necropolis, Caere, 39

- Sordo, tomb, 172
- Sorrento, territory, 11, 13, 15
- Sovana, 19, 98, 100, 101; cult at, 188; tombs: Grotta Pola, 102; Ildebranda, 102; painting in, 102; of the Siren, 102
- Sparne (Le), 98
- Sparta, 93
- sphyrelaton, 92
- Spina, 6, 10-11, 88, 93
- Statonia, 99
- stelae, 9, 149, 155, 158, 159, 160
 - Fiesole, 159, 73, 263; horse-shoe, 8, 158, 161; Larth Ninie, 159, 160; Rusellae, 138, 139; Volterra, Avile

Satie, Vel, 95

stelae-cont.

Tite, 159, 160, 69b, 260; see also

Fiesole stelae

Suessola, 13

Sulla, 145

Sutri (Sutrium), 62, 63, 66

Syracuse, 50

Syria, 41

- Tages, 70, 180, 190
- Talamone, 4, 19

Taranto, 93, 183

- Tarchon, 5, 70
- Tarquinii (Corneto, Tarquinia), 5, 37, 40, 50, 57, 59, 60, 62, 63, 66, 70-84, 85, 93, 94, 102, 106, 107, 128, 132, 139, 154, 180, 214, 244, 245, 267
 - and Arezzo, 173; and Bolsena, 105, 118; and Clusium, 166, 169, 170; and Greece, 28; and Rome, see Rome; and Vulci, 93; boundaries, 17, 84
 - bronze, 46, 28a, 233
 - bucchero, 46, 74; bucchero sottile, 46
 - cemeteries: Arcatelle, 73; La Turchina, 72; Monterozzi, 72, 73, 81; Poggio Gallinaro, 72; Poggio dell' Impiccato, 72; Poggio Quarto degli Archi, 72, 81; Poggio Selciatello, 72; Villa Bruschi, 72; Villa Tarantola (inscription), 196
 - cippi, 16
 - inscriptions, 173, 195, 196
 - ivory, 164
 - jewellery, 28b, 233-4, 241
 - magistrates, 122, 200, 201-3, 205
 - painting, tombs, 29, 75-81
 - pottery, 30, 93, 27c, 233
 - reliefs, 38b, 239-40, 243
 - sarcophagi, 36, 82, 83, 107, 40b, 241; of the Amazons (Ramtha Huzcnai), 82, 83; of the Baron, 82; of Laris Partunu, 82; of Laris Pulena, 82; of the Magnate, 82, 83
 - sculpture, 81-3, 40a, 241; slab, 89, 38b, 239-40

temples, 83; Ara della Regina, 31, 72

tombs, 42, 125; chamber, 73, 74; pozzetti, 72; of the Augurs, 76, 79, 93, 205, 31a, 236, 31b, 236-7, 32b, 237, 239, 245; of the Baron, 93, 245; of the Biclinium, 81; of the Bighe, 237-8; Bocchoris Tomb, 73; Bruschi, 82; of the Bulls, 75, 29a, b, c, 234-5; of the Cardinal, 35, 80, 192; Caronti, 81; Ceisinie, 81; Chariots, 75, 76, 78, 237-8; Funeral Couch, 78; Giglioli, 234; Hunting and Fishing, 75, 78, 30a, 235, 30b, 235-6; of the Jugglers, 79, 169, 35a, b, 238-9; Labrouste Tomb, 73; of the Leopards, 79, 191, 34a, b, 238; of the Lionesses, 78; Marzi Tomb, see Triclinium; della Mercareccia (of the Sculptures), 81, 89; Master of the Olympic Games, 77; of the Old Man, 78; of the Olympic Games, 23, 24, 76, 77; Tomb of Orcus, 33, 35, 75, 80, 125, 190, 204, 36, 37a, b, c, 239; of the Painted Vases, 78; Pulcella, 79; Querciola I, 79, 161, 191; Querciola II, 81; of the Reclining Warrior (Avvolta), 26; of the Shields, 80, 200, 234, 38a, 239; of the Ship, 79; of the Sow, 79; della Tappezzeria, 81; of the Triclinium, 78, 79, 191, 33a, 237-8; of Typhon, 81, 82; of the Warrior, 26, 73, 148

- urns, 27a, 232; Villanovan, 27b, 232–3
- Villanovan period, 26, 39, 70
- Tarquinius Priscus, 13, 128, 147, 173
- Tarquinius Superbus, 13
- temples, 31, 32, 189-90; Caere, 39; Faesulae (Fiesole), 161, 3d, 214; Orvieto, 3, 124; Pyrgi, 51, 184; Punta della Vipera, 51; Veii, 53; see also individual cities
- Tecum (goddess-Minerva?), 184
- Terracina, 67
- Tetnie, Arnth, 250
- Thansina, Vel, 104
- Theseus, 80, 187
- Tiber, river, 1, 19, 61, 63, 120, 123
- Ticino, river, 5
- Tinia (Tin, Tina), 51, 121, 182, 185-6, 188; cult of, Orvieto, 123
- Tite, A., stele, see Volaterrae
- Tolfa, 28, 37, 39, 40, 50, 52, 74
- Todi, 42c, 242–3
- Tolonios, L., 60, 185

tombs: aedicule, 101; Populonia, *67a*, 259 a buca, 26, 73; Caere, 44 a caditoia, 42

cassetta, 153, 158; Volaterrae, 148

a cassone, 25

- chamber, 21, 73, 74, 99, 107, 156, 70a, 261; Caere, 41, 42, 43; north of the Arno, 158; Orvieto, 123; Populonia, 141, 142; Veii, 56; Vetulonia, 130; Volaterrae, 149-50; ad area scoperta, Veii, 56; con tramite a forma di fossa, Veii, 56
- circles, Marsiliana, 112
- corridor tomb, 73
- cube tomb (a cubo or dado), 42, 101, 103, 55b, 251
- dolio, Florence, 156; Volaterrae, 148 Etruscan, 16
- fossa (trench), 8, 25, 107; Caere, 39, 40; Veii, 54, 55; Visentium, 106; Volaterrae, 148
- niche, Blera, 55a, 251
- pediment, 101
- portico, 103
- pozzetto, 25, 129; Caere, 39, 40; Florence, 156; Visentium, 106; Volaterrae, 148
- pozzo, Veii, 54, 55
- temple tomb, 101, 102
- trench tombs, see fossa
- Torcop Group (vases, Caere), 49
- Toscanella, 106
- Trajan, inscription, 17
- Trasimene lake, 122
- Treia, river, 63, 66
- Trevignano Romano, 17, 37, 63
- tripod a verghette, 6
- Troilus, 75
- Trojans, 36, 95, 49b, 249, 50a, 254-5
- Troy, 231
- Tuchulcha, 80, 190
- Tuscan atrium, 9
- Tuscan temple, 31
- Tuscania, 89, 106–108
 - cemeteries: Ara del Tufo, 107; Carcarella, 107; San Giusto, 107; Sasso Pizzuto, 107; Scalette, 107 dice, 108
 - uice, 190
 - magistrates, 200, 201 sarcophagi, 107, 108, 56, 252

- tombs: chamber, 107; fossa, 107; Grotta della Regina, 107
- Tusci, 2, 14
- Tuscolo, 14
- Tyrrhenoi, 2
- tyrrhena sigilla, 93
- Tyrrhenus (Tyrsenos), 70, 208
- Ulysses, 80, 102, 265
- Underworld, 79, 80, 94, 96, 104, 125, 126, 161, 189, 190, 191, 192, 217, 228, 250
- Uni, 51, 183, 184, 185, 188, 279; temple to at Pyrgi, 279
- Urbino, 18
- urns, 35, 36; from Caere, 8c, 219; Chianciano, 77a, b, c, 267; Chiusi, 76a, b, 266; 79a, 269, 81a, 270; Chiusi, Larth Sentinate, 81b, 270-1; Falerii, impasto, 24a, 230-1; Montescudaio, 72a, 262; Perugia, 89, 275; urn-statues, Clusium, 167; terracotta, 21a, 229; Villanovan, Tarquinia, 27b, 232-3; Veii, 58; from the tomb of the Volumni, 90, 275-6; Volaterrae, 71b, 262, 91, 276; see also individual cities

Vaccina, stream, 39

- Vada Volterrana, 152
- Vagienni, 5
- Valdelsa, 154
- Vanth, 96, 191, 50b, 249
- Vanth group (pottery), 94, 127
- Vegoia, 180
- Veii, 12, 28, 30, 33, 37, 52–62, 63, 64, 91, 121, 183, 184, 199, 206, 207, 214, 223 acropolis, Piazza d'Armi, 31, 53
 - Apollo of, 32, 186, 22, 229, 230
 - boundaries, 61, 62
 - bucchero sottile, 46
 - cemeteries: Grotta Gramiccia, 53, 54; Monte Michele, 227; Quattro Fontanili, 53, 54; Vacchereccia, 53; Valle la Fata, 53
 - houses: Macchia Grande, 54; Piazza d'Armi, 54; Quarticcioli, 54; magistrates, 201
 - Ponte Sodo, 54, 19, 227 pottery, 2b, 213
- portery, 20, 21

Veii-cont.

- sculpture, 52, 58; Apollo, 22a, b, c, 229; from Piazza d'Armi, 20c, 228; from temple of Minerva, 23a, b, c, d, 229–30
- temples: Campetti, 53, 61, 185; Juno Regina, 53; Piazza d'Armi, 31; Portonaccio (Apollo), 31, 52, 53, 3c, 214; Portonaccio (Minerva), 61, 22a, 229, 23a, b, c, 229–30
- tombs: chamber, 56; pozzo, 54, 55; trench, 54, 55; Campana Tomb, 29, 56, 191, *20a*, *b*, 227–8, 229, 268; Tomb of the Ducks, 29, 57
- tumulus, Monte Aguzzo (Chigi), 56 urns, 58
- Villanovan culture, 26
- Velathri, 146
- Velcha family, 33, 80
- Velianas Thefarie, 51, 278, 279
- Velimna, 275–6; Arnth, 178, 276; Larth, 90, 275–6
- Velleia, 17, 18
- Velletri, 14, 58, 204, 205, 3e, 214
- Vel Satie, see Satie, Vel
- Vel Thansina, sarcophagus, 104
- Veneti, 5, 6
- Vertumnus (God), 121, 207, 185
- Vetralla (Viterbo), 104, 108
- Vetulonia (Colonna di Buriano, Etr. Vatl, Vetalu), 6, 16, 28, 47, 85, 87, 88, 117, 128–39, 142, 147, 158, 162
 - boundaries, 18-19
 - bronzes, 40, 132, 133, 135, 137, 63a, 256, 64b, 257, 66a, b, 259
 - bucchero, 10c, 222
 - jewellery, 134, 135, 234, 64c, 65a, b, c, d, 257-8
 - cemeteries: Colle Baroncio, 129; alle Birbe, 129, Poggio alla Guardia, 129
 - and Marsiliana, 112-14
 - pottery, 63b, 256
 - sculpture, 135, 136
 - tombs, circle, continuous, 129, 130; interrupted, 129; Circolo degli Acquastrini, 130, 135; Circle of Bes, 130, 256; Circle of the Bracelets, 130, 257; Circolo della Costiaccia Bambagini, 134, 63c, 256, Circle of the Cauldrons, 133; del Duce (the

Prince), 130, 133, 135, 154, 194, 219, 259; del Figulo (the Potter), 130; Circolo della Franchetta, 133; of the Lictor (Littore), 128, 134, 136, 258; Circolo delle Migliarine, 135; delle Pellicce, 130; Circolo della Stele, 135; of the Trident, 133, 136, 148

- tombs, chamber, 130; del Diavolino, 130; Pozzo dell'Abate, 130; of the Three Boats, 133
- tombs: pozzetti, 129; ripostigli stranieri, 129, 137
- tumulus della Pietrera, 130, 135, 136 Villanovan culture, 26
- Vetusia, 14
- Vibenna, 15, 60, 95, 212
- Vico, lake, 63, 70, 108
- Vicus Tuscus, 14, 121
- Vignacce, 52
- Vignanello (Faliscan area), 66
- Villanova, 22
- Villanovan culture, 7, 22, 25, 26, 27, 105, 106, 118, 154, 210; see also individual cities; Caere, 39, 40; Chiusi, 162; Orvieto, 122; Populonia, 141; Rusellae, 138; Sarteano, 162; Tarquinii, 70, 72, Veii, 52, 53; Vetulonia, 129; Volaterrae, 148; urn, 27b, 232-3
- Visentium, see Bisenzio
- Vipiiennas, Avile, 60
- Visnai, Ramtha, sarcophagus, 53, 250
- Viterbo, 108, 109; bucchero, 93a, b, c, 277-8; see also alphabet
- Volaterrae (Volterra, Etr. Velathri), 6, 16, 93, 146–56, 195, 263
 - and Populonia, 140-41; and Rome, 128

boundaries, 17

- cemeteries, 147–8; (La) Badia, 149; Guerruccia, 146, 148, 149; Montebradoni, 148; Portone, 149, 150; San Girolamo, 149, 261; Ulimeto, 148; Villanovan, 148
- gates: Porta all'Arco, 146, *69a*, 260; Porta Diana, 146

inscriptions, 195, 196; 197

Le Balze, 146

- magistrates, 200
- pottery, 150, 171, 177, 70b, c, 261

GENERAL INDEX

Volaterrae-cont. sarcophagi, 150 sculpture, 149 stelae, 159-60; Laiatico, 160; Montaione, 160, Pomarance, 149, 152, 160; Tite Avile, 149, 160; 69b, 260 temple, 147 tombs: Casaglia, 157; Casalmarittimo, 157, 71a, 261-2; cassetta, 148; dolio, 148; fossa, 148; Inghirami, 70a, 261; pozzetto, 148 urns, 35, 150, 151, 177, 250, 71b, 262, 91,276 Villanovan culture, 26 Volsci, 14 Volsinii (Etr. Velsu, Velzna, Velznani), 19, 49, 70, 85, 100, 102, 108, 109, 120-21, 189; and Rome, 33, 86, 147, 202, 207 Apollo, 186 Fanum Voltumnae, 207 Roman city at Bolsena, 110, 119 temple, Pozzarello, 185 Volsinian vases, 120 Voltumna, 185, 207; see also Fanum Voltumnae Volumni, tomb of Perugia, urn, 90, 275-6 Vortumnus, 185 Vulca, 52, 59 Vulci, 16, 17, 19, 23, 40, 58, 59, 66, 70, 74, 81, 82, 84-97, 99, 100, 102, 111, 113, 120, 123, 127, 128, 166, 207 black-figure vases, 94 bronzes, 88, 92, 93, 4c, 215, 41c, 242 bucchero, 88, 94; sottile, 46 cemeteries: Cavalupo, 87; Osteria, 85; 87; Ponte Rotto, 87, 90, 95, 96, 97

cippus, 43b, 243 François tomb, 51, 49b, 50a, b, 249; see below tombs, François jewellery, 48, 41a, b, c, d, 241-2, 42a, b painted tombs, 95 Ponte Sodo, 54 pottery, 48c, 248; 49a, 249 sarcophagi, 36, 96, 125; of Ramtha Visnai, 52, 53, 250 sculpture, 30, 90, 92, 240, 43c, d, 243-4; statue from Grotta of Isis, 43a, 243 temple, to Heracles, 86 terracotta decoration, 97; 54a, b, 250-51 tombs, 42; of the Bronze Chariot, 84, 87; Campanari, 94, 102; chamber, 88; fossa, 87; François, 13, 34, 35, 36, 60, 94, 95, 96, 1, 212, 49b, 50a, b, 51, 249; Polledrara (Grotto or Tomb of Isis), 90, 91, 243; pozzetto, 87; of the Sun and the Moon, 89; of the Warrior (Avvolta), 87-8 tumuli, Cucumella, 89, 90; Cucumelletta, 89; Rotonda, 89 urns, 87 Villanovan culture, 26

writing tablet from Marsiliana d' Albegna, 116–17, 193, 94b, 278–9 writing, 193–8

Zagreb, mummy, 5, 195–6 Zeus, 182–3, 185, 186, 41c, 241–2, 87a, 274 zilath (magistrate), 51, 199–201, 203, 204, 207 ziro tombs, 163–4